$6 ⁰⁰

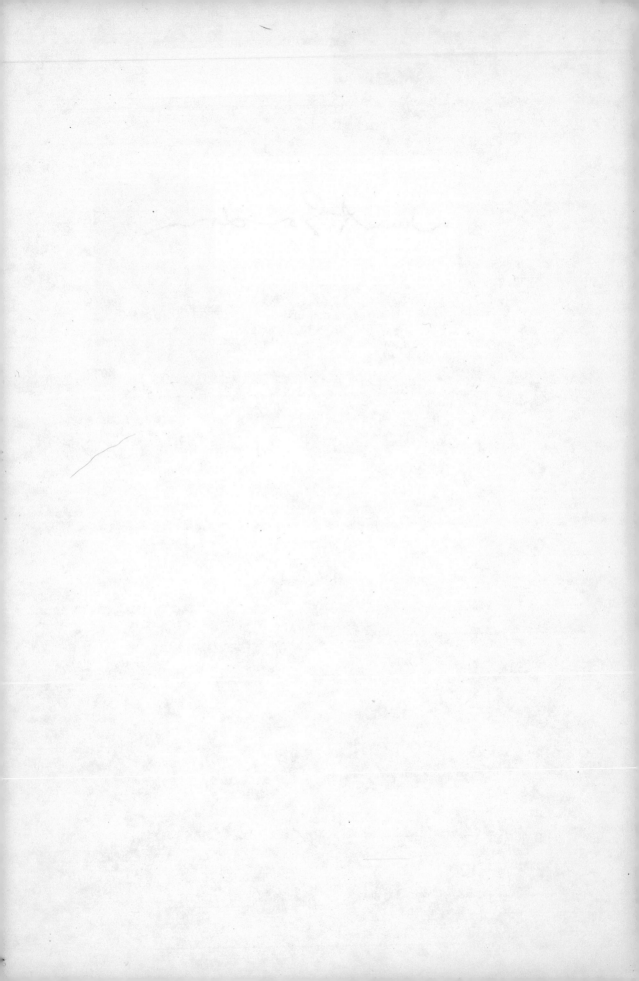

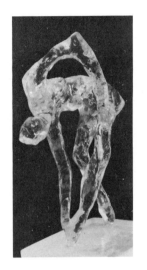

PLASTICS
AS AN ART FORM

PLASTICS
AS AN ART FORM

Revised Edition

THELMA R. NEWMAN

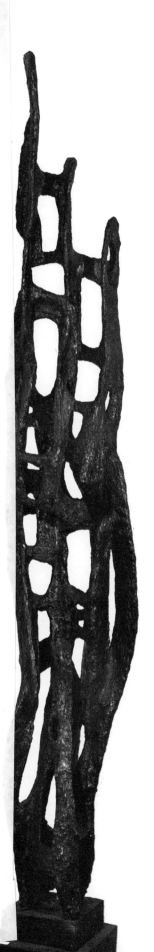

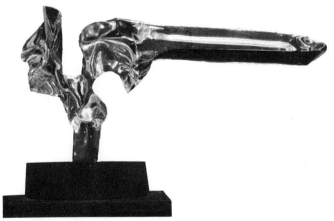

CHILTON BOOK COMPANY

Philadelphia New York London

To my boys: JACK, JAY *and* LEE

Contents

Illustrations

xiv

xv

COLOR PLATES

All photographs by Lou Thurrott unless
otherwise credited

Preface

This is essentially a source book for artists, craftsmen, and art educators who desire a foundation in plastics as an art form. To help achieve this purpose the text describes plastics' properties, processes, and art forms. It also seeks to establish potential directions for expression with these organic polymers.

A worldwide survey endeavors to introduce the reader to what is being done by artists working with plastics. Introductory experiments and explorations, as well, aim to acquaint the artist, craftsman, and art educator with what is new in the field of creative "plastics" expression, and to carry the reader toward the acquisition of a personal polymer vocabulary.

Publications in this field, to date, are either slanted toward the industrial arts or toward the industrial user. Industrial use, for its purposes, has couched information about plastics in deeply technical language. In order to describe plastics in lay terms, the most commonly used terminology is defined here as nontechnically as possible, so that the artist-designer can become reasonably conversant with the complex of polymer chemistry and engineering.

Transposing formula, property, and specification terms into nontechnical language has its special difficulties. It still remains a somewhat specialized terminology, but if the creative user is to go beyond elementary expression, he will need more informa-

tion, and will want to know how to apply theory to practice. Art projects are pictured in step-by-step descriptions to enable the reader to feel actual experience with these new materials and to provide the background for his future solo explorations.

At this writing, there are more than twenty different basic plastics with an infinite potential to combine and create new varieties. The limitations of the studio and the artist's preference for a direct approach exclude, for creative art expression, many of these varieties. Expensive and extensive equipment automatically helps to determine which plastics have the most potential. There are, however, many polymers that are easily adapted to art expression. Also, there are many families of plastics which, if the artist has creative insight, may provide future possibilities. Methyl methacrylate, polystyrene, polyethylene, polyester, epoxies, vinyls, silicones, and foams are among the plastics considered here in detail.

The artist's concern, too, for obtaining different and distinctive textures to suit his expression often runs counter to industrial standards of uniformity and accurate reproduction of textural variations. Light, color, texture, and form provide a unique basis for expanding plastics' practicability and the artist's vocabulary. Sometimes subtle, individual, and accidental variations are not feasible in industrial use (even when production is for decorative purposes). For example, an accidental effect—perhaps an internal bursting of a bubble—can produce excellent and unusual textures, but the inability to reproduce these variations consistently challenges the manufacturing requirement for standardization. In this case what is industrial waste is the artist's treasure. Although not mentioned in previous writings on plastics, directions for such use appear here for the first time.

Plastics have lives of their own—their own special identity. For the purposes of art expression, plastics can be used for their own sake and not as imitative or substitute materials. This, as much as any other factor, was the motivation that made this book an actuality. It is the underlying concept that influenced the entire presentation.

<div align="right">T. R. N.</div>

Contributing Artists

Amino, Leo
Anderson, Joyce and Edgar
Artschwager, Dick
Baden, Mowry
Baj, E.
Baldwin, John
Beasley, Bruce
Behl, Wolfgang
Benton, Thomas Hart
Bolomey, Roger
Booth, Cameron
Breer, Robert
Cassar, Marianne
Chamberlain, John
Chilton, Michael
Colombo, Gianni
Condopoulos, A.
Couzyn, Seymour
Crippa, Robert
Daphnis, Nassos

Davis, Gene
Del Pezzo, Lucio
Demarais, Joseph
de Moulpied, Deborah
Deshaies, Arthur
Dreher, Fred
Duca, Alfred
Elsocht, Robert
Epping, Franc
FeBland, Harriet
Frankenthaler, Helen
Friedensohn, Elias
Fuller, Sue
Gabo, Naum
Gallo, Frank
Hallman, Ted
Hamar, Irene
Harmon, Robert
Hatch, John
Higgins, Edward

Hinman, Charles
Hoener, Arthur
Hudson, Tom
Jacquez, Albert F.
Jones, Robert L.
Kauffman, Craig
Kentakas, D.
Klein, Yves
Koblick, Freda
Konzal, Joseph
Kosice, Gyula
Krauss, Russell
Krushenick, Nicholas
Kyriakou, T.
Landis, Lily
Lenson, Michael
Le Parc, Julio
Lepper, Robert
Levine, Les
Lichtenstein, Roy

Love, Arlene
Low, Jeffrey
Mallary, Robert
Manders, Jos
Marantz, Irving
Matlezos, T.
McClanahan, Preston
McGowan, Ed
Michel, Marie Louise
Mieczkowski, Edwin
Moholy-Nagy, Laszlo
Moore, Henry
Mortellito, Domineco
Nevelson, Louise
Newman, Thelma R.
Norman, Emile
Oldenburg, Claes

Ossorio, Alfonso
Oster, Gerald
Pereira, I. Rice
Persico, M.
Pevsner, Antoine
Polesello, Rogelio
Reid, Sara
Reiman, William
Riley, Bridget
Rubin, Irwin
Salberg, Lilo
Sandle, Michael
Schatz, Zahara
Severson, William
Siqueiros, David Alfaro
Sobrino
Specht, Peggy

Tadasky (Jadasuke Kuwayama)
Town, Harold
Tucker, Albert
Tucker, William
Vasiri, Mohsen
Vitale, Joe
Viterbo, Susy Green
Vrana, Al
Warhol, Andy
Weinrib, David
Wesselmann, Tom
Willet, Henry Lee
Wingate, Arlene
Winslow, Earl B.
Yvaral (Jean Pierre Vasarely)
Zammitt, Norman
Zerbe, Karl

Acknowledgment

A source book such as this owes its being to countless anonymous authors of technical articles, to museums and galleries throughout the Western world, and to the cooperative artists, craftsmen, architects, and designers whose work is represented here. They have generously given of themselves to make this book possible. The extent of my indebtedness is so great that a list of these authorities and direct sources would alone require a special section. I do not, however, forget their encouragement and faith in me and my work.

I want to express my appreciation, also, to Dr. William J. Mahoney, whose insight helped initiate this project and who closely counseled me throughout its growth. Special thanks, too, must go to Miss Madeline Van Woeart, "Girl Friday" who generously lent her talents and energies; and to Lou Thurrott, whose patience and skill as a photographer are unequaled.

My endless gratitude, also, to my patient sons who, not without interruption, lent moral support. And lastly, to the person who made possible all the intensive and extensive work, my devoted husband, Jack Newman—to him goes great indebtedness for his unselfish encouragement and assistance.

T. R. N.

PLASTICS AS AN ART FORM

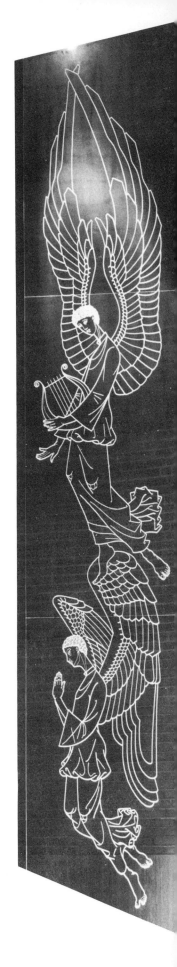

Plastics: The New Art Medium
An Introduction

Plastics have created a silent revolution in our time. They have achieved this by entering into areas affected by shortages after World War II and then dominating fields formerly satisfied by traditional materials. This plastics revolution happened so quietly, so functionally, that we seem to be suddenly surrounded or touched everywhere by plastics in some form.

It has been a hundred years since the last art material, photographic emulsion, was invented. The fact is most surprising when one considers the accelerated development of technology in our age. In itself, for the sake of newness, there is little justification for a new art material. Old substances are useful enough to help reflect the temper of an age. Actually, plastics are created mainly for industrial purposes. This new matter, though as versatile as any old forms, flexible enough to stand by itself as any other medium, is a material that strongly reflects its own era. Whether used for outer space and rocketry, or as a vehicle to express man's soaring imagination, plastics are certainly valid and likely representatives of today's world.

The qualities of plastics, a varied, flexible family of materials, unlike substances we have lived with for centuries, are new and sometimes unparalleled in nature. They have caliber and characteristics of their own. There is no valid precedent for their use. It is their unusually plastic,

1

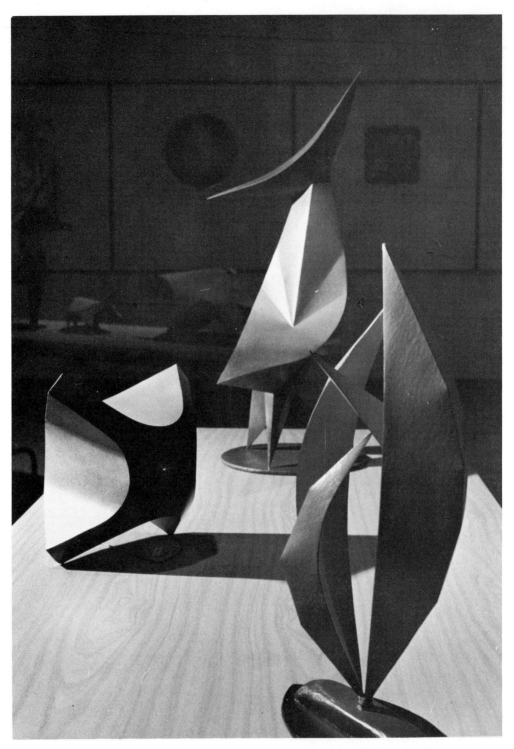

These sculptures by Peggy Specht of Toronto, Canada, are made from a cellulosic (man's first plastic) called Forbon (Parsons Paper, Holyoke, Mass., a division of the NVF Co.). This material responds like paper, inasmuch as it can be scored in any direction, folded, cut, painted and glued. It has quite a bit of dimensional stability, considering its light weight.

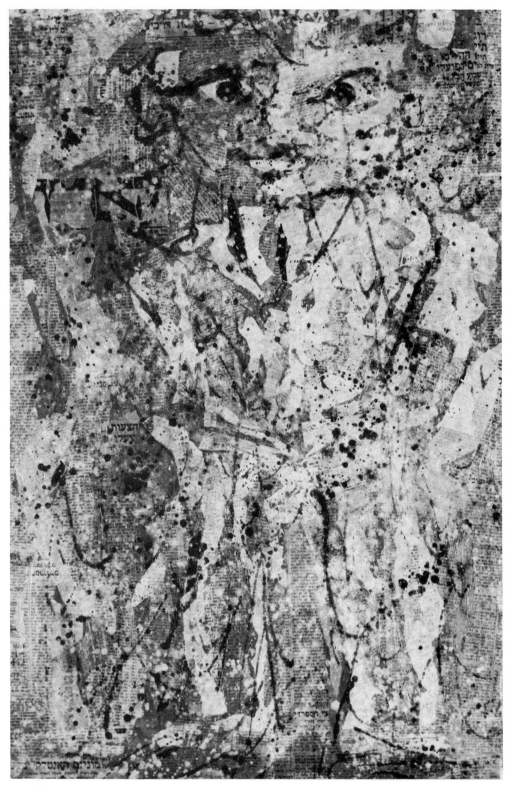

"Sitting Woman Variation" by Karl Zerbe shows the use of newspaper as a "painting" texture, both adhered and painted with acrylic emulsion. (21″ x 14″, 1961.)

Courtesy Karl Zerbe

3

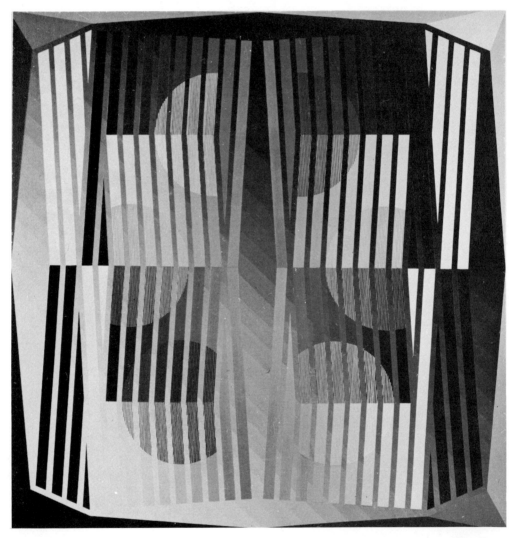

Edwin Mieczkowski. "Fuseli's Box" (24" x 24", 1964). Liquitex on masonite. Fine lines are made easier because of the quick drying of acrylic paint.

Courtesy Martha Jackson Gallery, New York

4

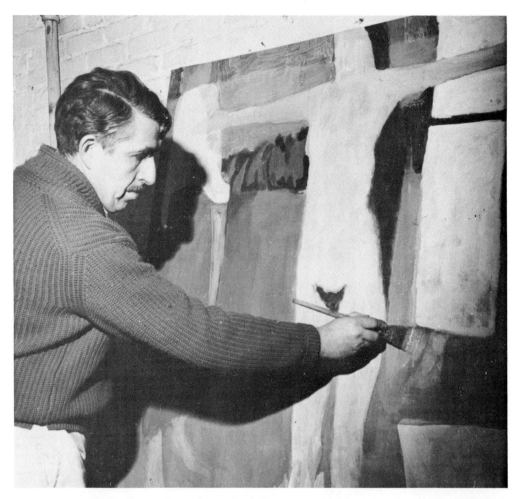

Irving Marantz applies a sheer glaze of acrylic over a freshly painted area just "minutes" after beginning.

Photograph by the author

formable quality that makes them a natural material for the artists' studios as much as marble, bronze, clay, or iron.

The new plastics' strange potential is bound to change traditional art forms because of the new technical demands and innovations that the substance requires. We will see that artists' expression has already been modified by these polymers. These new materials reach frontiers heretofore unknown to creative users of traditional media because they are capable of going beyond the capacity of other substances.

Just as the whole development of painting changed with the introduction of oil paint in the fifteenth century, five centuries later another breakthrough occurred. The meticulous hard edge of op art paintings would have taken endless hours in drying time if it were not for the quick drying polymers. Karl Zerbe's use of newspaper with his paint, Jackson Pollack's over-layered calligraphic paintings, Irving Marantz's flat broad planes or subtly glazed forms, Harriet Fe-Bland's translucent paintings—to name but a few of all those painters who have used these synthetic media—have found a change in their approach, technique, and style of painting. Or, they chose the media because of these new possibilities.

The painter who works with polymer media discovers a greater freedom in the

5

use of colors, mainly because there are no discoloring binders and drying time is reduced. Pigment, also, is no longer the only colorant because sand, paper, metals, etc., are some of the endless sources for color and texture with plastics. Many of the polymer media, acting as permanent adhesive binders, allow the painting surface to project away from its ground with more than impasto—like a bas-relief, bringing it closer to sculptural form. Robert Mallary was an innovator here, and in Italy we find the works of Roberto Crippa and Lucio del Pezzo moving into the realm of three dimensions in painting.

The sculptor also has produced Western world innovations. He can work directly with a material that is considerably lighter in weight than bronze, is cheaper, and still can compete in stability and structural strength. American sculptors Franc Epping and Lily Landis using epoxy materials find common ground with the Greek sculptor T. Kyriakou in innovating a dynamic, direct art form with a new material.

Artists have refined fiberglass reinforced polyester and epoxy techniques to achieve editions of a single sculpture economically. Frank Gallo's work exemplifies this technique.

The acrylics, too, have led to new but different paths as shown in William Reiman's and Fred Dreher's sculpture, Ted Hallman's weaving of yarns accented with acrylic shapes, and Freda Koblick's crystal acrylic structures. Each artist displays in his personal, unique way the highly individual and versatile range of plastics' expressive potential.

These artists, by way of experimentation, are successfully creating new technical solutions for their significant forms. Increasing numbers of artists are using different kinds of plastics every day, be-

"Ecco la Donna," completed in 1962, by Irving Marantz. Rhoplex on raw linen. (51" x 70".)

Courtesy Irving Marantz

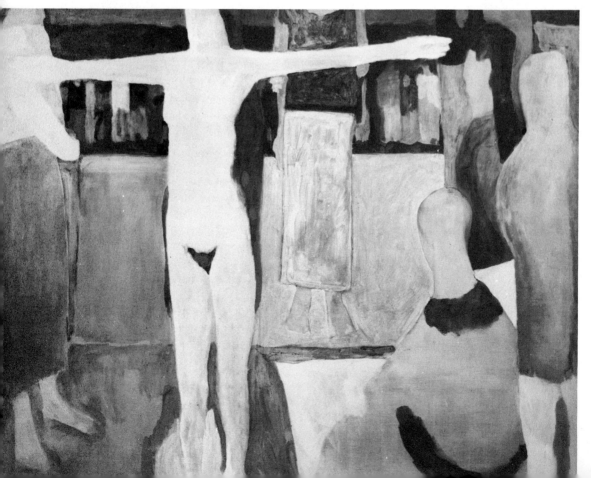

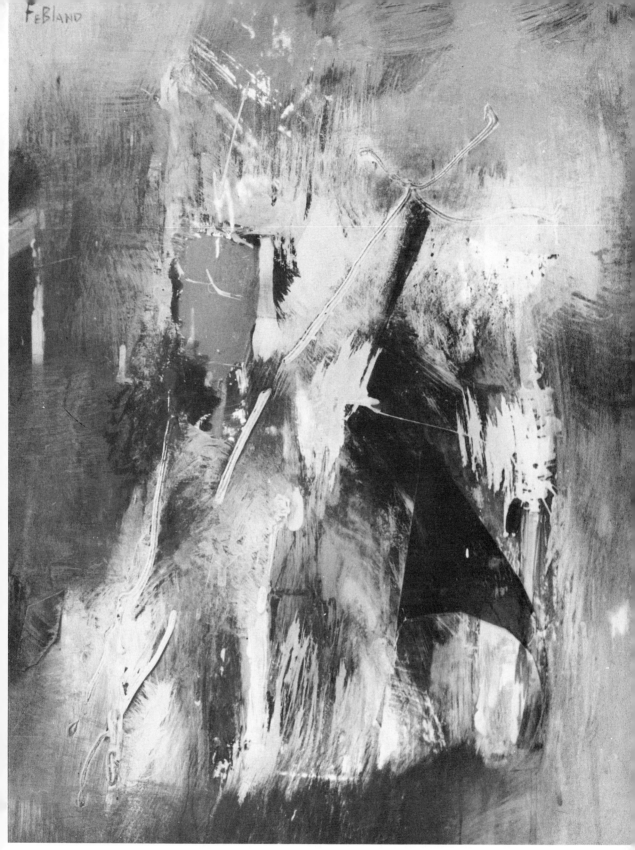

Harriet FeBland's translucent acrylic painting on clear acrylic sheet, "Forest."
(20″ x 24″, 1960.)

Courtesy Harriet FeBland

Robert Mallary uses all kinds of materials—glass, plastic, gravel—for his 18″x18″ polyester bas-relief called "Family Group with Animals" (1954) *Courtesy Collection of Lez L. Haas*

cause of the important advantages and stimulation to personal vision that this new medium affords. Contemporary explorations such as these have profound implications for the creation of new art forms. They have given us a new form of polychromed sculpture, three-dimensional and translucent paintings, sculptures, and jewel-like mosaics and panels, space definition without use of solid forms, organic convoluted foam walls, frozen fluidity, crystal-like masses and textures. These are a few innovations by leaders who dared venture into the forbidden territory of industrial materials.

The artist seeking suitable vehicles for his expression has at his disposal a rich variety of substances—polyesters, epoxies, acrylics, silicones, vinyls, polyethylene, polystyrene, urethane, and foams—some of the more pertinent plastics that artists can use. The problem of selecting the proper medium arises when the artist has to choose from a great variety of these

8

Vinyl with its preservative and adhesive qualities makes possible this bas-relief painting by Roberto Crippa called "Origine." (57 x 73 cm., 1962.) *Courtesy Galleria Schwarz, Milan, Italy*

Lucio Del Pezzo uses vinyl in a three-dimensional painting, "Piccolo Studi per un Quadro Napoletano." (29 x 22 cm., 1960.) *Courtesy Galleria Schwarz, Milan, Italy*

very different polymers. Which should he use? His choice should be based on his own needs in combination with a thorough acquaintanceship with the possibilities and characteristics of the various media. Selection or exploration is a continuing process and not one that is solved once and finally, at a single stage of the artist's development.

Or, it may be that as the artist's style changes, he will need a new instrument of expression. His evolving purposes and concepts may need this new instrument. What is learned from the material and process here is bound to bring forth some new techniques and variations in style and method. We must, however, remember to keep emphasis on material and

techniques in its "place." Material is the vehicle that transports the expression; technique is its agent; and significantly, the *idea, its essence*. Even though the emphasis of this book is on process and material, it must be cautioned that material should not dominate the artist, but the artist his material. With new substances that have radical visual and physical attributes the artist must use an equally radical imagination to discard old premises and processes.

Historical evidence points to the emergence of a changed aesthetic when a new medium is introduced. Remember how the echoes of the new photographic approach in the late nineteenth century resounded in impressionist painting? Some

directions can be interchanged from one medium to another, depending upon the artist's intent and the material's properties. Others require new solutions. But as with all media, these new polymers have their limitations as well as potentials. These have to be understood, not only through technical facility, but also with a mastery that is achieved through deep insight into new qualities.

I have learned, when lecturing about plastics, that concepts of color and texture really belonging to the opaque and solid media were often used as guideposts by students working with plastics. The results were merely imitative. Success was not achieved until the artist sensed and perceived the meaning of plastics' frozen fluidity. Edgar and Joyce Anderson ably demonstrated this plastic fluidity by freezing color as it flowed in the plastic liquid, not with ice, but with catalyst-generated heat.

Heretofore, materials used in graphic expression were relatively fragile when compared with the strength and lasting qualities of materials used in architecture and sculpture. The peeling, cracking, yellowing, and fading of the graphic media is no longer a problem with the stronger, light-stable, adhesive plastics.

Impastos, overlapping to any depth, embedding colorants and textures—as Zahara Schatz did with polyester resin and Lilo Salberg with pyroxylin—lend a new structural dimension to painting. Physical and chemical laws applicable to traditional graphic media are different for plastic art materials because of this potential. Transparency, too, finds even greater significance now than it did in yesterday's stained glass windows and rare small glass sculptures—color, size, and shape find free play—there is no limit and fewer limitations than with the older "translucent" media. Plastics, therefore, require proper selection and knowledgeable use so that the artist's intentions can be fluently expressed and can find some degree of permanence when

T. Kyriakou's "Entertainer" was also made with an aluminum filled epoxy (1960).

Courtesy New Forms Gallery, Athens, Greece

11

"Le Paix" (side view). Lily Landis constructed this massive aluminum and epoxy sculpture. (5'6" x 5', 1961.)

Courtesy Lily Landis

transported into time. Remember that sound substances can yield poor results when used improperly.

The ancients as well as the master artists of yesterday were very much concerned about the long-lasting qualities of their work. They worked tediously to achieve some degree of permanence. The concept of permanence does not seem to be an important predilection today. Many artists do not mind if their work has a temporary life. And because of the kind of life we live, we have relinquished much of our knowledge and interest in the technical problems of our craft to the manufacturers. Hence, we are dependent upon the manufacturer's reliability. We are at a beginning again, when using plastics, as the early artist was who had to compound his own materials. Since plastics have been borrowed from industry, much trial and error, adventure, innovation, and compounding are again necessary for the artist. If the artist is concerned with permanence, he has to be careful as to which plastics he selects. If this is not a preoccupation, then any number of plastics will produce excellent results, although not too permanent ones.

In either case, some testing and experimentation are necessary. Artist Alfred Duca developed vinyl in this way, as an early painting medium, marketed as Polymer Tempera. Some basic knowledge of the technical realm of plastics can be most helpful.

Some artists prefer to work toward direct accomplishment. Toward that end, the artist owes much to the scientist-engineer. Here is where he learns about using these infant materials—about what they are and how they can be developed into forms. He may even borrow laminating, molding, coating, and casting techniques as did William Severson and Deborah de Moulpied in their sculptural forms. Suzy Green Viterbo of Italy, using her husband's extruding machine, created convoluted forms as the hot plastic emerged from the machine's orifice.

Crystal-like masses and texture such as this polyester sculpture, "Metamorphosis of a Human" (by the author, 1961), illustrate a new consciousness toward translucency and transparency.

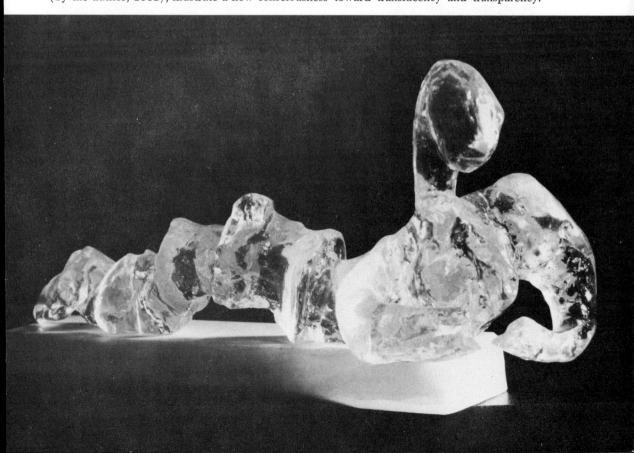

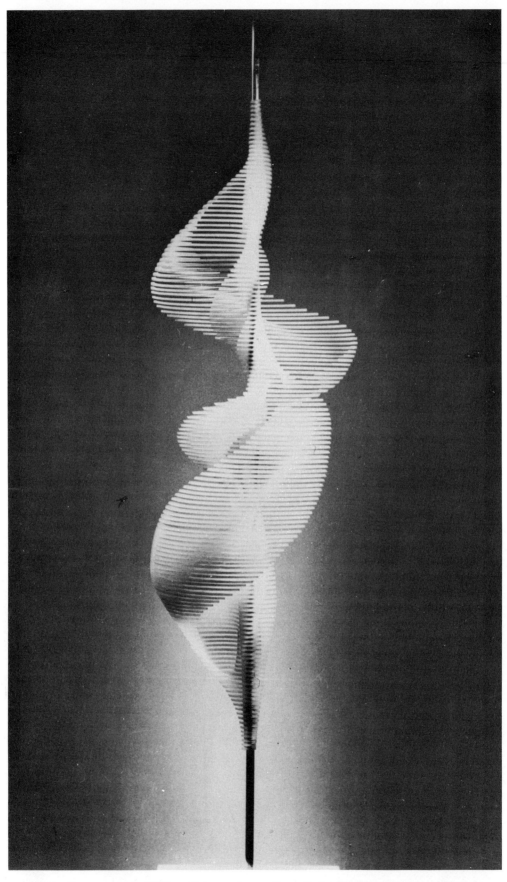

In another approach, William Reiman also used acrylic for his "White Study, 1961."

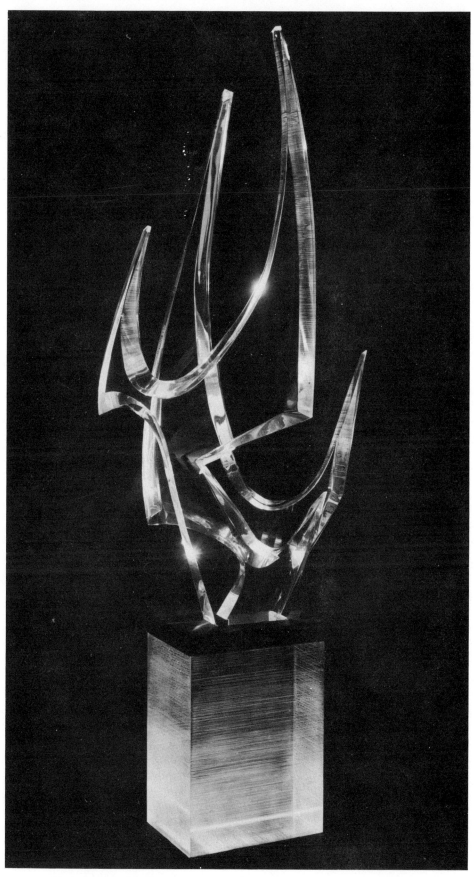

Fred Dreher, "Nightwings." Carved clear Plexiglas. (31″ x 12″, 1960.)

Photo by Chester Danett

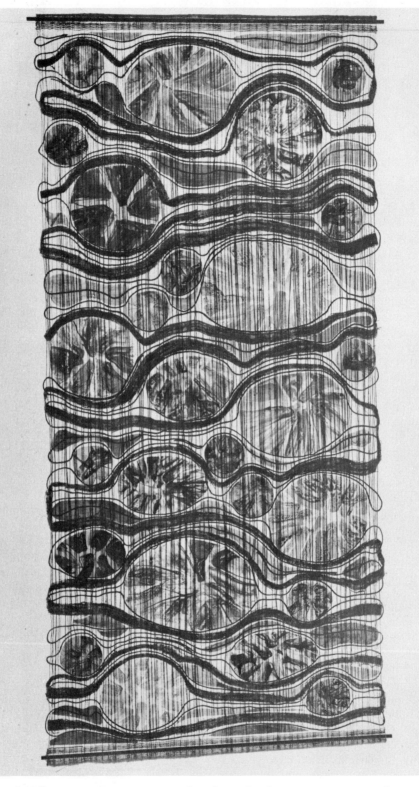

Ted Hallman weaves yarns accented with acrylic shapes creating a translucent, free-hanging woven painting. *Courtesy Ted Hallman*

16

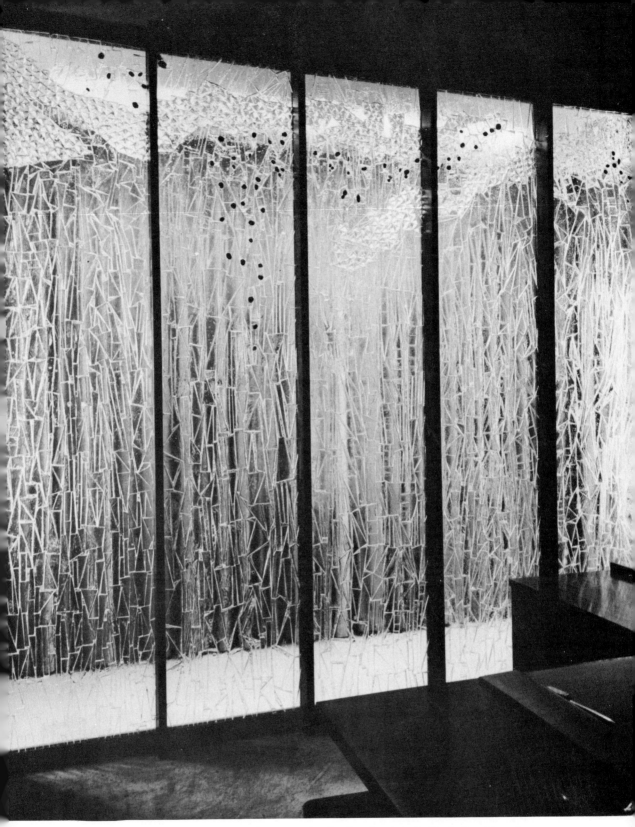

Freda Koblick's crystal-like acrylic screen for the Crocker-Angelo Bank, San Francisco, California, illustrates another approach with acrylic.

Courtesy Museum of Contemporary Crafts, New York

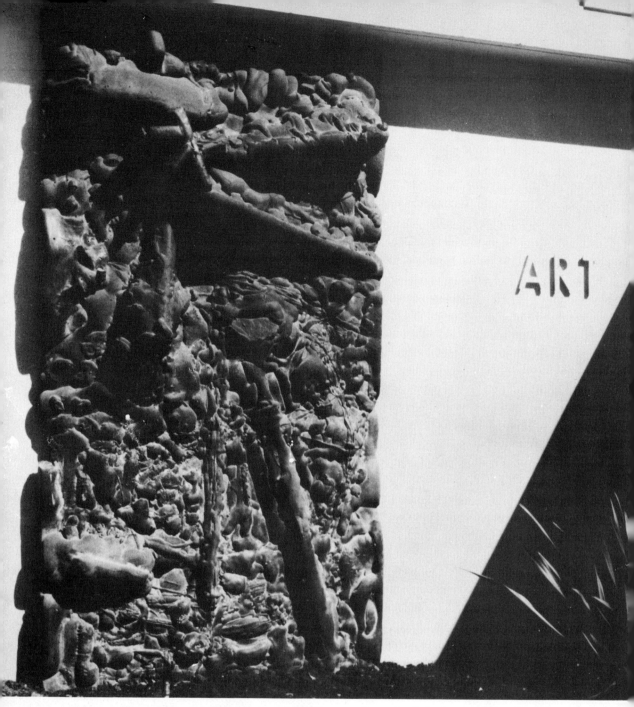

Roger Bolomey's organic convoluted foam sculptural relief of expanded polyurethane is a new art form that finds direct expression in a man-made material that has no peers in nature. (10'6" x 6', 1961.)

Courtesy Roger Bolomey

18

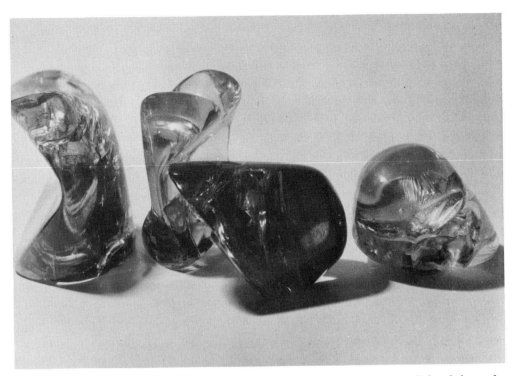

Joyce and Edgar Anderson ably captured a plastic fluidity in these small hand forms by freezing color as it flowed in the plastic liquid, not with ice, but with catalyst-generated heat.

Photograph by the author

The artist's leadership, his particular training, then, can bring the aesthetic, the quality level of our mass-produced plastic designs toward higher cultural attainment. His influence may beautify the implements of everyday living for everyone. The artist's vision unencumbered with preformed process and design standards and requirements can move dynamically to new frontiers. Occasionally he has an opportunity to work together with plastics engineers and chemists using plant facilities. In these cases he is capable of employing more complex methods and materials. Technologists are becoming more aware of the artist's problem and in most cases will volunteer assistance when asked.

Two acrylic panels created by Abraham Tobias at the Rohm and Haas plant are an example of how the engineer's knowledge of production, the chemist's understanding of polymer chemistry, and the artist's hands worked together, each contributing to the effective result. These panels, installed in the entrance area of the Brooklyn Polytechnical Institute, are formed of laminated layers of acrylic.

Laszlo Moholy-Nagy. "Double Loop" (24" long, 1946). Plexiglas.

Courtesy The Museum of Modern Art

19

The superimposed strata of subtle color variations, sandwiched between glass, are equally effective when seen by the transmitted light of the lobby or the reflected light from the street. John Hatch also worked with technicians for his windows at the Memorial Union Building of the University of New Hampshire.

Inventive and valid uses for plastics mark the work of Alfred Duca's lost-styrofoam casting. His invention, based on the lost-wax process but using styrofoam, provides a whole new direction for the artist-sculptor and industry as well.

Artists' facility with plastics leads to the mixing of plastic media, such as the use of acrylic with a polyurethane finish or cellulose, acrylic, polyurethane and fiberglass or fiberglass and acrylic—, any number of combinations will yield texture, color or moldability. Many of the sculptors from Great Britain combine plastics into suitable combinations. Michael Chilton often uses fiberglass, acrylic, cellulose and polyurethane in one piece. And Michael Sandle uses that combination with metal as well.

Use of plastics by artists recalls a prophetic statement written in 1946 by Laszlo Moholy-Nagy in his book *Vision in Motion*: "The new artist working with plastics inevitably has to take up scientific studies or else wait decades until knowledge about plastics becomes commonplace."

Much time has passed since this statement was written. Much that was mystery has been illuminated. Plastics are ready for artists' use. Yet the surface has only been scratched. Plastics as an art form is an open-ended area waiting for experimentation and exploration.

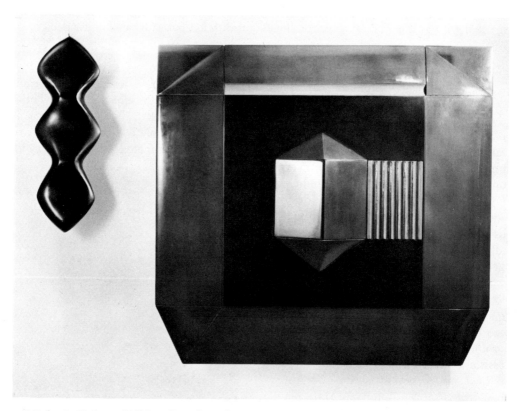

Michael Chilton. "Offshore" Multi-polymer: fiberglass and polyester, transparent plastic, cellulose and a very deep glazed effect accomplished by a final spraying of polyurethane.
Courtesy Michael Chilton

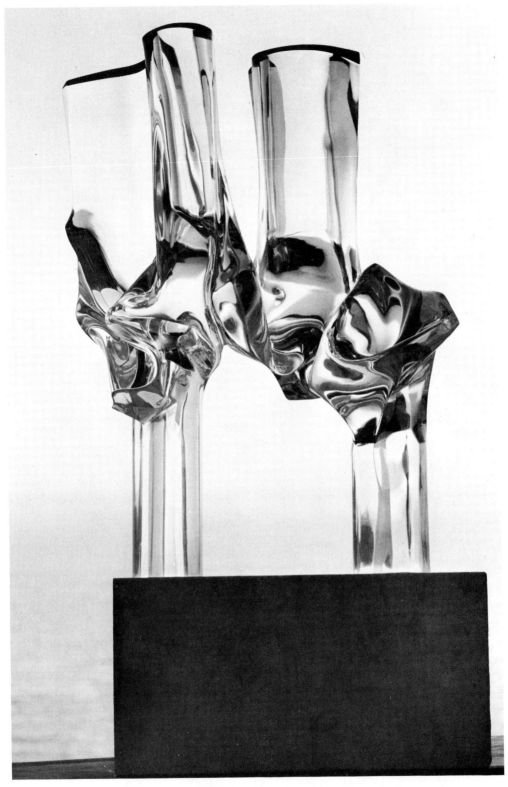

Bruce Beasley. "Untitled" (20″ x 30″, 1967). Cast acrylic.

21

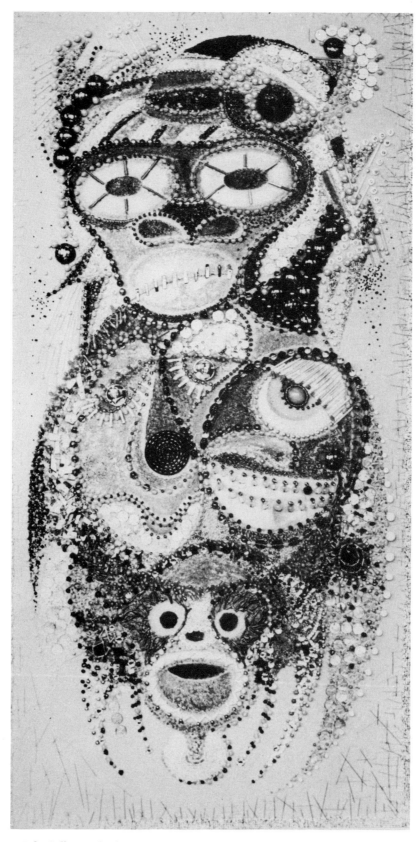

Lilo Salberg of Chile, using beads, shells, amber, mirror, metal, silk and cotton threads encrusted on fabric and painted with pyroxylin, created this exotic painting called "Memento Mori." (38" x 19".)

Courtesy Museum of Contemporary Crafts, New York

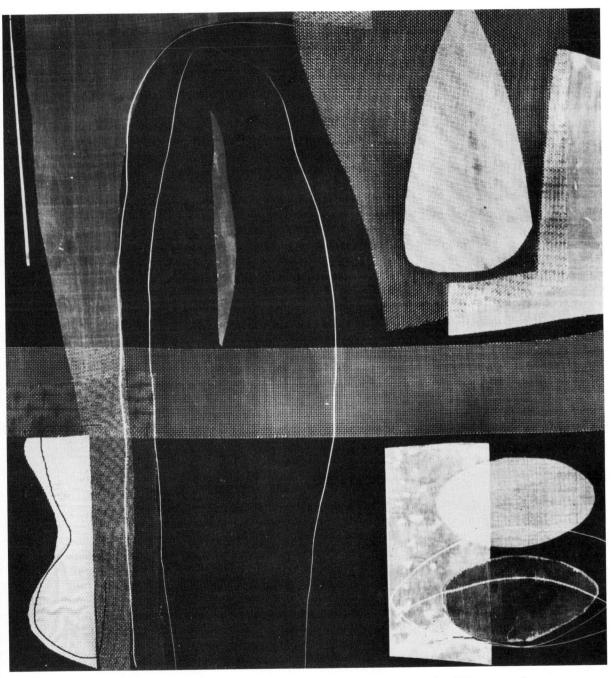

Zahara Schatz embedded color and texture with polyester resin in her "Abstraction."

Courtesy Bertha Schaefer Gallery, New York

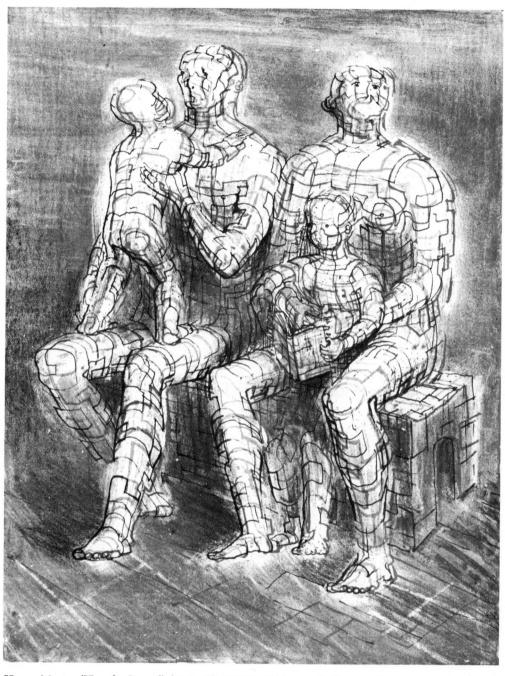

Henry Moore. "Family Group" (11″ x 8″, 1950). Lithographed printed in color on plastic.

Alfred Duca's styrofoam sculpture reposes in its bed of sand in preparation for his "Lost-Styrofoam" casting process. *Courtesy Alfred Duca*

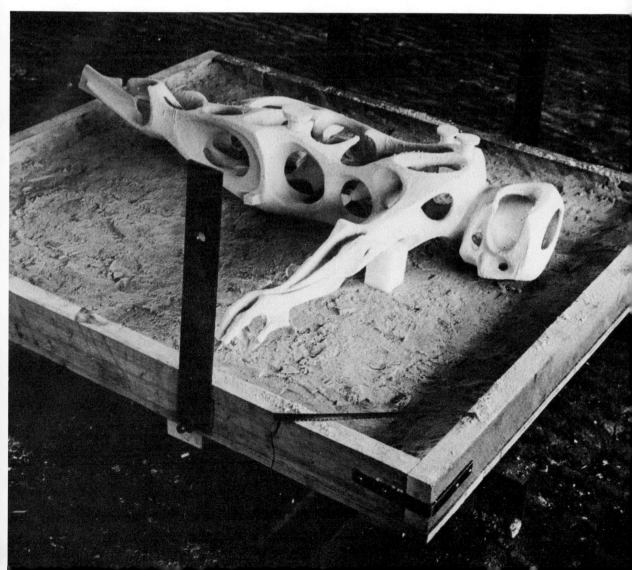

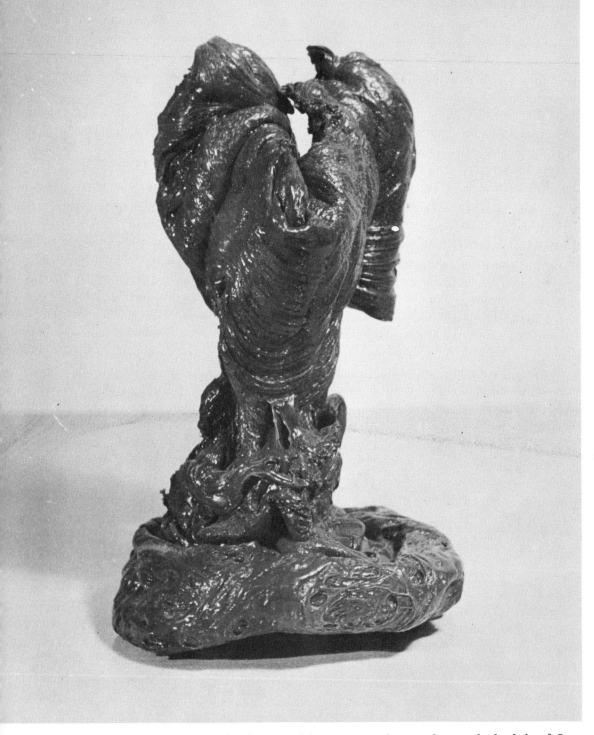

"The Victory of Samothrace" emerged from an extruding machine with the help of Susy Green Viterbo, an Egyptian artist living in Italy.

Courtesy Susy Green Viterbo

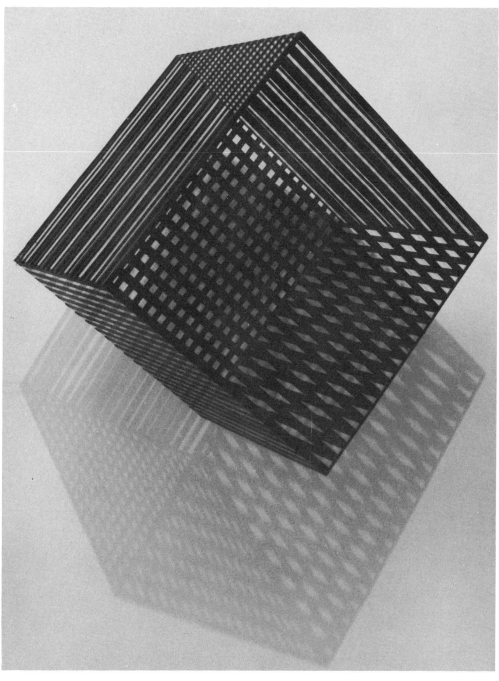

Yvaral, "Rescaux." Black resin in acrylic construction.

Properties of Plastics

One of the most important concerns of the artist, apart from the techniques of working with plastics, is primarily what a particular plastic can do. Plastics have a wide and diverse range of properties; each one is different. For knowledgeable selection and use, the artist must know what his material is like. This involves a plunge into a new vocabulary, unfortunately burdened with chemical and engineering terms. (If these terms are not defined in the text, they will be found in the Appendices and Glossary.) Initial exploration with plastics does not require any deep technical information, but, if one chooses to continue working beyond these primary experiments, a deeper understanding of technical language will be essential.

BASIC TERMINOLOGY

Out of coal, petroleum, natural gas, air, water, sand, and salt came the basic plastics that comprise this family of manmade materials. Each member has its own qualities and potential. In the strict sense of the word, a "plastic" is a substance which can be permanently formed or deformed under external stress or pressure, usually accelerated by the application of heat. The newly created form gains its shape by cooling, pressure, chemical action, or the removal of a solvent through evaporation.

A *plastic*, therefore, is any of a large and varied group of materials composed wholly or in part of various combinations of carbon, oxygen, hydrogen, chlorine, fluorine, and/or nitrogen. Though solid

in the finished state, it is *at some point in its process sufficiently fluid to be formed into various shapes.* This is accomplished through the application of heat and/or pressure.

Plastics are made up of two broad categories into which most of the polymers fall—*thermosetting plastics* and *thermoplastics.* Cross-linking of the thermosetting plastics holds chains of molecules tightly together. As a result, once the polymerization is completed and the polymer has hardened, heat will not soften it. The thermosets will *not* become fluid again if heat is applied but will remain solid up to their decomposition temperature. Clay is an example of a thermosetting plastic material.

The thermoplastics, on the other hand, are made up of coiled and long molecules intertwined in a tangled maze. When temperatures are normal, the molecules lie quietly. But once they are heated, the molecules begin to move around and the plastic becomes flexible again. Further heating causes the molecules to slip and slide over one another. The melted plastic becomes fluid. When cooled, the plastic will harden again and will go back to its original state or shape (this is often called plastics' "memory"). If heating continues, however, the thermoplastic will decompose. Metal is an example of a thermoplastic material.

The chemistry of plastics is very much like baking a cake. Most cakes are made up of basic substances such as flour, shortening, water, salt, milk, and sugar. Whether the baked goods becomes biscuit, cake, pancake, pie, or doughnut depends upon varying the quantity of the respective ingredients as well as the methods of mixing and cooking.

So the chemist by maneuvering comparable variations in ingredients, mixing and processing, creates a specific polymer. The plastics chemist actually takes natural resources apart, breaking them down to their basic molecules and atoms. With these building blocks he uses heat, pressure, or chemical action to cause these building blocks to combine in order to create the new polymer.

Almost all synthetic resins of plastics are *organic materials.* This means that they contain the element carbon. These organic substances can be remarkably numerous, large, and complex. (Inorganic molecules are relatively simple in their structure.) This happens because

PRESENTATION OF NEW PLASTICS MATERIALS

	Material		Material
1868	Cellulose Nitrate	1942	Polyesters
1909	Phenol-Formaldehyde	1942	Polyethylene
1909	Cold Molded	1943	Silicones
1919	Casein	1943	Fluorocarbons
1926	Alkyds	1945	Cellulose Propionate
1926	Aniline-Formaldehyde	1947	Epoxy
1927	Cellulose Acetate	1948	Acrylonitrile-Butadiene-Styrene
1927	Polyvinyl Chloride	1956	Acetal Resin (Delrin)
1929	Urea-Formaldehyde	1957	Polypropylene
1935	Ethyl Cellulose	1957	Polycarbonate Resin
1936	Acrylic	1959	Chlorinated Polyether
1936	Polyvinyl Acetate	1962	Phenoxy
1938	Cellulose Acetate Butyrate	1963	Polyimides
1938	Polystyrene	1965	Iomomers
1938	Polyamides (Nylon)	1965	Parylene
1938	Polyvinyl Acetals	1965	Polysulfone
1939	Melamine-Formaldehyde	1966	Polyphenylene oxide
1939	Polyvinylidene Chloride		

the carbon atom combines with other carbons as well as with atoms of other elements. If we could magnify a molecule of carbon-chain substances we would see that the carbon atom combines into long chains or rings with atoms of other elements hanging onto the sides. For example, if the chain forms into a six-atom ring, then this particular ring is known as the benzine ring. The backbone of these chains and rings is always carbon.

The bond or clinging force of the carbon atom, as it clings to the other atoms, varies considerably. In most cases the bond weakens as the atoms are heated. In these instances the substances are unstable as temperature goes higher. Organic or carbon substances are sensitive to heat. Heat and pressure can cause the unstable molecules to link and form a larger molecule. This is called *polymerization*. A substance much different from the original is created, and whenever the structure of a molecule is changed another different substance is formed.

Some molecules combine easily; others do not join; some can be made to unite by the introduction of a catalyst. Once the molecules are induced to combine, they do so with great rapidity. A molecule that has not combined is called a *monomer*. A monomer is the basic material the plastics manufacturer uses to make his plastic compound. The polymerized molecule may contain several thousand molecules of the original monomer.

The combining action of the molecules can be triggered by heat, pressure, catalysts, or combinations of these. A *catalyst* is a substance that can accelerate or retard a reaction. Although a catalyst enters into this action, it may be recovered practically unchanged at the end. Actually, these chemicals are not true catalysts because they become part of the cured plastic and cannot be recovered.

Most of the catalysts are used to trigger or speed up a molecular arrangement.

There are, however, negative catalysts that slow down the chain action. These are called *inhibitors*. We use both inhibitors and accelerators in formulating our plastic media.

Variations in material and methods of achieving polymerization make for a great number of plastics. Today's rich resource of different kinds of plastics seems incredible when one considers that the first plastic material, a cellulose, appeared on the scene in 1868.

Paving the way, in 1855, an Englishman named Alexander Parkes treated cotton with nitric acid in the presence of sulphuric acid and obtained nitrocellulose or pyroxylin. Later, collodion, a mixture of pyroxylin and ether, was used as a first-aid film to cover wounds. While applying collodion to a cut finger, it occurred to John Wesley Hyatt that this substance might provide the foundation for a substitute-ivory. (He was inspired in his search by a newspaper notice of a $10,000 contest for a substitute-ivory for use in the forming of billiard balls.) Trying various combinations, he mixed solid camphor with nitrocellulose, applied heat and pressure, and came up with the material we call cellulose.

The first modern plastic found many uses. Dentists utilized it, colored pink, as a light-weight replacement for hard rubber dental plates. Celluloid toys and shirt cuffs found their way to shops. Eastman manufactured celluloid photographic film in the 1880's.

Fifty-four years later, in 1909, Leo H. Bakeland, a chemist, found that mixing carbolic acid (phenol) with formaldehyde would produce a gummy material that would not dissolve or wash out of his test tubes. Named in his honor, Bakelite became a true plastic material—a substance that could be molded into any desired shape and set through heat and compression.

From that point on, progress was rapid. Combinations of different materials under varying conditions produced com-

plex organic polymers—each development yielded a plastic with its own unique properties. And each plastic in each family of plastics had its own strengths and weaknesses. Steel and brass, both classed as metals, have many qualities that characterize them as metals. Nevertheless, there is a great difference in what each can do, because of the variance in their properties. The attributes shared by them to a greater or lesser degree, however, rationally classify them as "metals." Plastics as well can vary considerably.

These properties, with their implied differences and variations, help govern technique and suggest which plastic will best suit a particular expression.

Within a delimited range, it is possible to modify a plastic's properties. For instance, you may like a particular crystal-like polyester resin and may wish to use it with metal. After some trials you find this water-white material breaks away from the metal because it is too brittle. Then, by adding another material you may be able to make the resin more flexible, thus allowing more contraction and expansion—compatibility with the metal. These changes are accomplished through the use of additives.

Additives may be used to change properties of a resin. An additive may give more heat stability or flame retardance to a polymer; other chemicals absorb ultraviolet radiation, thereby increasing color stability. (An architect may require a nonflammable material for a commission.)

Plasticizers are one of the most frequently used additives that can remarkably change a polymer. They act as lubricants between the polymer molecules, enabling the molecules to slip and slide over each other, an effect similar to that of heating. A flexible material is then formed. If additives are not chosen carefully, however, they may interfere with processing properties.

Then, each of the basic plastics has characteristics in common with the others and also properties that are unique to itself. Assigning plastics to thermosetting and thermoplastic designations and delineating, then, what especially pertains to each basic polymer group, is one way of presenting a picture of broad characteristics, limitations, and potentials. Some of these plastics are particularly important to the artist; others are not, mostly because of the heavy equipment and huge expenses involved in their fabrication. Nevertheless, in order to present a full view, each basic group is generally described here in chart form. Later, plastics that have the most potential as art material (because of ease and economy of application) will be expanded upon more fully.

Before fabrication, all plastics start as liquids, pellets, granules, sheeting, or film. This variety of form is necessary for manufacturing techniques. The shape of plastic influences its property only in an indirect way. Often a plastic with a certain property may come in one or two varieties, but whether pellet or liquid it is still the same plastic with the same properties.

PRINCIPAL GROUPS OF PLASTICS

Thermosetting Resins	*Thermoplastic Resins*	
Alkyds	ABS Plastics	Polycarbonate Resins
Allylics	Acetal Resin	Polyethylene
Amino Plastics: Melamine and Urea	Acrylic (Methyl Methacrylate)	Polyimide
Casein	Cellulosic	Polyphenylene oxide
Epoxy	Fluorocarbon	Polypropylene
Phenolic	Iomomers	Polystyrene
Polyester	Parylene	Polysulfone
Silicone	Phenoxy	Urethane
Urethane (Foams and Elastomers)	Polyamide (Nylon)	Vinyl

THERMOSETTING RESINS

Resin	Form Commonly Available	General Application	Heat Resistance	Moisture Resistance	Dimensional Stability	Effect of Sunlight	Burning Rate
ALKYDS (Polyester not included)	Liquid & molding powder	Used in enamels, paints, lacquers	Good 300°–350°F.	Little	Good	Slight	Slow to self-extinguishing
ALLYLICS	Monomers & prepolymers molding powders	Superior for outdoor use, impregnating & overlay papers, fabrics	Good 212°–350°F.	Very little	Good	Yellows very slightly	Slow to self-extinguishing
AMINO RESINS (Urea & Melamine)	Syrups, powder	Laminates, adhesives, papers, textile treatment, dinnerware	Melamines more heat resistant than ureas—to 170°F. for urea & to 270°F. for melamine	Some	Extremely hard surface	Slight color change	None to self-extinguishing depending upon fillers used
EPOXY	Molding compounds, liquid resins, foamed blocks, adhesives, coatings & sealants	Laminates, coatings, adhesives, cast products, flooring, critical rocket & missile applications	From −76° to 230°F. with some to over 260°C.	Excellent	Excellent —they adhere to a great many surfaces	None— withstand effects of weathering	Slow to self-extinguishing
PHENOLICS (Phenolformaldehyde, cast phenolic, phenol furfural, Resorcinol)	Solids, liquids, granulated, macerated, pelletized molding compounds	Thermal & acoustical insulation, binders, abrasives, electric switches, washing machine agitators	160° to 300°F. when filled with an asbestos filler, some molded phenolics can withstand temperatures up to 500°F.	Good	Excellent	Poor— darkens but maintains luster	Self-extinguishing

Clarity	Machining Qualities	Molding Qualities	Mold Shrinkage Per Inch	Toxicity	Resistance To	Art Studio Potential
Translucent to opaque	Good	Very good	0.0–0.006	Very rarely cause mild dermatitis; alkyds modified with glycols, styrene or vinyl chloride are primary irritants & sensitizers	Acids, ketones, esters, alcohol, chlorinated compounds, essential oil slight	Limited
Translucent to opaque (90–92% light transmission)	Good	High heat pressure	—	—	Acids & alkalis have very little effect	Very limited
Transparent to opaque (dependent upon filler used) with glossy surface	Good	Some ureas can be cured at room temp., but most cures are at elevated temp.	0.001–0.012	High toxicity in synthesis of the resins; formaldehyde a primary irritant; in cured state some people sensitive to formaldehyde in the resin-dust	Strong acids & alkalis can decompose them	Potential as fabricated materials, some use in room temp. curing ureas
Transparent to opaque when filled. Color usually light straw yellow	Unfilled epoxy good, filled epoxy poor	Good	0.001–0.004 Very slight	Uncured epoxy is safe; amine curing agents are caustic causing severe tissue damage. Anhydride & alkinol amines are less toxic	Unaffected by water, weak acids, alkalis, many solvents & atmospheric influences	Almost limitless, great promise
Transparent to opaque	Very good	Used combined with other materials	—	End products all inert & nontoxic; during mfg.; exposure to phenol dangerous—can cause burns & severe dermatosis; combination of phenol & formaldehyde can cause reactions	Not attacked by weak acids & alkalis; decomposes when exposed to strong acids & alkalis	Some potential. Resorcinol is a room temp. setting adhesive with excellent bonding powers, others can be polymerized with catalysts & low heat

THERMOSETTING RESINS (Continued)

Resin	Form Commonly Available	General Application	Heat Resistance	Moisture Resistance	Dimensional Stability	Effect of Sunlight	Burning Rate
POLYESTER RESIN (Unsaturated polyesters)	Liquids, dry powders, pre-mix molding compounds, cast sheets, rods & tubes	Broad range of applications—buttons, bowling balls, boots	250°F. particularly resistant to heat & fire when modified by dichlorostyrene	Good, particularly when modified with acrylic	Excellent but warps in thin sections	Yellows slightly unless stabilized	Slow to self-extinguishing if so formulated
SILICONES	Resins, coatings, greases, fluids & silicone rubber	Molded material, release agent, paints, textile & leather treatment lubricant	300° to 600°F.	Excellent	A faithful mold material	Weathers well	None to slow

Clarity	Machining Qualities	Molding Qualities	Mold Shrinkage Per Inch	Toxicity	Resistance To	Art Studio Potential
Transparent to opaque. Color: water-white to pinkish or greenish	Good	Very good	Varies according to resin used—flexibility, speed & heat in curing, filler, etc.	Nontoxic, non-irritating	Attacked by ketones & chlorinated solvents; resistant to most acids, attacked by strong alkalis	Almost limitless, exceedingly versatile, needs little or no heat, can be catalyzed at room temp.; properties vary according to monomer with which it is mixed; e.g., a styrene-based polyester or acrylic-based polyester
Opaque	Fair	Excellent	0.0–0.005 Negligible	Inert, nontoxic, nonsensitizing & nonirritating	Silicone is a semi-inorganic polymer that is impervious to almost all acids, alkalis & is attacked only by a very few organic solvents	Has application in the studio: 1. as a release agent; 2. as a faithful room temp. curing mold material that can even be molded over wax without loss of the original image

THERMOPLASTICS

Resin	Forms Commonly Available	General Applications	Heat Resistance	Moisture Resistance	Dimensional Stability	Effect of Sunlight	Burning Rate
ABS (Acrylo-nitrile-Butadiene-Styrene)	Powders, granules, sheets	Pipe compounds, luggage, refrigerator parts, golf clubheads	140° to 250°F.	Good	Excellent impact strength & high flexual strength	Little to slight yellowing—withstands effects of weathering	Slow
ACETAL RESINS (Delrin by DuPont & Celcon by Celanese Corp. of Am.)	Powder for industrial molding & extruding	Pumps, gears, appliance and machine parts	185° to 250°F.	Some	High strength, stiffens—long service	Chalks slightly (ultraviolet stabilized compositions available in color)	Slow
ACRYLICS (Methyl Methacrylate)	Rigid sheets, rods, tubes, molding powders, syrups & liquid resin	Window panes, appliance housings, decorative panels, radome hoods for airplanes, radar plotting boards, fibers, etc.	140° to 210°F.	Excellent moisture resistance	High strength, relatively shatterproof	Excellent weatherability—most colors do not fade; material itself remains relatively unchanged, except for scratches	Slow—some grades fire-retarda
CELLU-LOSICS (Cellulose Nitrate CN, Cellulose Acetate CA, Cellulose Acetate Butyrate CAB, Ethyl Cellulose EC, Cellulose Proprionate CP)	Molding powders & flakes, granules, film, sheets, pellets, rods, tubes	Toys, beads, cutlery handles, film, coatings, CA release agent for polyester; CA is also extruded into rayon fabric	EC 115°–185°F. CA 140°–220°F. CP 155°–220°F. CAB140°–220°F. CN (Pyroxylin) 140°F.	Good surface luster, good moisture resistance	High CAB is the strongest & toughest of the cellulosics	CAB has particularly good weathering properties, others are affected slightly unless stabilized	Pyroxylin very high—others slow
FLUORO-CARBONS (Tetra-fluoro-ethylene, Chlorotri-fluoro-ethylene, Vinylidene, Fluoride, Fluorinated Ethylene Propylene)	Powder, granules, resin, molding powders	In electronics, machine parts, rockets, gaskets	350°–550°F.	Excellent	Highly stable, strong, extremely hard, high impact strength	None	None

Clarity	Machining Qualities	Molding Qualities	Mold Shrinkage Per Inch	Toxicity *	Resistance To	Art Studio Potential
Trans-lucent to opaque	Excellent	Good to excellent	Very little	—	Most acids & alkalis. They are soluble in ketones, esters, some chlorinated hydrocarbons	Because of heat & high pressure in fabricating, about the only present use for ABS polymers is in solid forms for machining processes
Trans-lucent to opaque	Excellent	Excellent	Little	—	Excellent resistance to solvents. Attacked by some acids & alkalis	A material competitive with metal but as yet little studio application here because of high pressure & heat necessary in fabrication
Crystal clear, some of "optical glass" quality, colors can be lightfast, > 92% light trans-mission	Fair for cast acrylic, excellent for molded acrylic	Excellent	Little	Nontoxic in final state; vapors of monomeric methylate harmful	Attacked by strong alkalis & acids; soluble in ketones, esters, aromatic & chlorinated hydrocarbons	Great potential as a machined form & for those skilled in polymer chemistry & engineering—the use of acrylic as a cast material; one acrylic form is used as a painting vehicle similar to oil paint
Trans-parent to opaque. EC is lightly amber	Good to excellent	Excellent for all cellulosics	Very little	Rarely causes dermatitis	Decompose with strong acids & alkalis; EC is widely soluble & the others are soluble in ketones & esters & softened in alcohol	Cellulose nitrate is known as pyroxylin and by the trade name of "Duco"—has been used as an art material; other cellulosics have application as release agents. Molding operations requiring high heat & pressure disqualify most forms of cellulosics for studio use
Trans-parent to translu-cent, except the opaque polytetra-fluoro-ethylene	Excellent. Will not stick to practically anything, not even themselves	Excellent. Will not stick to practically anything, not even themselves	Little	End products are inert & nontoxic; exposure to fluoro-carbon dust should be avoided	Resistant to all known chemicals & solvents other than molten alkali metals, fluorine at elevated temp. & some complex halogenated compounds	High cost & difficulty in fabrication (high heat & pressure) make these impractical for the art studio. They can, however, make long-lasting release agents & molds

* Pyrolysis-decomposition point (very high temperature) is dangerous in any resin because harmful gases are released.

Resin	Forms Commonly Available	General Applications	Heat Resistance	Moisture Resistance	Dimensional Stability	Effect of Sunlight	Burn... Rat...
POLYAMIDES (Nylon)	Granules, powders, filaments, sheets, rods, tubes	Electrical parts, housings, fabrics, coatings, toys, gears, hosiery, sutures	175°–400°F. Will also withstand extreme cold	Good	Tough, high tensile & impact strength, has resiliency	Slight discoloration	Slow to self-ext guishin...
POLYCAR-BONATES	Molding resin, film coating, fibers, elastomers & liquid resins	Switch housings, cages for experimental animals, ball bearings, photographic film, safety helmets	250°–300°F.	Good	Outstanding toughness, competitive with metals	Slight color change & slight embrittlement	None t... self-ext guishin...
POLY-ETHYLENE (Polyolefin)	Powders, pellets, sheet, film, filament, rod, tube, foamed	Containers, artificial flowers, toys, shoe parts, tubes, packaging	180°–250°F. Varies from low to high density polyethylene	Excellent	Rigid or flexible	Surface crazing unless brown or black	Very sl...
POLYPRO-PYLENE (Polyolefins)	Film, fiber, sheeting, molding compounds	Containers, films, molded forms, machine parts	250°–335°F.	Excellent	Lightest commercial plastic, highest distortion temp., strong & resilient—one type can be used as a hinge without fatigue	Poor, requires black	Slow

Clarity	Machining Qualities	Molding Qualities	Mold Shrinkage Per Inch	Toxicity *	Resistance To	Art Studio Potential
Transparent to translucent to opaque—easily scratched	Good to excellent	Excellent for industrial methods	Little	Nontoxic	Attacked by only strong acids & resistant to most solvents	Requires industrial procedures for processing. Only present feasible uses for nylon is as a filament to bind parts together for "invisible" floating castings, & as molds for other resins
Transparent to opaque—self-coloring difficult—transmits 85% light	Excellent for unfilled polycarbonates, can be polished to a high finish	Good for industrial methods	Hardly any	Odorless, tasteless	Solvents are methylene chloride, ethylene dichloride or tetrachloroethane, attacked by strong alkalis	It may be that polycarbonates will be developed so that they can be cast in the studio; however, there is at the present time a great potential in machining, carving & other three-dimensional or sculptural uses
Transparent to opaque but most often milky-white translucent	Fair	Excellent	Slight	Odorless, tasteless, inert, nontoxic	Resistant to solvents below 60°C. and 80°C. for high dusting polyethylene, very resistant to alkalis, slowly attacked by oxidizing acids	Has potential as an art material for indoor use. It is inexpensive & requires but kitchen-oven temperatures to process. Can be used in blow molding, vacuum forming, coating & casting
Transparent, translucent, opaque	Excellent	Excellent	1.5 to 2%/inch	Odorless, tasteless	Very resistant, attacked only by oxidizing acids	Has the same potential as polyethylene. PP forms make excellent molds for polyester resin

* Pyrolysis-decomposition point (very high temperature) is dangerous in any resin because harmful gases are released.

Resin	Forms Commonly Available	General Applications	Heat Resistance	Moisture Resistance	Dimensional Stability	Effect of Sunlight	Bur R
POLY-STYRENE (Styrene)	Pellets, granules, molding powders, sheets, rods, foamed blocks, liquid solution, adhesives, coatings	Toys, luggage, decorative objects, lamps, etc.	140°–250°F. Depending on the variety, these are heat resistant types—styrene acrylonitrile	Good	Usually brittle except for high-impact varieties—styrene butadiene types	Yellows, can be offset by light stabilizers (antioxidants & ultraviolet light absorbers)	Slow
VINYLS (Polyvinyl acetate, Polyvinyl acetals, Polyvinyl alcohol, Polyvinyl carbazole, Polyvinyl chloride, Polyvinylidene chloride [Saran])	Fine powders, resins, films, liquids, flexible & rigid sheets	Lamps, panels, toys, upholstery, flooring, luggage, shoe parts	120°–210°F. depending upon type	Good	Some are flexible or elastomeric, others are rigid—PVA (polyvinyl alcohol) very unstable, good as a release agent	Very slight	Slow self-guis
URETHANES (Isocyanates)	Foams, liquids, solid	Adhesives, foam, upholstery stuffing, coatings	180°–190°F.	Excellent	Unusual abrasion & tear resistance	Discolors rapidly under ultraviolet radiation	Slow flam sista varie

Clarity	Machining Qualities	Molding Qualities	Mold Shrinkage Per Inch	Toxicity *	Resistance To	Art Studio Potential
Trans-parent optically clear—90% light trans-mission) translu-cent, opaque & full range of colors	Good except for brittle varieties	Excellent	Slight	In polymerized form is inert & nontoxic; styrene when heated releases an odor (no record of toxicity). Best to use ventilation	Attacked only by oxidizing acids; soluble in aromatic & chlorinated hydrocarbons (turpentine, benzene, acetone)	Has potential for "indoor" art use (not considered long-lasting). Lends itself to decorative & sparkling effects. Styrene pellets also add texture to polyester
clear-transparent, translucent, opaque	Rigid vinyl chloride & vinyl chloride acetate are excellent, the others are fair to poor	Vinylidene chloride is excellent; others are good	Slight	Vinyls are nontoxic, only irritants are in plasticizers & additives that are sometimes used	Strong acids attack them slightly; soluble in ketones & esters; there is a water-soluble variety of PVA	There is potential in the art studio; much more exploring needed. There are some vinyl paints (polymer tempera), and some sculpture work has been done with vinyls. PVA acts as an excellent release agent for polyester resin; & polyvinyl acetate is an excellent binder & adhesive for collage impasto techniques
translucent to opaque; usually white to yellow	Fair	Good to excellent	Slight	Polymerized urethanes are nontoxic & inert; diisocyanates used in its formulation are dangerous at that mfg. point. Polyurethane monomers may cause skin & eye irritation	One variety is affected by everything; another is resistant to everything including most solvents (Texin)	There have been applications of urethane foam, but great caution must be exerted to avoid inhalation of poisonous vapors. Urethane adhesives offer some potential to the art user at present. New molding materials have been made of urethanes

* Pyrolysis-decomposition point (very high temperature) is dangerous in any resin because harmful gases are released.

MODIFYING PLASTICS' PROPERTIES

Foams

Although each plastic has its potential based on its innate properties, the range of possibility can be increased or decreased depending upon what additives are employed. Foams are one example of this.

Actually, foams are expanded plastics. They are made of the same materials that give us solid plastics. During the manufacturing process, air or some other gas is introduced so that gas-filled cells are distributed throughout the mass. The result varies with the original polymer type. Plastic foams may be rigid or flexible, hard or soft, open-celled or closed-cell types, high and low temperature foams. In every case, however, they are lightweight and strong; types with closed cells are also buoyant and usually water-resistant.

These expanded plastics may be classified as to whether they are thermosetting or thermoplastic; according to their rigidity, flexibility, or semirigidity; and according to their cellular structure—whether they have open interconnecting cells or closed nonconnecting cells; and whether they are pre-expanded or foamed-in-place.

The density, rigidity, and proportion of interconnected cells are important physical determinants of the foam's properties. The range of cellular plastic is very broad. Some foams may have the appearance of raw cotton, others have the texture of hardwood. The scope is great and the future promises even larger varieties. The most extensively used and promising foams are rigid urethanes and rigid polystyrene. The main disadvantage to these two is their flammability. Some expanded plastics also absorb too much moisture. The susceptibility of a plastic relates back to the original plastic and its moisture absorption rate.

Polystyrene (styrofoam) is the leader among rigid plastic foams. It is low in cost, readily available, easily fabricated, strong, durable, and resistant to moisture. It has high strength-to-weight ratios. Closed cell polystyrene is produced in varying densities by expanding the polystyrene with a gaseous blow agent. Some are extruded through orifices into shapes, others molded into forms.

Although untreated polystyrene burns, one type is available that is made self-extinguishing.

Foamed urethanes are newcomers. These urethanes are a wide variety of promising foams. Expansion of urethanes can be achieved by a low boiling point solvent, such as fluorinated hydrocarbon. The heat of the reaction causes the solvent to expand through vaporizing. The released gas remains permanently in the closed cells. Proportion of plastic and reactant controls the rigidity of the foam. Another method introduces water during the reaction, triggering the release of carbon dioxide gas which then causes the foaming.

Urethanes are an exciting art material, but one serious drawback is that producing these foams is dangerous because the urethanes (isocyanates) are toxic and must be handled with care and adequate ventilation. These rigid urethanes are excellent for sculpture. They are very light, strong, and resistant to water. They can be purchased in the solid form as blocks of varying sizes. There is a less volatile foam system of the polyether type which can also be self-extinguishing, and, although it is less toxic, precautions should nevertheless be taken.

Vinyl can be foamed as well. It is accomplished chemically or mechanically with a vinyl plastisol as a base material. In the chemical process an additive is mixed with the plastisol releasing a gas (usually nitrogen) at fusion temperatures to create the foam. In the mechanical process, the foam is produced by mixing the plastisol with inert gas under pressure.

Vinyl foams are resilient, durable, flame resistant. Their surface can be treated in a variety of textures.

Phenolic is another new foam material. It is lightweight, has high stability, good heat resistance, flame retardance, and low cost.

FOAMED PLASTICS

Type of Plastic	Forms Available	Standard Sizes	Burning Rate
URETHANES	Slabs, sheets, blocks, custom shapes (open cell flexible); 2 & 3 package system for on-job mixing (open cell foam-in-place flexible); custom-made shapes, standard sized boards (closed cell, rigid); 2 & 3 package systems (closed cell, rigid, foam-in-place)	Open celled, flexible— 80″ max. width, 120′ max. length, 1/16″–15″ thickness	Self-extinguishing when especially compounded
POLYVINYL CHLORIDE	Open celled: flat stock in sheets & rolls; molded shapes; compounds	1/16″–5″ thick 24″–54″ wide	Self-extinguishing
	closed celled: sheets & molded shapes	36″ x 44″ 1/16″–2½″ thick	Self-extinguishing
CELLULOSE ACETATE	Rigid, closed cell foam; boards & rods	Boards: 1″ x ¼″; ¾″ x 6″; ½″ x 8″ any length; rods: 2¼″ any length	Slow
PHENOLIC	Liquid resin for foaming-in-place	—	Self-extinguishing
UREA-FORMALDE-HYDE	Block & shred	Block: 20½″ x 10½″ x 4½″	—
POLYSTYRENE	Product or shape of expandable beads; finished boards	Boards: 12″ x 16″ x 24″ widths; 1″–4″ thickness; 8′ x 9′ lengths Blocks: 2′ x 12′ x 8″ 4′ x 12′ x 8″	Slow or can be made self-extinguishing
POLYVINYL CHLORIDE	Liquid or paste	Foamed-in-place 3–30′ at 310°–400°F. closed or open cell	Self-extinguishing
SILICONE	Powder	Foamed-in-place at 320°F. Cell size less than 0.08″	Nonflammable
EPOXY	Prefoamed blocks	Up to 1′ x 2′ x 6′	Can be made self-extinguishing

Plasticizers, Plastisols and Organosols

Another means for modifying plastics' properties is the use of plasticizers, plastisols, and organosols. (Plastisols were mentioned earlier as a base material in the foaming of plastic.)

Plasticizers, plastisols, and organosols are closely related. A *plasticizer* has a solvent that is incorporated in the plastic or adhesive and does *not* evaporate. It increases the pliability, workability, and flexibility of the plastic. As more and more plasticizer is added the bonds between molecules of the resin become more slippery thereby producing a sliding effect. Thus, the plastic becomes more flexible.

A *plastisol* is a suspension of finely divided resin (a colloidal dispersion) in a plasticizer. The resin usually dissolves at elevated temperatures and when cool becomes a homogenous plastic mass. An organosol is also a suspension of finely divided resin, but in a volatile organic liquid. Elevated temperatures will also cause the main amount of resin to dissolve. It is at this temperature that the volatile liquid evaporates, leaving a homogenous plastic mass when the resin cools. Plasticizers are sometimes added to the volatile liquid.

Because a wide range of raw materials can be incorporated in plastisols and organosols, the formulator can achieve innumerable blends of properties to meet end-use requirements. The final product may be soft and flexible or approach vitreous hardness. Plastisols and organosols can be resistant to heat, cold, and chemicals; or tough, resisting impact, tear, abrasion. They can be odorless, tasteless, and nontoxic, or the converse of this. Fine detail and unlimited color as well as crystal clarity may be obtained.

Foaming and the addition of plasticizers, plastisols, and organosols change some of the properties of plastics. There are also additives that maintain or improve the quality of the resins. Some additives are stabilizers, slip and anti-block agents, pigments, fillers and reinforcements. Sometimes the resins are compounded with mold release agents and modifiers.

Stabilizers

Stabilizers are ingredients added when compounding the resin in order to maintain the chemical and physical properties at, or close to, their original values. Oxygen, heat, and ultraviolet light threaten the storage (shelf-life) and service-life of some resins. "Weathering" by oxygen and radiation can be controlled by the addition of special stabilizers. Exposure to air, chemical reaction of some metals used as pigments, may also stimulate oxidation.

Oxidation results in discoloration of resin and decomposition as well. It is symptomized by increased melt-viscosity, brittleness at low temperatures, decreased flexibility. *Antioxidants* must maintain their antioxidation performance during storage, processing, and the service-life of the finished piece. In order to work properly they must be permanent, nonblooming (not slowly migrate to the top), nonbleeding (non-exuding). Also, they must not discolor during processing or when the item is exposed to light. They must not affect any of the properties of the resin; they must be nontoxic and odorless.

Ultraviolet light often accelerates the oxidation of resins, usually resulting in discoloration of pigment and plastic. Carbon black has proved to be one effective additive, but it imparts a blackness. These submicroscopic particles of black screen out all sorts of dangerous light rays when the carbon black particles are evenly dispersed in the resin. To counteract the degrading effects of ultraviolet radiation, ultraviolet light absorbers are used, as we shall see when we work with the particular plastic. These ultraviolet absorbers are effective only for light-stability. There are some clear, water-white ultraviolet absorbers sold under the trade name "Tinuvin" by the Geigy Chemical

Company and "Uvinul" manufactured by the General Aniline and Film Corporation.

Colorants

Colorants serve three functions: decoration, stabilization, and loading. Of the three, of course, the first—decoration—has the most significance for the artist.

Some color compounds act as stabilizers because of their actinic screening property. Carbon black is one we will note again later, on the Fillers and Reinforcements chart. When a colorant acts as a filler, it loads the resin with its mineral value. There are optimum amounts of pigments that can be used advantageously before a reversal sets in and the resin is weakened by too much pigment-filler in proportion to the amount of resin. Manufacturers, however, can supply specific proportions of pigments for their resin.

The decoration function involves color mixing and matching, hue quality (such as transparency, translucency, and opaqueness) and texture. Within these bounds the painter has found tremendous scope. The potential here is even greater because all the techniques of the painter can be employed along with many of the texture qualities found in three-dimensional forms. Your versatility here is governed only by the scope of your experience and the limits of your expression.

Considerations: Colorants and colorant systems for plastics must be selected to meet the requirements of each material, process, and end-use. Some of the considerations are: lightfastness (will the colored plastic be exposed to outdoor light); weather resistance; heat resistance (is heat used in processing and for its end-use); chemical resistance (will the color be subjected to attack by acids or alkalis); migration (will the color "ooze" or separate out of the resin); dispersion (can the colorant be effectively ground and dispersed to provide maximum color with minimum grit). The technique of grinding pigment is important, too, in order to achieve the best consistency, brilliancy, stability, and maximum durability.

Types of Colorants: In the plastics field colorants are usually classified into three categories—dyes, organic pigments (some chemists call these dyes as well), and inorganic pigments. The major distinction between dyes and pigments is that dyes transfer their colors to the host and pigments carry or impart their own color. Another distinction between dyes and pigments is that dyestuff is a mixture that absorbs certain wavelengths of light while transmitting other wavelengths; and a pigment absorbs some wavelengths while reflecting others. Both can be synthetic or natural. While dyes are characterized by excellent clarity and transparency and high saturation, inorganic pigments are insoluble in resins and usually are opaque. There are some translucent examples. Dyes have poor stability under light and heat, while inorganic pigments have excellent heat and lightfastness.

The organic pigments fall between those two categories. Some organic pigments have very good heat and light fastness and brightness as well as transparency, while others are opaque and dull. Most of the time, color intensity can be controlled through the pigment concentration.

Although inorganic pigments are the most permanent colorants, there are some that are not so good as a few of the organic pigments. For instance, chrome yellow and vermilion are unreliable. On the other hand, in the last few years some organic pigments have been in use that are just as permanent as corresponding shades in the inorganic line. The Hansa yellows, halogenated anthanthrone (orange), naphthol "ITR" red are more permanent than historic alizarine, and perylene and special vat-type quinacridones are even more permanent than "ITR" red. Synthetic organic colorants are constantly developed.

45

Color Processing Techniques

It is best to buy color already dispersed in a vehicle compatible with your plastic; otherwise, complex processing techniques must be carried through. Sometimes, however, for dependable color and custom effects you may wish to process your own colors.

Most colorants are furnished as very fine, dry powders. Usually they do not easily become dispersed or incorporated into the resin and require special treatment.

Polyester and epoxy resins are dispersed in a compatible vehicle such as CAB or Plastolein epoxy plasticizer (Emery Industries), or else in some unpolymerized resin material. Styrene monomer can also be used. They usually are in a paste form that is easily mixed into liquid resin by stirring. The concentrated paste-vehicle binder can be used in any intensity up to the point where it would be foolish to heavily load the resin with pigment because little extra color value will be obtained beyond that saturation point.

Probably the most ideal colorant for color stability is stained glass. A finely ground colored glass powder which acts both as colorant and filler has recently been developed.* As a pigment it has all the advantages of colored glass. It is lightfast, transparent, is easily dispersed, and is resistant to weather, heat and chemicals. As an inorganic filler it helps to reduce shrinkage during curing, increases rigidity, hardness and compressive strength and decreases the burning rate of the form.

The thermoplastics present another problem. Most of the time these polymers are made by mixing the resin, plasticizer (if used), stabilizer, and pigment together in a heavy-duty mixer. After thorough mixing, the mass is melted, sheeted, chopped, and sized (through a sieve). Another method entails the pigment being ground in a plasticizer on a three-roll mill and then the resulting paste added to the resin compound on a two-roll mill or stirred into it.

Pellets and powder such as polystyrene and polyethylene can be dry colored. Mineral oil is often added to polystyrene to aid in even dispersal of color. No dispersing aid is needed for powdered polyethylene. The smaller the resin-particle size the more even the dispersal throughout the plastic.

The mixing procedure is simple. Place pellet or powder, dispersing aid if necessary, and powdered color into a jar, leaving enough room for tumbling, and proceed to shake the jar vigorously until the color appears evenly mixed.

When pigments are not soluble in casting resins, uniform coloring can be obtained by grinding the pigments together with a plasticizer such as dioctyl phthalate or with a portion of the resin or, if polyester resin, with a little monostyrene on a roller or ball mill. The following proportion is suggested for transparent values:

100 parts polyester resin
0.025 parts pigment ground with
0.025 parts dioctyl phthalate

Anthraquinone dyes that have good strength and brightness in a wide range of transparent colors are suspended and sold as "Fluid Dyes."[1] These dyes are also soluble in zylol (but not water). They are stable up to 650°F. and the best way to get color dispersion for polystyrene pellets. Add a little bit of color at a time and immediately shake and tumble the pellets vigorously until the color is dispersed. Remove pellets from jar and spread on aluminum foil to "dry."

Color Palettes

The most heat-stable, but not necessarily transparent, pigments offered today are:

* Potters Brothers, Inc., Carlstadt, N.J.

[1] Patent Chemicals, Inc., 335 McLean Blvd., Paterson, N.J.

INORGANIC PIGMENTS / Organic Pigments — Colorant Properties and Resin Compatibility

Pigment columns (left → right):
1. Black, Yellow, Red; Iron Oxide
2. Ceramic Black
3. Green: Hydrated Chrome Oxide
4. Chrome Green
5. Blue: Ultramarine Blue
6. Iron Blue
7. Turquoise: Chrome-Cobalt-Alumina
8. Cobalt Aluminate
9. Ochres—Buff-Brown
10. Ceramic Yellows—Antimony, Titanium, Chrome Oxide
11. Nickel Titanium Yellow-Buff
12. Zinc Chromate Yellow
13. Molybdate Orange
14. Chrome—Orange, Yellow
15. Chromium Sulfide, Yellow
16. Manganese Violet
17. Chrome-Tin Pink
18. Cadmium Mercury Maroon, Red, Orange
19. Cadmium Sulfo-Selenide, Maroon, Red, Orange
20. Zinc Oxide White
21. Zinc Sulfide White
22. Titanium Dioxide, White
23. Natural inorganics—Siennas, Iron Oxides, Umbers
24. AZO, Brown, Yellow-red, Green, Blue (organic)
25. Anthraquinone Yellow-red, Green, Blue, Brown (organic)

Colorant Properties

Property	1	2	3	4	5	6	7	8	9	10	11	12	13	14	15	16	17	18	19	20	21	22	23	24	25
Brightness	P	P	F	F	F	F	F	F	P	F	F	F	F	F	E	E	F	F	F	F	E	E	P	E	E
Hiding Power	F	E	E	F	P	F	F	F	F	E	E	E	F	E	P	F	F	E	E	F	F	E	F	P	P
Tinctorial Strength	P	P	P	P	P	P	P	P	P	P	P	P	P	P	P	P	P	P	P	P	P	F	P	E	E
Transparency	LU	O	O	LU	LU	LU	O	O	LU	O	O	O	LU	O	LU	LU	O	O	O	O	O	O	LU	T	T
Acid Resistance (Concentrate)	P	F	F	P	P	F	E	E	F	E	E	E	P	P	P	F	E	P	P	P	P	P	P	P	P
Acid Resistance (Dilute)	F	E	E	F	P	E	E	E	F	E	E	E	F	F	F	E	E	F	F	F	F	P	F	P	P
Alkalis Resistance (Dilute)	F	E	E	P	F	P	F	P	F	E	E	P	F	P	E	E	E	E	E	E	F	F	F	F	F
Heat Resistance	F	E	P	P	E	F	E	E	P	E	E	F	P	P	E	E	E	E	E	F	F	F	E	P	P
Lightfastness Heavy Concentration	F	E	E	F	E	E	E	E	F	E	E	F	F	F	E	E	E	E	E	E	E	E	E	P	P
Lightfastness Tint	F	E	E	F	E	F	E	E	F	E	E	F	F	F	E	E	E	E	E	E	E	E	E	P	P
Migration Resistance	NM	NM	NM	NM	NM	NM	NM	NM	NM	NM	NM	NM	NM	NM	NM	NM	NM	NM	NM	NM	NM	NM	NM	M	M
Resistance to Oxidizing Agents	F	E	F	F	F	F	E	E	F	E	E	F	F	F	F	F	E	E	E	F	P	E	F	P	P
Resistance to Reducing Agents	F	E	P	P	F	P	P	E	E	E	F	P	F	F	F	F	E	E	E	F	P	F	F	F	F
Weathering Resistance	F	E	F	F	F	F	E	E	F	E	E	P	F	F	F	E	E	F	F	E	F	F	E	P	P
Cost	LO	MO	LO	LO	LO	LO	H	H	LO	MO	MO	LO	LO	MO	H	MO	H	H	H	MO	MO	LO	LO	LO	LO

Resin Compatibility

Colorant / Resin	1	2	3	4	5	6	7	8	9	10	11	12	13	14	15	16	17	18	19	20	21	22	23	24	25
THERMOPLASTICS																									
Acetals	L	L	L	L	L	L	L	L	L	L	L	L	L	L	L	L	L	L	L	L	L	L	L	N	N
Acrylics	N	N	L	N	L	L	W	L	N	W	W	L	N	N	N	L	L	W	W	L	L	L	L	N	N
Cellulosics	W	N	W	N	W	N	W	W	N	W	W	W	N	N	L	L	W	N	N	W	W	N	N	L	L
Nylons	L	W	L	N	W	N	W	W	N	L	L	N	N	N	W	W	W	N	W	N	N	W	N	L	L
Polyethylene	W	W	N	N	W	W	W	W	N	W	W	L	L	L	W	W	W	W	W	L to N	L to N	W	L	N	N
Polypropylene	W	W	L	N	W	W	W	W	N	W	W	L	L	L	W	W	W	N	W	N	N	W	N	N	N
Polycarbonate	L	L	N	N	W	N	W	W	N	L	N	N	N	N	W	W	W	N	W	N	N	W	N	N	N
Fluorocarbons	L	W	L	N	L	N	W	W	N	W	W	N	N	N	W	W	W	N	W	N	N	W	N	N	N
Polystyrene	W	W	L	L	W	W	W	L	W	W	W	W	L	L	W	L	W	W	W	L	W	N	W	N	N
Vinyls (Flexible)	L	L	N	L	L	L	W	W	L	W	W	N	W	W	W	W	W	W	W	L	W	N	L	L	W
Vinyls (Rigid)	L	L	N	L	L	L	W	W	L	W	W	N	W	W	W	W	W	W	W	L	W	N	L	L	L
Amino Resins	W	W	L	L	W	W	W	W	L	W	W	L	W	W	W	W	W	W	W	N	W	N	LZ	N	N
Diallyl Phthalate	W	W	L	L	W	L	W	W	L	W	W	L	W	W	W	W	W	W	W	N	W	N	N	L	L
THERMOSETS																									
Phenol Formaldehyde	W	W	L	L	W	W	W	W	W	W	W	W	L	L	L	L	L	L	N	W	W	W	W	N	N
Polyester-Alkyd	W	W	L	L	W	L	W	W	L	W	W	L	W	W	W	W	L	W	W	N	W	N	L	L	L
Silicone	W	W	L	L	W	W	L	W	N	W	W	N	L	L	N	N	L	L	N	W	N	W	N	N	N
Epoxy	W	W	L	L	W	L	W	W	L	W	W	L	W	W	W	W	W	W	W	N	W	N	L	L	L
Polyurethane (Elastomers and Foams)	W	W	L	L	W	L	W	W	L	W	W	L	W	W	W	W	W	W	W	L	W	L	L	L	L

Key:

- W — Widely used with resin
- L — Limited use with resin
- N — Not recommended
- E — Excellent performance
- F — Fair to good performance
- P — Poor performance
- T — Colorant is transparent at normal concentrations of use
- LU — Colorant is translucent at normal concentrations of use
- O — Colorant is opaque at normal concentrations of use
- NM — Nonmigratory at normal concentrations of use
- M — Colorant will migrate in vinyl, polyethylene, and impact styrene
- LO — Low cost
- MO — Moderate cost
- H — High cost
- V — Varies with individual formulations

	DYES				ORGANIC PIGMENTS																									
	Acid, Chrome and Direct—wide color range	Basic Dyes Wide color range	Basic Dye Bases Wide color range	Nigrosines and Indulines—Wide color range	Bone Black	Carbon Black	Indanthrone Blue	Pigment Green B	PTA/PMA Toners Blue, Green	Phthalocyanine Green, Blue	Nickel AZO Green Yellow	Hansa Yellow Light Yellow	Benzidine Yellow, Xylidide	Naphthol Dark—Lt. Red	Pyrazolone Lt. Red	Red Lake C Lt. Red	PTMA Toners Violet—Med. Red	Toluidine Maroon—Lt. Red	Thioindiogoid Copper-Maroon	Helio Bordeaux Maroon	Alizarine Maroon	Madder Lake Red	Pigment Scarlet	Na, Ba, Ca Lithols, Maroon—Lt. Red	Lithol Rubine Bluish-red	B.O.N. (2B-MN Salt) Maroon-Lt. Red	B.O.N. (2B-Ca Salt) Maroon-Lt. Red	Chlorinated Para Light Red	Para Red	Quinacridone
	E	E	E	E	P	P	E	P	E	E	F	E	E	E	F	E	E	E	F	F	F	F	F	F	E	F	E	E	E	F
	P	P	P	E	P	P	E	F	P	P	P	P	P	F	F	P	P	P	F	F	F	P	P	F	F	P	P	F	F	P
	E	E	E	E	P	E	E	F	E	E	E	E	E	F	F	E	E	F	F	F	F	F	F	F	F	F	F	F	F	F
	T	T	T	O	LU	O	T	LU	T	LU	LU	T	T	LU	LU	T	T	LU	LU	LU	T	T	T	T	T	T	T	LU	LU	T
	F	F	F	P	P	F	F	P	F	F	F	F	F	F	P	P	P	F	P	F	F	P	F	F	F	P	F	F	P	P
	F	F	F	P	F	E	E	F	F	F	F	F	F	E	P	P	F	E	E	F	P	F	F	F	P	F	F	F	F	F
	F	P	P	F	E	E	E	E	P	E	F	E	E	E	P	P	P	P	F	F	F	F	F	F	P	F	F	F	P	E
	P	P	P	F	E	E	E	F	P	E	E	F	F	F	F	F	F	F	F	P	F	F	F	F	P	F	F	P	F	F
	E	E	E	E	E	E	E	P	E	E	E	E	E	E	F	E	E	E	E	P	E	P	E	F	E	P	E	E	E	F
	P	P	P	P	E	E	F	P	P	F	E	F	F	P	P	P	P	P	P	P	P	P	P	P	P	P	P	P	P	F
	M	M	M	M	NM	NM	NM	F	M	NM	NM	M	F	NM	F	M	M	M	F	NM	F	NM	F	F	F	NM	NM	M	M	NM
	V	V	V	V	F	F	F	F	P	F	F	F	F	F	F	P	F	F	E	F	F	P	F	F	F	F	F	F	F	F
	V	V	V	V	E	E	F	F	P	F	F	F	F	F	F	E	F	F	P	F	F	P	F	F	F	F	F	F	P	F
	P	P	P	P	F	E	P	P	P	E	P	P	P	P	P	P	F	P	F	P	P	P	P	P	P	P	P	P	P	P
	LO	LO	LO	LO	MO	LO	H	MO	H	MO	LO	MO	MO	MO	MO	LO	H	MO	MO	LO	MO	MO	MO	LO	MO	MO	MO	MO	LO	H
	N	N	N	N	L	L	L	L	L	L	L	L	L	L	L	L	L	L	L	L	L	L	L	L	L	L	L	L	L	L
	N	L	N	N	L	L	L	L	N	W	L	L	L	L	L	L	L	L	N	L	N	N	L	N	N	N	N	L	N	N
	N	L	L	L	W	W	L	N	N	W	W	L	N	L	L	L	N	N	L	L	L	L	W	N	L	N	L	N	N	N
	W	N	N	W	W	W	N	N	N	W	N	N	N	N	N	N	N	N	N	N	N	N	N	N	N	N	N	N	N	N
	N	N	N	N	L	W	L	N	N	W	N	N	N	L	L	L	N	L	L	L	L	N	L	N	L	N	L	N	N	L
	N	N	N	N	L	W	L	L	N	W	L	N	N	L	L	L	N	N	N	N	N	N	N	N	N	N	N	N	N	N
	N	N	N	N	L	W	L	N	N	W	L	L	N	L	L	N	N	N	N	N	N	N	N	N	N	N	N	N	N	N
	N	N	N	N	N	N	N	L	N	W	L	N	L	L	L	N	N	N	N	N	N	N	N	N	N	N	N	N	N	L
	N	N	N	N	L	L	L	L	N	W	L	N	L	L	L	N	L	L	L	N	L	L	L	N	L	L	L	N	N	L
	N	N	L	N	L	L	W	W	N	W	L	N	L	L	L	N	N	N	N	L	L	L	N	L	L	W	N	N	N	W
	L	L	L	L	L	W	L	N	N	W	L	N	N	N	N	N	N	N	N	N	N	N	N	N	N	N	N	N	L	L
	L	L	L	L	L	L	L	L	L	W	L	W	L	L	L	L	L	L	L	L	L	L	L	L	L	L	L	L	L	L
	N	L	N	L	L	L	L	L	L	W	L	L	L	L	L	L	L	L	L	L	L	L	L	L	L	L	L	L	L	L
	N	N	N	W	L	W	L	L	L	W	L	W	L	L	L	L	L	L	L	L	L	L	L	L	L	N	N	L	L	L
	N	L	N	L	N	N	L	L	N	W	L	L	L	L	L	L	L	L	L	L	L	L	L	L	L	L	L	L	L	L
	N	N	N	N	N	N	L	L	N	L	L	N	L	L	L	L	L	L	L	L	L	L	L	L	L	L	L	L	N	L
	N	N	N	N	L	W	L	L	L	W	L	L	L	L	L	L	L	L	L	L	L	L	L	L	L	L	L	L	L	L
	L	L	L	L	L	W	L	L	L	W	L	L	L	L	L	L	L	L	L	L	L	L	L	L	L	L	L	L	L	L

Nickel-titanium yellows
Cadmium-sulfide yellows
Cadmium-sulfo-selenide reds
Mercury-cadmium reds
Quinacridone reds [2]
Ultramarine blue
Cobalt aluminate blues
Chromium oxide and hydrated chromium
oxide green
Phthalocyanine blue [2] and green

The most *permanent* and *transparent* pigments (organic and inorganic) are:

Hansa yellow
MAPICO low opacity yellow (iron oxide)
Anicidide AADA light yellow
Special benzylidine-type diazo yellow
Indanthrone orange (Tetra-carboxylic
derivative)
Perylene type vat Bordeaux (red violet)
Dioxazine carbazole (deep purple)
Phthalocyanine green (blue green)
Ferric nitroso bentanaphthol (warm green)

Other Considerations

Some plastics and some colors are neutral and do not affect the color-life of a cured piece of plastic, others trigger reactions that cause changes in the original hue, value, and intensity of a pigment. For example, polyester resin without promotor can be clear (water-white); however, when cobalt naphthanate, a promotor, is added the hue of the resin turns from clear to pink-purplish in tint. This would naturally affect the original color.

Certain pigments, like black and red (when combined with polyester resin), slow down the resin cure, requiring higher concentrations of catalyst. There are other pigments that accelerate the resin cure, therefore requiring less catalyst. In using vinyl chloride resin, for instance, iron and zinc pigments accelerate thermal degradation of the resin and should not be used. In any case, accurate use of color begs for the mixture of different colors, resin quantities, and catalyst on a trial basis by forming color chips and recording their contents

[2] Change color at 600°F.

and proportions. In this way the artist will be able to determine the exact proportion of color-catalyst-resin in his system, and failures can be avoided. In every case, tests should be made before mixing large batches of color.

Fillers

Another additive is fillers. A wide variety can be used. Fillers extend the plastic by making a smaller quantity cover a greater area, like thinning soup to feed more people. Most fillers turn transparent resins translucent or opaque. The reason for this change is that the indexes of light refraction of resins and fillers differ, thereby blocking some of the light transmission. If, however, a filler can be found that has the same index of light refraction as your resin, then transparency will be maintained along with added strength.

Some fillers add other important property values such as thixotropicity and nonflammability. Some fillers, while extending the quantity, give added strength by reinforcing. Asbestos and glass fillers can slow down the burning rate of a flammable plastic or decrease the self-extinguishing time.

Cellulose, cotton flock, macerated fabric, woodflour, mica, china clay, calcium carbonate, sisal felt, rag, aluminum silicate, microballoons, silica, putty, and mineral filler are some of the most common filler materials.

One special type of filler is the so-called thixotropic filler. "Cab-o-sil," "Ultrasil VN-3" and clay are some of the materials that make a resin more thixotropic. This type is added to liquid resins to prevent flow on inclined or vertical surfaces. It also allows one color to be applied next to another with a minimum of diffusion. Thixotropic fillers provide ease of mixing, stirring, and application; when mixing is completed, however, the resin's viscosity rises sharply thereby reducing or eliminating any flow due to gravity. Addition of thixo-

tropic fillers allows for "vertical lay-up" —application of liquid resin on large vertical surfaces without appreciable resin drainage. In addition to "Cab-o-sil," "Ultrasil VN-3" and china clay, polyvinyl chloride and finely divided silica make excellent thixotropic fillers. "Ultrasil VN-3" * is similar to white carbon black type thixotropic reinforcing fillers with improved water resistance. It is somewhat translucent and it does not retard the cure of polyesters. Up to five per cent may be mixed with polyester resin without whitening the compound. Epoxy resins react similarly; cure time will be the same as in unfilled resins.

Generally, fillers reduce the cost of fabrication by using less resin; facilitate the fabrication process by introducing easier "handling" properties; impart their specific properties to a piece; reduce the possibility of trapping air bubbles when that is not desired.

All fillers have some effect on the gel and cure-times of resin. Rigid rules cannot be given because the effect will vary according to the type and mass of resin involved. In the case of polyester resin, for example, in thin sections ($\frac{1}{32}$ of an inch or less) most fillers retard gelation; as thickness increases, however, many fillers cause faster gel times. Asbestine and fine silica will have little effect in a resin section $\frac{1}{16}$ of an inch to $\frac{1}{4}$ of an inch thick, while mild acceleration will occur in sections greater than $\frac{1}{4}$ of an inch and in the resin pot. Calcium carbonates are accelerators in all cases, except in the thin sections, and china clay always inhibits the gelation and cure.

* Henley & Co., Inc., 202 E. 44th St., New York 17, N.Y.

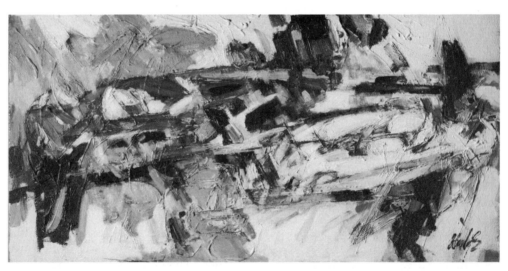

Russell Woody. "The Ambulance Went By." 24″ x 48″ 1963. Acrylic paint. Masonite was turned to the rough side for this extruded-line painting. Washes, glazes and opaque paint were employed over a preliminary build-up of three-dimensional line. The line, squeezed from a bottle, consisted of a mixture of one part modeling paste, and three parts color. Paints were also mixed with modeling paste and gel medium for heavy brush strokes (no knives were used); the impasto paint was worked and reworked over the understructure with the painting sometimes being placed in a vertical position and sometimes in a horizontal direction. The final effect is that of a very heavily textured oil painting. A varnish composed of five parts of polymer medium and one part matte medium was applied to the finished work. *Courtesy Russell Woody*

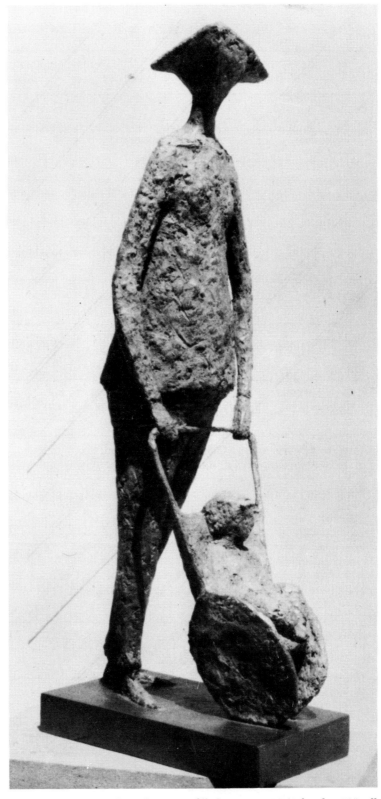

Franc Epping used an aluminum filled epoxy in 1959 for this 20″ tall
sculpture, "Stroller." *Courtesy Franc Epping*

FILLERS & REINFORCEMENTS

Types of Fillers	General Description	Mold Shrinkage	Color	Resistance to Heat
Organic				
Cellulose Derivatives Ground flour Wood flour	Finely ground from pine, fir, spruces & some hardwoods	Slight	Good	Moderate
Shell flour	Grinding walnut, pecan, or peanut shells	Moderate	Good	Moderate
Cellulosic Fibers Cotton flock	Cotton clippings or caustic purification of cotton linters	Slight	Good	Moderate
Alpha cellulose	Alkaline-treated wood pulp	Slight	Excellent	Moderate
Sisal fibers	Obtained from leaves of tropical shrub—agave fibers chopped to ¼–½"	Slight	Very good	Moderate
Comminuted Cellulose Chopped paper	Sheets of paper impregnated with resin-dried sheet cut into fragments	—	—	—
Textile by-products (macerated fabric)	Cutting clean cotton cloth into small pieces	Slight	Moderate	Moderate
Lignin & lignin-extended fillers Ground bark	Grinding bark of Douglas fir trees	Slight	Moderate	Moderate
Protein fillers Soybean meal	Grinding bean residue after oil extraction	Moderate	Moderate	Less than moderate
Keratin	Feathers, hoofs, hog bristles calcined & used as fillers	—	—	—
Nylon, Orlon, Dacron	Chopped fibers	Moderate	Very good	Moderate
Carbon fillers Carbon black	Carbon	Slight	Verk dark	Very good
Inorganic (mineral fillers):				
Asbestos	Chrysotile (hydrated magnesium silicate) most commonly used	Slight	Green, Gray to White	Good, brittle high temp.

Cost	Used With	General Uses	Outstanding Properties
w	Phenolic, urea	As molding compounds	Particle size can be as fine as 200-mesh & yields smooth surfaces. Not good for use above 325°F. Has a fibrous structure.
w	Adhesives	As extenders for resin adhesives	Walnut flour has some wax & yields a high gloss, luster, & moisture resistance. Aids plastic flow
h	Phenolic	Filler for molding compounds	Tends to absorb water
h	Light colored urea, melamine	Filler for molding compounds	Good color—white
w	—	Molding powder	Moderate impact resistance. Usually mixed with wood flour
—	Pulp & resin	For dried resin board	—
h	Many resins	Molding compound	Moderate impact value. High bulk. Not free-flowing—thixotropic
y low	—	Partial replacement for resin in molding powders because cellulose is a natural binder	Dark colored filler
y low	—	—	Less moisture resistance than wood pulp
w	Translucent urea	Molding	Less brittle than alpha cellulose. May be drilled & tapped without cracking
h	Thermosetting resins	When mixed with thermosetting resins creates a "wear-proof" product	Superior resistance to moisture & mold growth
derate	Seldom used with polyester allylics, or polyethylene	For stabilizing action against sunlight and weathering	Does not reinforce very much. Dark color and brittleness. Adverse effect on curing rate with peroxy catalysts
w	Thermoplastics polyethylene, polypropylene fluorocarbons & polyester, silicone, etc.	For molding compounds where good heat resistance is desired	Incombustibility. Unique fiber structure—mixes easily with other materials. Good insulation. Resistance to corrosion. High impact strength. Stiffness

FILLERS & REINFORCEMENTS (Continued)

Types of Fillers	General Description	Mold Shrinkage	Color	Resistance to Heat
Inorganic (mineral fillers):				
Mica	From mineral muscovite—a complex potassium aluminum silicate	Very low	Very good	Moderately h
Quartz	Ground quartz	Very low	Very good	Superior
Silica	Finely divided synthetic silica as well as foundry sand	—	Excellent	Very good
Glass Flake	Thin flakes of molten glass blown into a tube	—	—	—
Fibrous Glass (Fiberglass)	Filaments from molten glass which is passed through tiny orifices	Very slight	Moderate translucent	Very good
Chopped Strands	Bulk cut strands	Very slight	Moderate translucent	Very good
Rovings	Ropelike bundle of continuous strands	Very slight	Moderate translucent	Very good
Reinforcing Mats	Chopped or continuous strands in nonwoven random matting— weights from 0.75 to 10 oz. sq. ft.	Very slight	Moderate translucent	Very good
Milled Fibers	Bulk, small filamentized bits	Very slight	Moderate translucent	Very good
Yarns	Twisted yarns with after-finish	Very slight	Moderate translucent	Very good
Surfacing & Overlay Mats	Nonreinforcing monofilaments in random matting. Surfacing mat is stiff. Overlay is fluffy & soft	Very slight	Moderate translucent	Very good
Woven Fabrics	Woven cloths with after-finish available in different weaves	Very slight	Moderate translucent	Very good
Woven Rovings	Coarse, heavy fabrics	Very slight	Moderate translucent	Very good

Cost	Used With	General Uses	Outstanding Properties
derate	Thermosetting resins & compatible with most resins	Readily wetted by most resins	Good heat resistance
ry high	Phenolics	Molding compounds	Very high heat resistance—quartz filled phenolic can withstand temperatures up to 5000°F.
—	Pyrogenic (synthetic) silica excellent with polyester & epoxy; also polyethylene	For thixotropicity	Translucent
—	—	For resin binders	Good strength. Good moisture resistance
ry high	Melamines polyesters epoxies phenolics silicones	—	—
w	As above	Molding compound	Multidirectional
w	—	Performing unidirectional reinforcement	Directionality as desired
dium	—	Parts with simple contours	Translucent. Multidirectional
dium	—	Adhesives & castings, anticrazing filler	Multidirectional
h	—	Unidirectional reinforcement	Unidirectional
h	—	To improve surface smoothness	Multidirectional. Fine texture. Overlay mat drapes well
h	—	For complicated surfaces where extra strength is necessary	Pulls easily around curves, drapes well. Very strong. Unidirectional or bidirectional
dium	—	Where extra strength is needed	Gives extra support

53

FILLERS & REINFORCEMENTS (Continued)

Types of Fillers	General Description	Mold Shrinkage	Color	Resistance to Heat
Diatomaceous Earth	Amorphous fossils consisting of remains of diatoms	Very slight	Very good	Moderate
Clay	Kaolinite, mineral clay of hydrated aluminum silicate	Very slight	Translucent good	Moderate
Calcium Silicate (Wollastonite)	Fluffy acicular calcium silicate	Very slight	Translucent excellent	Moderate
Calcium Carbonate	Ground chalk from 2.5 microns (coarse) to 0.05 microns (ultra-fine)	Very slight	Excellent	Very good
Miscellaneous	Carborundum & epoxy— Titanium Dioxide	Very high resistance to surface abrasion. Both pigment and filler		

Cost	Used With	General Uses	Outstanding Properties
medium	—	—	Lower specific gravity
medium	Polyester epoxy alkyd polyvinyl chloride	For premix For thixotropicity	Gloss and smoothness. Reduced shrinkage. Improved machinability & fabrication
medium	Polyester	Molding compounds for thixotropicity	Low water absorption. Smooth, transparent surface
low	Polyester epoxy & thermoplastics e.g. polyethylene polyurethane foam	Pigment & extender, molded, extruded, calendered, premix, & band lay-up (2 microns)	Lacks resistance to acids. Good mar resistance. Improved toughness. Good mixing. High sheen
—	—	—	—

Reinforcements

Although fiberglass is not in the chemical sense an additive, it does serve an additional purpose and is an "added" material. Today fiberglass is one of the most successful and most widely used materials for reinforcement of plastics. It is used to give additional support to polyesters, epoxies, phenolics, melamines, silicones, furanes, as well as some of the thermoplastics. In strength-to-weight ratios, plastics reinforced with fiberglass are stronger than any commercial material.

The fiber forms of glass are easily handled and flexible. By proper placement of the fiberglass material the reinforced product can be controlled directionally. Fiberglass is strong (glass filaments—tensile strength over 200,000 psi) and offers tremendous impact strength when combined with plastics. It is also chemically stable. This means it will not rot, mildew, or oxidize. It is also unaffected by most acids (except hydrofluoric and hot phosphoric) or by weak alkalis.

Fiberglass is dimensionally stable. There is no shrinkage or stretching of fiberglass in processing (unless the "weave" is pulled out of shape). At maximum stress, individual fibers show less than 3% elongation.

Fiberglass resists heat and can withstand temperatures up to 1000°F. and cannot absorb moisture beyond surface wetting.

It is available in a variety of plastic-suitable forms. There are woven cloth, tape, woven roving and continuous roving, chopped strands, milled fibers, and mat. Of all, woven cloth provides the highest all-round physical strength (40% greater than mat). On a weight basis it is also the most expensive. For some purposes, however, other forms of fiberglass serve better. Fiberglass mat (40% cheaper than cloth) follows in strength, ending with chopped strands and milled fibers for the least strong. Fiberglass mat soaks

56

up a great deal of resin and is more difficult to apply around curves. Woven roving has strength approaching that of cloth at a price slightly higher than mat. It has the uniform formable characteristics of cloth but requires a surfacing cloth or mat because of its coarse pattern.

Fiberglass cloth can be woven in many different ways—as any woven fabric. The standard widths are 38", 44", 50", and 72" on varying roll lengths (often 120 yards per roll—but can be purchased by the yard).

Fiberglass woven roving is a coarse, square-weave fabric made from 12 to 60 untwisted strands of glass. Widths vary from 42" to 80" and roll lengths are from 50 to 100 yards. Fiberglass is classified by its weight. In cloth a .013" to .015" thickness weighs about 10 ounces per square yard. One layer of 26-ounce woven roving is roughly equivalent in strength to three layers of 10-ounce cloth (per yard).

Fiberglass chopped strand mat is composed of random patterned two-inch fibers loosely bonded together with a high solubility resinous binder or by a kind of stitching known as "needling." Mat comes in widths of 38" and 76". Roll length for two-ounce mat is 150 feet; for one-and-a-half-ounce mat it is 200 feet. They are used for products requiring omnidirectional strength with bulk and where tolerances of thickness (they are thicker than woven fiberglass) are less important. Chopped strand is available chopped to lengths of one-quarter of an inch and up. They are packaged in paper cartons.

Unwoven roving is composed of various numbers of parallel strands (ends) of continuous filaments. Roving can be chopped and used as the basis of reinforcing mat. It can also serve as long-length reinforcement where high, unidirectional strength is required.

An important consideration in using any type of fiberglass is the material's surface treatment. Some fiberglass is coated to assure maximum wetting and

Fiberglass Mat

Chopped Strand

Plain-weave Woven
Fiberglass Cloth

Fine Strand Finishing Mat

Milled Fiber

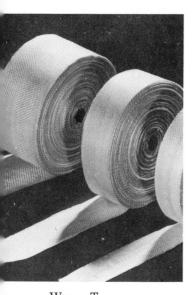

Woven Tape

Nonwoven Undirectional Fabric

Woven Plain-weave Fiberglass Rovin

Eight varieties of fiberglass reinforcements.

Courtesy Ferro Corporation, Fiber Glass Division

binding action between the glass and the resin to be used. Fiberglass can be easily impregnated or it may be difficult to saturate. Some fiberglass materials are impregnated with accelerator; this would increase the resin's setting time. Others are coated with silicone which would repel saturation. It is important to know if the *finish* on the fiberglass is compatible with the resin being used. Will it assure maximum wetting (or penetration of the resin)? Is it compatible with the resin being reinforced? With many fiberglass drapery fabrics, the surface treatment of the fabric does not permit resins to penetrate the fibers. They may have a silicone finish. These are release agents for many resins. It is simple to tell when complete wetting occurs: the fiberglass disappears and takes on the color and translucence (if translucent resins are used) of the polymer.

A new variety of reinforcement material is a thermoplastic spunbonded polyester called Reemay.* It has good tear strength and toughness, high bulk and porosity, good wickability, is non-raveling and is easily handled. It can easily be printed, sanded, dyed or embossed and because of its porosity can be coated with pyroxylins, vinyls, acrylics, polyesters and epoxies by roller coating, brushing, impregnating, printing or laminating. It is available in 39, 45, 52 and 58 inch sizes and various textures.

Inhibitors and Accelerators

Some resins have a limited shelf-life or pot-life. This means that they can be stored for just a limited period without polymerizing or hardening. In order to increase the shelf-life of a resin, stabilizers or *inhibitors* are added. Unsaturated polyester resin, for example, is relatively unstable. When stored at room temperature the shelf-life may be from a month to a year. If exposed to sunlight, polyester will polymerize more rapidly. This

is due to the effect of the shorter wavelengths of light which can produce free radicals in the resin and thereby initiate polymerization without the presence of a catalyst. Therefore, it is better to store polyesters in polyethylene coated cans than in glass jars. (If you find your polyester curing prematurely, it may be due to a chemical reaction with the solder from the seam of the can.) The stabilizers used in the case of polyester resin are mostly antioxidants such as the polyhydric phenols.

Opposite of inhibitors are accelerators or promotors. *Accelerators* are added to a resin to enable the polymerization reaction to proceed either at lower temperatures or at a greater rate. Promotors (accelerators) do not usually cause polymerization of a resin in the absence of a catalyst. They serve as triggers, starting the chemical action. These promotors are used where the application of external heat is not employed but where room temperature curing is desired.

Cobalt naphthanate is an effective example of a promotor often used with methyl ethyl ketone peroxide (MEK) catalyst in polyester resin. Its presence in polyester resin discolors it slightly. There are completely water-white (crystal clear) room temperature curing resins without a promotor-catalyst system.* There is a caution: if the promotor is added by the user, care should be taken never to mix the catalyst and promotor directly together because of a possible explosive reaction.

SOLVENTS AND PARTING AGENTS

Although they are not additives, this is probably the best place to discuss the role of solvents and parting agents. Solvents are chemicals that would dissolve a particular plastic before curing. (Almost all cured thermoplastics can be

* DuPont-Old Hickory Plant, Nashville, Tenn.

* Poly-Lite 32-032, 32-033 (Reichhold) Poly-Lite 91-919, very crystal-like, almost like acrylic.

dissolved in a solvent.) They are particularly necessary for cleaning tools and instruments. Acetone is one example of a solvent for uncured polyester resin and methyl methacrylate. Sometimes combinations of solvents work better, such as methyl alcohol and acetone.

Parting agents, sometimes called separators or mold release agents, are substances to which a particular plastic will not stick. They may be many different kinds: sheet materials, waxes, water solutions, solvent solutions, emulsions, and other plastics. The sheet material often is polyvinyl alcohol sheeting, cellulose acetate, etc. Waxes can be from carnuba to paraffin. Water solutions may be polyvinyl alcohol in aqueous solution, methyl cellulose, casein. Some solvent solutions would be acetone, ethyl acetate, etc. Emulsions are generally wax emulsions. Other plastics that act as separators are polyethylene, fluorocarbons, and silicone. Different plastics will separate from the separator, as stated on the specification sheet. Consider requirements for fidelity and mold porosity.

When selecting a plastic suitable to artistic expression, there are three basic questions. First, what kind of plastic; what form would it have; could it be a liquid, sheet, paste, powder, pellet, or film? Second, what kind of cure would be practical: room temperature, lamp, or oven? Third, what processing methods would be feasible?

Antoine Pevsner used man's first plastic—celluloid—in 1924–26 for his sculpture "Torso." (29½" high.)

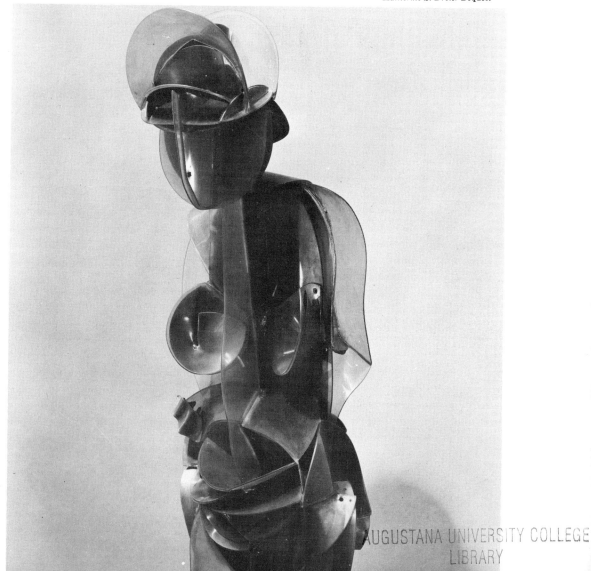

Laminating, Casting, Foaming, and Fabrication of Plastics

Industrial processing techniques are about as diverse and varied as the kinds and numbers of resins that comprise the plastics families, but most of these methods are complex and costly, often involving large and complicated systems of machinery. The capital outlay for processing can be huge.

Although these involved methods are not at all possible for the small user, more and more artists are contracting for the complicated part of their process to be formed by custom plastics processers. The mechanical nature of these processes and their uniform results, however, may not be desired by the artist who is concerned with creating "by hand" directly, particularly if the single addition of an expression is his more likely aim.

Basic processing techniques used by commercial fabricators also may be helpful to the artist inasmuch as they may provide clues for new hand-processing methods. And because each art statement contains its problems of expression and its technical solution, a knowledge of the potential range in the solving of technique questions can aid the artist in arriving at the most expeditious result. Ironically, many of the commercial methods of fabrication have been borrowed from the artist in the first place and given a mechanical muscle, the machine. The most pertinent commercial processes are covered here and the more remote methods are described in the Appendix.

Basic commercial methods involve molding, casting, laminating, coating, machining, spraying, heat forming. Since

all of these processes had their seeds in the artisan skills of the past, basic skills will already be known to the artist. Nevertheless, new techniques are needed for handling these different, unique materials requiring treatment peculiar to plastics' substance and form. Therefore, a new look at old methods and the creation of new solutions are in order.

OPEN MOLDING

At some point, plastics are all thermoplastic. That is, they are soft enough to be formed and shaped, and then become solid in the finished state. This plastic condition suggests a fundamental method—molding. There are many variations of this family of processes, many of which involve highly complex and expensive machinery, but there is a variation, *open molding*, used most frequently with thermosetting resins. (Because it does not require pressure, it is not considered strictly a *molding* method.) This system often requires hand-lay-up and is therefore quite suitable for many sculptural effects. In open mold procedures, resin-impregnated cloth or mat is layered

in the open mold and allowed to set. Or, the impregnation of the mat or cloth can be accomplished by spraying or brushing on the resin while the cloth or mat is draped in an open male or female mold. A thixotropic-formulated resin should be used to prevent the fluid plastic from draining off the cloth to the surface. (Thixotropic materials resist gravitational pull, and will remain wherever they are placed.) The gel or cure of these resins is usually at room temperature. Some resins will partly cure at room temperature and require final cure at low oven temperatures.

Wood, plaster, metal, glass—almost any hard material—can be used as the mold. But the rigid mold-form has to be coated with a release agent and cannot have undercuts which would lock the hardened or cured form in the mold and prevent its removal. Flexible molds, supported with a plaster of Paris removable base, will permit some undercutting.

Boat molding is the most common open-molding operation today. Mold costs in this kind of production are low.

This diagrammatic photograph shows stages of construction. After a gel coat (1) is applied, glass mat (2) is overlaid. More resin (3) is added and this is covered with glass cloth (4) and impregnated with more resin (5). It is finished with a layer of a woven roving and resin (6 and 7).
Courtesy Modern Plastics

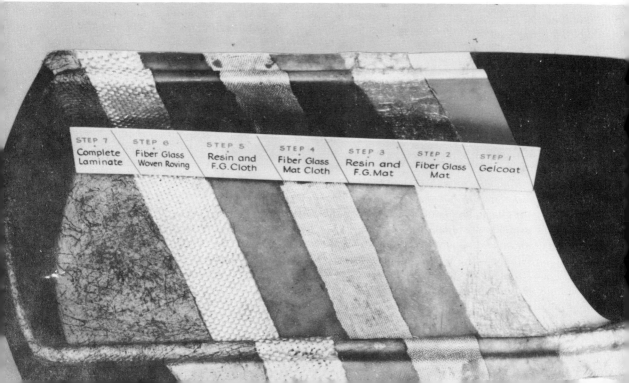

STEP 7 Complete Laminate — STEP 6 Fiber Glass Woven Roving — STEP 5 Resin and F.G. Cloth — STEP 4 Fiber Glass Mat Cloth — STEP 3 Resin and F.G. Mat — STEP 2 Fiber Glass Mat — STEP 1 Gelcoat

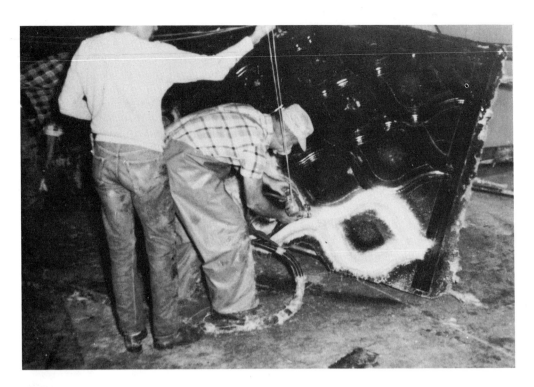

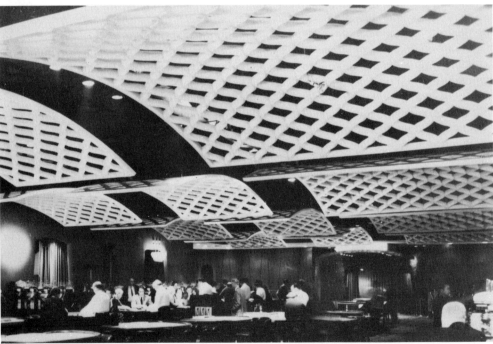

Top: Fiberglass saturated with polyester is sprayed onto a mold. When gelled, the openings that form the grille pattern were trimmed out with a knife.

Bottom: The result is an effective mass without weight. The shell interior of the grille was covered with a half-inch-thick foam overlaid with a polyester (Mylar) film. Then the area was sprayed with more polyester and fiberglass and rolled with a roller to tamp down the laminate. When cured a little beyond the gel stage, the patterns were again knife-trimmed.

Courtesy Modern Plastics

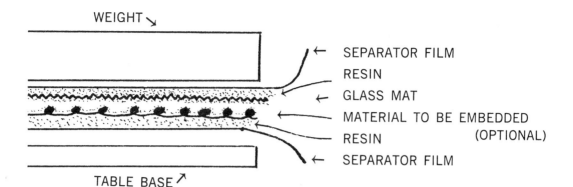

WEIGHT

← SEPARATOR FILM
RESIN
← GLASS MAT
← MATERIAL TO BE EMBEDDED (OPTIONAL)
RESIN
← SEPARATOR FILM

TABLE BASE ↗

LAMINATING

Laminating is a process that goes hand in hand with open molding. (The industrial counterpart is called "high-pressure laminating.")

Essentially, the commercial operation requires high heat and pressure. Reinforcing material of cloth, paper, wood, or glass fibers is held together by impregnation of the reinforcing material with plastics. If a flat sheet is to be produced, the reinforced impregnated sheets are stacked between a sandwich of highly polished steel plates. They are then subjected to heat and pressure in a hydraulic press which cures the resin and presses out the air while it squeezes the layers into the desired thickness. Sometimes this operation is performed with matching dies which press the lamination into a molded form.

A room temperature adaptation of this procedure can be accomplished without any great amount of pressure. Instead of a sandwich of highly polished steel, the base can be glass, aluminum, wood, plaster, or any hard release agent coated surface. It should be remembered that the texture of the surface will be reflected in the surface texture of the finished object. Glass and cellophane give the glossiest surface. Wax, wood, and plaster will have a duller finish.

Reinforcing material is placed directly on the coated surface, or the surface can be impregnated with resin before the placement of cloth. Then more resin is poured onto the reinforcing material, completely saturating it to avoid separation and weak areas upon curing. Fiberglass and papers become transparent or translucent when completely saturated with resin. Colored shapes and textures can be inserted next. It is a good idea to coat the objects that are to be laminated to avoid air bubbles. The next stratum of reinforcing material is then placed over the first layer. When the second reinforcing piece is added, care must be taken not to form or trap air bubbles. Since heavy mechanical pressure is not used, bubbles should be rolled out or pressed out from between the strata, while at the same time evenly distributing the resin. When the second reinforcing layer is applied, it too is then saturated with more resin. (Some craftsmen find better results, fewer bubbles, if they impregnate the layer before attaching it to the previous surfaces.) This operation can be continued until the desired thickness is reached. When the lamination reaches a gel state (gelatinous—like jello) it can be trimmed to the desired shape with a sharp knife, razor blade, or scissors. Use care in cutting to avoid separation of the laminated layers. If a shiny surface is desired, cellophane can be added to the top layer. Again, air bubbles have to be pressed or rolled out.

A great variety of effects, all sizes, colors, textures, and shapes, can be accomplished with this technique. Experience in forming flat laminates can lead to the controlled warping of areas into three-dimensional results.

A prepreg (pre-impregnated) reinforced material that cures rapidly under ultra-violet light over 120°F. and which undergoes little or no heat buildup due to exotherm has been developed (Cordo Division of Ferro Corp.). The material has indefinite storage life under ordinary light conditions and room temperature. Cordo has also developed an efficient ultraviolet source—1400 watt UV output, 97% of total.

Laminating

In this series, sculptor William C. Severson constructs his sculpture using an open-mold laminating technique borrowed from boat molding.

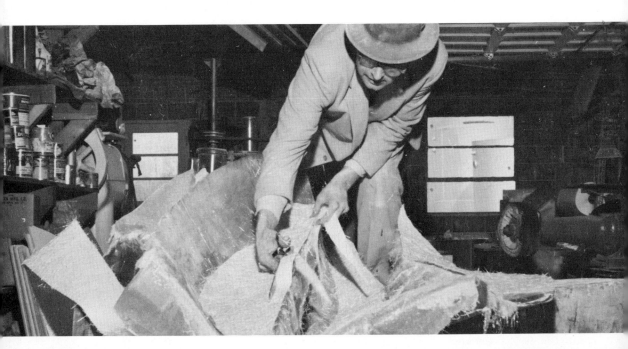

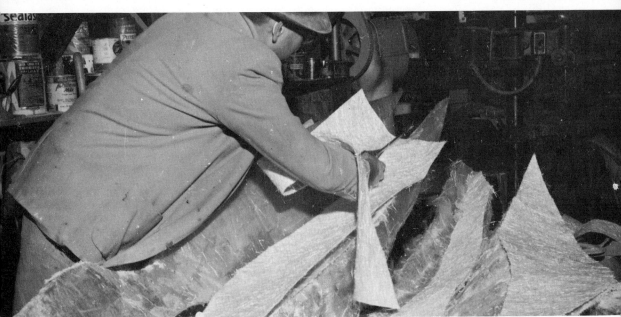

Fiberglass mat is cut to size.

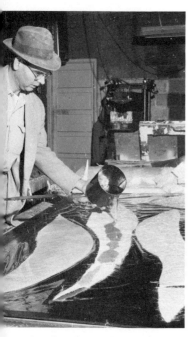

Catalyzed and thoroughly mixed polyester resin is poured onto the fiberglass mat that rests on cellophane.

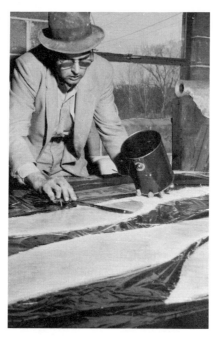

The polyester resin is spread over the fiberglass mat with a spatula.

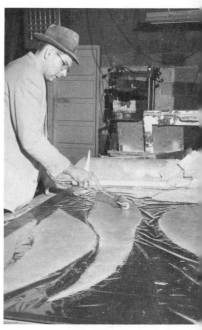

After the fiberglass is evenly distributed, a roller is used to help impregnate the mat and release trapped air bubbles.

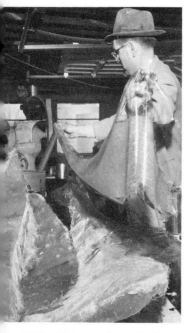

Still sticking to the cellophane backing, which will impart a glossy, smooth finish, the saturated form is lifted for application on an open mold form.

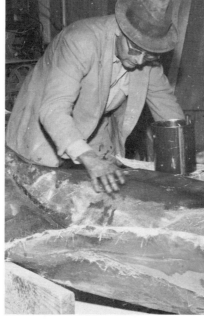

The polyester impregnated mat is pressed into position.

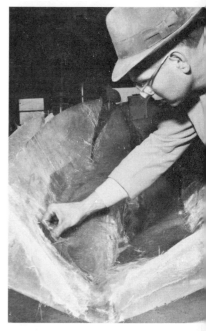

Individual air bubbles are "worked" out of the mat with pressure.

65

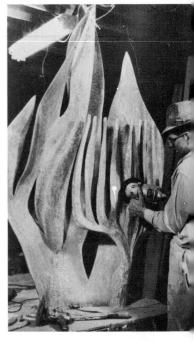

By pulling the cellophane, the artist can modify and shape the fiberglass form.

Another layer of saturated glass mat is added to the previously applied fiberglass.

With a disc grinder, William Severson smooths the fully cured polyester sculpture until he achieves a surface that modulates the light to his preference.

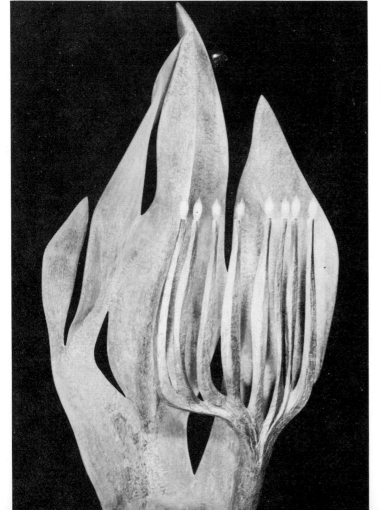

The finishing operation completed, this translucent, fiberglass reinforced, polyester resin Menorah called "Pillar of Cloud" is ready to be installed.

Photos courtesy William Severson

CASTING

Another family of techniques, as varied and versatile as molding, is the related process known as casting. Casting, originally used for other plastic families of materials—metals and liquids, like clay, cement, plaster—finds itself augmented today by the development of new directions in the modus operandi of casting suitable for its unique but versatile nature.

The history of plastics casting has been short. The first successful plastic-casting operation by Dr. Baekeland, with phenolics as star performers, occurred in 1906. It was not until 1954 that the acrylics were first cast into sheets, rods, and tubes, and casting really became an important process. Today many kinds of plastics join in their ability to be cast. Most of the thermosetting resins make excellent castings.

Essentially, the difference between casting and molding is that no pressure is used in casting. Generally, the plastic material, sometimes heated beforehand if it is thermoplastic, is poured into either an open or closed mold and cured at the proper temperature. When cool and hard, the new form is removed from the mold.

Typical molds used to cast plastics may be one-piece open molds, molds with a core for hollow castings, split molds (2 pieces or more), and flexible rubber, vinyl, or silicone molds. Mold materials may vary from metal, plastic, rubber, plaster, to sand—depending upon the kind of plastic used, the nature of the article to be cast, the number of copies, and the size of the final article.

Advantages to casting are many. The cost is low, extensive equipment is not necessary, machinery and finishing are minimal.

General Casting Procedure and Mold-Making for Casting

In casting operations, the resin cures in bulk. Because of its volume and the commensurately large amount of exotherm generated by catalysts in thick sections, curing has to be watched closely. Care must be taken to dissipate the heat or slow down the curing action, otherwise the form will shrink excessively and crack. Thin sections dissipate heat rapidly but thick sections build up to very high temperatures. Such temperature differentials between core and surface can cause great strains and cracking. Carefully selecting and measuring the concentration of catalyst, accelerator, and the amount of filler used (if any) can help control the heat generated by a mass of plastic as it polymerizes.

In casting thermoplastic resins one method used to reduce the exotherm and excessive shrinkage is to use a prepolymerized "casting syrup." Normally, styrene and methyl methacrylate monomers are clear, colorless liquids with the viscosity of water. By heating these materials in the presence of a catalyst, polymerization takes place. If it is stopped at an appropriate point, the syrup has greater thickness (will not run too easily and leak from the mold); has already had some shrinkage; has a shorter curing time and emits less exothermic heat during the cure.

When polymerizing polyester casting resins, the rate of heat evolution has to be controlled. Selecting a catalyst with a slow reaction rate like tertiary butyl hydroperoxide is one recommendation. When casting thin sections as much as 0.5% tertiary butyl hydroperoxide can be used, but in very large or thick castings the concentration may have to be reduced to 0.1%. It is also advised that larger castings be allowed to gel at room temperature and then gradually heated in an oven to 200° to 250°F. to complete the cure. If the casting is very large, the mold should be placed in a water bath and then heated. This allows the exothermic heat to be dissipated more rapidly (heat conduction is better in water than in air) and the water would also

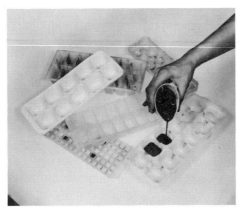

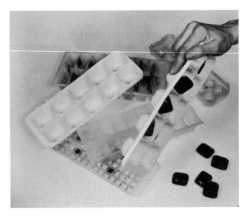

Simple ready-made forms such as this assortment of polyethylene and polypropylene ice-cube trays make excellent molds for casting polyester resin.

Pour catalyzed and colored polyester resin into the cubicles.

After completely curing the resin, twist and tap out the polyester forms as if they were ice cubes.

slow down the external heat, allowing for a more gradual temperature buildup.

Another method of reducing cracks caused by shrinkage in the mold during curing is to add a flexible resin (or a plasticizer) to the rigid resin. Strains are better absorbed in a softer, less brittle casting.

Still another method is to add an inert filler to the polyester casting resin. It can be 20%–25% of sand flour or Silene to 60%–65% for talc. Fillers, however, make the castings more opaque. After a certain point, if too much filler is used they also make for a structurally weak casting because there is a lower proportion of resin or binder concentration. Glass or cotton fillers (the fibrous kind) can increase strength if kept within the 5% to 10% limit.

Selection of a good mold material will help achieve a successful casting. There are several silicone rubber mold materials on the market. These are made of plastic that can polymerize at room temperature. Their silicone composition builds in a natural release agent allowing for the plastic casting material to separate from the mold. Many of these silicone rubber compounds can be heated in an oven so that the contained plastic resin form can be completely cured. An excellent ma-

terial, called "Silastic RTV" Number 501, is manufactured by the Dow Corning Company. It gives excellent reproduction and long life which, in the long run, minimizes its relatively high cost. (See Casting Technique on page 300.)

There are now excellent, relatively inexpensive room temperature vulcanizing (RTV) mold materials that require no heat. Merely by mixing two components together and pouring it over your positive you will have a reliable, highly defined, long lasting material. One is put out by Flexible Products Company, Flexipol Elastomer 9027/6104 system. Adhesive Products Corp. has two good systems: Adrub TRV 7122-2 and Kwikset, Adrub RTV. (See description in Chapter 7, Working with Vinyls, the section on room temperature curing vinyl molds.)

If the original object to be molded can withstand 450°F., then hot-melt vinyl molding material also does an excellent, flexible, exacting job.

The hot-melt vinyl can be purchased as polymerized material and then melted at 350°F. for pouring over the mold; or it comes as a milky liquid which first has to be fused at 350°F. for 15 minutes and then remelted at 425°F. to 450°F. and

Making a Mold with Hot-Melt Vinyl

Pour the vinyl chloride mixture into a pan that can be temperature-controlled, such as this electric frying pan. Cover and allow the vinyl hot melt to fuse at 350°F. (depending upon the manufacturer's suggestion) for about fifteen minutes.

Meanwhile, place forms to be molded (in this case, glass cullet) into a pan or box, arranging them so that there are spaces all around each form.

After the vinyl mixture fuses, raise the temperature to the melting point, in this case 450°F., stirring the mixture occasionally to make certain that the melted areas are evenly distributed. Keep covered after all the mixture has melted. Lower the heat at that point to about 400°F. for two to three minutes so any air bubbles can rise out of the mixture.

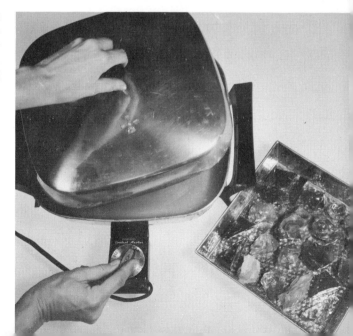

69

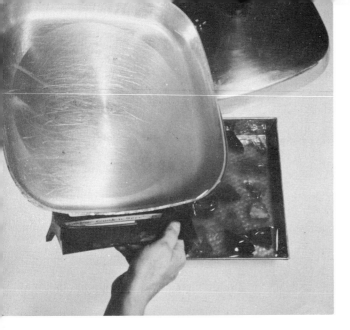

Then, quickly and deftly pour the melted vinyl from one end to the other over the forms. A better mold can be made if the air beneath the forms can be vacuumed or shaken free before the hot melt hardens, and also if the mold forms are heated slightly, thereby slowing the solidifying process and allowing trapped air to escape.

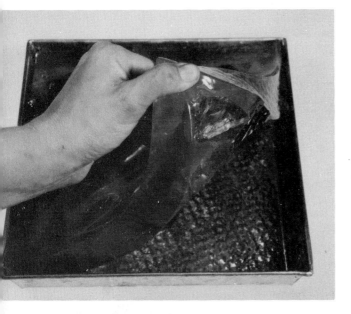

After the vinyl cools, it forms a flexible, tough mold. Lift it out of the pan starting at one corner and pulling in the direction of the opposite corner.

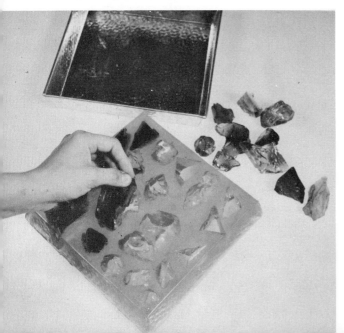

Then, remove the original forms and you will find an accurate, long-lasting impression. Every texture, speck, and crevice is recorded.

There should be a small amount of leeway between the mold and jacket to allow for expansion of materials and to permit the "rubber" mold with its contents to be easily removable. Seymour Couzyn's frog was easily released from its mold because there was a layer of paper towels (removed now) placed over the rubber mold-form before the plaster jacket was poured.

then poured over the positive form to be molded. After the vinyl mold material cools, it is easily pulled away from the object and leaves a faithful image. Vinyl is also a natural release agent for many resins.

The method for making a mold with these materials is the same as forming a mold out of any other heavy fluid substance. In closed-mold construction, accommodation must be made for a vent so that trapped air can find an exit as the plastic is poured into the mold.

If there are thin sections in the mold and the cast object is to be rather heavy, it is wise to build a plaster jacket around the mold for support. To make sure that the rubber mold containing its rigid

plastic can be easily removed from the jacket with no breakage, severe undercuts should be avoided. There should also be a small amount of leeway between the mold and jacket to allow for expansion and removal. If moistened paper towels are wrapped around the rubber mold before the jacket is poured, an adequate space will be left for easy release.

Simple molds can be made of polyethylene as well by heating the positive or negative, sprinkling on the powdered polyethylene, heating it again, and repeating the operation until the desired mold thickness is reached. Polyethylene is a natural release material for many resins.

71

Blow Molding

Another important method employing thermoplastic materials is blow molding. Basically, blow molding involves stretching a softened piece of plastic against a mold and with air pressure forcing it to conform to the interior surface of the mold. When the plastic cools it takes the shape of the mold.

Actually, the introduction of air into a hot mass and forming it is not a new idea. Celluloid dolls and rattles and Ping-pong balls were made that way in the late nineteenth and early twentieth centuries. It is also possible to perform very simple blow molding experiments in the art studio, using a vacuum cleaner for the air-pressure source. Because of the vacuum's limited pressure, only very small forms can be blown into the female mold. The great problem is maintaining a hot mass of plastic because the air from the vacuum cleaner tends to cool the plastic before it has formed completely.

Airplane blister windows were formed in the very simple manner of clamping a piece of softened acrylic sheet across the open top of a sealed box. Low air pressure was admitted to the box, blowing the heated acrylic into a semisphere. Air pressure was maintained until the acrylic blister cooled.

Industrial blow-molding equipment has become highly developed and refined since the first blister window. Variations from an injection molding type to an extrusion type have been perfected and combined into more complex machinery.

Vacuum Forming

A method closely related to blow molding is its reverse—vacuum forming. A child blowing a bubble with bubble-gum and mouth performs a similar mechanical blowing operation—and if he sucks back the air he reverses his bubble form, often with sticking results. Thermoforming is another name for this kind of molding operation. There are many variations.

The acrylic blister window was also formed in the reverse way to the blow molding operation. A vacuum could be created in the box causing the bubble to form inward. Outside dimensions and the thickness of the structure of acrylic and the clamped-on shape or ring (a circle opening, a square, or whatever) would determine what shape the blister would become at the base.

Today's industrial processing has developed complicated machines that both heat and mold the thermoplastic sheet without manual transfer of forms.

This vacuum forming machine consists of three frames that fit tightly into each other by tongue and groove. Their dimensions should probably not exceed eight inches by eight inches. The top two frames can tightly hold a thin thermoplastic sheet between them. The bottom frame is covered with pegboard (perforated hardwood) and a hole is drilled into one side of the frame to tightly accommodate the vacuum hose. All joints have to be taped and/or sealed with foam rubber gaskets so that when the vacuum pressure is applied the air will be sucked downward through the perforated holes into the bottom frame and out the vacuum cleaner hose. If the frame's joints leak air, there would not be enough pressure to form the plastic sheet. The resulting "machine" is a base-box covered with pegboard and containing the hose opening. Tightly fitting onto that is the double frame which also firmly sandwiches a sheet of plastic.

To operate the device, textured objects are placed upon the perforated sheet. These can be made of almost any hard material, including plastic forms. They will become the positive form that will be recorded in plastic. To work the machine, the plastic sheet which is compactly and securely held between the two frames is heat-softened on both sides (perhaps over an electric burner) and then quickly put into place over the third box frame. When vacuum pressure

Vacuum forming machine by Dymo-Form Co.

Vacuum forming machine called Di Arco Plastic Press by O'Neil-Irwin Manufacturing Co., Lake City, Minn. Mold form is being put into place.

Craig Kauffman. "Red-Blue" (89″ x 45″ x 5″, 1964). Polymer paint
on vacuum formed Plexiglas. *Courtesy The Museum of Modern Art*

These cellulose acetate butyrate (Eastman Chemical's Tenite Butyrate) sheets were vacuum formed over chain-link fencing, striated fiberboard, metal rings, bolts and washers fastened to a background, and Masonite drilled with one-inch holes.

Courtesy Eastman Chemical Products, Inc.

is turned on, the rapidly sucked out air pulls the softened plastic over the shapes. This pressure is maintained until the plastic cools and has hardened. At this point the power is cut and a bas-relief is pulled away from the male mold. These forms can then become molds for casting textured shapes, or they can be used directly as repeat designs to form a panel.

Vacuum forming machines vary in size from 7″ x 7″ to 18″ x 18″ and in price from $300.00 to $1000.00. Large

pieces can be vacuum formed by commercial establishments such as sign makers. Vacuum forming is a very simple process and can be easily used in the studio. There are low-cost vacuum forming machines on the market and it is also possible to build a form with wood and masonite, using the vacuum cleaner again, for vacuum pressure.

Use of Hydrocal (U.S. Gypsum) or Reichhold's water-extended polyester, Poly-lite 32-177 (an excellent quick,

75

Les Levine. "Plug Assist II" (36" x 50" x 28" deep). Made of butyrate Uvex through vacuum forming.

easy to de-mold substitute for Hydrocal) are very good mold materials for vacuum forming. Wood and metal are also good. No parting agents are necessary. Holes should be drilled throughout the mold for efficient drag for conformation. These holes, or exhaust ports are best drilled in the lower relief areas of the mold for rapid air evacuation.

The best types of sheeting are vinyl chloride, ABS plastics, cellulose acetate butyrate, acrylic and polyethylene. Sheeting comes in various colors and translucencies. There is much possibility here for use of light-kinetics. Unusual effects can be made by using thermoplastic sheets that may be translucent with a multi-lensed or plastic diffraction grating and polarizing sheets. Overlaying sheets and using lights can create exciting optical effects. Edmund Scientific Company, Barrington, N.J., distributes a variety of these thermoplastic sheets.

Things to Remember
When Vacuum Forming

1. Don't let your thermoplastic overheat. It may smoke slightly, but if it starts to form bubbles, the sheet is too hot.

2. Avoid large solid objects. All the air cannot be pulled from a large object unless there are spaces for the vacuum to pull through.

3. Avoid objects that have too much overhang (objects will be locked in place).

4. The larger the object the thicker the gauge of plastic has to be, because the more the plastic is stretched, the thinner it becomes.

5. Use only one plastic sheet at a time.

6. When moving from the heating stage to the vacuum forming stage, work as rapidly as possible to prevent cooling and then hardening of the plastic too soon.

7. If you do not get a sharp, well-formed article:

 you may not have heated the plastic long enough;

 you may not have transferred the plastic from the heater to the former rapidly enough;

 you may not have held the vacuum suction on long enough.

Vacuum Forming

Place objects on the bottom half of a box that has a perforated base and is fitted to a vacuum cleaner.

The top two parts of the frame should fit together tightly, holding a thin thermoplastic sheet in their juncture.

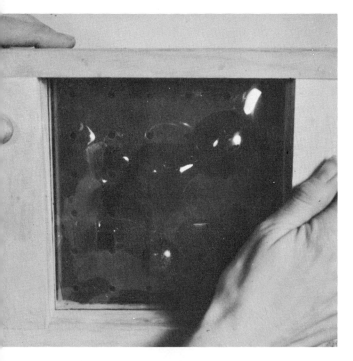

Heat-soften the thermoplastic sheet. Place the double frame section containing the thermoplastic sheet on the mold base of the contraption. Work quickly.

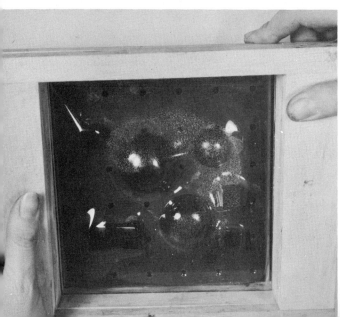

In the instant that the hot sheet is placed over the mold forms, turn on the vacuum cleaner, which will draw air from between the objects, pulling the heat-softened plastic tightly over the mold forms.

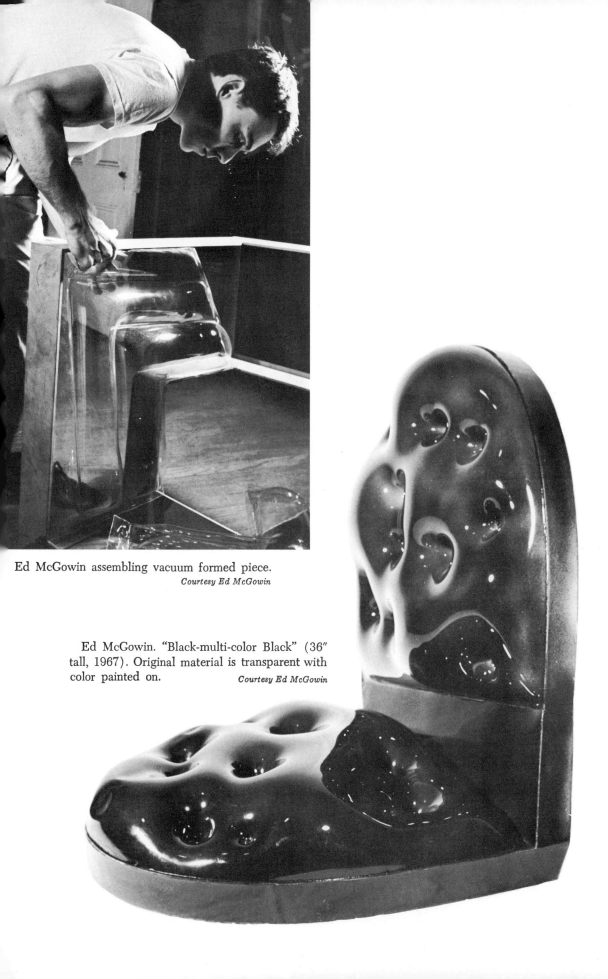

Ed McGowin assembling vacuum formed piece.
Courtesy Ed McGowin

Ed McGowin. "Black-multi-color Black" (36″ tall, 1967). Original material is transparent with color painted on. *Courtesy Ed McGowin*

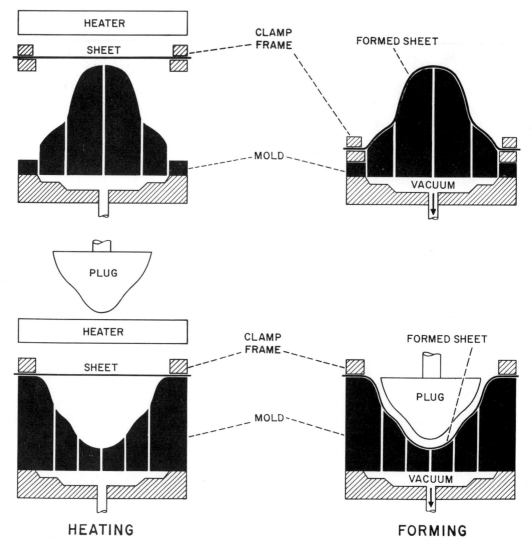

HEATING FORMING

Drape-forming over a mold is a variation of the basic vacuum-forming process. Plug assist is another variation that helps to distribute the softened plastic sheet evenly over the mold.

Courtesy Eastman Chemical Products, Inc.

Drape Forming

A commercial variation of the above technique is called drape forming. This is a related process. A thin plastic sheet held in a clamp frame that is mounted above a male mold, is heated. Then the clamp frame containing the heated sheet is lowered, stretching the soft material over the male mold to the lowest mold level. When the sheet is sealed at the edges to the base of the male mold (all this accomplished quickly) the vacuum is applied, pulling the soft plastic down over the mold.

Bag Molding

Bag molding is an adaptation of the above technique for thermosetting plastics. Plastic in this case is enclosed in a bag or film and vacuum pressure is applied under the form, or pressure is applied over the form with a coverplate or autoclave. Heat is applied by steam or radiant heat, curing the thermosetting plastic.

Foam Vaporization Casting

The reverse of the above casting method is a new approach for casting metal sculpture developed by the Boston artist Alfred M. Duca. He calls it "foam vaporization" casting. The artist carves his form directly into cellular expanded polystyrene. This is a material that is lightweight, stiff, and easily shaped. The finished sculpture is packed in a clay-bonded green sand (or sodium-silicate bonded sand) mold with its gates and vents (to allow for entrance of metal and exit of gases and air). It is gated and risered in the usual fashion as for bronze casting. The molten metal is then poured in through the prepared channels (with the polystyrene form still present) thereby vaporizing the polystyrene with its heat and completely replacing it. On completion the metal (bronze, ductile iron, aluminum) replaces the polystyrene much as it would have in the lost-wax (cire perdue) process. A faithful reproduction is obtained in this patented process.

Cold Metal Casting

Cold metal casting or resinated metal casting is the technique of mixing metallic granules, powders or flakes with polyester resin, often in a gel coat. Usually the proportion of the mixture is three parts of the metal (by weight) to one part of thixotropic resin. The trick is to keep the metallic granules from settling to the bottom of the mixture, hence, the necessity for thixotropicity; it holds the metal particles in suspension.

Metallic granules of at least 100 mesh are optimum. (Metal granules can be purchased from Metals Disintegrating Company, Elizabeth, N.J.) Proportions of the mixture can change. For instance, if a lightweight metal such as aluminum is to be used, then one and one half parts of aluminum filler is added to one part resin. Similarly increase the portion for heavy metals such as bronze.

Embedment, Potting, and Encapsulating

Embedment, potting, and encapsulating are other variations of casting technique. The terms "embedding and potting" have essentially the same meaning but vary in their fields of application. Embedments are enclosures of objects in resin for preservation and display. The resin is *always* colorless and transparent. In *potting*, components are enclosed in resin for the purpose of insulation and protection. Transparency is not important here. *Encapsulating* is essentially the same as potting.

Before an object is enclosed in resin its nature has to be assessed. Of what material is it made? Is it metal? What color does it have? These questions are necessary because: 1) certain metals inhibit and others accelerate the resin's cure; 2) some materials contract and expand at different and incompatible contraction and expansion ratios to the resin; and 3) the catalyst (and promotor if used) may bleach certain colors.

If there is a source of strain in the object to be embedded, fillers should be used and a plasticizer will help to reduce the strain. Brittle castings are apt to crack if the expansion of the embedded object should exert enough force. If large metal pieces are to be embedded, it is best to effect a very slow cure. Leaving the casting at room temperature for a week before oven curing is not unusual. Sometimes curing in a water bath kept at 150°F. with an infrared lamp minimizes separation and cracking. It is best, too, to raise and lower the heat gradually in order to reduce stress development. Copper and metals containing copper act as inhibitors and prevent the proper polymerization of resins such as acrylics. These metals have to be coated first with cellulose acetate, clear enamel, sodium silicate, or polyvinyl alcohol.

Before an object is embedded, however, it requires special preparation. First, the object must be completely dry.

81

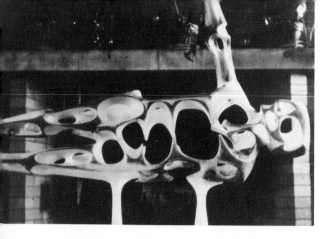

Alfred Duca's foam polystyrene carved model of "Adam" is approximately five feet from head to toe.

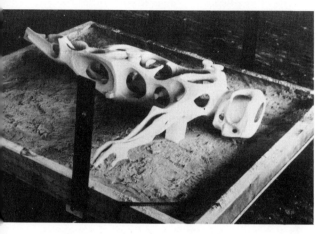

The refractory-coated pattern (two coats of a wash containing a zircon flour suspended in alcohol; the first coat was allowed to dry overnight, the second is applied immediately before molding) lies on sand on a mold base preparatory to molding.

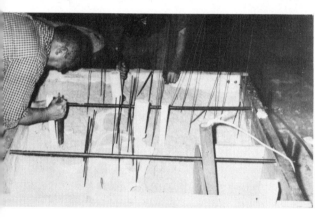

After "Adam" was placed on the base sand (sodium silicate bonded sand: approximately 75% A.F.S. 80 and 25% A.F.S. 110 mesh sand), sand was carefully tamped around the figure and then gates and risers of polystyrene foam were attached to the casting. Vent rods were used to permit setting the mold with CO_2 gas and some nylon venting tube was placed in the vicinity of the pattern to help eliminate the gas. Care was taken that no air should come near the pattern. (Air creates cope surface defects caused by the sooty deposit left by burning polystyrene foam in the presence of air.)

Removed from its sand bed, the finished casting of "Adam" in ductile iron is faithful to the finest detail of the original.

Photos courtesy Alfred Duca

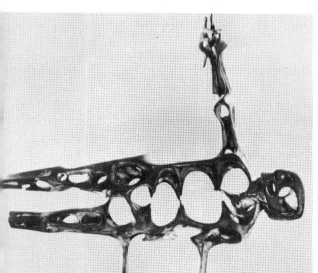

82

Presence of water will impart a haze to the cured resin. Drying hard, nonporous objects in an oven would ensure absence of moisture. Freshly killed biological specimens such as insects, or leaves, wood, etc., should be placed in a desiccator over calcium chloride for at least three days. This will cause decay, as drying proceeds, leaving a hollow shell. Delicate flowers can be completely dried out by completely covering them in crushed cereals such as oatmeal, or cornmeal, or cream of wheat which has been first heated to drive off its own moisture. Dry

to see a layer line of separation between the two pourings when the cured piece is held in certain positions. For specimens that are heavy and would sink, again a first layer is poured. At gelation the object is positioned on the resin and the next layer is promptly added. Air bubbles have to be jarred free. For large castings, cure should take place in a bath by placing the mold in water. This helps maintain a constant temperature.

When using a polyester casting resin, the mixture of catalyst, as with all castings, is critical. For castings one-half

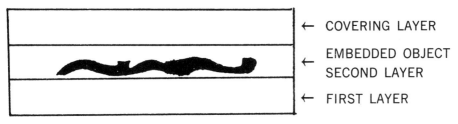

← COVERING LAYER

← EMBEDDED OBJECT
 SECOND LAYER

← FIRST LAYER

Embedment.

silica-gel powder can be used as well. The completely covered flower specimen has to be stored at room temperature for three to seven days. And the powder has to be removed gently from the dried and brittle petals. Blowing air through a straw is helpful. It is also best to thoroughly saturate the object with catalyzed resin so that spaces previously filled with air can displace the air with resin.

After the specimen has been prepared and the mold has been suitably coated, the mixed resin is ready for slow pouring. This operation can be performed in one, two, or three steps. If the object is difficult to position—it may float or sink if its specific gravity is different than the resin monomer—then a special treatment is necessary. For floating specimens a first layer is poured, and when it gels the specimen can be pinned into place. After the resin sets completely and the positioning pin is removed, a second and final layer can be poured. Air bubbles should be shaken free. It is sometimes possible

inch thick use 0.45% tertiary butyl hydroperoxide (0.5 cc. per 100 grams of resin), and for sections one inch thick, use half this ratio; for sections over one inch add 0.1% catalyst.

For curing, the poured, gelled casting can be heated at 250°F. (resin temperature) for five minutes or thirty minutes in a 170°F. oven followed by thirty minutes at 250°F. This high heat will discolor organic materials; it is only suggested for inorganic objects. Organic specimens should be cured at a lower temperature (150°F.) for a shorter period (ten minutes oven time). If this final curing takes place immediately after gelation, the casting will have its highest clarity. If turbidity in the final piece is desired, then long delays will produce this. Sometimes a tackiness on the top surface is caused by air inhibiting the cure. To eliminate this, cover the top exposed surface of the casting with cellophane or sand and grind down that surface later to remove whatever tackiness remains.

83

FOAM PROCESSES

There are special techniques for working with foams. Many artists are using these new materials as a means to an end (i.e., Alfred Duca) and as the end product itself. Methods of working with foams depend upon the kind of foamed plastic used. It should be recalled (check chart page 43) that foams may be flexible, rigid, open-celled, or closed-celled. The structure helps determine which process would be most effective.

Foam-In-Place

Foam-in-place is one popular method, particularly with urethanes. This technique involves mixing the liquid reactive components of the foam formulation together and pouring them into an open cavity or mold. In just a matter of seconds, the mix begins to foam and rise (like yeast-saturated flour in a warm oven), flowing throughout the cavity and filling all areas. As the foaming takes place the material adheres tenaciously to the support walls. In foams such as polyurethane, highly toxic gases are released and require the protection of a mask for breathing, as well as good ventilation. Roger Bolomey, an artist who uses expanded rigid polyurethane, wears an organic filter mask.

Spray-Up

Another method for working with foam is the spray-up technique. This method employs very fast reacting foams (so that they do not sag or drip from vertical surfaces before they foam). These are supplied in two component systems which are stored separately. They are fed in separate streams to a gun, either externally mixed or internally mixed in the gun; the material in both compartments atomizes with the air, and foam pours out. Another gun, a new internal mix variety, emits a high velocity stream of foam that expands virtually at the time of impact with the surface to be foamed or the cavity to be filled.

Frothing

A newer technique that does not require special equipment is a frothing method developed by DuPont. This process involves the use of special techniques to introduce blowing agents or tiny air bubbles under pressure into the liquid mixture of foam ingredients. Actually the mixture expands before the start of chemical reactions which gel the foam. In conventional techniques the foam mixture expands 30 to 40 times to reach its final volume; in this method, the mixture expands three- to sixfold. These lower-density froths can be poured, knifed, and applied without causing collapse. Exotherm and pressure are much less, too. The frothing material looks much like aerosol-dispensed shaving cream.

Machining

Rigid stock, in slabs and blocks, can be machined and bonded together like any solid plastic. Conventional hand or power woodworking tools can be used. It is best, however, to operate the moving part at a high speed using a slow feed. Plane and curved surfaces may be cut with electrically heated nichrome wire. Either heat melting cutters or shear type cutters can be employed. Adequate ventilation should be available to take away dangerous dust particles that are released during the cutting of these foam cells.

Chemical Blowing

Chemical blowing is used in foaming open and closed-cell plastics, particularly the vinyls. Chemical formulations for making many of the vinyl foams are very exacting. Some blow-in-place applications are possible with these.

Bead Expansion

Polystyrene comes in beads which can be expanded through the application of heat, such as a heat lamp. Other techniques are by hot water or the oven. In the former, beads are submerged in a sealed mold in hot water until they ex-

pand. They can also be placed into a mold and the bead-containing mold can be cooked in hot water until the beads expand. In the oven method, beads are placed on a tray in a 275°F. oven and allowed to expand. Steam and radiant heat have also been used in industrial processing.

Foam-Expansion Molding

The molding of expandable polystyrene can be accomplished by several different techniques: steam chest, autoclave, steam probe, conduction and induction heating.

The *steam chest* method introduces heat directly into the mold containing polystyrene beads. In the autoclave method, a perforated mold is introduced to steam within the autoclave. The steam probe system introduces a rod of steam into the mold cavity which is filled with pre-expanded polystyrene beads. Steam is injected and the probes are withdrawn immediately. Another method, conduction heating, is used for thin-wall moldings.

Silicones can be foamed into a rigid foam at room temperature. These foams are of two liquid components that have to be blended together in a high-speed mixer for about thirty seconds and then poured. They expand from seven to ten times. Their reaction exhibits an exotherm which rarely exceeds 150°F. In fifteen minutes the silicone has expanded completely and cures completely in about ten hours. These foams release hydrogen gas and *require ventilation.*

Phenolics can be foamed by chemical means and by premixed cellular mortar that consists of microscopic hollow phenolic spheres bonded together with other binding resins such as phenolic, epoxy, or polyester. The material has a putty-like consistency with high strength and light weight. Mixtures of cellular mortar, such as these, can be cured at room temperature. This plastic can be troweled into shape or pressed into a mold.

FABRICATION METHODS

Fabrication of plastics is another class of many techniques. It involves forming of sheets, rods, tubes, etc., and machining, cutting, bonding, and sealing of thermoplastics and thermosetting plastics into finished products.

Heating and Softening

One of the characteristics of thermoplastics is that the material can be heated until soft and then it will cool into the new shape. If reheated, its "elastic memory factor" will cause it to return to its original form. Errors can be corrected in that way. One of the most frequently formed thermoplastic materials, upon which this description will be based, is acrylic or polymethyl methacrylate (Plexiglas by Rohm and Haas, Lucite by DuPont) in sheet form. When heated to a forming temperature of approximately 340°F. it becomes soft and pliable, like rolled-out dough before baking.

Four general rules should be followed when forming acrylic sheets. First, 2.2% should be allowed for shrinkage. This must be kept in mind when cutting for a prescribed, precision size. Second, the whole sheet should be heated uniformly from 320°F. to 360°F. except for strip heating. Third, the sheet should be completely formed before it cools below its minimum forming temperature of 235°F. to 275°F. (depending upon the type of acrylic). Fourth, slow uniform cooling minimizes internal stress and results in truer contours. Acrylic should cool to 140°F. to 160°F. before the stress forming is removed.

Two methods are recommended for heating or softening the acrylic sheet: one is to suspend the plastic vertically from clamps to an air-circulated oven; or second, to line trays with soft cloth (to prevent scratching of the plastics' surfaces) and heat the sheet while it lies flat on the tray. Radiant heating, if carefully controlled, can be used as well. It

is difficult to attain a uniform surface heat, though.

Bending

The simplest forming method is the use of bending. Using a strip heater which softens just one section of the sheet will allow smooth and accurate bending.

Forming

Another method is forming. Here, a form for a base or support is necessary. These can be made of gypsum plaster, wood, metal, thermosetting resins, masonite—anything that will not change shape at the softening point of acrylic. After treating the sheet to the proper temperature, it is removed from the oven and draped over the form. The edges have a tendency to move away from the base shape and have to be held in place by various devices, depending upon the shape of the mold. Clamping rings, C-clamps, pressure, rubber bands are some of the devices used. Covering the cooling shape with a flocked rubber sheet helps to maintain gradual cooling.

Machining

Machining thermoplastics involves a thorough knowledge of woodworking tools and techniques as well as the special characteristics of each thermoplastic material. All thermoplastics can be machined on both conventional woodworking and metalworking machinery. The following recommendations apply to all thermoplastics and their general machining operations.

Because heat softens thermoplastics, the heat generated by friction in machining operations has to be considered. Otherwise the plastic will get gummy and stresses will be induced. To overcome this, coolants should be employed; there should be adequate clearance between the tool and plastic; and machinery should be operated at high speeds with a light cut and slow feed.

A ten per cent solution of water-

soluble cutting oil or compressed air jet make the best coolants. Care must be taken with the selection of a coolant because some can chemically attack plastic surfaces.

Generally, tools should be run at as high a rate of speed as possible. The tools should not have pointed ends but be ground to a slight radius to avoid scarring. Carbide-tipped or diamond-lapped tools should be used if possible. These can be used at higher speeds without excessive heat buildup. The only two exceptions are acetals and polycarbonates. These should not have a slow spiral design or a scraping-cutting action but rather the configurations generally used for brass or mild steel.

Specifically, acrylics, polycarbonates, acetal, and nylon often machine better than metals. Fluorocarbons and polyethylene machine easily but require more care to hold close tolerances because of their flexibility and high rate of thermal expansion. General purpose styrene is highly brittle and has to be fed slowly with liberal dousings of coolants.

In *sawing*, most of the saws used for cutting metals may be used for plastics. Teeth should be designed to allow for sufficient clearance. Circular saws should have carbide blades. Band saws can be used to cut curves in flat sheets. "Skip tooth" and "buttress" saws have been designed for band saw work with plastics. Carbide-tipped saws are necessary for glass-reinforced laminates because the glass is too abrasive for steel saws. If possible, a diamond-to-steel saw is best.

In *drilling*, twist drills designed for thermoplastics can be purchased. Plastic drills provide a maximum clearance for the cutting edges. There should be a slow, careful feed before breakthrough in drilling to avoid chipping. A high speed spiral drill with a 118° point is best for drilling glass-reinforced laminates.

Acrylic and high-impact styrene sheets can be *punched* and *sheared* when heated. (This is better than punching

86

and cutting when blanking dies.) They should be preheated from 180°F. to 200°F. to minimize crazing and cracking. Acetate, butyrate, flexible vinyl, and polyethylene can be cut at room temperature without heating.

Grinding can be accomplished with an open grain silicon carbide wheel used in a water jet. Other wheels tend to gum up and burn the stock.

Turning can be achieved on a metal cutting lathe with cutting tools at a zero or slightly negative rake angle. Surface speeds of 500′ per minute with feeds of .004″ to .005″ per revolution will cut a clean continuous chip in acrylic.

Bonding Methods

Bonding methods vary from use of heat to adhesives and solvents. Most "glues" for plastics are formulated with plastic, rubber, epoxy or latex for creating mechanical bonds in joining dissimilar or insoluble materials. Solvent bonding agents are formulated for joining plastics to plastics, specifically for acetates, acrylics, butyrates, polystyrenes and vinyls.

Thermoplastics can be *heat welded.* Using an electrical strip heater heated to the critical temperature of 660°F., the two edges of acrylic are brought together to contact the heated blade for thirty seconds until the surfaces begin to boil and smoke. At this point, the heater blade should be pulled away and the edges quickly pressed together with pressure (about 150 lbs. per square inch). Pressure must be maintained until the plastic slowly cools to below its softening temperature.

Friction welding uses the rubbing of two parts together until they are soft enough to join.

Another bonding method is the use of *cementing* materials. There are three general methods of bonding acrylic to acrylic. One is using capillary action or the surface tension action of a solvent; second, soak-cementing, using a mono-

mer solvent; and third, reactive cementing.

In preparation for cementing acrylics, it is best to apply solvent-resistant tapes to within $\frac{1}{16}$ of an inch to the areas that are to be cemented. The surfaces must be smooth and free of chips and fit together without gaps and without the application of pressure.

Capillary cementing requires the application of a solvent such as ethylene dichloride with a brush or eyedropper to the edges which are to be joined. Both sides should have an application of solvent. Only light pressure should be used to hold the parts together until the cement bonds the edges. The time may vary from a few minutes to an hour or longer. For a stronger joint, a fine wire, such as display wire, can be inserted between the two edges that are to be bonded; the solvent is then applied and allowed to seep into the joint. Before pressure is applied the wire is pulled out. This allows for a greater softening of the area and a firmer bond because of the extra solvent.

In *soak cementing*, the edges are allowed to soak in acrylic cement (for Plexiglas it is Plexiglas Cement II) for approximately seven minutes. When carefully removed, excess cement should be drained. The surfaces to be cemented should then be joined and contact pressure applied for only a minute to allow the soft edge to wet and soften the surface of the other part. Pressure of one to five pounds per square inch should be maintained for at least an hour. The remaining cement in the pan should be discarded; it is useless because of the evaporation of one of its ingredients.

Reactive cementing is recommended where strong joints are necessary. This cement sets by chemical reaction; it shrinks less and can fill in minor mismatches and crevices. It has a fast initial set and good weathering resistance in addition to high strength. To make the cement, mix resin, catalyst, and promotor

together according to instructions. The cement is applied (in the most facile manner for the object), slight pressure is exerted to eliminate entrapped air bubbles, and the cement is allowed to cure.

After cementing, *annealing* the acrylic to a temperature below forming (softening) results in greater dimensional stability of the product. The strength of the joints is improved because the trapped solvent can evaporate.

Molded acrylics do not cement together well. Pressure often causes stress cracking.

Other thermoplastics can be cemented by mixing an amount of extra catalyst to resin to increase the catalyst ratio and applying it between the forms or edges to be bonded. Roughening the surface to be adhered with coarse sandpaper increases the "tooth," and helps create a better bond. The resin then fills in scratches as it cures.

Specifically, cellulose acetate can be cemented together with a strong bond. Use either a solvent-type (acetone or acetone and methyl "cellosolve") or a dope-type consisting of a solution of cellulose acetate in a *solvent* or a *mixture of solvents* (cellulose acetate plastic 130 parts by weight, acetone 400 parts by weight, methyl "cellosolve" 150 parts by weight, and methyl "cellosolve" acetate 50 parts by weight).

Cellulose acetate butyrate and propionate may be cemented according to the technique described for cellulose acetate. Methylene dichloride, acetone, and chloroform number among their solvents.

Cellulose nitrate can also be bonded according to the method used with cellulose acetate. Acetone forms a good joint. Ethyl cellulose bonds best when solvents are employed or solvents are bodied with ethyl cellulose plastic. The parts should be in contact with the solvent for one to three minutes before assembly. Both surfaces should be wetted if possible prior to joining. Oven drying or annealing at temperatures of 120° to 130°F. makes for a better bond.

Nylon (polyamides) is very difficult to join. Phenol containing 12% of water and joined under pressure for five minutes makes a fairly satisfactory union. Some forms can be cemented with epoxy or resorcinol resins. Polyethylenes do not react with solvent-type cements. Heat sealing is the best technique. Although there are some cements available for high density polyethylenes, the joints have to be cured under heat and pressure.

Polyvinyl alcohol can be cemented to itself with water or solutions of 10% to 20% of glycerine or ethylene glycol in

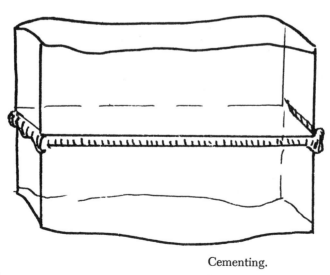

TOO MUCH PRESSURE APPLIED, CUSHION SQUEEZED OUT BEFORE SOLVENT ACTS ON SURFACE

Cementing.

Dick Artschwager's sculpture "Dresser, F45" is constructed of Formica (urea-formaldehyde) the same way furniture is made. The piece is framed in "T.V. Mahogany." The drawers of the dresser do not pull out and the "mirror" at the top of the dresser is in bright yellow Formica.

Courtesy Dick Artschwager

Sculptures such as this by Sobrino ("Transformation Instable Juxtaposition, Superposition 'D'") are comprised of many small units cemented together.

Courtesy Galerie Denise René, Paris

water. Resorcinol adhesives bond poly-vinyl alcohol sheeting and tubing as well.

Polyvinyl chloride and vinyl chloride acetate copolymers can also be cemented by solvents. Acetone and methyl ethyl ketone (MEK) are good solvents for vinyl chloride acetate resins. Dope-type adhesives work well here, too.

Relatively inert plastics such as the vinylidene chloride copolymers are diffi-cult to bond. Dissolving a small amount of vinylidene chloride into a solvent such as cyclohexanone or tetrahydrofuran and warming the solvent slightly will create a moderately good bonding agent. The bonding edges have to be exposed to the solvent for a longer period of time. Epox-ies are also good adhesives for vinylidene chloride.

Cementing of thermosetting plastics raises a problem that is easily solved with thermoplastics. *Thermosetting materials are not soluble in solvents.*

Generally, for bonding, smooth sur-faces have to be roughened and all grease and dirt removed. Adhesives that have a chemical formulation similar to the thermosetting plastic usually work well. Phenolic-epoxy and elastomer-phenolic-epoxy formulations blend and work well. Sometimes, as in polyester resin, resin mixed with a slightly higher amount of catalyst will bond edges and parts to-gether.

In summary, there are many considera-tions in selecting the proper adhesive. Is the adhesive selected for bonding, seal-ing, coating, or impregnating? The kind of adhesive must be determined. Would a solvent base, water base, mastic, film, liquid, paste, or powder be most prefer-able? How would the adhesive be ap-plied; by brush, knife, spray, dip, roller, extrusion, capillary action? How much time, pressure, and temperature can be employed? And finally, the end uses must be evaluated. Will the bonding have to be resistant to outdoor weather condi-tions such as wind, abrasion, water, sun-light, as well as to chemicals? Is flexi-bility a requirement? With those factors properly weighed, an adequate selection of adhesive can be made.

CARVING

Another process, one that is often mis-used, is carving. Thermoplastics lend themselves to carving techniques. Some-times a whole piece is carved much like a piece of stone or wood; at other times the plastic is carved by incising lines and shapes into its surface. This internal carv-ing technique has great potential, but has found popular, sensational, and hack-neyed application in an abundance of paperweights, key chains, powder boxes, and lamp bases incised with rosebuds and other flora and fauna.

Acrylic lends itself to carving. It ma-chines well, takes a high polish, and its optical clarity is unequaled, especially when combined with its linear character-istic of piping light. Edge lighting be-comes a relatively simple feat as will be seen on pages 208 and 209.

Utilizing the light refraction quality of an acrylic block, handsaws, files, and drill can be used to carve into a block and create three-dimensional forms. The sculpture can then be finished and pol-ished. Jan deSwart works in large blocks to fashion his sculptured forms. The only drawback is the high cost of a solid block of acrylic. It is one of the most precious of plastics.

FINISHING METHODS

Sometimes plastics fabrication requires an extended operation—that of finishing. It may be necessary to scrape, sand, buff, polish, or decorate the processed piece. Finishing requires correcting defects without disturbing other areas.

Sanding and Polishing

Lathes are recommended for buffing, sanding, and polishing operations. In fin-ishing thermoplastics, special care must be taken to avoid overheating, to make sure that tools are sharp enough, and that

the machine operates at the proper speed. Excessive speeds, hard buffing wheels, excessive pressure should be avoided. Specifically, a standard belt or disc sanding machine as well as portable sanders may be used. Sawed edges and other tool marks can be removed by sanding with medium grit (60–80) paper or belt to be followed by wet sanding with wet or dry sanding paper or belt. Starting with 150-grit and working to 400-grit is recommended as preparation for machine buffing. When hand buffing is used, the sanding should be brought to 600-grit refinement.

A muslin wheel dressed with tallow and abrasive brings acrylic to a high surface polish. This should be followed by using a clean, soft cotton flannel buffing wheel revolving at 1800 to 2000′ per minute. By keeping the acrylic in constant movement, friction-induced heat can be avoided. The final buffing should be at 2000 to 2400′ per minute with a very loose flannel wheel.

For thermosetting plastics *polishing* should be accomplished with greaseless compositions on a muslin buffing wheel. For cutting down minor marks, a composition of buffing powder as a grease binder is recommended.

Coatings

There are surface coatings available for glass-filled polyester, epoxy, and melamine laminates to cover pinholes and other blemishes. *Coatings* are applied by spraying, dipping, or brushing and then final drying occurs in a warm air circulating oven. Infrared drying often causes hot spots and results in crazing, distortion, and wrinkling.

Hand finishing sometimes involves operations using a scraper with a sharp bladed tool that rides over the surface of the plastic without nicking. Filing is accomplished by using a coarse cut file with thin-topped teeth that is held firmly and filed in one direction. Wet sanding is superior to dry sanding because of less tendency for the paper to clog up.

The Plastic Quality

The fact that plastics have their own qualities cannot be stressed too strongly. We are surrounded by hundreds of poor examples where the wrong plastic was used for a product and therefore performance was poor; and hundreds of examples where plastics were used as imitators. It is not surprising that plastics have been and still are used to duplicate metal, wood, fabric, clay, stone, and even glass, because those are substances that have been with us for centuries; and perhaps because the *only* denominator common to all plastics is that they are truly *plastic*. They all can be molded—at some point they are soft. This is new material to mankind—not like wax and pitch, but a plastic material that can be poured to look like marble, or wood, or glass.

Plastics' tremendous potential can be overwhelming, too. Few natural substances converted by mankind can offer the multiple advantages of light weight, strength, stiffness or flexibility, smoothness of joint detail, a full range of texture and color, transparency to opacity. Artistic judgment as to what plastics will do that other materials cannot do requires a new look at art technique.

Structurally, polymers have a molecular order unique to each plastic. Physically, they have a "life" of their own. Even though they can ably imitate, they need not be substitute materials; however, too often they have been fabricated to match an older model.

The screwdriver is a good example of how old designs with wood have been

lifted and applied as a solution to the plastic handle design. The wood handle had to be carved and therefore the handle was in part a product of its own technical limitations. The wood could not be molded as plastic, nevertheless plastic screwdriver handles still resemble the wood model but could be *easily* capable of much more imaginative designing.

The most ideal examples are foams because they have no peers in nature except for lava. There are no preconceived ideas to conform to here. And entirely new methods have been developed for applying and designing with foams. Foaming-in-place is one instance that points to a tremendous potential.

Polymer chemistry has developed remarkable means and substances in other respects, too. Plastics can be formed with no flame or applied heat to firm them—as in other welded or cast forms; they can have a strength and durability equal to bronze and steel and yet can be transparent, too.

These properties can lead to profound changes in traditional media areas, such as painting and sculpture. Since "plastic" paints can also act as a binder, painting can take on some of the aspects of bas-relief by projecting away from the background.

Second, rich textures can also be applied.

Third, the support and material can become one—in some cases there is really no background, but a back and front to a reversible painting, intended to be seen from two sides.

Fourth, since plastic paints "dry" quickly, it takes only minutes for a layer of paint to cure. Being able to glaze and scumble easily and quickly brings a new flexibility to painting.

Fifth, without color-modifying vehicles and binders such as the yellowing oils and varnishes in paints, colors can be more brilliant.

Sculptors have found new dynamic expression in plastics, too. Naum Gabo, for

94

instance, was able to mold space without defining it with solids; no traditional material would permit a solution to Gabo's significant forms. Amorphous masses of foams, translucent fiberglass impregnations, and transparent strength of epoxies lead to entirely new definitions of space.

But one of the most unique properties, unleashing great possibility, is the potential of most plastics to have strength as well as transparency-translucence. Although true transparency is not new (stained glass has been with us for centuries and there are a few glass sculptures), glass has limitations that are overcome with plastics. For instance, use of glazing to hold glass fragments together in stained glass is not necessary with plastics because of their room temperature adhesive property. Solutions such as this for old media as well as for its own potential require a new treatment and a deeper insight into the meaning of transparency. Paintings that use light as well as traditional aspects of texture, color, and form project into another dimension. And sculptors such as Edward Higgins use plastics to effect space distortions that take on some aspects of painting techniques (e.g., foreshortening to exaggerate distance and size).

Light, through transparent and translucent plastics, expands the artist's realm. It is at once basic—without light we could not see—and using light the artist has greater command of his communication through internal and external modulation.

Transparency goes beyond surface. Capable of richly decorated skins and projections into the background, there is simultaneous perception at different depths into different spatial locations. The top surface can become a tantalizing barrier that is visually penetrated to reach depth elements while also seeing the inner and outer whole at the same time.

What are these plastics' painting and sculpture qualities of transparency?

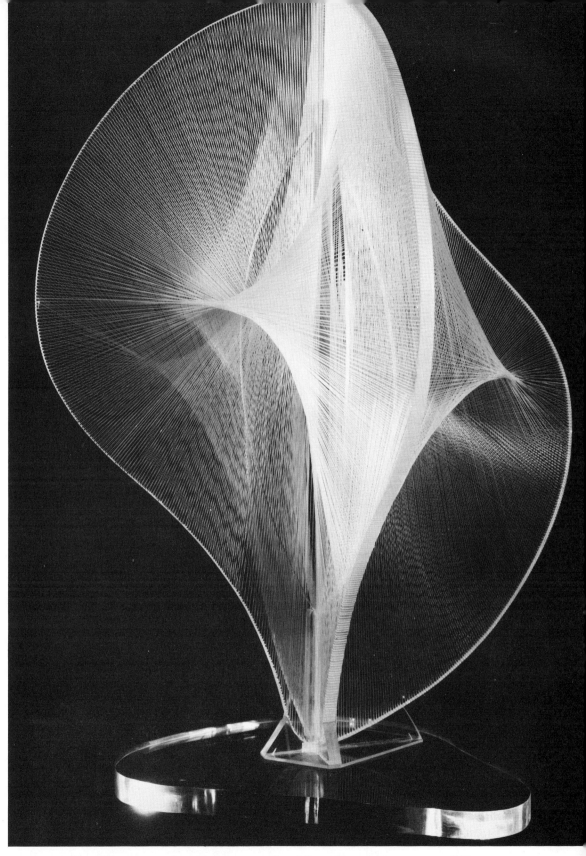

Naum Gabo molds space without defining it with solids in "Linear Construction #2" of acrylic. (3′ high, 1949.)

Courtesy Otto Gerson Gallery

Sculptors such as Edward Higgins use plastics to effect space distortions that take on some aspects of painting, such as foreshortening in perspective. ("Untitled," 1963. Welded steel and epoxy, 19″ x 54″ x 25″.)

Courtesy Leo Castelli Gallery

1. Transparency allows the passage of light, uninterrupted or interrupted by incision, embedment, coloration, or overlaying texture.

2. Transparency permits both the inner and the outer to be seen at the same time. It reveals the structure of the design. If it is a transparent sculpture, negative voids and volume would be seen as well as a play of planes inside the form.

3. Transparency imparts a feeling of suspension to embedment, a time-space pendulousness.

4. Transparency intensifies color because light is just slightly diffused by tints and viscosities.

5. Transparency brings the front to the back and the back to the front.

6. Transparency blends with the environment and allows the surroundings to play within its transparent form, the viewer being able to see through the material to its background. Outside movements play with the form.

7. Transparency requires both reflected, incidental, and transmitted light for advantageous display of its internal and surface forms. It demands air space around it.

8. If uninterrupted, both light and sight can pierce the form and vision becomes "lost" through environmental distraction.

9. Transparency can glitter and reflect from its shiny surface like a mirror, if facets and textures do not interrupt and capture this light path.

Transparency, then, depends upon constantly changing relationships between the foreground and background because as light changes its direction and intensity, the dependent transparency relationship is modified, too. Nuances of texture, pattern, color, and form integrate dynamically when plastics' full potential is realized.

Transparency permits both the inner and the outer to be seen at the same time as in this carved acrylic sculpture "Cathedral" by Fred Dreher (1958).

Photo by Chester Danett

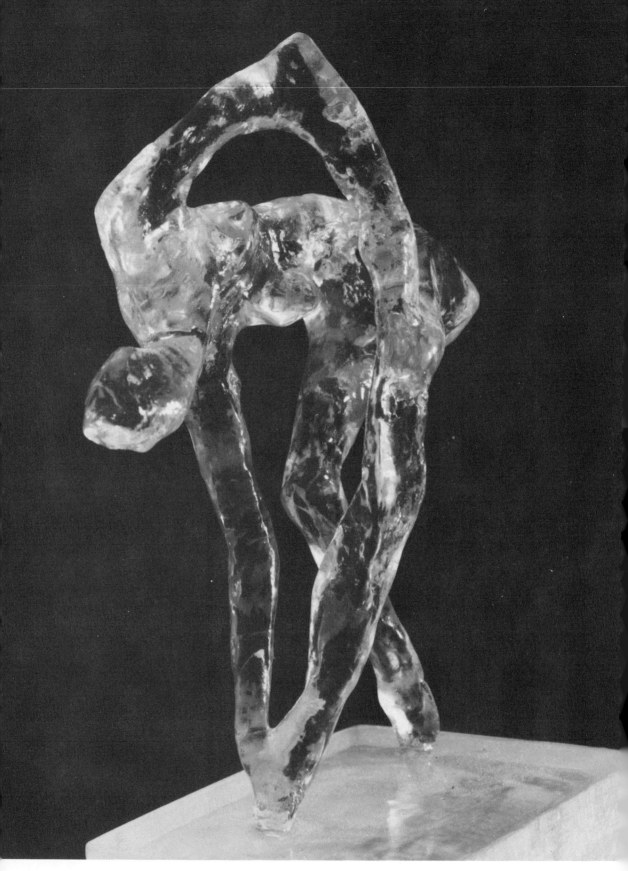

Transparency brings the front to the back and the back to the front. ("Dancer I," 1961, by the author.)

Working with Polyester and Epoxy Resins

POLYESTER RESINS

Unsaturated polyester resins are among the easiest handling resins used in the plastics industry.* They color easily, can be cured at room temperature, can be relatively resistant to weathering, fire, and corrosion and, most important, can cure without the releasing of liquids or gases. Laminations with fiberglass are exceptionally strong and lightweight as well.

Polyester can be formulated to meet almost any requirement. Varieties can be made rigid or flexible, nonburning, impact resistant, ultraviolet light resistant, crystal clear, translucent, opaque, thixotropic, fast curing, slow curing, and to meet almost any other requirement. Some resins are particularly formulated for lamination where there are thin sections, others are compounded for casting thick sections.

* Distinguished from the saturated type used in cloth fibers such as Dacron.

PROPERTIES OF POLYESTERS

The properties of polyester resins can vary, too.

1. BURNING RATE

 From slow to self-extinguishing (chlorinated compounds slow the burning rate to self-extinguishing). When polyester burns, the flame is not large but the smoke is excessive.

2. COLOR

 Most varieties are light pink to greenish-gray in tint. Some kinds are crystal water-white, resembling acrylic in clarity.

3. COLOR STABILITY OF THE RESIN

 The resin deteriorates in time under ultraviolet light exposure but can be stabilized with additives. Under indoor light there is practically no change in color.

4. EFFECTS OF CHEMICALS

 There is almost no effect (unless under long exposure) from soaps, weak acids, vegetable oils, kerosene, gasoline, lubricating oils, alcohol, and carbonated beverages. If allowed to soak in water, the surface of polyester will whiten. Some protection can be applied to lessen whitening.

5. HARDNESS

 Rockwell (M) Value 115/1 and Barcol Value 40–45.

6. HEAT STABILITY

 Will soften very slightly under 250°F. Hardens under higher temperatures. Will retain shape in boiling water, but can be heated and pressed back into shape if warped.

7. MACHINING PROPERTIES

 Works well with plastic cutting wheels. Can be buffed to a high gloss.

8. ODOR

 Polyester emits a gaslike odor when uncured. No odor when completely polymerized. However, if an object is kept in an enclosed area, a distinctive polyester odor can be detected.

9. REFRACTIVE INDEX

 At least 1.5591 at 77°F.—if a filler is used with a refractive index close to that of polyester, most of the clarity will remain.

10. SHELF-LIFE

 The liquid resin will last approximately one year at room temperature. If kept at lower temperatures, the resin will not polymerize for longer periods of time. Light and heat will polymerize it. It is best to keep the resin in a dark, cool spot. Older resin needs less catalyst to cure it.

11. SHRINKAGE

 The average shrinkage in volume is 7.5%, linear shrinkage 2.5% or 25 mils per inch. Filling of the resin with fiberglass, sand, etc., cuts down shrinkage to 1% or less, depending upon the type of filler used.

12. SPECIFIC GRAVITY

 1.26 gm. per cc. Since the specific gravity of water is 1, polyester resin is slightly heavier and would be slightly less in volume than water.

13. STRENGTH

 Tensile strength—4000 psi
 Flexural strength—10,000 psi
 Impact strength—1.2 ft./lb.
 ⅛" fiberglass cloth lamination will increase
 Tensile strength to 25,000 psi
 Flexural strength to 40,000 psi
 Overall compressive strength of the lamination is 34,000 psi

14. Solvents

 Acetone will affect the surface of polyester resin and slowly disintegrate it.

15. Viscosity

 300 to 500 centipoises—closely resemble the viscosity of varnish.

16. Weathering

 Exposure to outdoors will eventually (after many years) cause yellowing, dull the surface of polyester. The surface, however, does not craze or crack. Frequent and rapid temperature contrasts, from hot to cold, will not crack polyester but will cause some warping if the material is not properly framed.

A Working Procedure

1. Study the entire operation thoroughly.
2. Assemble all necessary equipment and materials.
3. Prepare working area and preliminary operations such as cutting cellophane, wood, waxing your mold, etc.
4. Pour your resin, mix the proper amount of filler, stabilizer, color—as the situation requires—into the resin, and the catalyst last of all. Stir well.
5. Pour catalyzed resin onto surface or into mold.
6. Protect pouring from dust. Except for trimming gelled piece, do not disturb work until fully cured (stresses are built in at this point).

How to Begin

After studying the entire operation thoroughly, gather together all the necessary equipment and materials, including your base panel.

In a mixing container (paper cup, tin can, coffee container, polyethylene bowl) drop ¼ tsp. of "Tinuvin P" (or other ultraviolet light-stabilizer) for each three ounces of polyester resin.

Since "Tinuvin" is a powder, it needs to be dispersed. Pour into the cup containing the U-V stabilizer just enough styrene monomer to "dissolve" the "Tinuvin."

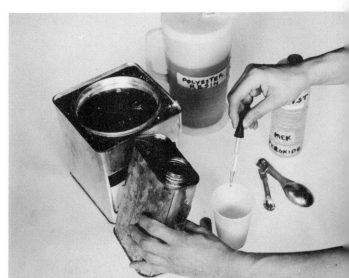

101

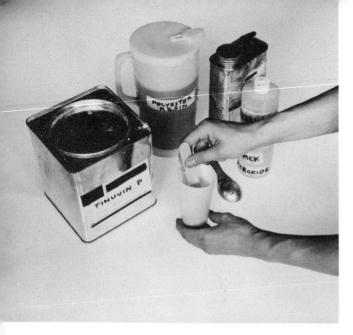

Stir the mixture well with a tongue depressor, spatula, paint stirrer, or any clean glass, wooden, or polyethylene stick or rod.

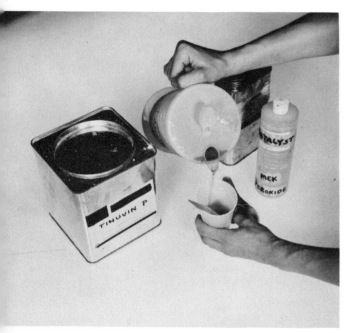

Pour your measured amount of polyester resin into the U-V stabilizer mixture. Again carefully stir the ingredients together without introducing excessive air into the mixture.

At this point, if a thixotropic resin is necessary to keep the resin from running, a thixotropic filler should be added, such as "Cab-o-sil." Introduce small amounts of the filler to the uncatalyzed resin until the desired viscosity is obtained. Mix well. Or if another type of filler is necessary, add this filler the same way.

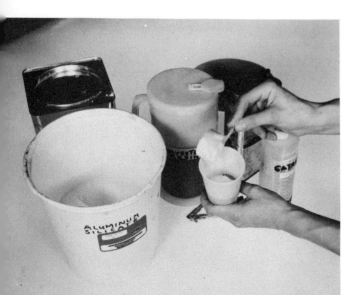

Again, at this stage, if color is desired—with or without filler—add small amounts of color and stir very, very well until the color is evenly dispersed and the desired intensity of hue is reached. Usually a very small amount of color will produce satisfactory results.

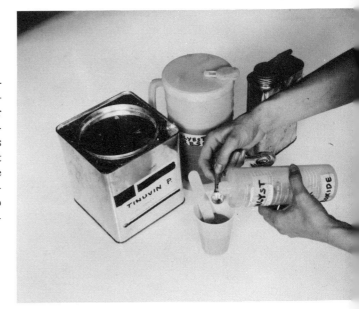

Finally, the prescribed amount of catalyst—usually methyl ethyl ketone peroxide—is measured and poured in with the other ingredients. Again, thoroughly stir this mixture until you are certain that the colorless catalyst is evenly dispersed. From this point on, the amount of "pot-life" or working time depends upon how much catalyst you used—it should be anywhere from 25 minutes to an hour (increase or decrease of pot-life depends upon your project requirements).

Assembling Material

A typical preparation would consist of:

1. The visualization or design for the project.
2. A clear working area.
3. Resin.
4. Catalyst.
5. Separators, fillers, stabilizer, color, etc.
6. Tongue depressors or mixing sticks for stirring.
7. Clean empty cans or paper cups for mixing.
8. Aluminum, glass or ceramic measuring spoons for proportioning catalyst, etc.
9. Paper towels or cloths and solvent (acetone) for cleaning.
10. Special ingredients for project: such as brushes, glass, putty strips.

Constructing a Base Panel

There are many kinds of bases for polyester resin—some are economical and simple to construct, others are more expensive and complex. Your choice depends, of course, on your needs and aims. Here are six different ways.

The most expensive and most professional way is to frame a sheet of acrylic (from ⅛" thickness to over ½", depending upon the size of your panel) with aluminum, other metals, or wood, making certain that you have a tight seal. The aluminum framing in these illustrations is a storm-window construction containing a vinyl weatherstripping—this helps keep the liquid resin from leaking through the frame and holds it on the acrylic.

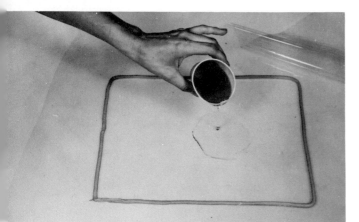

A very simple method: On a piece of cellophane, waxed paper, polyvinyl acetate sheet, or polyethylene sheet, lay a coil of window stripping putty (e.g., Mortite), clay, or wax to the desired outside dimensions. Press the edging firmly so that the material grips the surface. (The surface chosen will determine the type of finish you will have on the back of your panel.)

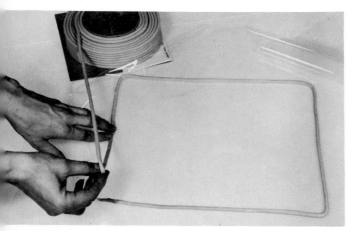

Pour your catalyzed polyester resin into the dam made by the putty, clay, or wax stripping and onto the cellophane until the pool of resin reaches the planned thickness.

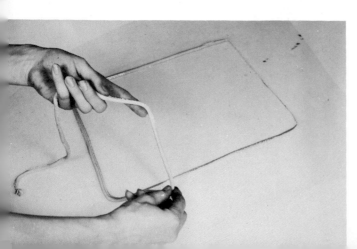

After the resin gels, strip away your edging. Make certain that residue of the stripping is removed. The solvent for putty is kerosene and for wax it is alcohol, toluene, or xylene. You may trim the edge now with a sharp knife or pizza cutter. If the resin has cured, the edge can be filed and sanded clean. Try not to disturb the piece until it is fully cured.

104

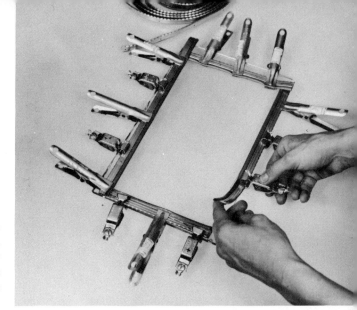

Using aluminum containing vinyl weatherstripping, place this around the edge of a glass panel that has been coated with wax or silicone, using pressure clamps. When the resin gels, remove clamps and lift away the vinyl-clad aluminum weatherstripping.

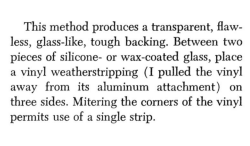

This method produces a transparent, flawless, glass-like, tough backing. Between two pieces of silicone- or wax-coated glass, place a vinyl weatherstripping (I pulled the vinyl away from its aluminum attachment) on three sides. Mitering the corners of the vinyl permits use of a single strip.

Clamp the two pieces of glass, separated by vinyl stripping, with pressure clamps, leaving one edge unsealed.

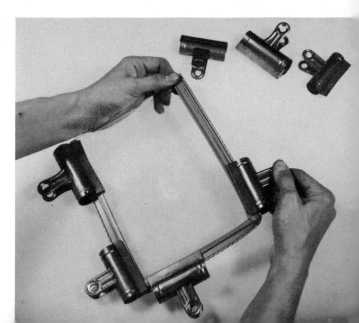

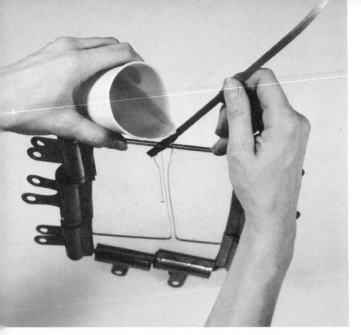

Then, pour your catalyzed polyester resin between the sheets of glass. This can be quite difficult and messy unless you use a trick—insert a thin smooth stick or metal between the glass into the opening. Then, instead of aiming your pouring at the aperture, drip the resin onto the stick. Capillary action will drain the resin into the aperture with no loss of material. If you cannot brace the form with your fingers, then wedge the panel vertically between weights.

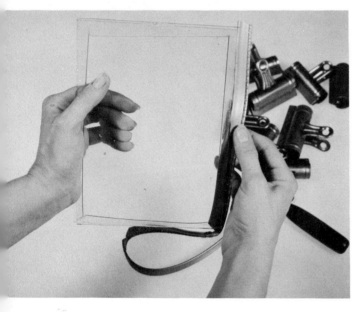

Upon *complete curing*, pull away the vinyl stripping, without separating the glass sandwich.

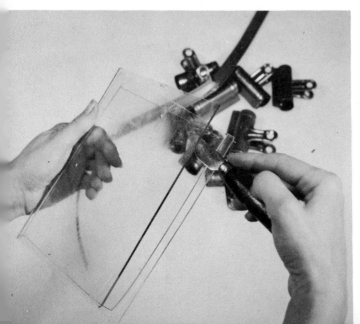

Then, with a flat instrument, or knife, wedge apart the two pieces of glass from both sides. It should pull away easily, if properly coated, revealing a glossy, hard, clear polyester panel.

106

This method produces a strong, translucent sheet. First, pour a small amount of catalyzed resin onto a sheet of cellophane.

With a stick or tongue depressor, spread the resin—pouring into a thin layer on the cellophane.

Place your fiberglass mat or cloth onto the resin.

Pour more resin onto the fiberglass and distribute it evenly with a tongue depressor until the fiberglass looks transparent, leaving no dry or "fuzzy" areas.

Place another sheet of cellophane onto the impregnated fiberglass, starting from one corner and smoothing it with your hand toward the bottommost edge. The cellophane should be wrinkle free.

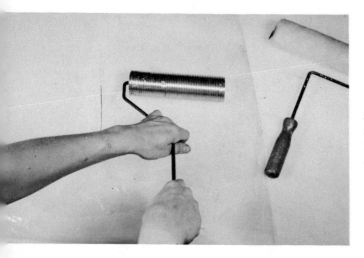

With a rolling pin, dowel, brayer, paint roller or especially grooved aluminum roller for fiberglass, press out air bubbles and distribute the resin by applying pressure evenly as you roll the instrument in all directions.

When the resin-impregnated fiberglass gels, trim the edge with a scissors or sharp knife taking care not to delaminate (separate) the fiberglass edge. If you allow the fiberglass to cure completely—this sets up fewer strains in the panel—you can then file and sand the edge.

Upon final curing peel away the cellophane from both sides. The result is a tough, smooth, translucent sheet.

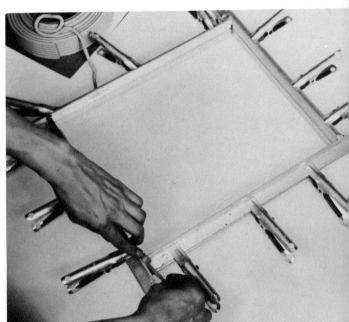

This method produces a rigid, sturdy, transparent panel. Place *L*-shaped strips of cast aluminum around all four top and bottom edges of an acrylic sheet (thickness of acrylic should be determined by the size of your piece). Clamp the two *L*-bars and acrylic together all around.

Seal the corners, top and bottom, with clay, wax, or putty. This sets up a liquid-tight dam to contain a resin-pouring on both sides. (It is necessary to pour resin on both sides of the acrylic sheet to equalize contraction, expansion, and tensions—otherwise the sheet may warp.)

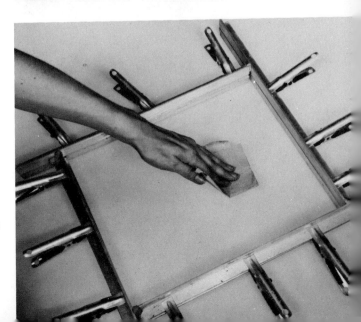

Sand both sides of the acrylic with coarse sandpaper to give the acrylic "tooth" and prevent later delamination of the resin.

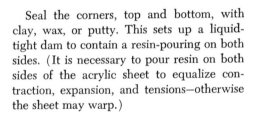

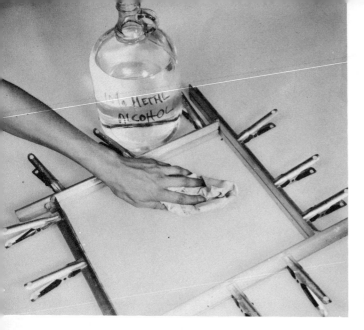

Clean both sides of the sanded acrylic with alcohol, making certain that all grease, wax, and dirt are completely removed.

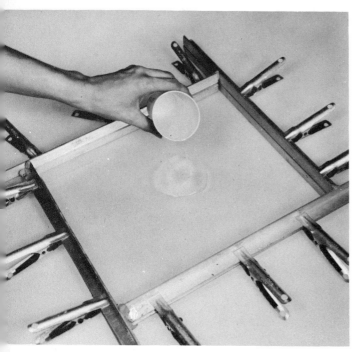

Now, pour your catalyzed polyester resin, first on one side, which will become the back, covering it to the desired thickness (perhaps ¼"). When it cures on that side, turn the panel over. The front side of the panel is now facing you waiting for decorative treatment. After the artwork is cured, pull away the sides of aluminum and you will have a workmanlike piece ready for framing.

Color

Transparent organic pigments (vat dyes) can be obtained for polyesters to yield stained glass quality colors. All colors should be evenly dispersed in a polyester compatible base. Powdered colors may sometimes be dissolved in a little styrene monomer. When transparency is not necessary, opaque and trans-

lucent pigments could be used. Usually a very small amount of color, well dispersed in your resin, will provide enough hue intensity. Try small amounts at a time.

Marbleizing effects can be achieved by dripping color into a filled (with filler) resin and not stirring the mixture very thoroughly.

Color Mingling

A very simple and yet effective technique that ably demonstrates polyester resin's fluid quality and also the effects of color mingling is this first project.

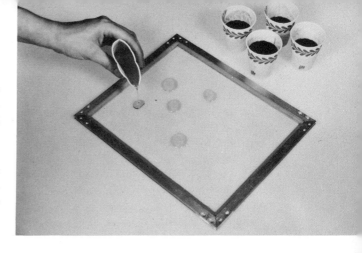

Mix small amounts of four or five basic colors, such as yellow, blue, red, green, and brown. Catalyze the mixture and distribute small amounts over your prepared panel. (This one is acrylic.)

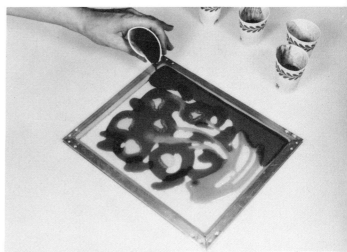

Continue distribution of the other colors. You can "draw" by dripping the colored resin in a planned pattern which will become more vague as the colors mingle and fuse, creating new nuances of hue, until the plastic movement of color freezes, capturing this motion at gelation.

This black and white result does not show the jewel-like quality of color and texture. See color section.

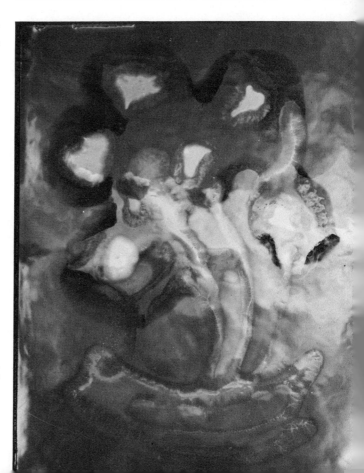

111

Catalyst

The most commonly used catalyst is methyl ethyl ketone (MEK) peroxide. Occasionally, special applications will call for benzoyl peroxide, or cumene hydroperoxide. These are usually used when curing heat has to be brought slowly to final polymerization.

Each manufacturer suggests his own proportions for catalyzing his resin, usually noted by percentage—in this kind of work, a most unscientific way. Use the manufacturer's formula and your own judgment as your guide. For instance, a thick casting which has a larger mass to cure will become too hot if the manufacturer's formula were to be applied. The cure will result in large cracks because of the excessive exotherm being built up.

Conversely, if just a thin coating is to be applied, the prescribed proportion will be inadequate because of thinness and also because air usually inhibits the cure of polyesters. Therefore, the surface will remain tacky for a long time. Here is where your own judgment should be used. It sounds like Grandma's recipe, stating proportions by handfuls and generalizations—but with a bit of experience this rule should carry you to success: For thick castings reduce your catalyst; for thin applications increase the catalyst concentration—all of this in proportion and using the average suggested formula as a guide.

For those with little experience the following table may be helpful:

If thick sections of polyester resin are desired, it is necessary to reduce the amount of catalyst in the mixture. Otherwise there will be severe cracking. A great thermal action causes the resin to shrink excessively, thus resulting in large cracks and breaks, warping the piece out of shape. This photograph of a corner of a panel illustrates what will happen with excessive exotherm. *Photograph by the author*

	Volume RESIN	Volume CATALYST
Laminating Resin (thin) Layers	2 tablespoons (1 oz.)	20 drops
	6 tablespoons (3 oz.)	¼ teaspoon
	1 cup (8 oz.)	½ teaspoon
	1 pint (2 cups)	1¼ teaspoon
	1 quart	2½ teaspoon
Casting Resin (thick) Sections	1 tablespoon	3 drops
	4 oz. (½ cup)	24 drops
	1 cup (½ pint)	48 drops

Promotors can be used to decrease the gel time. A gelation from 30 to 60 minutes (depending upon room temperature) can be reduced to less than 10 minutes. It must be cautioned that promotor and catalyst should never be mixed together or with the same implements because of explosive results. Promotors, cobalt naphthanate is one, discolor the resin to purplish or blue-grayish tones. Some colorants and fillers can act as a promotor. It is best to make tests before attempting a large piece.

Resin Proportions

One ounce of resin will give a $3/64$-inch coating to 30 square inches. A $1/16$-inch coating will cover 23 square inches.

If resin is used to saturate fiberglass cloth (7½ oz.), 2 oz. will cover a square foot; 2¼ oz. of resin will impregnate 10 oz. fiberglass cloth and cover one square foot. More than 5 oz. of resin is required to saturate 1 oz. fiberglass mat to cover 1 square foot; and over 9 oz. of resin is needed to impregnate 2 oz. glass mat per square foot coverage.

RESIN CATALYZATION CHART FOR POLYESTERS USING MEK PEROXIDE °

MEK Quantity		POLYESTER Quantity						
		Pint	Quart	#10 Can	Gallon	5-Quart	5-Gallon	
½%	oz.	0.1—	0.2—	0.5+	0.7+	0.9	3.6	
	cc.	2.7	5.4	16.2	21.6	27.0	108.0	
	tbsp.	0.6—(tsp.)	1.2—(tsp.)	1.1+	1.5+	1.9	7.6	
¾%	oz.	0.1+	0.3—	0.8+	1.1—	1.3+	5.4	
	cc.	4.0—	8.1	24.3	32.4	40.5	162.0	
	tbsp.	0.9 (tsp.)	1.7+(tsp.)	1.7+	2.3—	2.8+	11.4	
1%	oz.	0.2—	0.4—	1.1—	1.4+	1.8	7.2	
	cc.	5.4	10.8	32.4	43.2	54.0	216.0	
	tbsp.	1.1+(tsp.)	2.3 (tsp.)	2.3—	3.0+	3.8	15.2	
1½%	oz.	0.3—	0.5+	1.6+	2.2—	2.7	10.8	
	cc.	8.1	16.2	48.6	64.8	81.0	324.0	
	tbsp.	1.7+(tsp.)	1.1+	3.4+	4.6—	5.7	22.8	
2%	oz.	0.4—	0.7+	2.2—	2.9—	3.6	14.4	
	cc.	10.8	21.6	64.8	86.4	108.0	432.0	
	tbsp.	2.3 (tsp.)	1.5+	4.6—	6.0+	7.6	30.4	

Resin weights were calculated at 9.0 per gallon. Slight adjustments may be necessary for variance in resin weight from this figure. A minus (—) following the number indicates scant measure; a plus (+) means slight increase over amount shown. Measure in teaspoons (tsp.) where indicated rather than tablespoons.

° Courtesy RAM Chemicals, 210 East Alondra Blvd., Gardena, California.

Gel Coats

A polyester gel coat is a specially prepared plastic coating that can be sprayed or brushed on like paint. Available like paint in all colors and transparency-to-opacity, it differs from paint in that gel coats cure and "dry." A gel coat can be flexible, rigid, thixotropic, chemical resistant, fire retardant—but it is always a coating.

Most gel coats are applied to about a $\frac{1}{32}''$ thickness. They are catalyzed the same as polyester resin, using relatively more catalyst because of the thinner area.

Some gel coats cure tacky, because air inhibits the surface. Sealing off the air with a layer of cellophane is one solution; another is using a wax-type gel coat. When the resin cures, heat generated in polymerization melts the wax and floats it to the surface. Thus a top coating of wax seals the gel coat from the inhibiting air and a hard surface is obtained.

See Chapter **Three** for a description of *Cold Metal Casting*.

Water-Extended Polyesters

Water droplets are now being used as an extender for a special water-extended polyester resin.* The advantages over other fillers is that exotherm and also flammability are reduced. These resins are available in a "mayonnaise" consistency material and in thermosetting foams. Conventional polyesters will not work as water-extended polyesters.

Minute droplets of water are added to these polyesters while high speed, high shear mixers whip the mixture into a "mayonnaise" consistency. Large castings made of this material can gel in two minutes, demold in 6–10 minutes with a $\frac{1}{2}$ to 4% shrinkage during the cure (depending upon the exotherm). 15% of salt can be added to the 50–60% water level to avoid freezing. 25% of calcium chloride eliminates freezing down to $-76°F$.

Dyeing agents can be incorporated into either the water or resinous phases. Adhering of these polyesters to wood, aluminum, steel, concrete, polystyrene, acrylics and nylon can be accomplished by using a good contact bonding adhesive.

Water-extended polyesters are a good substitute for Hydrocal. Cure is very fast, about five minutes; shrinkage is great.

Flameproofing Polyester Resin

Polyester resin loses some of its transparency and sparkle when flameproofed, but certain conditions may require lack of flammability. In that case a recommended formula is:

Polyester Resin	100.0
Chlorowax 70	12.0 to 15.0
(1 level tablespoon of Chlorowax 70 to 2 oz. resin)	
Antimony Trioxide	12.0 to 15.0
Plus fillers and catalyst	

Mix together with an impeller-type mixer for dissolving and dispersing the flame-retarders into the polyesters. Chlorowax 70 may also be dissolved in about 30% of styrene monomer to 70% Chlorowax. The resultant polyester is self-extinguishing (after exposure to 30 seconds of a Bunsen burner flame) in less than 20 seconds.

Fire retardant polyesters also may be purchased. They usually are unpromoted resins. You would have to add the promotor before the catalyst.

Crystal Clear Polyesters

There are exciting new crystal-like resins (water-white) that are almost indistinguishable from acrylic. Apparently the promotor is no longer a tinting factor and UV radiation does not seem to change the color of these clear resins. It is important to use one percent MEK Peroxide with these resins because of the bleaching quality of the peroxide. This percentage should be maintained even

* Ashland Oil Company, Columbus, Ohio (Aropols Q6300, Q6310, Q6326 and Q6341). Reichhold Chemical Company, Polylite 32-177.

114

Sara Reid in studio casting a ten foot sculpture (one of a series) for The Manila Electric Company. She used Diamond Alkalis 6912, a crystal clear polyester resin. Wood molds or jackets, lined with a heavy gauge Mylar, were used for casting the basic components that were later added to the ten foot unit.

Model for lobby (110' x 50', 1969) of the Manila Electric Company, Manila, Philippines.

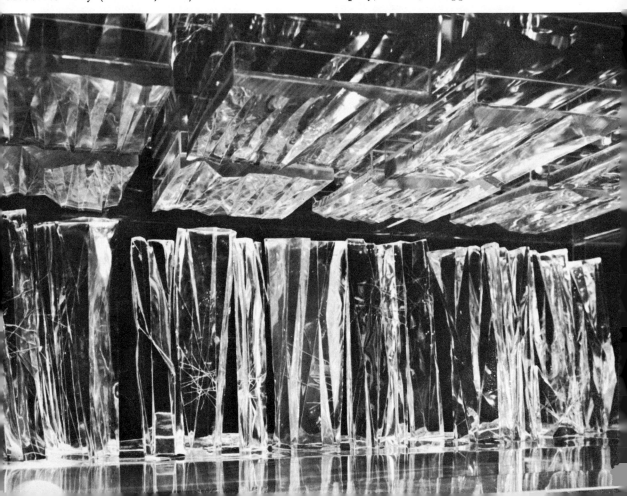

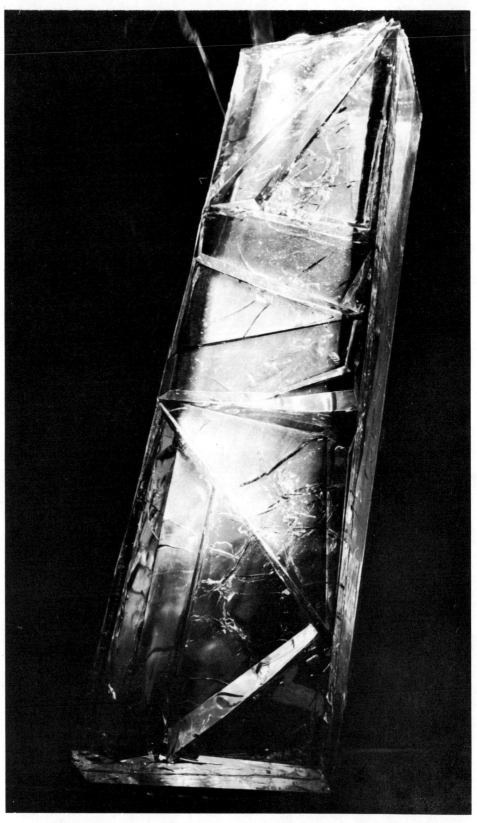

Single "plyon" sculpture of polyester resin. This one is 10' x 2' x 18".

when casting pieces over three inches. When increasing thickness of the casting, instead of cutting down on the peroxide, add some inhibitor (but that will change the color) or cast in no more than two inch layers at a time, until the desired thickness is reached. If a mistake is made, and too much catalyst is used, refrigeration will delay the cure by dissipating the heat.

The best crystal-clear resin is *Diamond Alkalis 6912* (comes from California). When mixing the resin it has a pinkish-straw color, but as the resin cures and is exposed to light the tint disappears and the resin is absolutely crystal clear. Reichhold has a resin that approaches crystal clarity; its temporary number is Polylite 91-919. (Use of ultraviolet inhibitors such as Tinuvin is not necessary and would mar the clarity of these resins.)

Micro-Wave Curing

If you have a micro-wave oven, try curing the slightly catalyzed polyesters in it. Micro-wave energy shortens curing time and "jars" free remaining air bubble entrapment.

Problem Clinic

These are the results to expect if you make errors:

1. Cracking of Castings
 Cause:
 Internal strains.
 Cure:
 a. Use less catalyst or a slower reaction type of catalyst;
 b. Immerse casting (protected from water) in water during cure. Heat is dispersed more rapidly in water;
 c. Use a flexible resin with the usual resin. A proportion of 90% by volume of regular resin to 10% of flexible resin is usually adequate;
 d. Fillers also help reduce internal strains;
 e. Avoid use of embedments of a different contraction and expansion ratio; e.g., glass chunks.

2. Warping
 Cause:
 a. Erratic temperatures;
 b. Unequal thickness—uneven curing;
 c. Handling form prematurely.
 Cure:
 a. Design for evenness—don't have extreme changes in thickness and thinness;
 b. Equalize stresses by placing equal amount of resin on both sides of panel;
 c. Do not disturb form during cure;
 d. Slow down curing rate;
 e. Keep form in a room with even variations of temperature.

3. Milky Color of Resin: Blushing
 Cause:
 Water contamination.
 Cure:
 a. Keep container of resin tightly closed and away from dampness;
 b. If form is completed, keep water off of work.

4. Tacky Surface
 Cause:
 a. Incomplete polymerization;
 b. Air inhibition.
 Cure:
 a. Increase amount of catalyst;
 b. Cover surface with cellophane if possible;
 c. Use a gel coating; or
 d. Heavily catalyzed resin coating.

5. Dull Surface
 Cause:
 a. Dust, film, type of resin;
 b. Wax in resin or on surface will cause dull finish.
 Cure:
 a. Keep surface clean and free of dirt;
 b. Use a glossy type of resin coating.

6. Bubbles
 Cause: Air.
 Cure:
 a. Fill space with resin;
 b. Press out air bubbles;
 c. Dry out plants and gently fill with resin to displace trapped air;
 d. Stir resin without lifting out mixing stick.

7. Dull Spots
 Cause:
 Delamination; resin starvation.
 Cure:
 a. Less pressure in fiberglass filled lamination;
 b. More resin in area;
 c. When trimming edges use a very sharp knife.

8. Translucency When Transparency Is Desired
 Cause:
 Water, pigment, dirt, other additives.
 Cure:
 a. Keep resin tightly covered;
 b. Use of dyes for clarity instead of translucent or opaque pigments;
 c. Testing of additives before mixture.

9. Pits and Lack of Adhesion in Spots
 Cause:
 Water, or releasing material.
 Cure:
 a. Keep water and release agents away from resin;
 b. When resin is to stand for a while, keep covered.

Things to Remember

General process instructions can be found in Chapter III. The following are more detailed procedures when using polyester resin.

When Laminating

1. Always use a release agent—sheet or coating—on your base or mold.
2. Apply even thicknesses of resin to avoid warping.
3. Trim while resin is gelled with a pizza cutter or pastry knife. This avoids dragging and tearing of the edges.
4. Finishing can be accomplished merely by applying a final coat to the panel.

When Casting

1. Unless you use a self-releasing mold like vinyl or silicone, always coat the mold with a release agent; e.g., preferably polyvinyl alcohol, silicone, or wax.
2. Decrease the catalyst concentration as you increase your thickness.
3. If in doubt, cure your form (well protected by aluminum foil) floating in a water bath.
4. If embedding, completely dry out specimens.
5. You can finish the casting to a glossy surface *without* any sanding or grinding or polishing by coating the polymerized form with a highly catalyzed mixture of polyester resin.

When Machining

The thermosetting plastics are of an abrasive nature and are hard on tools.

1. Carbide tools or even diamonds are recommended. Chrome-plated carbon steel can be used.
2. Tools ground for cutting brass, those that scrape rather than cut, are best.

3. Use about 800 to 1000 feet per minute, but when using high-speed steel cutting and drilling tools cut speed by 25%. Reduce speed, too, for glass- and asbestos-filled resins.
4. Do not force drill, use light pressure.
5. If there is a need to grind and sand polyester, use water and a grit as fine as 180 or 220.
6. For effective sawing of glass-reinforced laminates use a carborundum abrasive rubber-base wheel, ⅛″ thick. Contour sawing can be accomplished using a skip-tooth blade in a band saw.
7. Polishing of polyester is standard—use red then white buffing compounds followed with a clean soft wheel. (Polishing is not necessary if you paint the object with a coating of the same resin.)

Polyester as a Painting Medium

A new direction in painting is the use of polyester resin—a room temperature curing resin—as a painting medium. Early attempts at using polyester as a painting vehicle were unsuccessful because twenty minutes to a half hour saw the gelling of the pigments and the palette knife stuck fast to the canvas. Some artists prefer a longer working period.

Robert Elsocht with the help of chemist Gordon Rook developed a gesso formula, prime coat formula, and a polyester impasto base that allow a long period for drying for those who object to the quick cures.

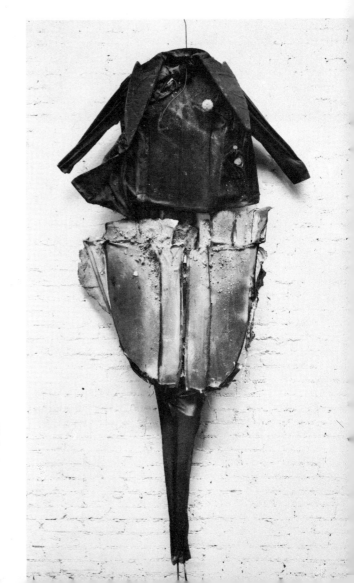

Robert Mallary. "Blue Angel." 7′ tall 1961. A tuxedo impregnated with polyester resin. *Courtesy Allan Stone Galleries*

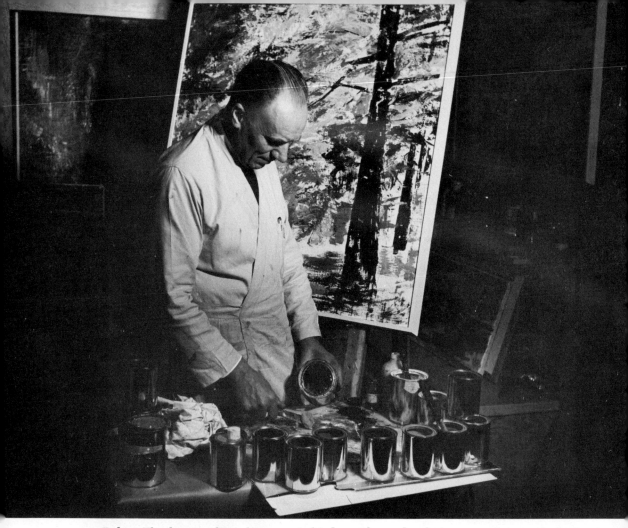

Robert Elsocht mixes his polyester resin binder with powdered pigment and stores the basic colors in cans. Now he is creating the exact color he wants on a glass palette. *Courtesy R.C.I.*

The gesso formula is applied to the canvas in four thin coats, allowing two to three hours of drying time between coats.

GESSO FORMULA

Ingredients	Parts Volume
Titanium dioxide	1
Zinc oxide	1
Calcium carbonate	1
Glue size	1
Add ½ to 1 cup of linseed oil to each gallon of gesso	

A thin coat of activated prime coat is applied after the gesso has thoroughly dried. The prime coat is what catalyzes the resin and permits completion of the painting weeks after it is started.

ACTIVATED PRIME COAT

Ingredients	Parts Volume
½ second cellulose acetate butyrate, 20% in ethyl acetate	100
Cyclobe-anone peroxide, 50% in di-methyl phthalate	16
Butyl acetate	50
Toluol	34

After the prime coat has dried, the following pigments are laid out on glass for mixture with the polyester impasto binder:

light and medium chrome yellow
molybdate orange
toluidene red
phthalo blue
phthalo green
titanium dioxide white
raw umber
burnt sienna
carbon black

"Tahoe" is a polyester painting by Robert Elsocht that illustrates the unusual luminous texture obtained with this material and the artist's impressionistic style. *Courtesy R.C.I.*

POLYESTER IMPASTO BINDER

Ingredients	Parts Weight
Cab-O-Sil	30
Bentone 38	13
Talc (Sierra #21)	250
China clay	500
Rutile titanium dioxide	5
Polyester resin (RCI Polylite 8130)	400
½ second cellulose acetate butyrate, 10% in ethyl acetate	80
Tricresyl phosphate	28
11% cobalt octoate	2
Xylol	10
Dow plasticizer 276V9	8
1% silicone oil SF69 in xylol	8
Styrene as needed for proper working consistency	

The polyester binder is mixed with the powdered pigments and applied with a palette knife directly to the canvas which has been coated with gesso and catalyzed prime coat.

The texture is rich and the material permits a soft luminous blending of bright colors. There is a brilliance in these paintings not possible to capture in oil painting. Unusual glazing effects can be achieved and unlike the other fast-drying polymer media this is one plastic binder that allows for long-range curing.

Projects with Polyester Resin

The following series of projects for bas-relief and sculpture carry you through a vocabulary of technique. Each method can be complete in itself or combined with others to form highly expressive works of art.

121

Bas-Relief

PRESSING MOLD SHAPES IN RESIN

Gather materials. Spray molds (wood, plaster, ceramic, metal) with silicone spray.

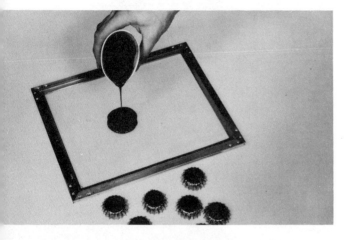

Pour a layer of pigmented, catalyzed polyester resin onto a prepared panel.

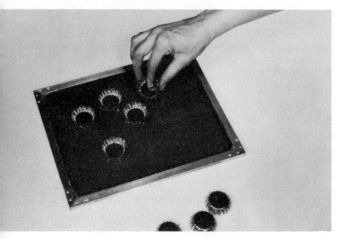

Press forms into the resin.

At gelation, carefully remove forms with the aid of a knife that releases the suction-like bond.

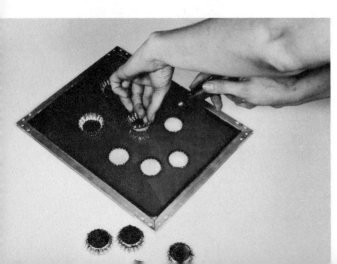

122

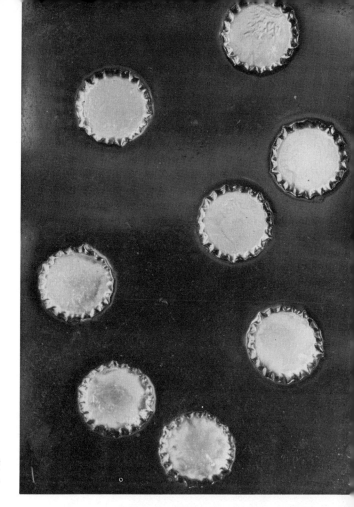

Completed panel is red with variations of red around the crystal-like edges of transparent forms.

Texturing of Resin

ROUGH CUTS

Pigment and catalyze resin in one color. (Think in terms of two colors.) Pour the first color into a thin sheet on a prepared panel (about ⅛" thick).

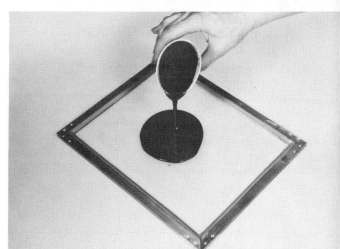

When gelled (different degrees of gelation will yield different textures) deliberately disturb the sheet of resin by lifting sections of gelled resin off with a tongue depressor or knife and placing it over other areas.

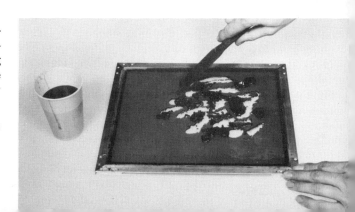

123

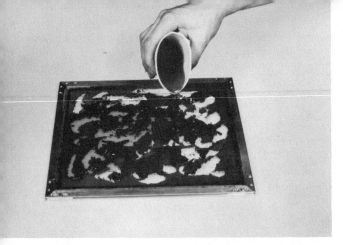

Pour a second color of catalyzed resin over whatever sections you wish.

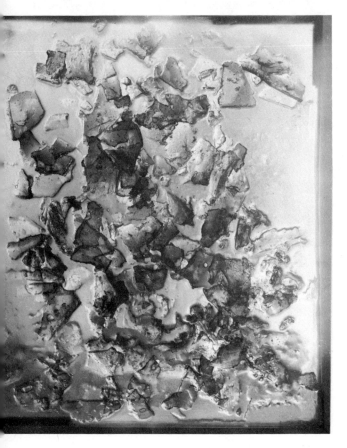

The result shows many different values and intensities of color—some darker and richer, some pale—as well as the overlaying effect of one color on another.

Finger Painting

Mix a very thick paste of polyester resin, color, "Cab-O-Sil" and catalyst until it has the consistency of finger paint. Place the thick paste on a prepared panel with the aid of a tongue depressor.

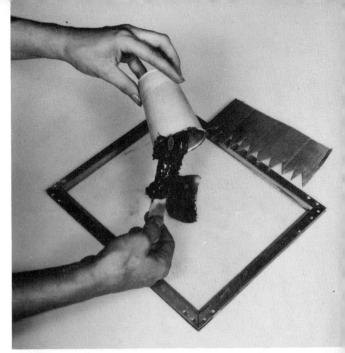

Spread the thick mixture evenly over your panel with a stick or tongue depressor.

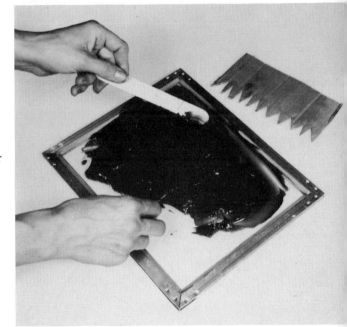

Using sticks, combs, cardboard, gloved fingers, press your design into the resin. Extra pressure brings up the clear acrylic background, less pressure yields variations in value. The material can be worked and reworked as a finger painting until the resin gels.

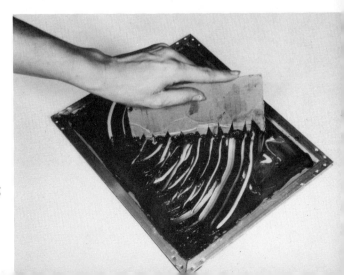

125

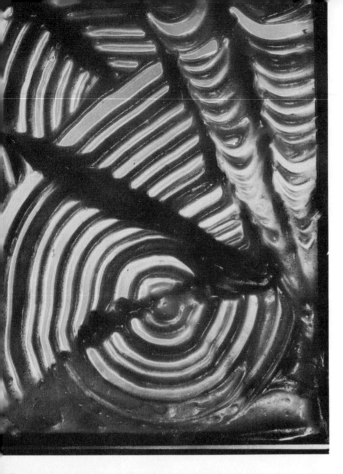

One result using a thick but soft-edged mixture of filler and resin.

Another variation showing crisper edges, using a more viscous mixture.

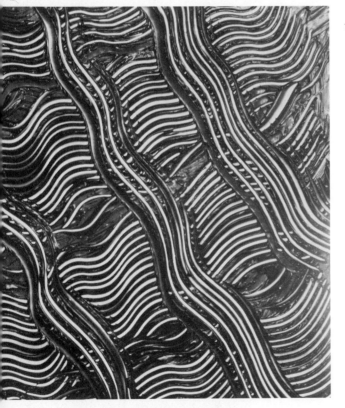

Adhering Objects

Saturated Sponges

Dip shaped sponges into catalyzed and pigmented polyester resin.

Place them on a layer of pigmented or clear catalyzed polyester resin.

The result is a heavily textured piece with opaque and transparent areas.

127

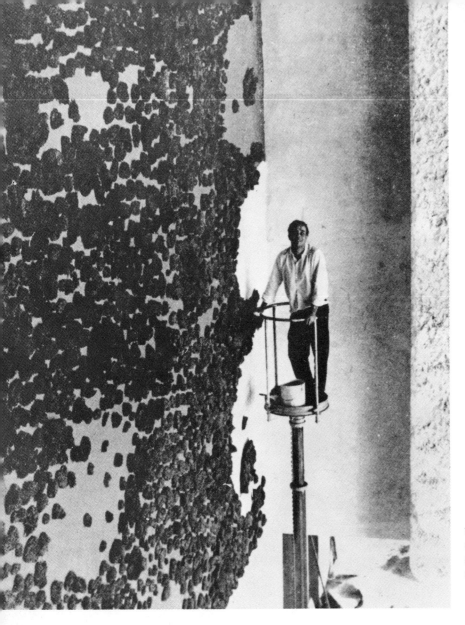

The late Yves Klein used this technique for an opera house mural at Gelsenkirchen, West Germany.

Courtesy Museum of Contemporary Crafts, New York

PREMOLDED FORMS

Gather clear precast polyester cubes—see illustrations on page 62 and pour a thin layer of polyester resin (always catalyze the resin unless warned not to) on a prepared panel.

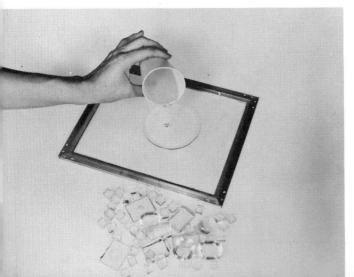

128

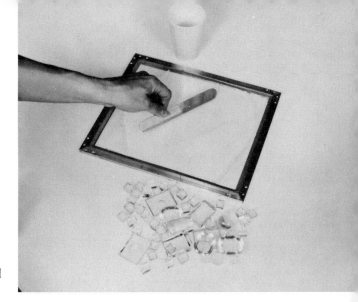

Spread the resin evenly over the panel with a tongue depressor.

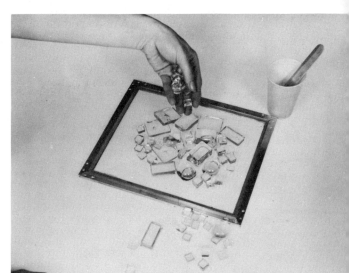

Scatter the polyester cubes onto the coated panel. Wherever there is no resin to help the cubes adhere, add a few drops of resin.

The result is a crystal textured panel catching light as it pipes through and around the forms.

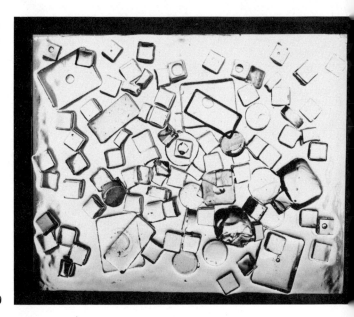

129

Gather and prepare rods, circles, and rings. Cut rods to size by scoring a line on the rod with a saw and

snap the rod in two.

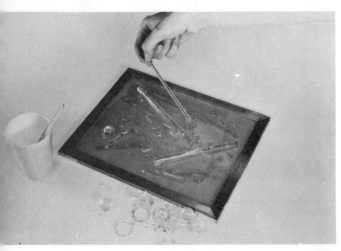

Then, place the forms on a bed of resin.

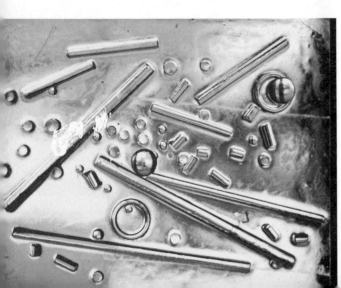

The result is a variation of the last project, but using strong linear and staccato shapes rather than masses of forms.

130

Another variation uses strips of acrylic. Place the cut strips on a thin bed of resin. Allow to gel. Then pour a filled or opaquely pigmented layer of color around the forms.

The result shows glowing shapes as light pipes through the acrylic, intensified by the opaque background.

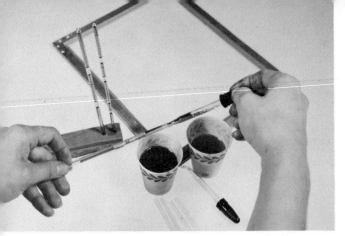

Fill tubes or straws of acrylic with alternating bands of air and colored resin by squirting varying quantities of resin into the thin tubes with a pipette.

Stand the filled tubes in a bar of clay, to keep the color from leaking out, until the color gels.

Pour a layer of resin onto a prepared panel and clean or cut off the ends of the rods. Arrange these in the bed of resin.

The result: a festive, gay-looking panel.

132

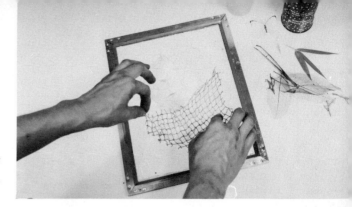

Arrange a collection of various kinds of material on a bed of resin. With a brush, coat and saturate the forms.

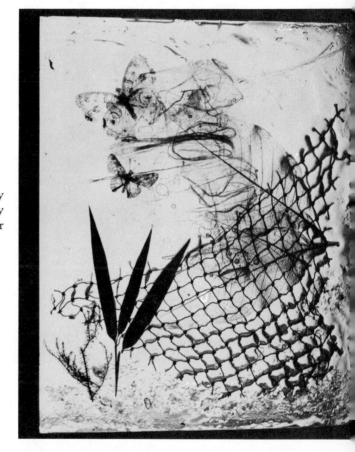

The result: a composition of permanently embedded forms, some rendered partially translucent by the impregnating resin; other textures are still opaque.

The 74″-high decorative screen by Emile Norman laminates glass and plastic together.
Courtesy Emile Norman

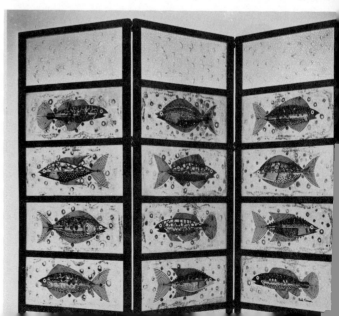

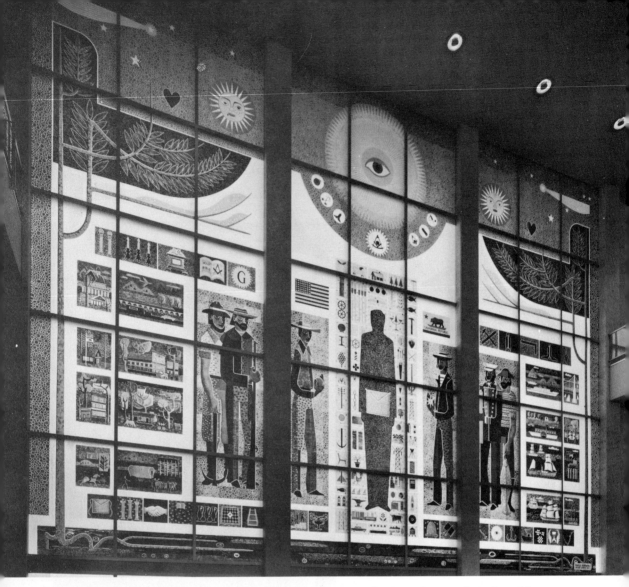

This large historical window (three stories high and 48′ wide) of the California Masonic Temple, by Emile Norman, uses glass embedded in resin. *Courtesy Emile Norman*

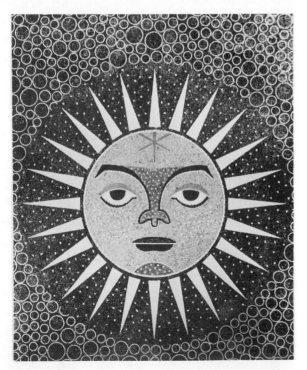

This is a close-up of part of the Masonic window. The background circles are sliced from plastic tubing and the color-texture is composed of irregular glass tesserae and granules. *Courtesy Emile Norman*

134

Place precast colored cubes of polyester onto a resin-coated panel as in mosaic design technique, leaving spaces between the forms.

Pour a thixotropic opaquely pigmented mixture of resin into a nozzle-topped polyethylene "squeeze" bottle.

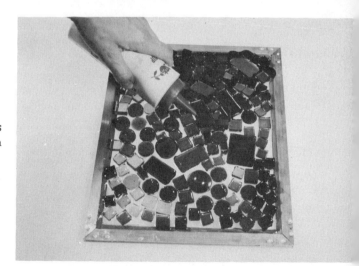

Squeeze the mixture between the cubes as if grouting—but try not to spill any resin on the cubes.

If some resin does leak onto the tessarae cubes, remove it by wiping with an acetone-saturated swab.

135

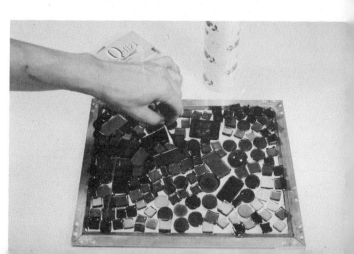

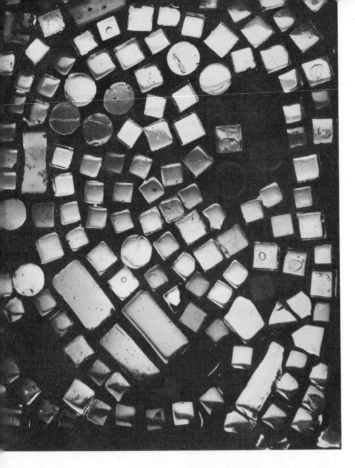

The completed piece is amazingly jewel-like because the cubes of color are intensified by the opaque "grout" mixture.

This is a close-up of tesserae panel by Sara Reid made of polyester resin sheets that have been sliced and then added mosaic-fashion to a panel without using a grouting mixture.

Photograph by the author

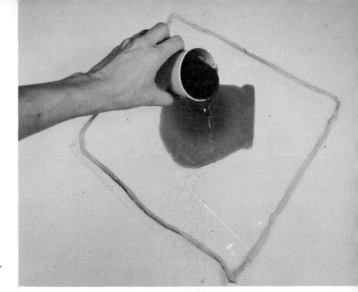

Overlaying Cut Forms

Pour pigmented resin on a sheet of cello-phane.

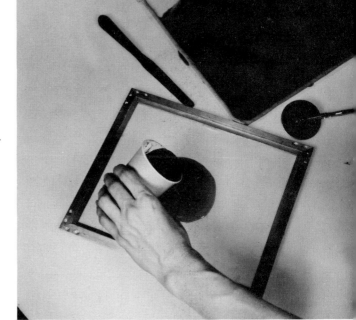

While the sheet is curing, pour more col-ored resin onto a prepared panel.

When the resin has gelled, cut shapes from the gelatinous sheet with a pastry trimmer or pizza cutter. These do not rip and tear the resin as do knives.

137

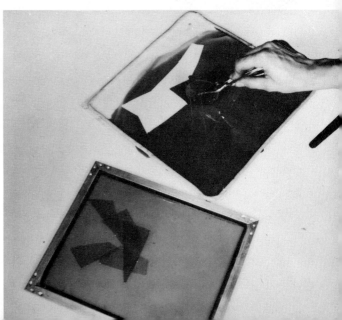

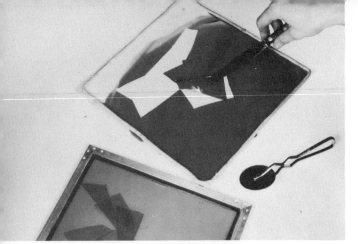

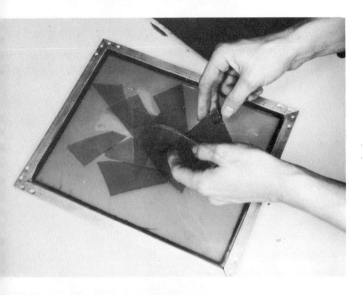

With a knife, lift the forms and place them on the uncured resin-coated panel.

Each time a piece is placed on the panel, coat the preceding layer so that a solid bond will be made on curing.

The completed panel displays effective texture and color patterning.

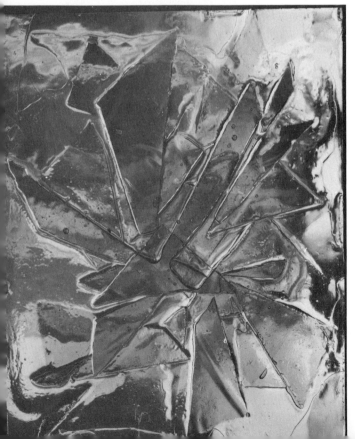

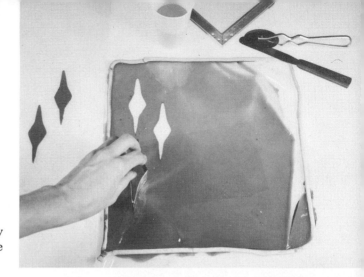

Variations are unlimited. Here a cooky cutter is used to press out patterns from the gelled resin.

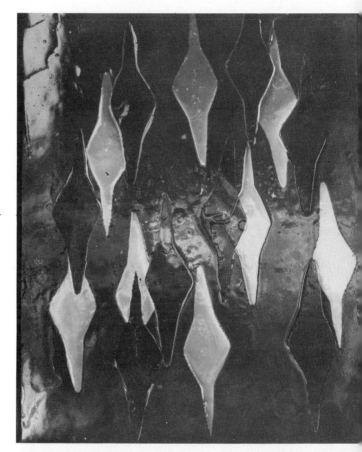

Another result showing a more formal arrangement of forms.

Still another variation using "crumbs" of leftover resin as well as texturing the surrounding areas.

Photograph by the author

139

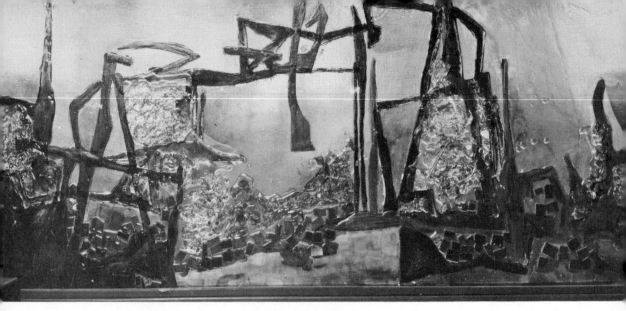

"Aftermath" by Sara Reid shows the use of overlaid strips of resin, pieces of polyester tesserae, and roughened resin, all combined into one expression.

Photograph by the author

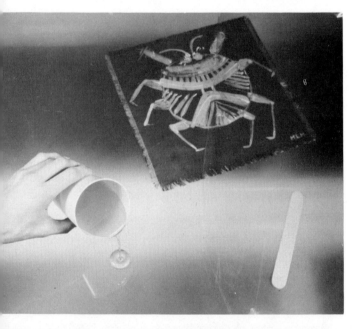

Impregnating

CLOTH

Pour a small amount of flexible polyester resin on a smooth sheet of cellophane and spread evenly.

Place the fabric on top of the resin.

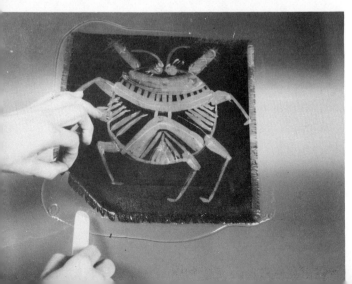

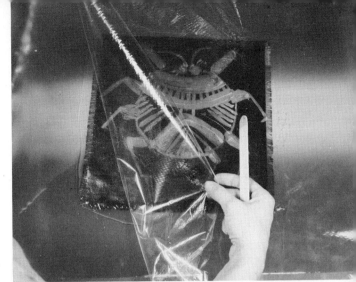

Overlay another sheet of cellophane, starting at one end and smoothing it down to the opposite edge.

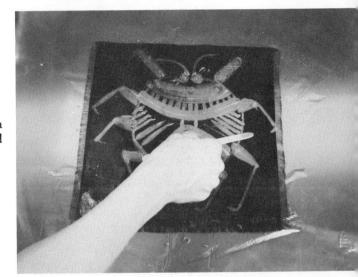

With a smooth edge (sand smooth) of a tongue depressor, press out air bubbles and evenly distribute the resin.

Marie Louise Michel's batiked translucent silk, impregnated into a rigid form.

RICE PAPER

Brush a coating of polyester resin over a prepared panel.

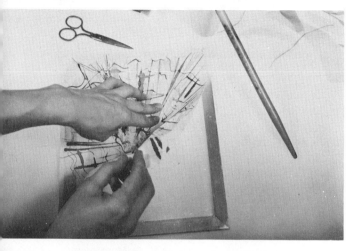

Starting at one end, smooth a watercolor drawing done on rice paper over the panel.

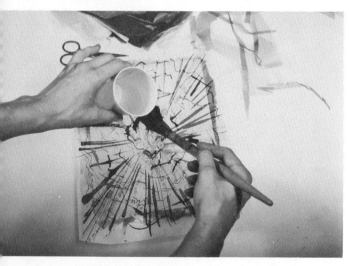

Coat the painting with another layer of resin.

Trim the excess from the edge with a sharp knife.

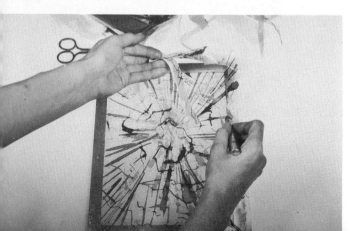

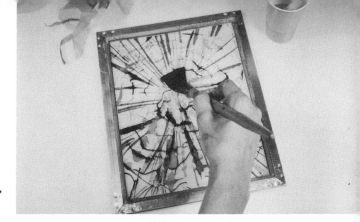

Reverse the panel and coat this "back" side with resin.

Tear or cut paper (this is tissue paper) shapes—can be done now or at the beginning of the process.

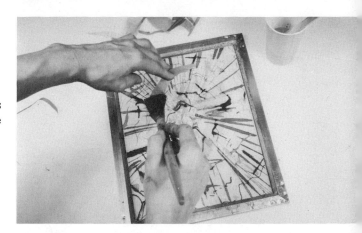

Coat each shape as it is applied. This eliminates trapped air and the parts adhere better.

The completed design can be left at this stage or other techniques can be applied to the form—such as cut shapes of gelled resin.

143

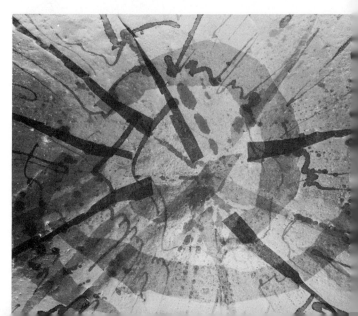

Laminated Forms

Assemble materials.

Pour some clear resin onto a sheet of cellophane and spread (remember, the resin should be catalyzed).

Place the first piece of fiberglass (mat) over the resin-coated cellophane.

Lay each piece of the design on the impregnated fiberglass.

144

Pour more clear resin over the design forms.

Position a second piece of fiberglass over the saturated design.

Again, pour more resin over the new layer of fiberglass. This process can be continued to any thickness.

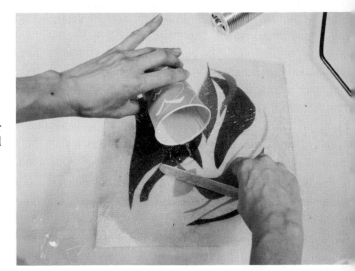

Place a second sheet of cellophane over the lamination, starting at one end and smoothing it to the bottom edge.

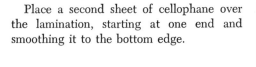

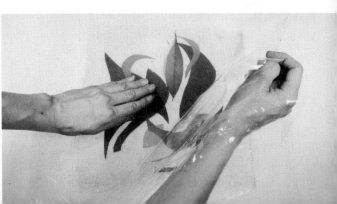

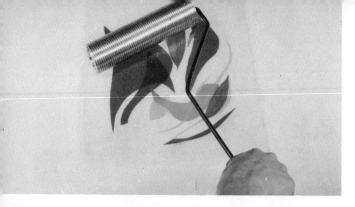

With brayer, dowel, rolling pin, or roller, roll out air bubbles and evenly distribute the resin.

When the panel gels, trim edge with a sharp blade or . . .

when it hardens too much for a blade to cut through, use a scissors for trimming.

The completed translucent panel.

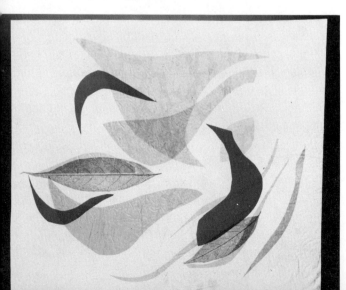

146

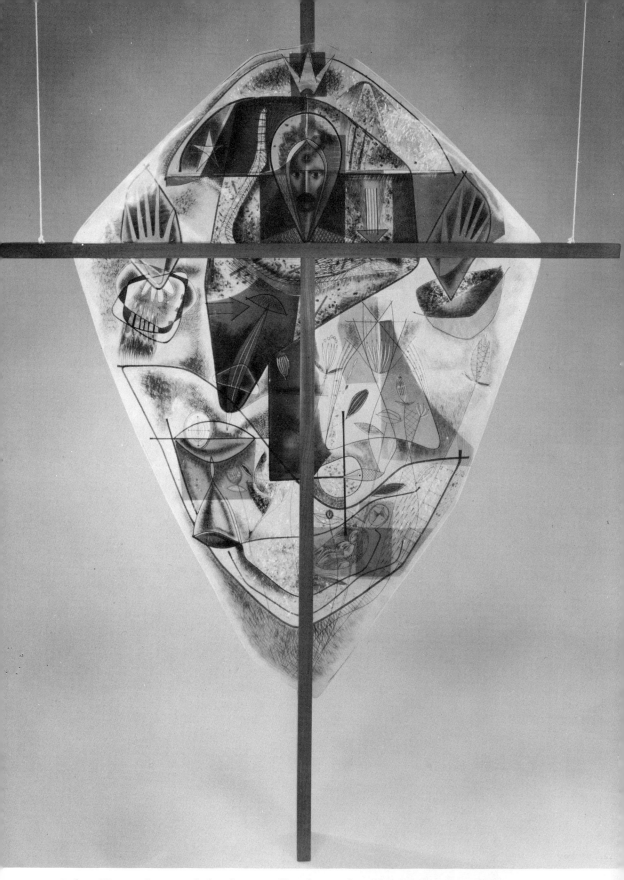

Robert Harmon laminated glass between fiberglass in this polyester form for a private chapel.

Courtesy Emil Frei Associates

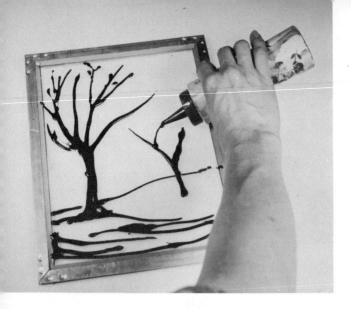

Combination of Adhering and Drawing

Mix a highly thixotropic mixture of pigmented polyester resin. Place the material in a squeeze-bottle. Draw your picture with the resin as it is squeezed through the nozzle aperture.

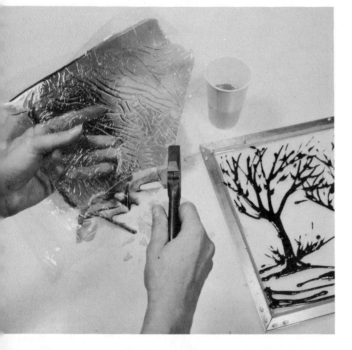

Break small pieces from fully cured colored polyester sheets. Shatter the pieces.

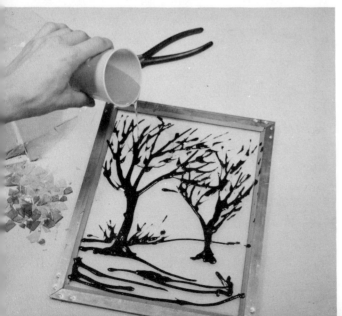

Pour a small amount of clear resin on the cured panel wherever the fragments of color are to be placed.

Position the colored bits into this fresh resin.

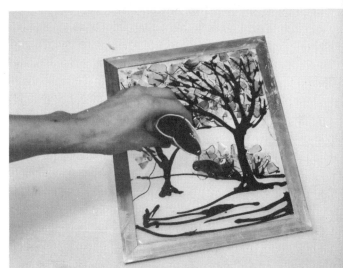

Add different colors of resin to the rest of the panel until it is completed.

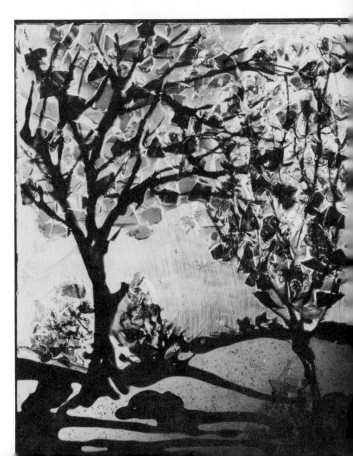

The completed panel.

149

Using a Thixotropic Mixture

SAND

Lay out areas of your design on a ply-wood, masonite, clay, plaster, or stone background—almost any rigid backing material will work well.

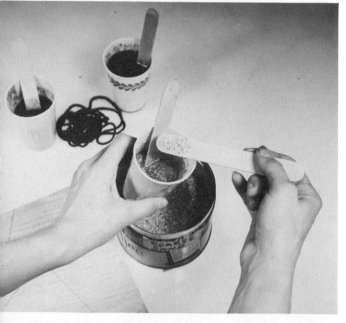

Mix sand with some resin until the desired consistency is achieved. Catalyze when ready. Sands can be found in a wide array of color. These mixtures can be readied and then catalyzed before application.

Spread the sand-resin material into the prescribed area, tamping it down a little with your applicator.

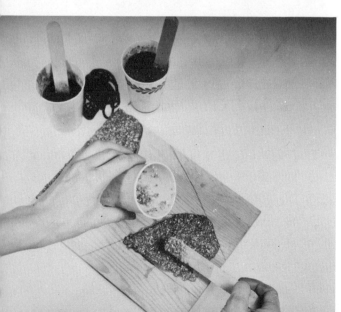

If desired, apply yarn, or string, to define areas. Then, saturate the yarn with clear catalyzed resin.

A close-up of the richly textured result. Notice that each kind of sand produces a different value and coarseness.

A 30" x 40" panel by the author.

151

An 84″ x 30″ panel by the author.

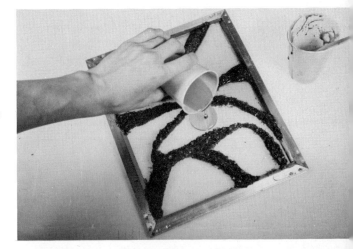

Place a mixture of sand and resin on a prepared panel to enclose areas that will later contain colored resin. You can model the sand almost like clay if it is "dry" enough.

Pour colored resin into area enclosures after the sand dam gels.

The completed panel yields stained-glass color brilliance with the functioning texture of sand dividers.

See color section.

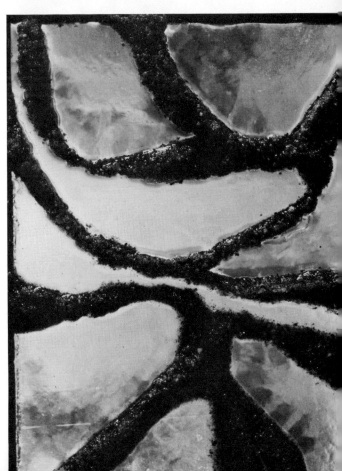

This is another approach that has a more sculptural treatment of the sand areas.

Photograph by the author

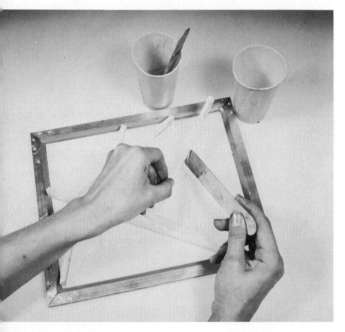

Take acrylic strips, cut to size, and place them in a shallow pool of resin.

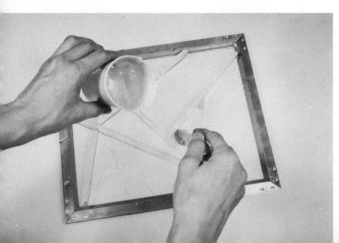

With a thixotropic mixture of colorless resin, seal areas where the strips touch one another, thereby sealing off areas to contain resin.

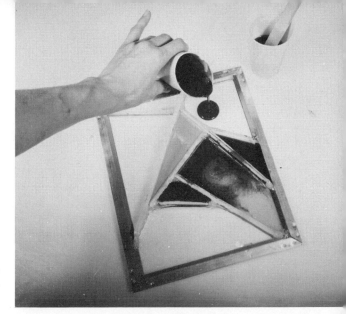

Pour your different colored resins into the enclosures after the background and joint-"cement" gels.

The finished panel displays the acrylic light piping factor as well as separated brilliant areas of color. Nuances of color shading are blendings that have fused at the point of mingling.

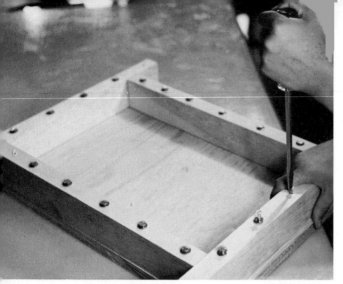

Casting into a Wax Mold

Construct a container to hold molten wax out of wood. Aluminum, glass, and ceramic will work but wax tends to shrink away from the sides of those containers.

Then, melt wax and pour it into the mold. A good wax formula is Esso's Microcrystalline 3602 with the addition of a little heavy duty motor oil to give it a flexible consistency. Or Esso's MicroVan 1650 with enough #30 Motor Oil to reach the desired consistency and paraffin to harden it, if necessary.

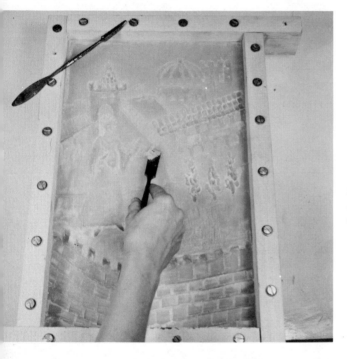

Think in reverse and carve a negative mold (or if you wish the plastic to appear in reverse, then carve the wax in the positive). Make certain that you do not have any undercuts that would hamper the removal of a rigid form. A liquid can easily seep under a shape and then when it hardens, removal is exceedingly difficult.

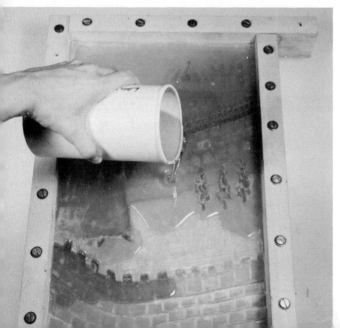

Mix resin and pour onto the wax, filling the mold to the desired depth. Color and texture can be added to a first pouring and when that gels, additional resin can be poured onto the partially cured layer.

156

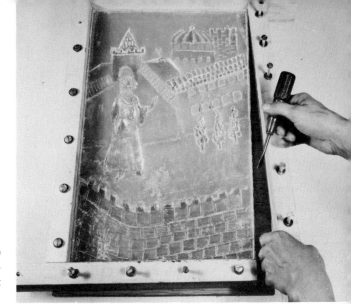

When the form has cured, remove one side of the mold and pry up the cured plastic from the wax. Clean off any wax that might stick.

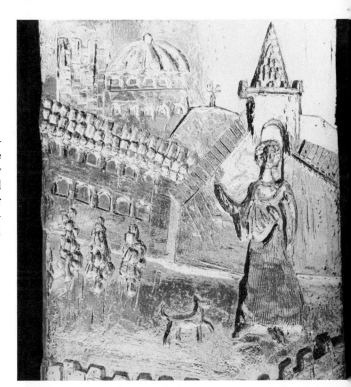

This finished panel has just slight variations in thickness allowing for an even single cure. The technique displays an amazingly compatible relationship between the mold material, wax, and the positive-polyester resin. They are cousins—petroleum by-products; both are plastics, fluid at some point; both are translucent. (Detail)

This panel ably demonstrates the effective relationship between mold and model—a contrapuntal relationship. Wax gives the polyester its shape; then the resin gels, holds its shape, and develops exotherm for curing, thus melting the wax. But the plastic keeps its shape and eventually cools; so does the wax, getting back the form it originally gave to the plastic.

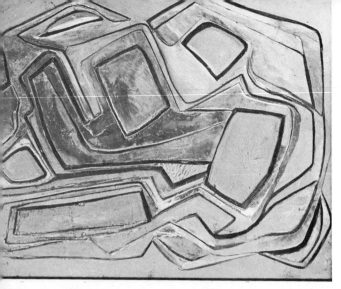

This panel has extreme differences in thickness. To solve the "curing" problem, the thicker areas were cast first and when they gelled, succeeding layers were poured until the entire panel was filled to the desired thickness.

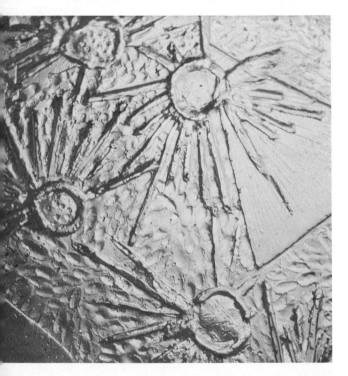

A detail from a decorative panel by Sara Reid using dental wax and this technique.

Photograph by the author

Sculpture

Casting and Carving a Solid Form

Find a leakproof container, or construct one of rigid cardboard. Coat and seal seams and interior with wax. Pour polyester resin into the form. Consider the amount of resin you use before you add the catalyst. Remember that very thick castings should have less catalyst even if it takes the form two weeks to cure. When the casting solidifies and the outside is tacky, paint a mixture of highly catalyzed resin on the surface. When this surface coat cures, you will have a tack-free form.

158

For color effects, there are many ways. One simple and effective method is shown here. Attach "invisible" nylon sewing thread or fishing line to the colored, cured plastic shapes and tie these to a tongue depressor or a stick that is large enough to lay across the mouth of the container.

Insert these color shapes in the resin; adjust the cord to the proper length and rest the stick across the top of the container.

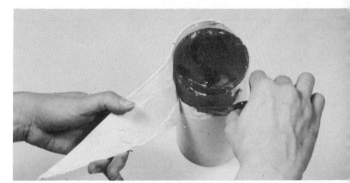

After curing, peel away the cardboard. If the surface is still tacky, brush on a coating of heavily catalyzed resin.

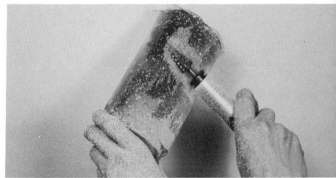

With carving tools, preferably a flexible shaft tool with an abrasive wheel, shape the plastic mass. After all carving is completed, coat the sculpture with highly catalyzed resin. This eliminates the need for a tedious finishing operation of sanding, polishing, and buffing.

The completed sculpture prismatically distorts the internal color. As the shape revolves, the inside color interest is modified, moving along with the outside facets and planes.

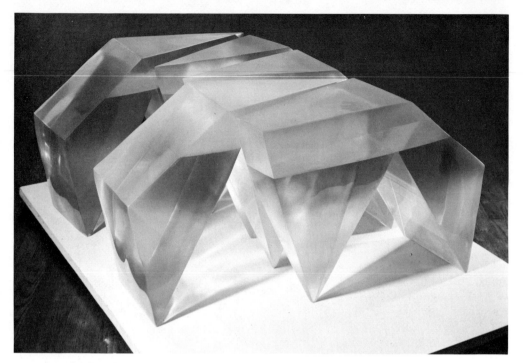

David Weinrib. "Inverted Pyramids" (22" x 40" x 42", 1967). Cast polyester resin.

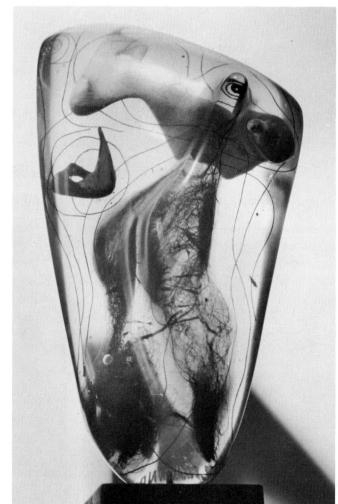

Leo Amino's sculpture of cast polyester resin, "Family," was executed in 1948. Its internal color and texture interest help focus one's eye movement and direct vision throughout the shape from the inside to the outside surface.

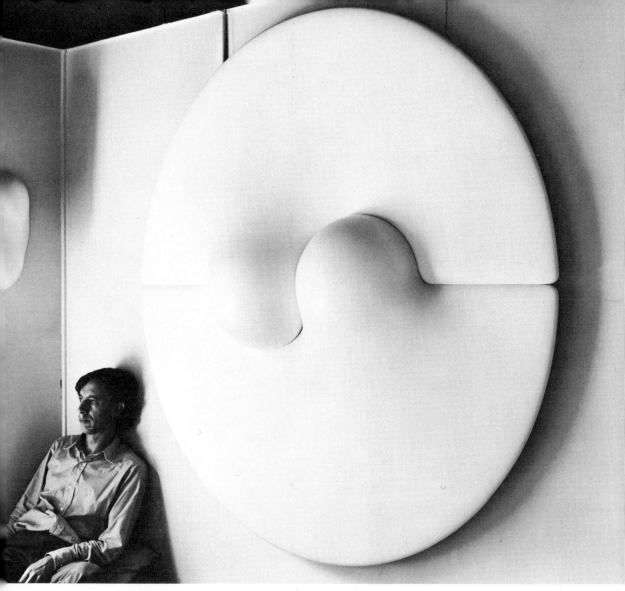

Jos. Mandus. "Untitled" (1968). Fiberglass and polyester with a pvc coating.
Courtesy Jos Mandus, Holland

David Weinrib. "Statium" (3′ x 3′ x 18″, 1966). Cast polyester resin.
Courtesy Whitney Museum of American Art

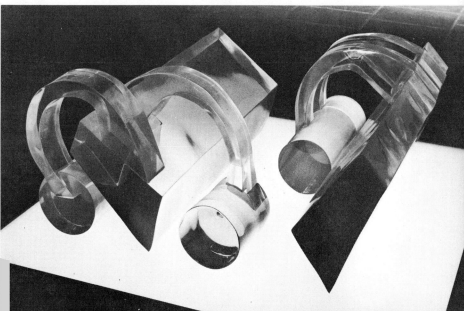

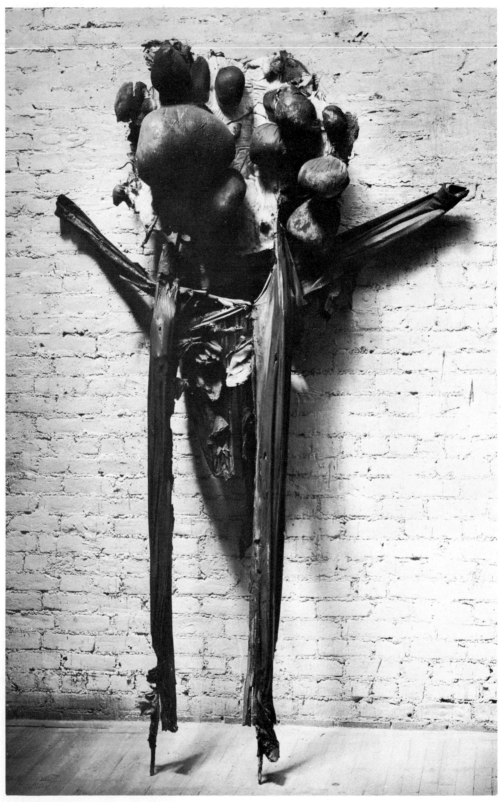

Robert Mallary. "The Juggler" (7½′ high, 1962). Tuxedo impregnated with polyester resin.

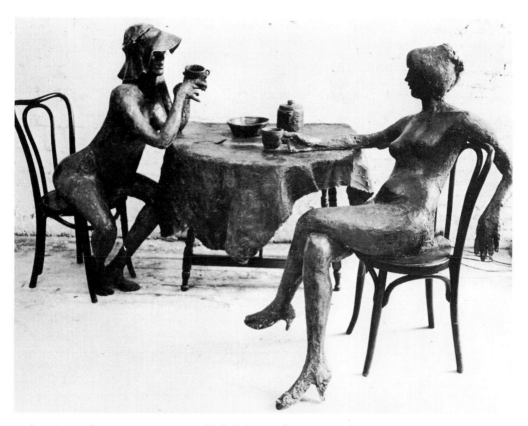

Arlene Love. "Two Women at a Table" (life size figures, 1965). Polyester resin.

Seymour Couzyn used a pigmented filler of marble dust for his polyester cast sculpture, "The Prophet." *Photograph by the author*

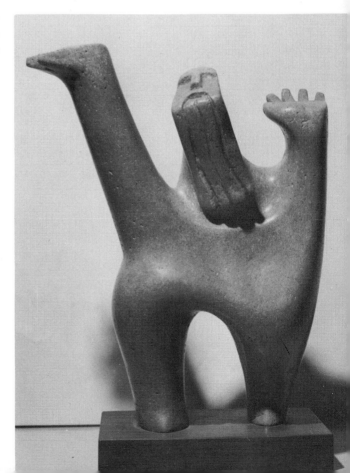

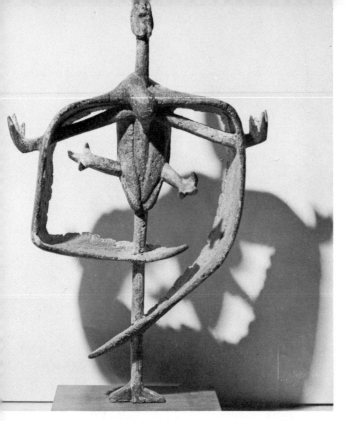

Mr. Couzyn employed a similar mixture for "Insect Form." The result is surprisingly strong for a form containing very thin areas. Filler incorporated into a cast piece helps to dissipate some of the exotherm, provides faster cures, and increases the strength of the form. *Photograph by the author*

Lost Wax Casting

Model and/or carve your wax sculpture. Add sprues to insure an even flow of polyester throughout the form. Only one sprue was necessary in this sculpture. The legs were used to distribute the resin and eliminate air. Somehow *unfilled* resin allows air to rise to the surface before gelation.

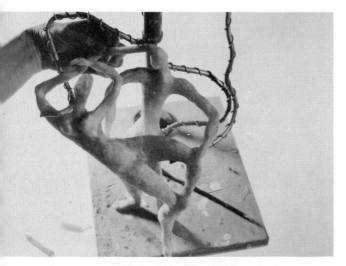

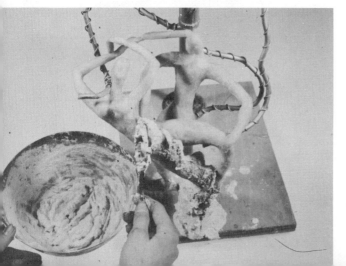

With an investment mixture of 1 part plaster of Paris to one part of Perline (a volcanic ash) and enough water to make a thick paste, coat the entire form until the investment is one to two inches thick at the outermost points. Leave two holes at the top—one for air and one for pouring.

164

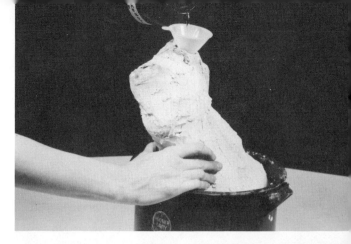

Melt or burn out the wax from the invested sculpture. If cracks develop in the investment, coat the mold on the outside with plaster. Then fill the mold with fresh shellac and pour the shellac out again. This coats and seals the plaster, and if there are any remaining fissures, the shellac will seep out, warning you to mend the crack. Allow the shellac to dry. Now pour a release agent, such as polyvinyl alcohol, into the mold.

Pour the polyvinyl alcohol out of the form. Do this two or three times, each time allowing a few minutes' drainage and drying time. You can save the used polyvinyl alcohol in a separate container.

When the release agent dries, pour your lightly catalyzed filled or unfilled polyester resin into one of the openings, filling the cavity to the brim. Somehow air is rarely trapped, but you have to reserve a bit of resin because the air will rise and the resin level will lower. When this happens, add some more resin.

When the resin cures, carefully chisel away the waste mold. If a part of your sculpture should break off, do not despair; it can be repaired by using more heavily catalyzed resin as an adhesive.

165

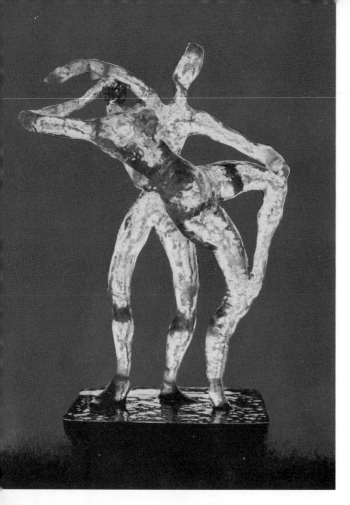

Clean away all bits of plaster. Brush the sculpture with a heavily catalyzed coating of resin. This sculpture was mounted by propping it in an aluminum (pot pie) container and pouring colored, filled resin. Upon curing the aluminum was peeled away and the ballet figures were ready for display.

"Woman Clear," 22" tall, was made in two sections. I deliberately used normally catalyzed resin which caused the resin to cure with fractures and cracks due to excess exotherm. These cracks were later filled with translucent clear, heavily thixotropic resin, sealing the fissures, and the surface was later coated. The fractured internal texture creates a fascinating light-capturing interest.

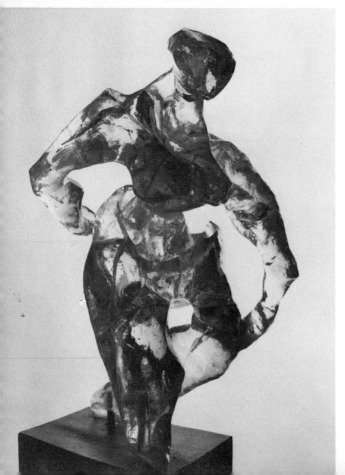

Polyester-Impregnated Fiberglass Sculpture

Form an armature of aluminum armature wire, chicken wire, or any rigid material.

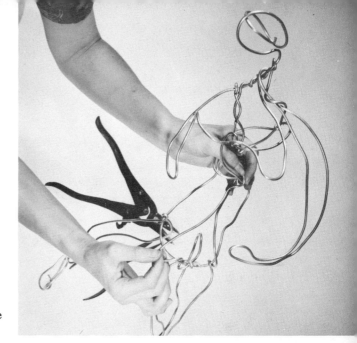

Saturate strips and pieces of fiberglass mat or cloth in polyester resin. Wear gloves to protect your hands.

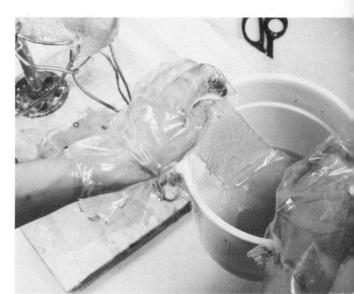

Apply the saturated fiberglass to the armature. Smooth the fiberglass to effect the desired shape.

167

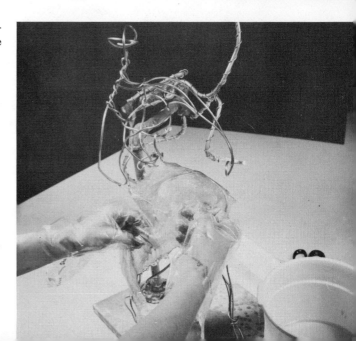

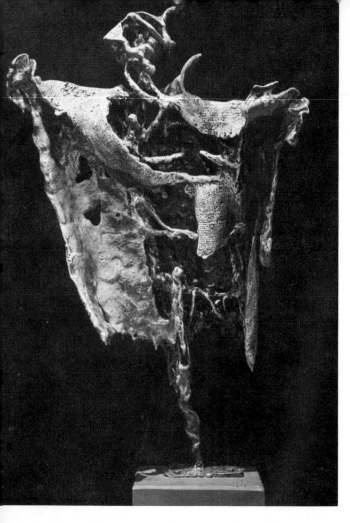

"Fear," John Baldwin, 30″ high. This sculpture started as a burlap sack. John Baldwin finds that fiberglass impregnated with polyester has almost limitless scope. He sands it, chisels it, rasps it, saws it, drills holes in it and adheres parts to parts. If too much of an area is removed, it can be built back up and reworked. The artist uses almost anything as a temporary support upon which the first layers of fiberglass are framed. It may be steel, wood, wire mesh, cardboard or papier mâché. After the initial fiberglass structure is set, the support material is bent, pulled or hosed away, leaving a free standing shell on which to build. The material is so strong it can be self supporting and span large areas. Some of his pieces are colored chopped fiberglass or a combination of woven, pressed and chopped glass fibers—depending upon what Professor Baldwin wishes to express.

Courtesy John Baldwin

William Tucker. "Untitled" (1966). Four part sculpture of painted fiberglass and polyester resin. *Courtesy Kas Kasmin, Ltd., London*

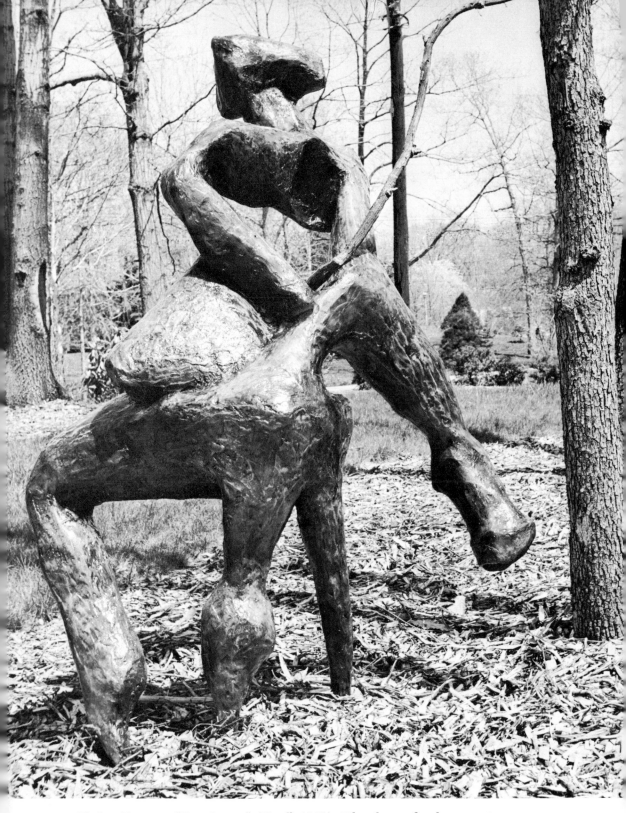

Thelma Newman. "Don Quijote" (5' tall, 1968). Fiberglass and polyester resin.

Building a Polyester Sculptural Form

Take your precast polyester cubes. Place some polyester resin on two sides to be adhered.

Adhere the two shapes that were coated with resin. Repeat the operation as if building with "blocks" until the entire structure is constructed.

See color section.

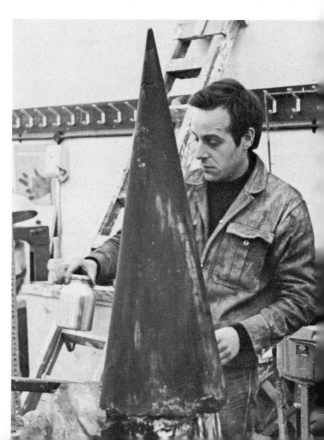

Michael Sandle at work.
Courtesy Michael Sandle

170

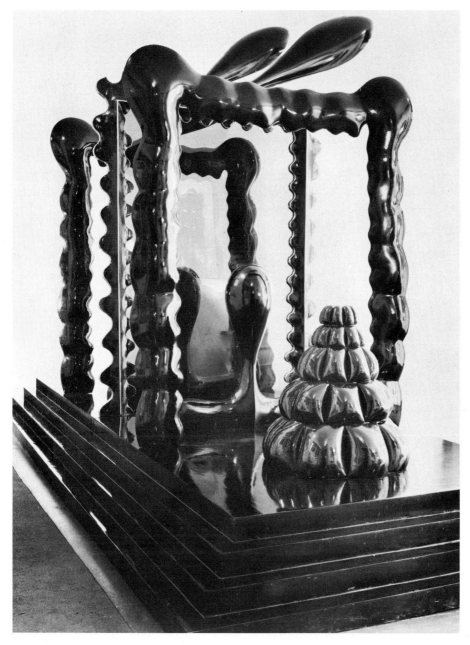

Michael Sandle's mixed media sculpture, "Oranges and Lemons" (169″ x 72″ x 50″, 1966).

A plaster shape is made and when dry painted with grey cellulose primer-filler. Dents and scratches are stopped with cellulose knifing filler (cellulose putty). The form is rubbed down with various abrasive papers (wet) and finished with polishing compound.

The positive is waxed and coated with separating agent (PVA) and a mold is made of fiberglass, using plasticine to build up outside walls where necessary. Finishing mat is used first before the chopped strand mat.

When finished, the molds are polished and air holes or defects are rectified.

The molds are then filled in the standard hand lay-up manner, again using finishing mat first, so that the fibers are not noticeable when the resin shrinks.

When cured, the fiberglass positive is rubbed down once more and sprayed with polyurethane. It is rubbed down and polished then for the last time.

Photo courtesy Michael Sandle

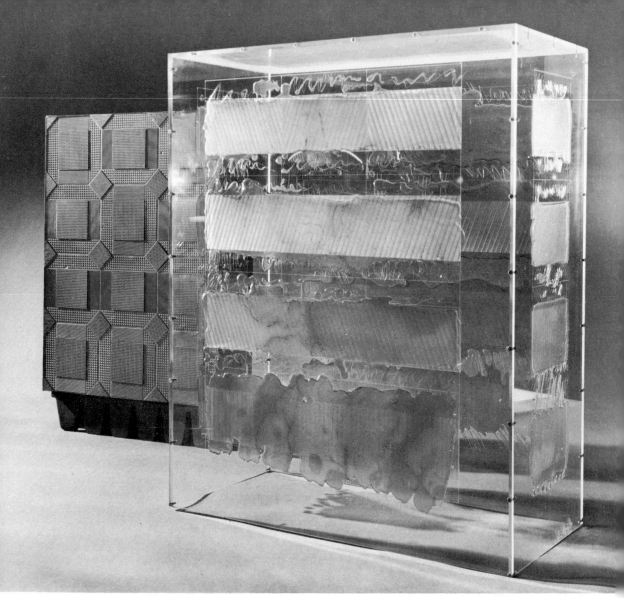

Tom Hudson. "First Million Object and Limitless Space" (29″ x 24″ x 12″, 1965). Acrylic, polyester and fiberglass and wood.

WORKING WITH EPOXY

Epoxies are included here because their properties vary very slightly from those of polyester resins making little difference in application. Epoxies also are similar to polyesters in consistency and form. In some cases, an epoxy may be superior to polyester, inasmuch as shrinkage is very, very low, water resistance is better and dimensional stability is higher. Most frequently though, the small margin of advantages does not warrant the higher cost of epoxies. The same casting, coating, laminating and machining procedures can be followed, using epoxy instead of polyester resin.

Polyester Modified by Epoxy

It is possible to co-react epoxy resin with a low molecular weight polyester resin. The resulting polyester alloy has improved strength values and improved chemical resistance with a light amber color. This is somewhat technical, but helpful to some who would look for those properties. This epoxy-polyester alloy is an epoxidized poly-butadiene with a double bond (molecular arrangement), easily cured with organic acids.

Curing of the epoxy-polyester* combination can be fast or slow, but requires final hardening at elevated temperatures. Since there are not enough acid groups in the polyester, a highly acidic curing agent such as fumaric acid ground to a fine mesh or a short-chain, highly acid polyester is used as a promotor along with benzoyl peroxide and tertiary butyl perbenzoate.

Accurate mixture has to be made:

 20% Epoxy
 80% Polyester
 1% Benzoyl peroxide paste
 1% Tertiary butyl perbenzoate

After this combination is well mixed, the manufacturer's suggested amount of promotor is mixed into the batch. Epoxy-polyester alloys are useful for casting sculpture, coating, and laminating.

Easy curing, with no need for special conditions or precise temperatures; curing without the evolution of by-products; wetting of and adhesion to a wide variety of different types of surfaces; and no size limitations are other property advantages that make epoxy resins effective materials for an art media.

Epoxy Putties

Devcon Corp., Danvers, Mass., manufactures epoxy resin base putties containing approximately 20% epoxy and 80% metallic filler. This is put onto a base with a spatula-like form.

In addition, there are also epoxy putties ** that can be handled very much like clay after the stick of epoxy is thoroughly kneaded with the stick of hardener (1:1 ratio). After hardening in 1½ hours at 70°F. the material can be machined, drilled, sawed, filed, sanded, and painted. It can also act as an adhesive if pressed onto any clean, dry surface.

Colorants

Colorants can be purchased for epoxy resin. It must be remembered that epoxies are usually not quite so clear as polyester and the slight straw cast will also affect the color.

Curing Systems

Generally the aliphatic and aromatic amines (e.g., metaphenylene diamine) are used for room temperature curing systems. The major limitations are safety and that the heat distortion point is about 180–200°F. Acid curing systems, such as the phthalic anhydrides (e.g., hexahydrophthalic—HHPA), usually require oven-curing at more elevated temperatures. This raises the heat distortion point to 300°C. and brings excellent thermal stability. Lewis acids cure only at elevated temperatures and yield high temperature strength as well.

An excellent water-white epoxy cure would involve the following:

* Oxiron polyester alloys. FMC Corp., 633 Third Ave., N.Y.C., or 2121 Yates Ave., Los Angeles, Calif.
** Epoxy Bond, Atlas Mineral Products Division, Mertztown, Pa.

Ingredients:

100 parts DER 332 (Dow Chemical) unsaturated epoxy

3 parts Dowanol Ep (Dow Chemical)

75 parts HHPA—dibasic acid hardener (phthalic anhydride—hexahydrophthalic)

5 parts Argus DB VIII catalyst (Argus Chemical)

Method:

1. Heat hardener and epoxy resin separately to 100°C.
2. Age for a half hour.
3. Mix proportions together.
4. Put back into oven at 125°C. for 2 hours; then at 150°C. for 4 hours.

The above oven temperatures are for a 1″ thick piece; thicker castings require reduced temperatures.

* Lubrizol Corp., Cleveland, Ohio 44117

The release agent for an epoxy casting such as the above would be silicone.

A different type of epoxy curing agent, light and clear in color (refractive index 1.508), producing castings with minimal shrinkage and stress, is available. *Lubrizol* CA-23 * also has exhibited superior resistance to ultra-violet discoloration. Best of all, according to toxicology reports, this curing agent is *"non-irritating to the skin,* irritating to the eye and toxic if ingested." It can be used in room temperature curing and in laminates up to ¼ inch in thickness; and may be oven-cured up to 150°F. Mixing of catalyst into resin should be very, very thorough avoiding air entrapment.

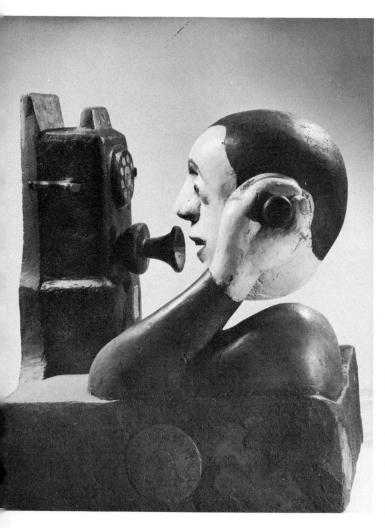

Thiopoxy 60 and 61 (Dewey & Almy Chemical Division, W. R. Grace & Co., Cambridge, Mass.) are modified epoxy compounds that form extraordinarily hard surfaces when cured overnight. The material can be used as a coating over concrete, wood or metal. This is Elias Friedensohn's "Pyramis and Thisby" (26″ x 23″ x 15″) of epoxy over wood and then painted. *Courtesy The Contemporaries*

PROPERTIES OF EPOXY

There are as many varieties of epoxies as polyester. In general, the properties of epoxy resins are as follows:

1. BURNING RATE
 (Length of time a piece will support a flame after having been held in a Bunsen Burner for a fixed period)—slow-burning. A flame-retardant epoxy can be purchased—this is a brominated variation.

2 COLOR
 Water-white, light straw to amber. Some varieties can be water-white but require curing at elevated temperatures. Transparent to opaque.

3. COLOR STABILITY OF THE RESIN
 The resin may degrade in time to become slightly more amber-brown.

4. EFFECTS OF CHEMICALS
 Very good resistance to many acids, most alkalis and solvents.

5. HARDNESS
 (Rockwell M-value) 82 for amine curing systems and 100 for anhydride curing systems.

6. HEAT STABILITY
 Very good at 250°–550°F.

7. MACHINING PROPERTIES
 Excellent.

8. ODOR
 The curing systems exhibit an odor and can be quite dangerous if inhaled. Good ventilation is most important.

9. REFRACTIVE INDEX
 1.61, almost as good as polyester resin (1.54) and acrylic (1.49).

10. SHELF-LIFE
 Varies from hours to years, depending upon the type.

11. SHRINKAGE
 Very low volume of shrinkage (makes epoxies excellent adhesives).

12. SPECIFIC GRAVITY
 1.15–1.20.

13. STRENGTH
 Tensile—(psi) 8500 (amine), 12,000 (anhydride)
 Flexural—14,500 (amine), 18,500 (anhydride)
 Impact—(Izod, 1 ft. lb. in./of notch) 0.39 (amine), 0.70 (anhydride)
 Compressive—(psi) 17,000 (amine), 15,500 (anhydride)

14. SOLVENTS
 Xylene, acetone, toluene.

15. VISCOSITY
 Sometimes quite viscous, epoxy materials can be thinned somewhat when slightly heated above room temperature. Other epoxies vary in viscosity between mineral oil consistency all the way to thick paste.

16. WEATHERING
 Exceptional water resistance, practically complete resistance to fungus, are two properties that lead to excellent weathering of epoxies.

Projects With Step-by-Step Photographs

All the projects made with polyester resin can be formed with epoxy as well. In addition the following have achieved great popularity throughout the world.

Because of light weight, adhesion to armatures, outdoor weatherability, and ability to accept fillers, epoxies filled with various fibers have been popularly used for sculpture.

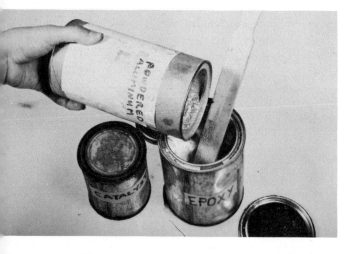

Epoxy Sculpture

Pour aluminum powder or the appropriate filler into an epoxy base.

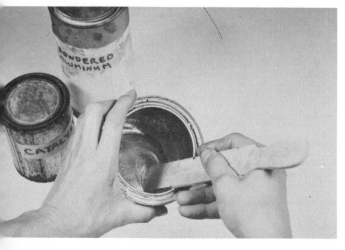

Stir the mixture very well. Keep the filler below 40% of the resin content.

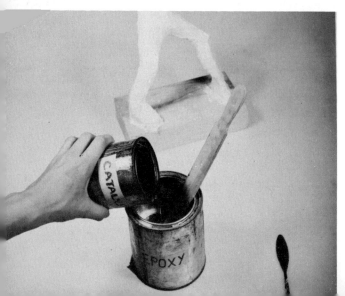

Pour the exact amount of catalyst recommended into the filled epoxy mixture and stir well.

176

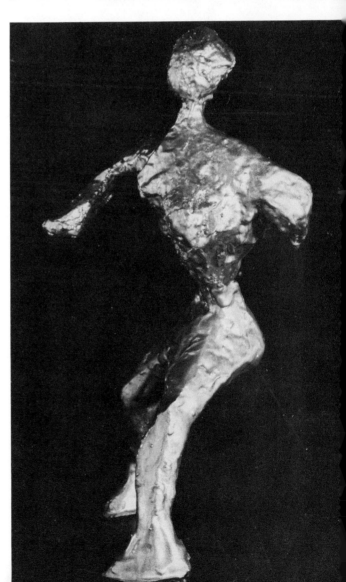

Coat your sculpture armature or base (in this case it is a plaster form) with the catalyzed epoxy mixture. Apply as many layers as desired.

The completed sculpture is very strong and can withstand many extremes in weather conditions.

177

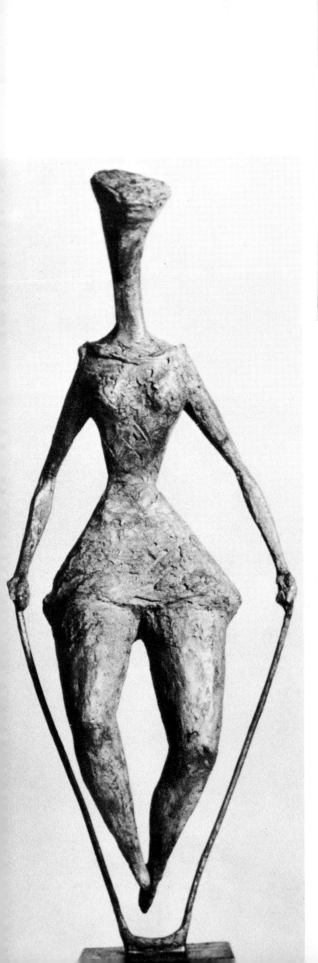

Lily Landis starts with a welded steel armature covered with chicken wire. Then she applies epoxy filled with aluminum to the armature. To achieve her highly polished surface, Mrs. Landis refines the outside form with a knife and files. The final patina is achieved with a heavy gauge sanding cloth mounted on a wheel. Her forms are rather large—this one is 5′6″ x 5′. In spite of their massiveness, they are relatively lightweight and have weathered well in the outdoors.

Franc Epping uses the same armature as for direct plaster—a coat hanger wire for sculpture up to 10″, and ¼″ welding rod for sculptures up to 35″, reserving aluminum tubing for larger work. She creates volume around the armature by attaching screening for smaller work and hardware cloth for larger areas. Sometimes Miss Epping uses steel wool as a filler whenever needed. For finishing, Franc Epping obtains some effects by burnishing the epoxy (she uses Sculpt Metal, a commercial mixture) with a spoon or any clean piece of metal.

Courtesy Franc Epping

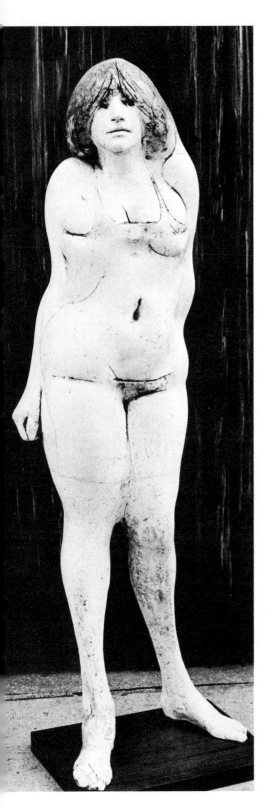

Frank Gallo. "Standing Beach Figure" (63″ x 18″ x 11″, 1965). Epoxy resin layed up in a mold. *Courtesy Graham Gallery*

Frank Gallo. Close-up of "Standing Beach Figure." *Courtesy Graham Gallery*

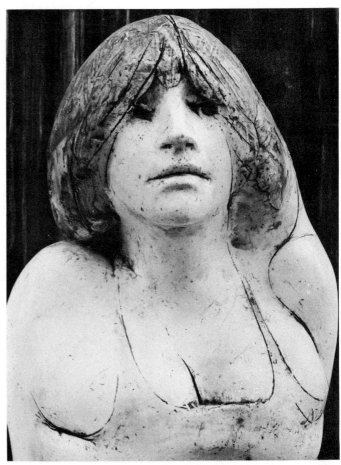

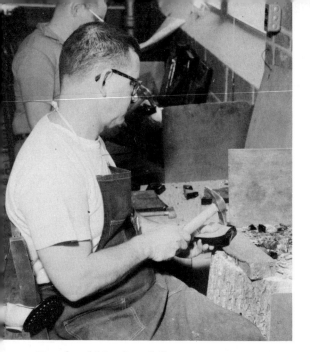

Faceted Glass and Epoxy

Brilliantly colored glass, usually an inch to two inches thick, arranged in a matrix of concrete and made into panels and windows, has been a popular contemporary technique. But substitution of epoxy in place of concrete has opened up enormous possibility for mass color effects, size, and texture. The epoxy can be colored and mosaic can be applied to the matrix integrating with the interior and exterior design effects.

Cut the thick glass dalles to size by rubber-cementing the pattern over the glass and cutting them to approximate size and shape with a hammer. *Courtesy Willet Studios*

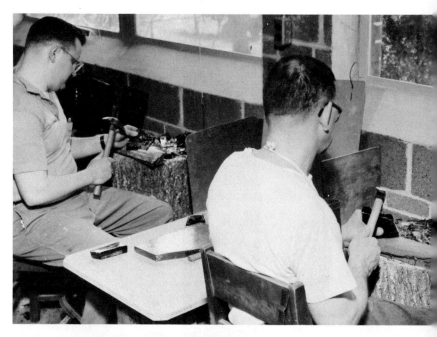

Chip or facet the thick glass with hammers, further refining the size.

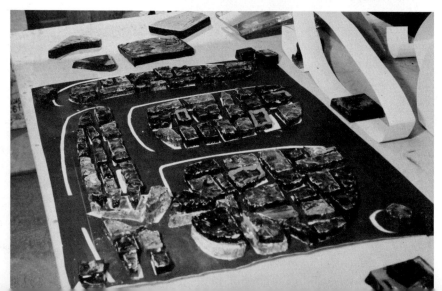

Glue the glass shapes to heavy paper pattern, preparatory to pouring the epoxy matrix. (The lumiere design in the background is used by the Willet Studios as a color guide for glass selection.)
Courtesy Willet Studios

180

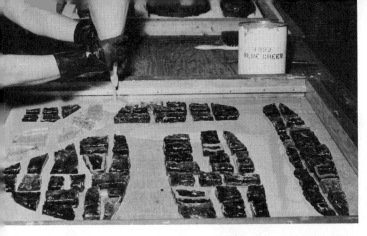

Place the glass, glued to its pattern, into a wooden pan or mold. Grease the form and pour filled epoxy resin around the faceted glass covering all the spaces between the shapes. *Courtesy Willet Studios*

If the glass is to be on two levels—a lower depth for the glass and a greater thickness for the matrix—place a greased cardboard dam around the glass dalle designs. An economy can be effected with increased strength and less weight—cut styrofoam to fit loosely between the dalles.

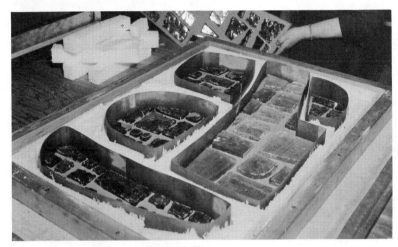

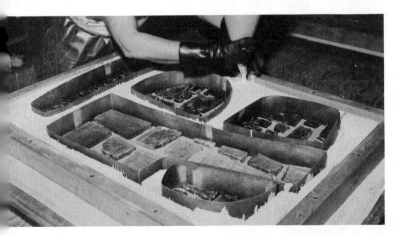

Pour more filled epoxy over and between the styrofoam, covering it. Then remove the dikes of cardboard, and pour more epoxy between the matrix and the glass, anchoring both areas.

The completed panels, with interior and exterior effect, sitting next to the matrix carton, show the effectiveness of this jewel-like quality. The thick glass intensifies color and eliminates the need to paint the glass as in stained glass design.

Courtesy Willet Studios

181

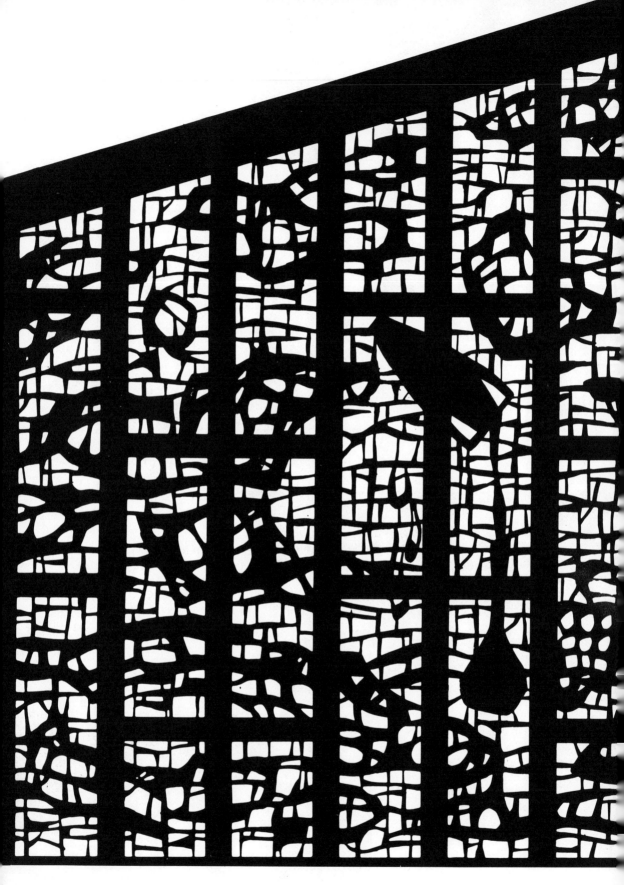

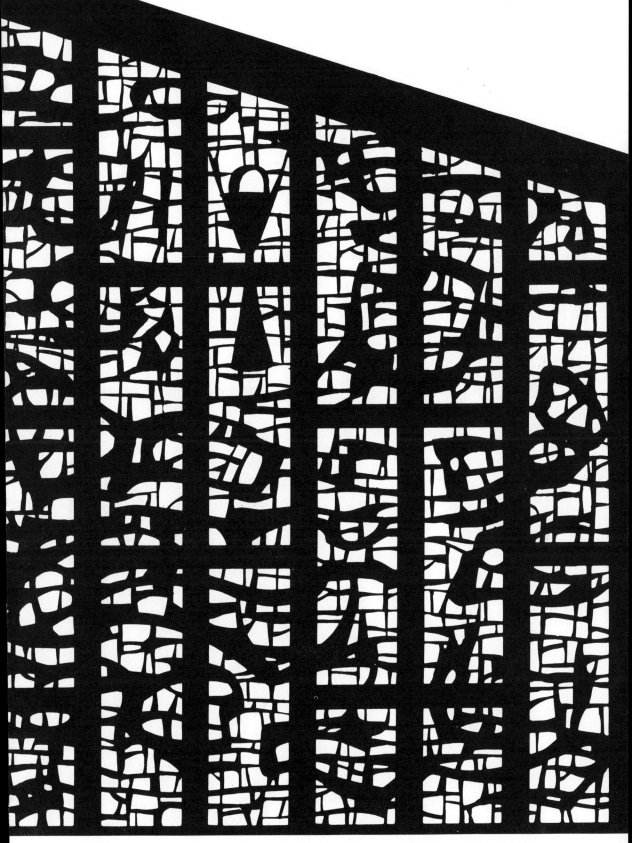

This is a matrix pattern by Henry Lee Willet for a portion of the sidewall of St. Mark's Episcopal Church in New Canaan, Conn. (24' x 14'6".)

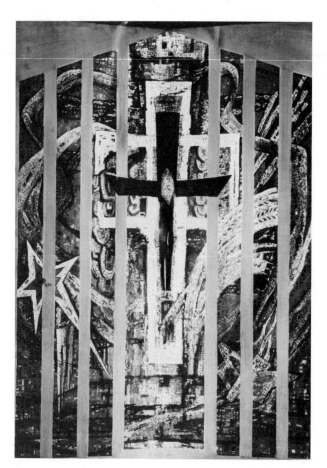

This window by Henry Lee Willet for a chancel interior shows the use of glass dalles and mosaic set in epoxy.

Courtesy Museum of Contemporary Crafts, New York

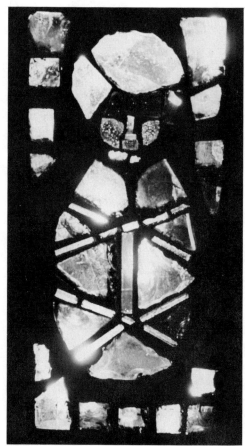

Marianne Cassar's glass and epoxy panel, "Bambino."

Courtesy Museum of Contemporary Crafts, New York

Working with Acrylics and Other Plastic Solids

Acrylics are perhaps the best-known plastic group. Most of us are familiar with "Plexiglas,"[1] "Lucite,"[2] and "Perspex."[3] Because of easy machinability and striking results due to acrylic's optical clarity there have been many commercial and hobbyist attempts, using the solid form. Acrylics are adaptable to both painting and sculpture using molding powders, liquids, syrups, and the solid form.

Industry seeking large consumer markets has also developed a few forms of acrylic for fine-art painting. These are now marketed by major artist-paint man-ufacturers, with widespread acceptance. As painting vehicles, the acrylics and vinyls have revolutionized painting concept and technique as the introduction of oil painting did in the fifteenth century. Virtually every paint manufacturer markets a polymer painting medium.

ACRYLIC AS A PAINTING VEHICLE

Properties and Potential

These new painting vehicles, replacing oils and varnishes, are usually emulsions or compounded into a paste form with

[1] Trade name for Rohm & Haas acrylic or methacrylate.
[2] Trade name for duPont acrylic.
[3] Trade name for Imperial Chemical Industries, Ltd. acrylic.

the same consistency as oil paint. They dry or cure upon contact with the air in about 20 minutes. And except for an acrylic compounded into a paste consistency which is soluble in turpentine, the other emulsions and pastes are water-soluble. This means that water can be used to dilute the emulsions and to clean brushes and implements before hardening sets in.

Characteristically, acrylic painting vehicles dry to a water-white, colorless consistency with a hard surface. Because of this clarity, pigments retain their brightness without the yellowing caused by aged oils and varnishes. Rapid drying speeds up the entire painting process with no loss of painting quality. In fact, more spontaneity is possible with these new materials—a mood can be expressed more directly.

Quick curing of underlayers allows for overpainting to be done without the traditional drawn-out processes. Therefore, scumbling, an overpainting process where a layer of paint is applied over another colored layer and then scratched through to reveal part of the undersurface, is one potential. Glazing, too, is feasible. Thin, transparent layers of paint can be overpainted with a more immediate buildup of form.

Some companies offer a filler material, gesso and modeling paste, compatibly mixed with acrylic, to allow for impasto techniques. Thick applications of paint with rich texture effects can now be achieved without breaking, chipping, or peeling away.

Another notable breakthrough with these acrylic paints is that the traditional "fat-to-lean" rule is no longer necessary because each layer of paint cures and succeeding layers grip each other into a homogeneous mass without the inhibiting effects of pigments. Contingently, there does not have to be any concern about the chemical reaction of pigments.

The potential of acrylic paint does not cease here. Because of acrylic's excellent

Irving Marantz uses Liquitex acrylic gesso as a coating on his canvas, Liquitex Polymer Emulsion as his binder, and Bocour Pigments for color. *Photograph by the author*

He mixes binder and color together on a glass palette and applies the paint directly with a brush. See page 6 for the completed painting. *Photograph by the author*

Karl Zerbe's work makes rich use of collage materials and textured application of color. Here he prepares a piece of paper that he will later adhere with some paint binder to his ground.

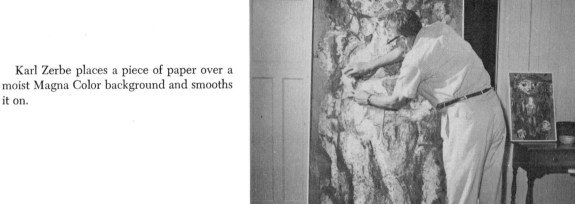

Karl Zerbe places a piece of paper over a moist Magna Color background and smooths it on.

Placing his painting in a horizontal position, Mr. Zerbe spatters and drips pigmented acrylic, using a stick.

Photographs courtesy Karl Zerbe

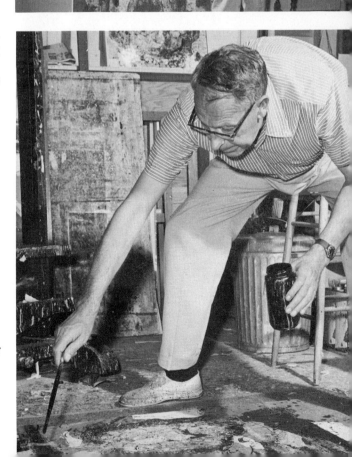

187

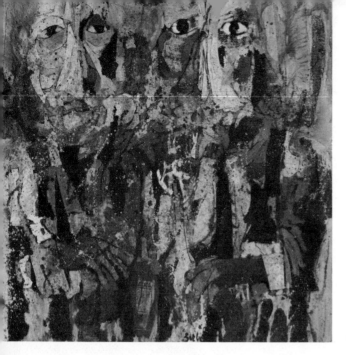

Karl Zerbe, "Two Hooded Figures" (1961) Acrylic.

Karl Zerbe, "Number 8, 11" (1960) Acrylic.

Mohsen Vasiri. "Untitled" (39" x 71", 1962). Sand and polymer paint on canvas.
Courtesy The Museum of Modern Art

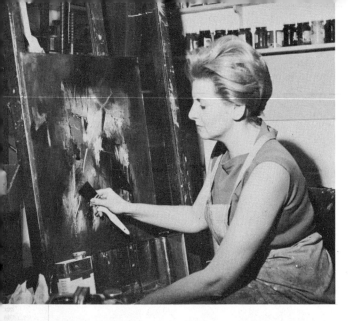

Harriet FeBland uses Liquitex acrylic
emulsion, utilizing brush or palette knife on
canvas.　　　*Photograph by the Author*

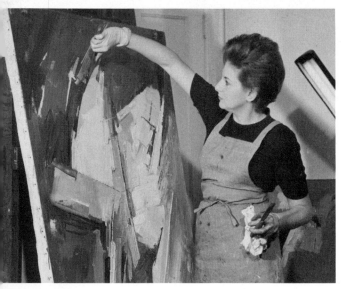

Sometimes, for flat glazing, in order
to separate further the layers of color, she
also uses Liquitex Matte Medium. Here and
there are placed pieces of gauze for a tex-
ture effect and colored celluloid-acetate for
touches of intense glossy color. Both of these
materials are adhered with acrylic paint.
　　　Photograph courtesy Harriet FeBland

Some of Harriet FeBland's paintings are
made on clear acrylic sheet with acrylic
emulsion as the painting vehicle. Here she
is seen knifing her first strokes.
　　　Courtesy Harriet FeBland

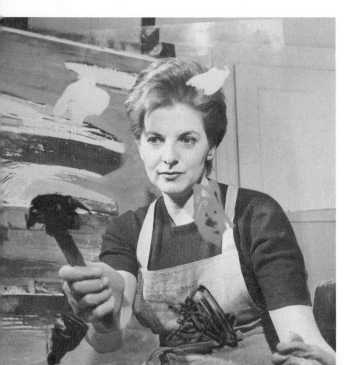

190

To solve the problem of back-lighting her translucent paintings, Mrs. FeBland set up a master panel with lights at regularly spaced intervals that will also accommodate various sized mats. *Photograph by the author*

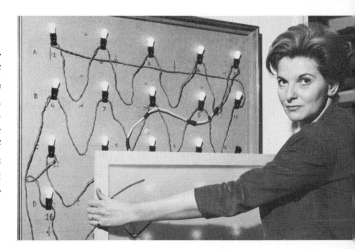

A fiberglass diffusing panel is placed over the illumination to soften the hot spots of light and provide a "heat shield." Then the lights are individually turned on and off, depending upon the intensity and effectiveness of each light position for the particular painting. Following the final light pattern of the master panel, a specific background is designed and wired for each painting's light box. *Photograph by the author*

Harriet FeBland, "Winner" (24″ x 30″, 1961). Acrylic on clear plastic.
Courtesy Harriet FeBland

191

bonding and impregnating properties, textures such as papers, fabrics, sand, etc., can be permanently adhered to the painting ground. Karl Zerbe uses newspaper as a texture in his painting and Harriet FeBland combines gauzes and celluloid in her painting on a transparent acrylic sheet. Both approaches provide rich texture. Mrs. FeBland takes further advantage of acrylic's transparency by backlighting her paintings, each with a special lighting pattern—see illustration.

Because of the water-clear transparency of the acrylic binder, colors are more brilliant. The hue tends to dry slightly darker. Both their brightness and darkness can be controlled through adjustment in preliminary color-mixing procedures. Brightness potential is what prompted Siquieros to experiment with various synthetic media. Returning from a trip, Siquieros discovered that some visitors had carried his canvases outside into the brilliant sunlight. He was horrified to see how dull and faded his oil colors looked in bright sunlight. It was at that point, so it is reported, that Siquieros decided never to use a medium that could not stand up under those lighting conditions.

Acrylic paint can be applied to a variety of supports, canvas as well as brick, masonite, gesso, wood, concrete, plastic, preferably a rough surface which has more "tooth" for acrylic paint. Acrylic paints can be handled as if they were oil colors, fresco, watercolor, or egg tempera. In fact, they have a versatility that can be chameleon-like in imitativeness. Nevertheless, their technical flexibility in application is excellent. Any working preference can find a compatible solution with the acrylic vehicle. For instance, if the artist hatches and stipples characteristic of egg-tempera technique, the end result will amazingly resemble an egg-tempera painting; or diluting the paint to a very thin consistency will bring out its "watercolor" qualities.

Unlike some vinyl painting vehicles,

192

acrylic emulsions do not require any plasticizers but remain tough and flexible indefinitely and therefore can be used on any kind of ground.

Types of Acrylic Paint

Acrylic paints are now marketed under several trade names, in various consistencies, and "soluble" in different solvents. Rhoplex AC-33 is a water-based acrylic resin emulsion manufactured by Rohm & Haas Company. Lucite 44 and 45 is another acrylic dissolvable in turpentine, toluene, and xylene, developed by E. I. duPont de Nemours & Company, Inc.

Lucite 44 and 45 comes in a dry state and has to be mixed with xylene or toluene to liquify it. Most artists use oil tube colors for pigmentation, thereby gaining some of the advantages of the acrylic medium with a familiar texture. All of these paints will harden completely in two hours. The turpentine-soluble materials can be softened and reworked after drying. Dried colors on the palette can be reused; they merely develop a skin while standing on the palette. Turpentine will soften an area for blending. Because of this, it must be cautioned that turpentine should not be used as a thinner for these paints. They are, however, water- and alkali-resistant.

The water-soluble acrylic emulsions do not have the body of oil paint. Rhoplex AC-33 does not handle like oil or like casein either. One can, nevertheless, add modeling paste and extender to the acrylic emulsion and get impasto effects. Rhoplex can be made more brittle with the addition of a hardening agent—Rhoplex B-85. Both materials have the same properties, other than their body, as the "oil-type" acrylics.

Whatever methods are used, duration of time is kaleidoscoped into minutes from days of waiting to complete a passage in a painting.

Glossy-Matte Surfaces

The surface texture of a painting can be controlled by the ratio of pigment to

Michael Lenson's "Flight" makes rich use of transparency and glazing of thin layer upon layer with Liquitex acrylic emulsion on a Masonite ground. *Courtesy The Cober Gallery*

In preparation for his mural for the Harry Truman Memorial Library, Thomas Hart Benton applied a sealer over the original paint on the plaster wall to prevent bleeding action. Linen was then added with a polyester adhesive and covered with acrylic gesso. Finally, the mural was painted with acrylic paint. *Courtesy Harry S. Truman Library*

medium. A higher percentage of acrylic will result in a glossier surface. Transparent colors such as phthalocyanine and ultramarine can be quite brilliant because of the transparency of the vehicle. A matte surface can be achieved by increasing the amount of pigment up to four parts pigment to one of the acrylic. It is possible to increase the amount of pigment, and still retain binding power, particularly with Rhoplex AC-33, but the paint film can be easily stained and you run the risk of the paint cracking upon drying. (Other causes of cracking are a too absorbent ground, or too much hardener.) Actually, an excellent matte film can be obtained using the 4:1 ratio.

Modifying the Acrylic Vehicle

If a more viscous body is desired, Acrysol GS (Rohm & Haas) or high viscosity gums CMC-120-H or CMC-70-S-H

(Hercules Powder Co.) can be added until the desired thickness is achieved.

Acrysol GS is a sodium polyacrylate (12½% solid in water), clear amber in color, that can be dissolved in hot water. CMC-120-H and CMC-70-S-H are water-soluble cellulose materials supplied in a water dissolvable white powder. These gums are also useful as wetting agents when ground with pigment before being added to the resin.

Some artists may desire a harder paint surface. By adding an aqueous dispersion of Rhoplex B-85 (Rohm & Haas) to Rhoplex AC-33, a hard film will result. Rhoplex B-85 cannot be used alone because it is extremely hard and cracking will result because of the incompatible differences in the expansion and contraction ratio between paint and ground. No more than 25% (volume) of Rhoplex B-85 should be added to Rhoplex AC-33.

A. Condopoulos of Greece used an acrylic medium for "Composition." (1.60 cm. x 1.20 cm.)

Courtesy New Forms Gallery, Athens, Greece

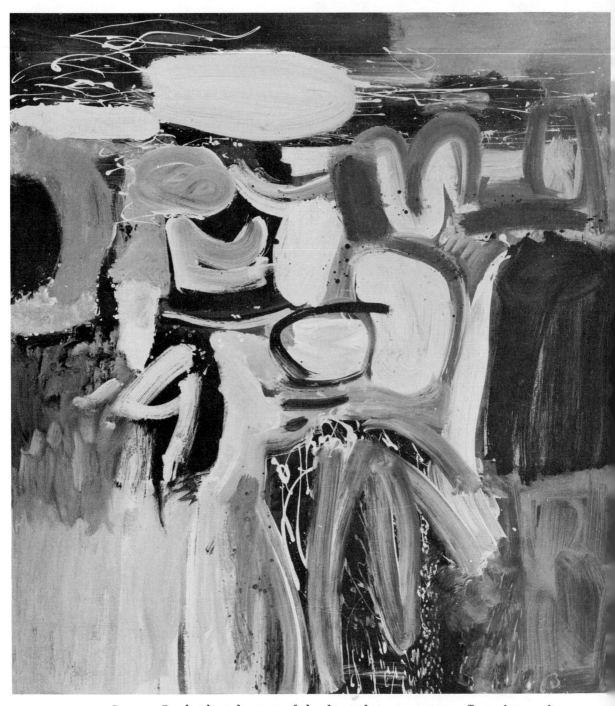

Cameron Booth takes advantage of the direct, free, spontaneous effects that acrylic paint affords whether brushed onto the ground or even dripped on.

Courtesy The American Federation of Artists

Gene Davis. "Anthracite Minuet" (7'9" x 7'7", 1966). Polymer on canvas.
Courtesy The Museum of Modern Art

Bridget Riley. "Current" (58" x 58", 1964). Polymer on composition board.
Courtesy The Museum of Modern Art

Both these paintings would have taken interminably long, if it were not for the quick-drying properties of the polymer paints.

Using mixed materials and pigments on an acrylic sheet with an acrylic binder, Robert Lepper created "Echo of the School of Paris" which is visible on both sides. (48″ x 30″, 1961.)

Both these paintings on shaped canvas are possible because polymer paints will not crack, peel or flake when rolled or folded.

Nicholas Krushenick. "The Red Baron" (8' x 6', 1967). Polymer paint on shaped canvas.
Courtesy The Museum of Modern Art

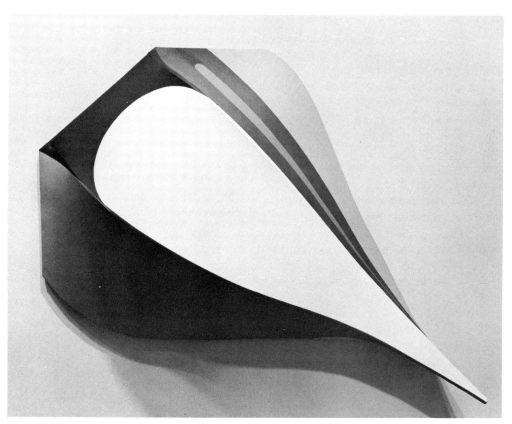

Charles Hinman. "Poltergeist" (61" x 16", 1964). Polymer paint on shaped canvas over a wood armature.

Courtesy The Museum of Modern Art

Although it does not directly relate to the acrylic binder, Tamol 731 (Rohm & Haas) acts as a compatible and effective wetting agent. A good pigment dispersion is necessary in order to avoid lumping and cracking of paint films. Tamol 731 reduces the grinding time, provides an efficient dispersion. It is a light-amber-colored liquid containing 25% solids suspended in water. Pigments are ground together, preferably on clean glass with a little dispersant such as Tamol 731 and water. After complete saturation of pigment in the dispersing agent, this color mixture is added to the acrylic emulsion. If the pigment is hard to wet, a wetting agent, such as Triton CF-10, should be added to the pigment grind.

For techniques of painting with acrylic. See Chapter 8.

USE OF SOLID ACRYLIC AND OTHER SOLID PLASTICS

Solid acrylic sheets and blocks have been a most popular material, perhaps because standard woodworking tools and methods can be used with these plastics—and the results are novel. The novelty of carving into acrylic block and the newness of forming and cementing a glasslike substance have been exploited toward the production of much ugliness. Roses carved into an acrylic block and the modern-type cigarette box are two of these common, poorly designed examples. Nevertheless, the very methods and materials used in fabricating the ordinary form still have much promise if we can forget about acrylics' sad beginning. Except for some commercial examples, mainly in the field of medical and museum display, such as George S. Krajian's work, very little internal carving is being done in the fine arts field. There are, however, many artists effectively using acrylic in fabricating their panels and sculptures.

Acrylic sheet is a cast thermoplastic produced in several formulations to provide specific properties for different ap-

plications. There are two main types—shrunk and unshrunk. "Shrunk" acrylic sheets will not shrink when heated to forming temperature and are manufactured to exacting standards of optical quality, surface finish, and thickness tolerances. Within this group are the heat- and craze-resistant acrylic sheet, flame-resistant cast acrylic sheet, and ultraviolet absorbing sheets (used as a protective background for art objects, protecting them from harmful UV radiation and increasing their expected life).

Unshrunk sheets show a uniform shrinkage of approximately 2% in length and width and 4% in thickness when heated to forming temperature. This acrylic is much less expensive than the shrunk types and serves as an excellent background or material for carving—wherever heat is not a factor or part of the process.

Sheets should be stored with masking paper on, to prevent dirt, acids, alkalis from attacking the surface as well as from scratching. Masking paper can be reused if kept clean by rolling loosely into tubes and storing in a clean dry place.

China marking pencils are best for marking the acrylic. Marking pens can also be used.

Coloring Solid Sheet

Acrylic can be purchased in a wide range of lightfast colors. If solid-colored sheets are not desired, acrylic can be colored in a number of ways:

A. Dip-dyeing
1. Immerse acrylic in a solution of acetone and dye—60 parts (by volume) acetone (3 glasses)
 40 parts (by volume) water (2 glasses)
 1 to 3 teaspoons of dye to a little acetone

2. add to the acetone-water solution and

3. stir well

200

4. immerse the acrylic in color-mixture from 3 seconds to 3 minutes, depending upon the depth of color desired

5. remove and rinse in water

6. then wipe dry with a soft cloth.

B. Coating of colored polyester resin

1. scratch and sand surface of acrylic to give it "tooth"

2. wipe with alcohol on flannel

3. make a coating-mixture of catalyzed polyester resin and color

4. paint or drip onto the acrylic surface

5. allow to cure

C. Solvent paint

1. using palette knife on glass, grind powdered acrylic pigment or dye with acetone and ethylene dichloride

2. apply to surface of the acrylic with a brush or palette knife

D. Acrylic paint

Acrylic paint can be sprayed or brushed onto acrylic. The paints can be gotten in a variety of viscosities from brushing and spraying types to a silk-screening variety, and consistencies from turpentine-soluble materials to emulsions that are water-soluble.

E. Acrylic coatings such as Acryloid B-7 (Rohm & Haas)

These quick-drying coatings can act as a binder for pigment, and also adhere well. Dissolve colorant into the coating and apply immediately with brush or palette knife.

Effects or "Defects" of Color Application

Many catastrophes to the commercial fabricator can be a boon to the artist. The manufacturer looks for standardization; on the other hand, the artist can tolerate one time texture effects, espe-cially since most of these can be predicted. The sculpture pictured on the jacket of this book utilizes many of these "defects" to achieve that rich variety of textured-color.

Migration of color; exudation or blooming of slightly soluble color one layer into another; recrystallization of color when in contact with solvents or solvating plasticizers; crazing due to solvent cutting along lines of strain (usually in a formed object) are the major "defects" or excellent texture effects—depending upon your point of view.

Etching and Carving

Etching an acrylic, cellulose acetate sheet—in fact, any solid, machinable plastic sheet—can be done as an end in itself, as a printing technique, or as a texture-light effect in carving a panel or sculpture.

Etching

In etching, place the transparent plastic sheet over the original drawing. Using a flexible shaft drill, an etching tool, awl, or a phonograph needle or dental drill embedded in a wooden handle or dowel, trace or scratch the lines onto your plastic from the original drawing. This etched sheet can now become the finished picture or be printed as an etching.

Etcher's ink or printing ink is rubbed into the scratched lines made by your engraving tool. Excess ink is rubbed off with dry flannel leaving a deposit of color only in the etch-lines. If this is to become a printing plate, the etched plastic is then placed on an etching press with paper and a felt pad to insure a deep and clear impression. Except for the use of a plastic plate which does *not* require an acid bath, the etching process is standard. Needless to say, it is more direct and simple.

Still another use of the acrylic sheet in printing, much like a wood or linoleum block, is illustrated here in step-by-step photographs.

1. BURNING RATE
 Various types from slow-burning to self-extinguishing to nonflammable.

2. COLOR
 Clear, transparent, optical quality.

3. COLOR STABILITY
 Some varieties are made in opaque color. Almost no degradation, continued clarity.

4. EFFECTS OF CHEMICALS
 Weak acids and weak alkalis have little effect on the surface; strong oxidizing acids and strong alkalis mar the surface.

5. HARDNESS
 Rockwell (M) value—93 to 80 according to the thickness.
 Barcol value—35–52.

6. HEAT STABILITY
 Will soften at 140°F. to 190°F., depending upon the type.

7. MACHINING PROPERTIES
 Excellent.

8. ODOR
 Sheets and blocks have no odor except when kept in an enclosed area for a prolonged period of time.

9. REFRACTIVE INDEX
 1.49 or >92% light transmission.

10. SHELF-LIFE
 Indefinite.

11. SHRINKAGE
 Shrunk type does not shrink; unshrunk varieties shrink uniformly at approximately 2% in length and width and 4% in thickness.

12. SPECIFIC GRAVITY
 1.18–1.24 depending upon the type.

13. STRENGTH
 Tensile strength—9,000–11,000 psi Impact strength—3.5 ft./lb.
 Flexural strength—14,000 to 16,000 psi Surface hardness—scratches easily

14. SOLVENTS
 Ketones, esters, aromatic and chlorinated hydrocarbons, such as acetone, ethyl acetate, ethylene dichloride, toluene, lacquer thinner—all these make excellent adhesives for acrylic.

15. WEATHERING
 Effects of sunlight are nil; water absorption is very slight. Overall weathering of acrylic sheet is excellent; it is often recommended for outdoor use.

Carving

Carving can be most effective if the behavior of light in acrylic is taken into account. A phenomenon commonly known as edge-lighting is peculiar to optically clear dense solids such as a polymethyl methacrylate sheet. A beam of

202

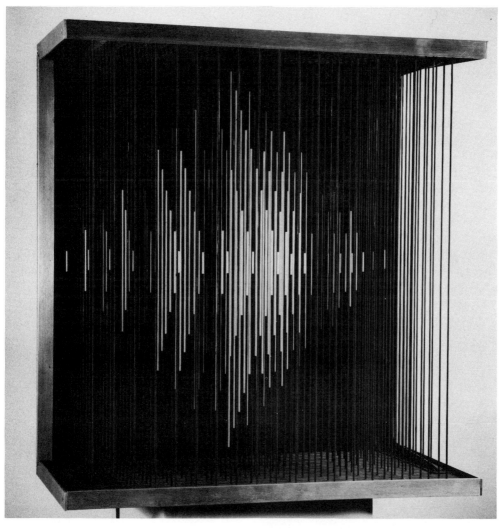

Yvaral (Jean Pierre Vasarely). "Instability #18" (20" x 19" x 10", 1961). Painted acrylic and wood.

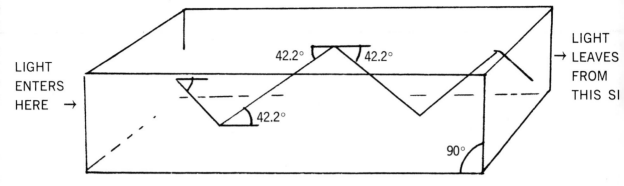

LIGHT ENTERS HERE →

42.2° 42.2°

42.2°

90°

LIGHT LEAVES FROM THIS SI

92% of light entering an unscratched sheet of acrylic will be transmitted by internal reflection to the opposite edge. If light inside the piece of acrylic strikes the surface at an angle greater than 42.2 degrees, it is bent so that it cannot escape into the air but must be reflected back to the other side of the plastic piece. The light will bounce back and forth until it reaches the far end, and glow.

light, parallel to the surface of a uniformly thick acrylic sheet, is from its entry through the edge, first refracted and then reflected from one polished surface to the other, bouncing through the sheet. About 92% of light can be transmitted through this intended reflection to the opposite edge of an unscratched piece. If, then, the surface is disturbed with scratches and carving, the sheet will "leak" light at those points.

Variations in cutting tools, sizes, and shapes, speed of grinding, angle and direction of the cut all are contingencies that will determine the quality of texture and light that is achieved. This need not be a hit-or-miss technique, but considering what is known about angles of light (see illustration) and the glow of light reflected from each incision, knowledgeable success may be achieved (see illustration).

Since 92% of light entering an unscratched sheet will be transmitted by internal reflection to the opposite edge, light inside a piece of acrylic that strikes the surface at any angle greater than 42.2 degrees, is bent so that it cannot escape into the air but must be reflected back to the other side of the plastic piece. Parallel sides, then, will cause the light to bounce back and forth until it reaches the far end. Light transmits through to

204

the end of the acrylic form. Then if the surface of the plastic sheet were scratched in some way, some of the light would reach the air and cause a glow as it does when light pipes through to the edges. When the angle of the air-plastic interface is disturbed, light reflects back. Disturbing the reflecting surfaces of a sheet of acrylic can be deliberately planned into a design that will "leak" light wherever the artist incised his lines. Drypoint etching, engraving, abrading, sandblasting, carving, silk-screening, printing, or painting can be made to glow while the background remains unlighted.

Here is one approach:

1. Set up your sheet acrylic over a flannel cloth (around edges) preferably on a box-frame with light coming through one edge (to light your cuts while in progress) and anchor or clip the piece over your sketch so that the sheet does not move.

2. Ready jigs, guides, and templates to help steady the hand tool when it is in operation—or whenever there is any risk of the tool running out of control.

3. Protect your eyes with a face mask or glasses from flying chips, and if you do a great deal of grinding use a mask over nostrils and mouth.

Etching and Carving

Place your sketch beneath the acrylic sheet. With a flexible shaft tool equipped with a fine drill, etch your lines or shapes into the acrylic, using some sort of a jig for support.

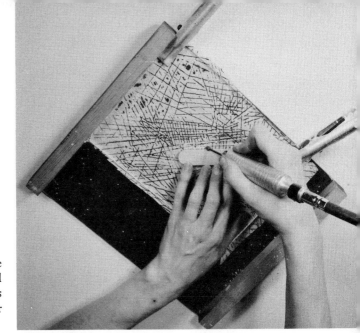

The finished etching showing simple straight lines of varying thickness. This etching can be complete in itself, the lines may be filled in, or the etching can be used as a printing plate.

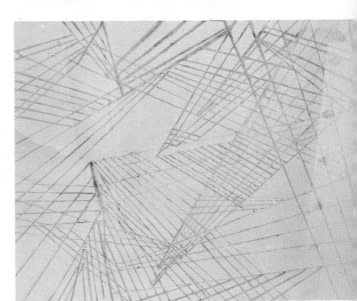

For printing, ink your brayer.

205

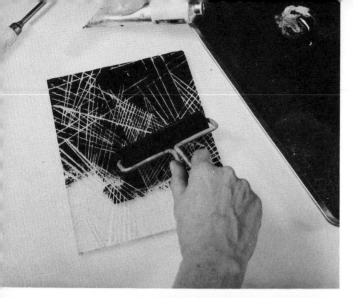

Apply ink with your brayer to the etched acrylic.

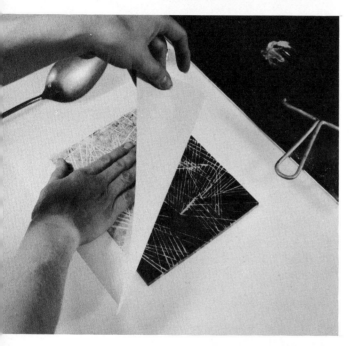

Place your printing paper over the inked plate.

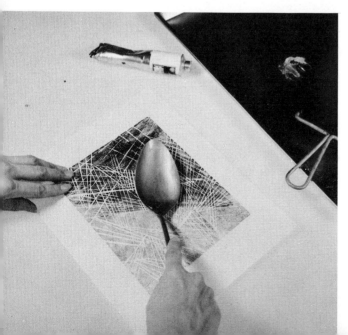

Transfer the inked design to the paper with some sort of pressure—in this case, a spoon-back is used.

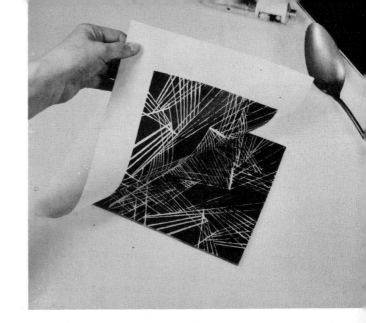

Lift your print from the plate.

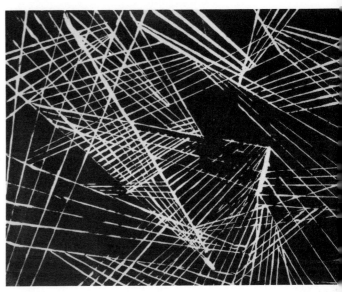

Editions running over a hundred can be made from acrylic plates with the same sharp definition as this completed print.

Moving away from simple etched lines, we see the enormous texture possibility with acrylic engraving achieved by Arthur Deshaies in his "A Cycle of a Small Sea: Sweet Spring." This was an edition of 50 prints. *Courtesy The Brooklyn Museum*

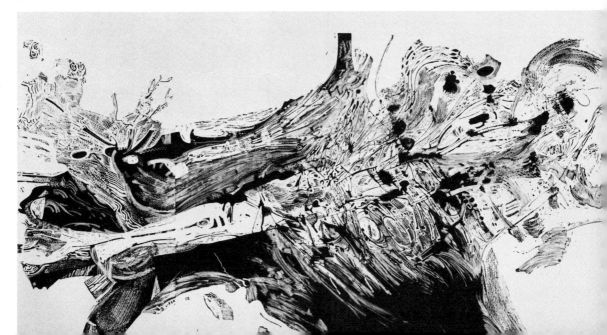

4. Clean your surface with isopropyl alcohol (99%) on long-nap flannel, now and whenever necessary as work progresses. Do not use a dry, hard cloth because electric charges build up and this friction aggravates the static and also may scratch the surface.

5. With a flexible hand-shaft machine and an assortment of bits—from phonograph needles to dental tools —carve into your acrylic sheet. If grit tools are used, take care to blow away particles instead of rubbing them away, again to avoid nuisance scratches that show up in edge lighting.

6. If possible, work most of your design in reverse because cuts on the rear surface show up more brilliantly from the front.

7. The further away you are from the edge-light source the deeper you should engrave.

8. Work the center of an area and then outward to the sides to keep outside edges from transmitting all the light.

9. When all the carving is completed, polish the edges of your sheet.

10. Then seal off edges with white acrylic paint where the light source is not to transmit. This prevents further loss or leakage of light.

The engineering of lines and cuts in the acrylic sheet requires its own rules and limitations. First of all, the nature and position of lighting and thickness of the material have to be considered. For instance, as said before, engraving should be deeper the farther away it is from the light source.

These are some professional hints that may help make a first attempt more successful: To keep the light within the sheet, so that it will only reflect outside the internal carving, aluminum foil tape

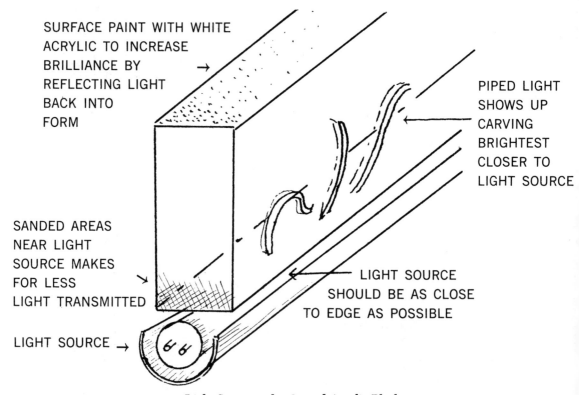

SURFACE PAINT WITH WHITE ACRYLIC TO INCREASE BRILLIANCE BY REFLECTING LIGHT BACK INTO FORM

PIPED LIGHT SHOWS UP CARVING BRIGHTEST CLOSER TO LIGHT SOURCE

SANDED AREAS NEAR LIGHT SOURCE MAKES FOR LESS LIGHT TRANSMITTED

LIGHT SOURCE SHOULD BE AS CLOSE TO EDGE AS POSSIBLE

LIGHT SOURCE →

Light Source and a Carved Acrylic Block

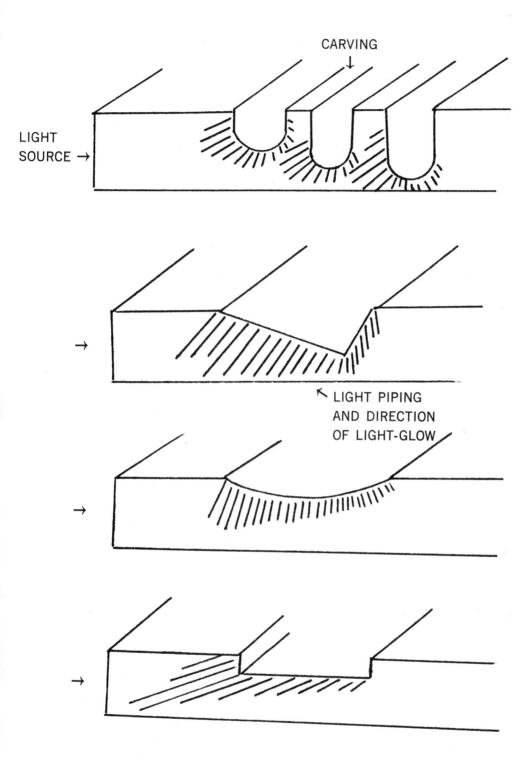

When the surface of a plastic sheet is carved, some of the light would reach the air and cause a glow. Incising lines at different angles and into varying shapes, as in this enlargement of carving shapes, will cause different qualities of glowing light.

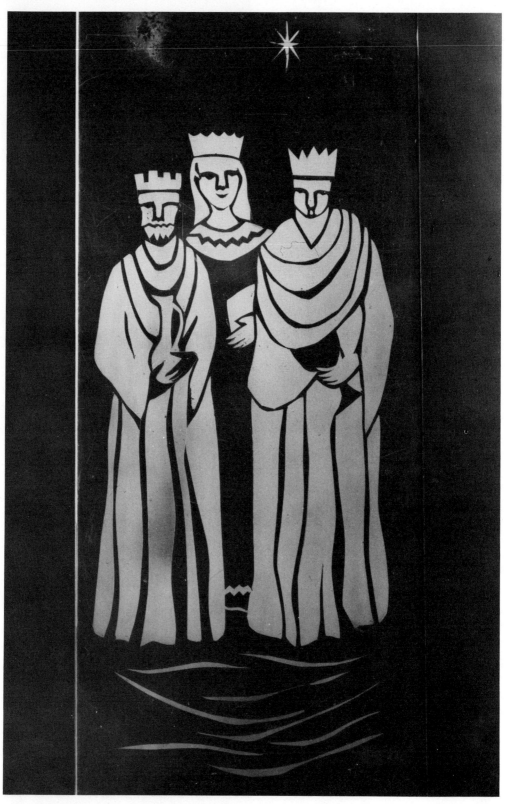

Sandblasting is a way of etching broad areas into a panel. This etching of the "Three Wise Men" is an example of etching with a very fine stream of sand done commercially. To prepare the panel for etching, see the following method—a simulated effect.

Mask the acrylic sheet with masking tape. Overlap edges slightly so that the joining of strips does not expose any acrylic.

Sketch your design directly onto the masking tape considering positive and negative areas as you would in making a stencil.

With a stencil or Exacto knife, cut around your outline by tracing the lines with your knife.

211

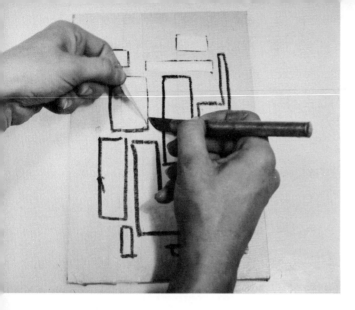

Lift off areas of masking tape that will leave the acrylic exposed for sandblasting—or in this simulated effect, spraying.

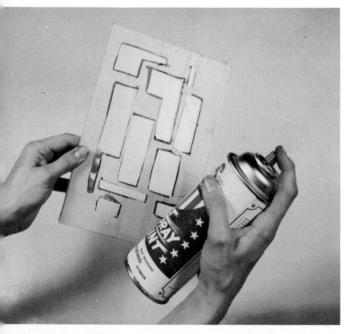

Deposit a spray of "frosting" on the panel. Allow to dry and continue to add layers of frosting until the desired depth is achieved.

Pull away the remaining masking tape. This etching effect can be useful for making a sketch-model for the more expensive sandblasting result.

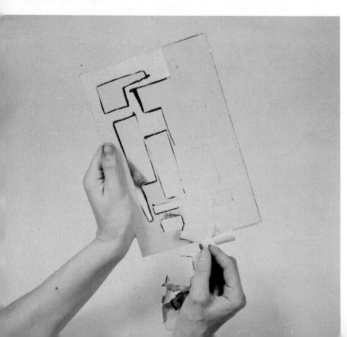

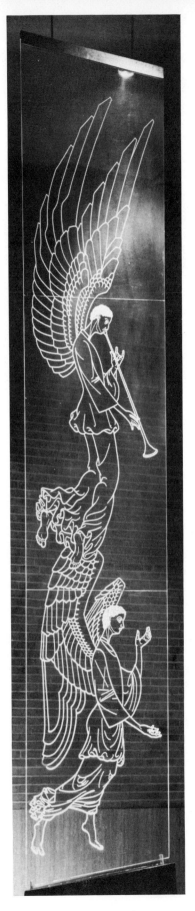
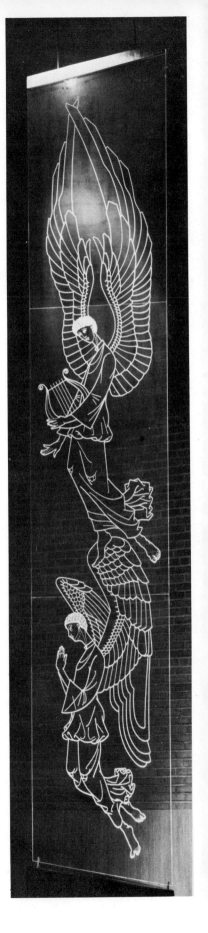

Details of the left and right carved acrylic panels made by Russell Krauss, as well as the overall view, show how the light source causes the carved lines to emit light.

Courtesy Russell Krauss

Irene Hamar. "Light
Keyboard" (4′ tall).
Acrylic cubes attached
with rods.

Courtesy Irene Hamar

or opaque white acrylic paint can be used
to seal edges. Outer edges of carving,
closest to the light source, will tend to
pick up the lighting.

Often, to determine the greatest depth,
holes can be drilled to act as a reference
of depth. Adhesive tape or masking tape
can be used around an area to prevent
marring from a drill that slipped.

After some initial experimentation you
will develop your own system.

Some other variations: Try superim-
posing different layers of sheets each
with a correlation section of your panel—
and each sealed off from light on different
sides. Another—drill holes in your panel,
enough to accommodate a small vertical
bulb which can give more intense light-
ing to different sections; if the acrylic in
each of these holes is stained around the
opening, colored light will be transmitted
to the engraving—or you could use col-
ored illumination. Animation can be
worked out by having lights alternate on
and off in different sections of your panel.

214

Machining

A natural adjunct to carving is ma-
chining. Machining here involves cutting
and drilling.

Sawing

Acrylic sheets, rods, and blocks can be
cut with any saw used for wood or metal.
Circular saws are advised for straight
cutting; jig or saber saws for curves or
small radii, band saws for larger curves
and cutting into thick acrylic. Routers
can be used for trimming edges.

Saw blades should be carbide-tipped
with square and advance teeth for circu-
lar saws. If a small amount of work is
to be done, the less expensive standard
hollow-ground blade used for ripsawing
wood can be used. All teeth should have
uniform height. If teeth are of uneven
height or with large space between
them, there will be excessive chipping.
Coolants are not necessary but if desired,
a 10% solution of soluble oil in water will
minimize excessive heating.

Lines were carved into acrylic and string was threaded over parts of "Linear Construction, 1943." Later on, Naum Gabo relied almost entirely on carved lines in his acrylic sculpture.

Courtesy Otto Gerson Gallery

Fred Dreher in his prismatic sculpture "Sentinels" used both incised lines and holes, as well as curved edges. The highly polished shapes contrast with the frosted base through which light is projected. He often conceals a light source in the sculpture's base. Mr. Dreher, using hand and handsaw, cuts his forms from one inch to three inch thick slabs. After refining his shapes with a file, the sculptor sands and polishes the pieces to a crystal clarity. The facets and planes of his sculpture transmit prismatic colors as light is introduced.

Photo by Chester Danett

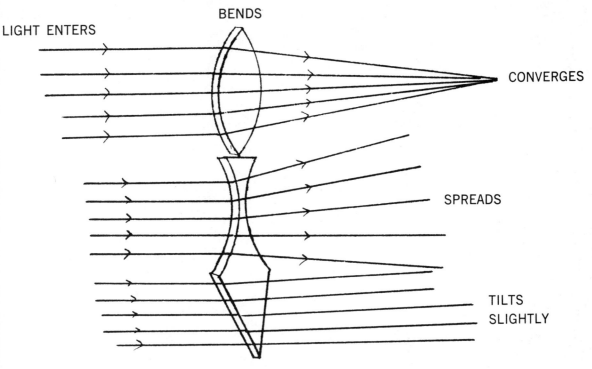

LIGHT ENTERS BENDS CONVERGES SPREADS TILTS SLIGHTLY

Not only do carved lines glow with piped light, but curved and straight acrylic edges also transmit light in angular directions.

In general, the thicker the material the slower the speed should be to prevent the cut from melting and sealing again. If a band saw is used, metal-cutting blades are best. Skip-tooth saws with 2–6 teeth per inch have been especially developed for plastics. These remain sharp for long periods of time.

Drilling

When drilling acrylic, twist drills, commonly used for metal, work well but for more efficient holes the drills should be dubbed off to a zero rake angle to prevent catching the material. Besides some oil coolant used for sawing, compressed air may also be employed.

Forming

Because acrylic is a thermoplastic, it can be softened and formed into almost any shape. If the material is not the correct shape upon hardening, it can be resoftened and shaped.

Some general rules for forming:

1. Acrylic sheets should be cut larger than the desired size to accommodate for shrinkage.
2. Except for bending (with a strip heater) the entire sheet should be heated uniformly to prevent stresses from building up in the sheet.
3. The entire forming operation should be accomplished before the sheet cools.
4. Cooling should occur slowly and uniformly.

Heating Methods

The most preferable method is in a forced air circulation oven operated by either gas or electricity and controlled by automatic temperature regulators. Sheets may be heated in this oven lying flat on soft flannel or hanging vertically from spring clamps.

Another method is infrared radiant heating. It is more difficult here to avoid hot spots and provide uniform heating. Radiant heating is only good for thick-

217

Louise Nevelson. "Transparent Sculpture I" (42″ x 36″ x 16″, 1968). Fabricated from clear acrylic sheet.

Preston McClanahan. "Clover Leaf" (24″ x 10″ x 10″, 1966). Fabricated from clear acrylic
sheet and mounted with a permanent light effect. *Courtesy Preston McClanahan*

Julio LeParc. "Double Concurrence—Continuous Light 2" (21" x 19" x 5", 1961). Black wooden box with an illuminated aperature in which 54 acrylic squares are suspended from 18 nylon threads; mirror backing, two reflectors, three sets of interchangeable pierced metal screens and two glass filters. *Courtesy The Museum of Modern Art*

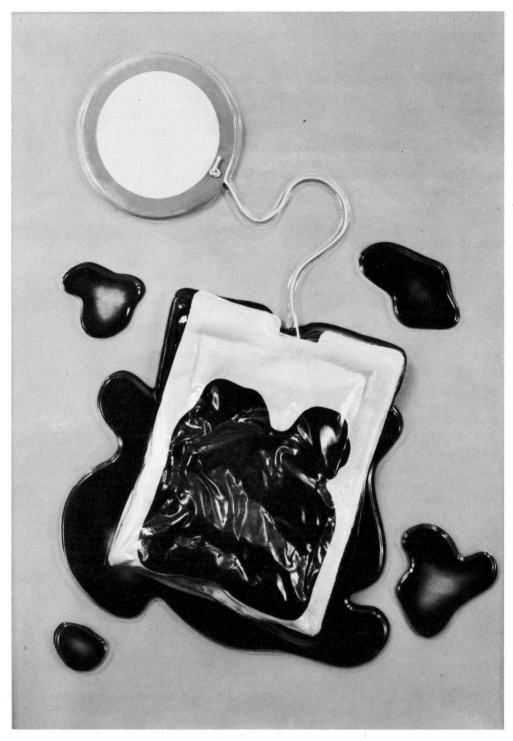

Claes Oldenburg. "Teabag from Series Four on Plexiglas" (39″ x 28″ x 3″, 1966). Serigraph printed in colors on felt with clear plexiglas and white plastic.

Courtesy The Museum of Modern Art

nesses up to .125" (⅛") when heated from one side or .250" thickness when heated from both sides.

Strip heaters are used to soften on the line along which the sheet is to be bent.

Forming Temperature

A temperature range from 240°F. to 340°F. is broad enough to cover all types of acrylics. Sheets change little between 290°F. and 320°F. Higher temperatures cause bubbling. (See cover-sculpture and the bubble texture.)

Thinner materials must be heated to a higher temperature than thick ones because thin sheets cool more rapidly than thicker sheets. It must be cautioned that forming at too low a temperature will result in unnecessary internal stress, crazing, and warping. During forming, the temperature should not be allowed to go below 275°F. If forming cannot be completed before the temperature drops to 270°F., the mold can be preheated and/or forming can take place in an enclosed area. Both methods can increase working time. Also, some molds, such as metals, cool faster than wood-reinforced gypsum, epoxy or polyester. The best temperature for the mold is 130°F.—this also allows for slow, uniform cooling. No trimming or cutting should be done until the acrylic cools because the sheet continues to shrink as it cools.

Clamping

Simple shapes can be held to the mold with rubber bands. More complex shapes require a clamping ring that follows the edge contour of the mold. "C" clamps and toggle clamps are also used.

Forming Methods

Most forming methods are commercial types that involve expensive equipment (see Appendix on Commercial Techniques). There are some, however, like blow molding, which was described earlier, that are feasible in a studio, home, or school.

222

An unconventional method is to heat the acrylic with a torch and manually shape the form, holding it in place until the form cools. This can be comfortably accomplished only when working with smaller sizes of acrylic. Or, a 600-watt spot heater can be used to soften the acrylic for forming.

Surface embossing can be used to produce a patterned effect. This can be done with a warm form that is pressed into the hot acrylic sheet and kept there until the form cools.

Cementing

Cementing acrylic to acrylic can bond almost invisibly into a unit, closely approximating a single piece. Strength of the joint will vary according to the cement and cementing technique used. At room temperature, it is possible to achieve 75% of what would be the tensile strength of a solid sheet of acrylic.

Types of Cement

It must be cautioned that most of the cements used contain volatile liquids which should not be inhaled. Some of these are flammable, too. Overexposure to cement vapor will cause drowsiness, dizziness, and nausea (see Appendix).

There are two general types of cement, *solvent cements* and *polymerizable cements*.

Polymerizable Cements

Solvent cements do not react on the surface of some acrylics (Plexiglas 55, a cast acrylic resistant to crazing, and Plexiglas 5009, a flame-resistant cast acrylic), and require a polymerizable cement. This cement can be applied at room temperature and is suitable for cementing *all types* of cast acrylic sheet. Cemented joints can be machined within four hours after joining. Has high strength and good weather resistance.

The formula of this cement—Cement 18 (Rohm & Haas)—is approximately as follows:

Forming a Sculpture

Several sheets of acrylic are formed, cemented, and shaped by cutting into a sculpture.

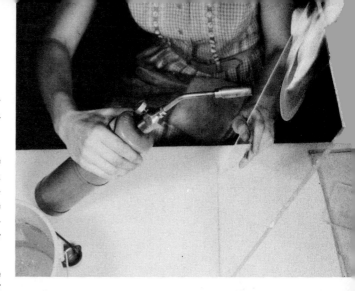

With an oxy-hydrogen* flame, if possible (I use a propane torch but it deposits carbon and oxy-hydrogen does not), soften the particular area where you choose to distort the acrylic sheet. The flame you see here is controllable. Keep a bucket of water handy for flame quenching.

* Since hydrogen is a light, odorless gas, the cylinder and attachments have to be tested for leaks. Hydrogen escaping unnoticed would rise to the ceiling and any spark could cause a flame. If you use this equipment, employ the necessary precautions; check for leaks with a soap solution at all connection points.

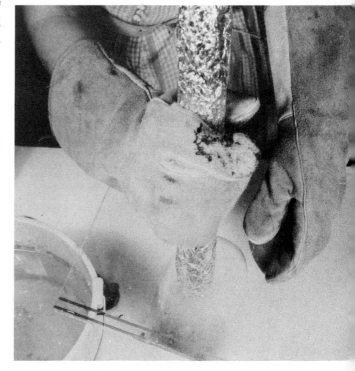

After the area is softened, bubbles will form (I deliberately try to achieve this texture). Use a weight or some constant pressure to distort the heated area to the shape you wish. Keep applying pressure until the acrylic cools.

Clean away carbon deposits by polishing the acrylic and then mix pigmented polyester resin and pour it onto the areas you wish to be that color. Continue this operation on as many sheets as you choose to use, with as many colors as you wish. Plan on these colors overlapping and fusing through transmitted light into new colors.

223

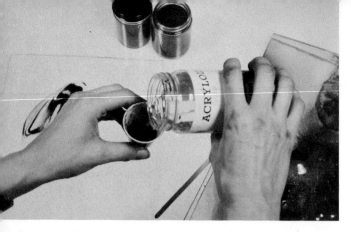

Mix Acryloid B7 with dry pigment. Stir well.

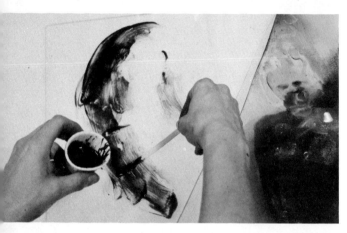

Apply the pigmented Acryloid, which is an adhesive, with a stick or palette knife to the specific areas. You can texture this material by scraping the cross-hatching.

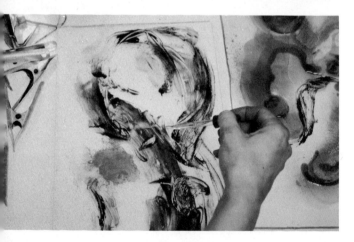

After all the sheets are formed and colored, add your acrylic solvent, in this case ethylene dichloride, to contact points of the first two sheets. Allow the areas to soften a little.

Join the first two sheets with pressure.

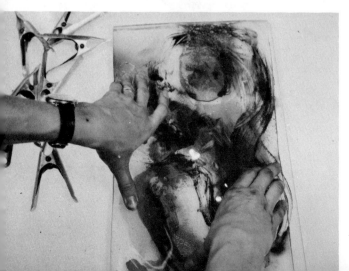

Use spring clamps or "c" clamps to hold the sheets together. They are often warped and require special pressure. If the ethylene dichloride does not cover all contact points, with a pipette drop some more between the sheets at joining points. Allow this adhesive to dry thoroughly and set—at least six hours. Remove clamps and join the next sheet, repeating the operation until all parts of the form are joined.

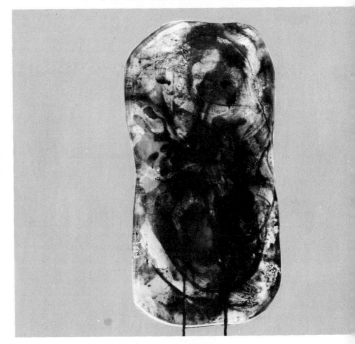

Using a handsaw, trim the edges to shape. Polish or flame polish the edges. Mount the sculpture on a base. The acrylic section of this sculpture is 14″ high, 6″ wide and 1″ deep. "Maternity II," 1963, by the author.

"Surrogate Mother" (1967), by the author. Laminated acrylic.

225

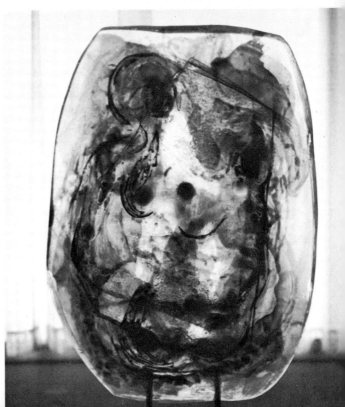

Composition	Trade Name	Suggested Use & Application	Approximate Soaking Time
60% Methylene Chloride & 40% Methyl Methacrylate monomer (inhibited with .006% hydroquinone by weight) and 1 capsule of benzoyl peroxide catalyst (204 grams of 50% strength) per pint	Cement II (Rohm & Haas) H-78 (duPont)	For outdoor weather resistance and maximum joint strength	5–15 minutes
90% Methylene Chloride 10% Diacetone Alcohol	Cement I-B (Rohm & Haas) H-94 (duPont)	Medium joint strength. Quick setting. Suitable for soak, dip, capillary cementing	3–10 minutes
1,1,2-Trichlorethane (vinyl trichloride)	Cement I-C	A "soft" joint, low in tensile strength. Crystallizes on outdoor weathering. Easy to use—soak, dip, capillary methods	5–10 minutes
Ethylene Dichloride	Cement I-C	Medium joint strength. Quick setting. Easy to use—soak, dip, capillary methods. Crystallizes outdoors.	3–8 minutes
Methylene Chloride	Cement I-C	Medium joint strength. Evaporates quickly. Easy to use—soak, dip, capillary methods. Crystallizes outdoors.	3–10 minutes

Part I. A viscous 50–50 mixture of methyl methacrylate monomer and methyl methacrylate polymer—4 oz.

Part II. A 50–50 mixture of benzoyl peroxide catalyst and camphor—2.4 grams

Mix Parts I and II together, then add

Part III. The liquid accelerator—5 cc.

Mix only what can be used in 30 minutes in disposable, unwaxed paper cups.

The viscosity of this cement can be lowered, making it easier to apply and bubble-free by adding 2 more ounces of methyl methacrylate monomer, carefully stirring it into well-mixed original 4 oz. of Parts I and II. Then increase the accelerator to 10 cc. instead of 5 cc.

Cementing Methods

Soak cementing—The acrylic part is actually immersed in solvent cement until the surface to be cemented softens into a "cushion," and then the parts are held with enough pressure so that the pieces fit without squeezing out any of the soft cushion (see illustration). If the joint looks cloudy, then moisture probably was present.

Dip cementing—One part of the acrylic to be bonded is dipped into the solvent long enough for the solvent to act. Then the parts are assembled.

Capillary cementing—The cement is introduced to the joint (parts already assembled) with a paintbrush, eyedropper, or hypodermic needle. Sometimes a fine wire is inserted into the joint before the cementing. After the cement begins to soften the acrylic, the wire is removed.

Glue method—A solvent cement can be thickened with clean acrylic chips or

shavings to produce a syrupy cement that can be applied like glue.

Assembling parts when solvent cements are used should be done quickly before the solvent evaporates from the cushion. The two lightly sanded or macined parts should be held together with gentle pressure for 15 to 30 seconds to allow a cushion joint to form.

Pressure should:

1. Squeeze out all air bubbles
2. Be even (1 to 2 pounds per square inch)
3. Be maintained until complete hardening to compensate for shrinkage (4 hours).

Jigs using spring clips, spring clothespins, and battery clamps hold parts together efficiently. After remaining under pressure for four hours, it is recommended that the cemented form be annealed to prevent crazing due to solvent entrapped in the joint.

Welding

Heat welding and frictional welding are other joining techniques; welding heat takes the place of solvent softening. Friction welding is much the same as lighting a fire by frictionally rotating twigs. Here, the welding rod is rotated using high speed and not too much pressure. Heat welding is done with a hot blade or hot gas, using as high a temperature as possible to avoid long exposure of the plastic to heat.

Annealing

Annealing is accomplished through prolonged heating of the cemented part at temperatures lower than those used for forming. Internal stresses and excessive solvents are eliminated that way. Annealing should be done *after the entire form is completed.*

The optimum annealing temperatures vary with each type of plastic because forming temperatures vary too. Generally, the annealing temperature should be 10°F. below the minimum temperature

at which the parts would begin to deform. The parts should also be dry and well supported during annealing and heat should be gradually reduced until the objects are cool.

Finishing

The finishing operation requires sanding, ashing, buffing, and polishing, but never too long in one spot, so as to prevent heating and distortion.

Sanding and *ashing* are necessary whenever there are scratches. Acrylic can be hand sanded with a wet, coarse *wet-or-dry paper 320 A* followed by 400 A or machine sanded with wet-or-dry (silicone carbide) 100 grit up to 240 grit on an orbital wheel sander. Edges can be sanded on a belt sander with 240 grit to 400 grit. Ashing is done on a buffing wheel with pumice and water.

Polishing is performed with a soft, loose buff 10″ to 12″ in diameter running 2000 to 2400 surface feet per minute or smaller forms at slower speeds—and without any additives such as wax. In hand polishing, wax can be rubbed on and then polished by hand.

Flame polishing is quick but requires practiced judgment. An oxy-hydrogen flame (Bernzamatic can deposit carbon but I use it) is best held 4–6″ from the acrylic edge and moving constantly at about 4″ per second. The speed should be slow enough to produce a polish in one operation without overheating and bubbling the edge. If there is bubbling, a second application of heat, after the edge cools, can restore the surface.

Molding Powders

Molding powders are supplied in colors and require heat and pressure. The minimum equipment for use of molding powders is an expensive Carver laboratory press. Edgar and Joyce Anderson solved this problem because they did not want to use colored sheet plastic but were trying to capture the "frozen fluidity" of plastic. (*Text continued on page 235.*)

Machining, Cementing and Finishing

The broad potential of acrylic sheet and blocks is amazing. All of the following illustrations use these very basic techniques.

These hands belong to sculptor Leo Amino, one of the earliest users of plastics in many different forms. Here is how he constructs his latest sculptures.

Score the outline of your shape, with a pointed instrument, onto the acrylic surface.

Cut these thin, small pieces on a jigsaw.

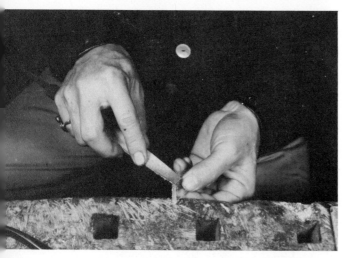

File the edges until they are clean.

On a board covered with aluminum foil, place your pieces and glue together with ethylene dichloride or another acrylic cement.

A completed bas-relief that has undulating areas and interest from both sides. Mr. Amino allows the negative spaces to function almost as importantly as his positive shapes. The spaces remind me of the vital pauses and rests one finds in music.

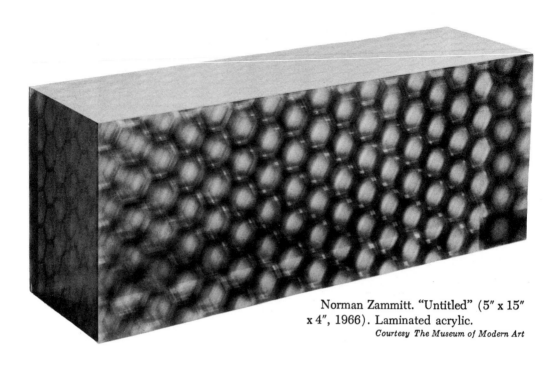

Norman Zammitt. "Untitled" (5" x 15"
x 4", 1966). Laminated acrylic.

Courtesy The Museum of Modern Art

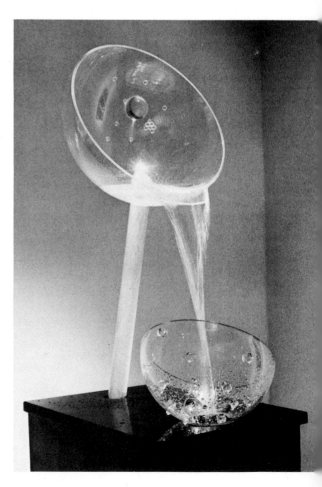

Gyula Kosice. "Divi All the Time"
(45" x 14" x 17"). Acrylic and water.

Courtesy Galeria Bonino

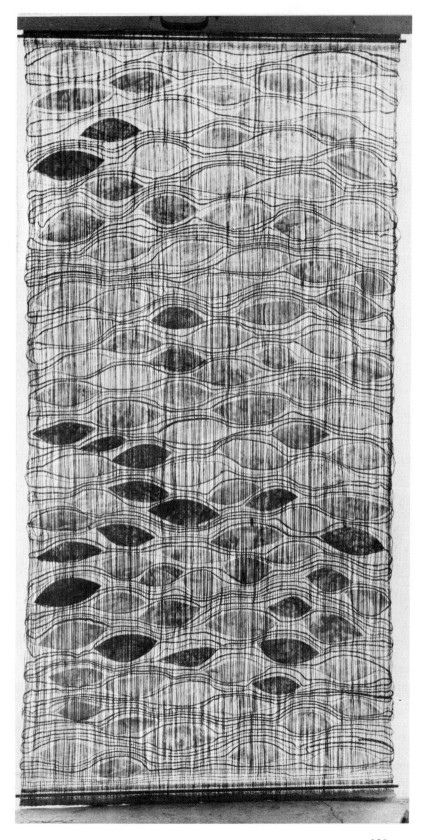

Ted Hallman cuts shapes from colored acrylic, cleans the edges, and weaves them into his wall hangings. *Courtesy Ted Hallman*

231

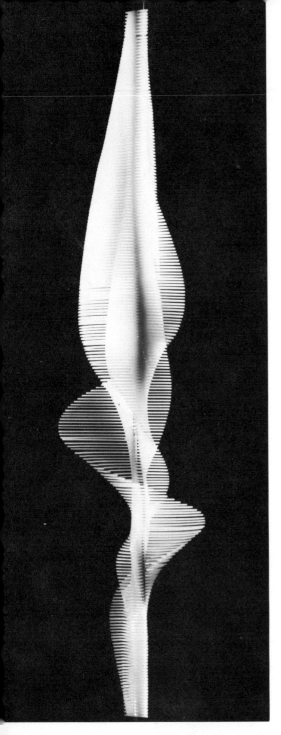

William Reiman in "White Study," using translucent Lucite, masses his individual forms by stringing them in undulating rhythms on a rod-axis. *Courtesy Galerie Chalette*

"The wonders of what light will do—on, in and through the faceted surface—the revelation of the normally hidden INNER sculptural forms, the play of complete transparency against shifting opacity and texture are some of the qualities which excite me and which I find to be unique to the medium of Plexiglas," said Fred Dreher, referring to "Ascension" (1960).

Photo by Chester Danett

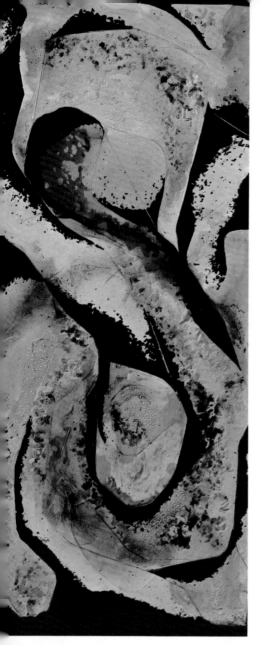

Thelma R. Newman. "Surrogate Mother." Acrylic and polyester resin.

Detail from "Surrogate Mother." Rich color and texture possible with polyester resin.

Thelma R. Newman. "Aerial Sea." Sand and polyester-fiberglass (4' x 8', 1961).

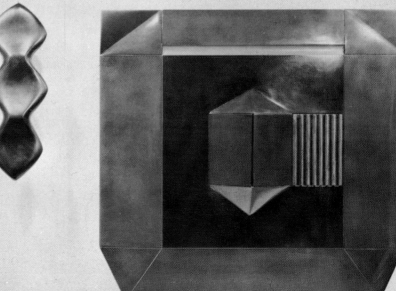

Michael Chilton. "Off Shore." Fiberglass and polyester resin, glazed with urethane.

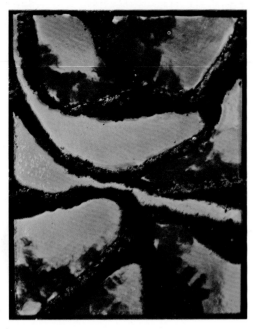

Thelma R. Newman.
"Labyrinth." Sand and poly-
ester (8″ x 10″, 1963).

Mowry Baden. "Irish Posi-
tion." Fiberglass and poly-
ester resin.

Bruce Beasley. "Untitled."
Cast Lucite.

Michael Sandle. "Crocus."
Fiberglass and polyester
resin.

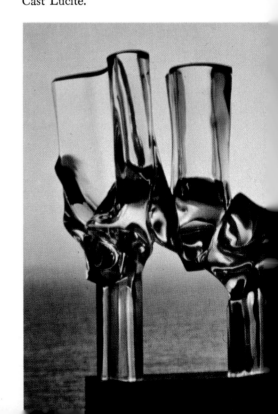

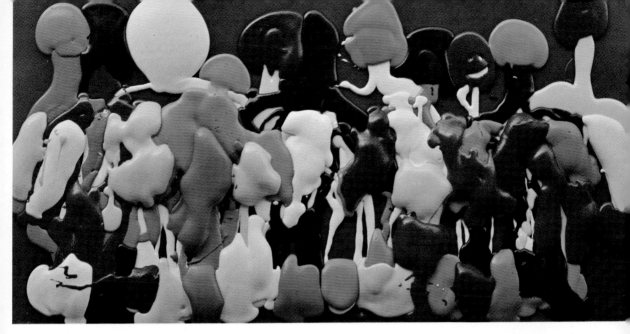

Joe Vitale. Polyurethane Panels. Plastic poured onto Masonite panels.

Courtesy Arthur Hoener

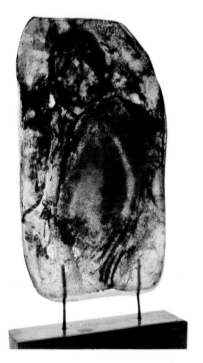

Thelma R. Newman. "Maternity." Acrylic (10″ high, 1″ deep, 6″ wide, 1963).

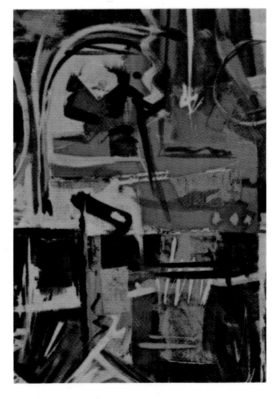

Arthur Hoener. Detail, "Seated Figure." A very heavy mixture of "Lucite" 45 was used and applied with a palette knife to obtain the color density.

Courtesy Arthur Hoener

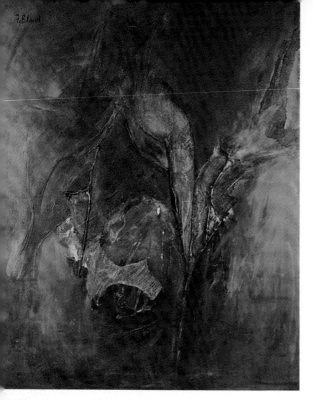

Harriet FeBland, "Nights, Pleasures and Days." Acrylic on canvas (40" x 50", 1961).
Courtesy Harriet FeBland

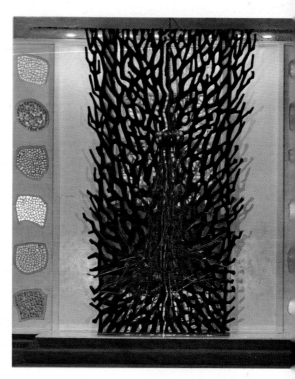

Jeffrey Low. Ark Doors for Temple Israel, Binghamton, N.Y. (16' high, 1968). The stained glass behind the Ark doors were set in epoxy. The doors themselves, meant to symbolize the Burning Bush, were at first sculptured of urethane foam and then a texture of epoxy mixed with sand was applied over the urethane foam. The work was then cast into aluminum. The entire form was then painted.

Thelma R. Newman. "Fire Wall." Polyester Tessarae, (39" x 40", 1963).

Close-up of a section of the Ark door.

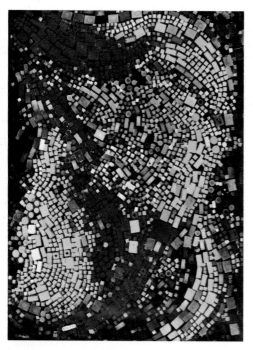

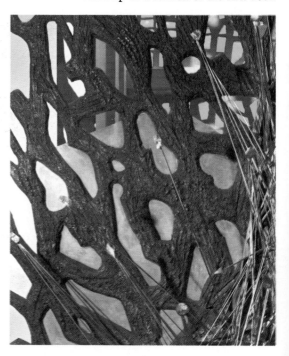

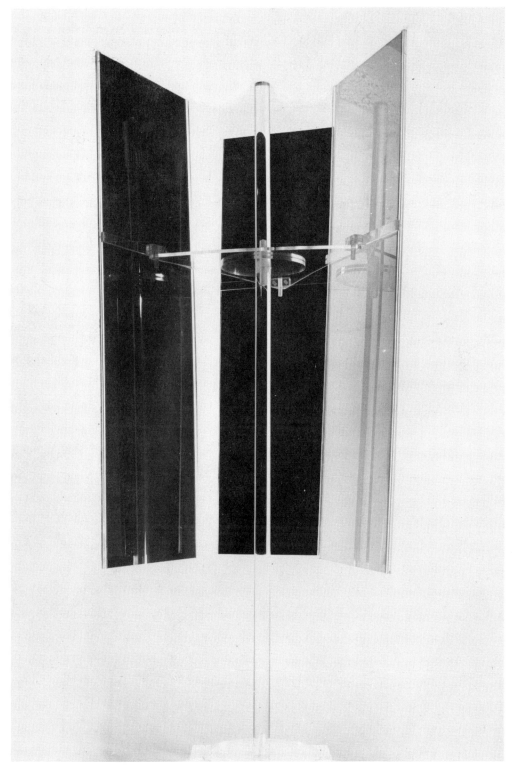

Nassos Daphnis in "2-J15-63" uses acrylic for its structural strength, as a support, and for its linear and light-modifying solidity.

Courtesy Leo Castelli Gallery

Molding Powders

Artists Edgar and Joyce Anderson could, by varying heat, pressure, and color, make a "bubbly pancake" . . . *Photograph by the author*

. . . or a textured, hard, shiny mass.
Photograph by the author

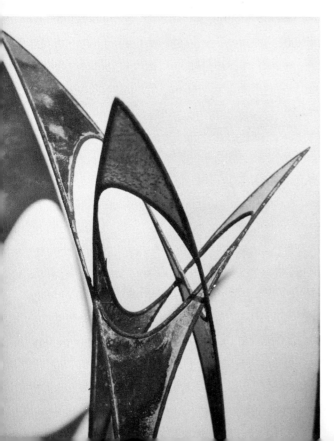

After forming the acrylic sheet, they shaped their creation under a 600-watt spot heater, machined and cemented their forms. Detail of a sculpture by Joyce and Edgar Anderson.

Photograph by the author

(Text continued from page 227.)

They purchased an old hydraulic truck jack, a secondhand electric stove, some tractor parts, and welded up a 9″ x 12″ electric press with removable, polished stainless steel platens. On the lower platen, sprayed with silicone mold release, they placed their molding powders in colors and patterns and put this platen into the heated press where the plastics flowed due to heat and pressure from the jack. Then they clamped the platens and placed them in cold water. By varying heat, pressure, and color they could make a "bubbly pancake" ³⁄₃₂″ thick, 8″ x 10″ from a ¼″ layer of molding powder. The powders were heated to 255°F. and left in the press for 5–10 minutes until the temperature reached 300°F. Pressure was increased as the plastic started to melt (they used safety glasses to look between the platens) until the pressure was about the full capacity of an eight-ton jack. Then they clamped baby "C" clamps on the back of the platens and with pliers, pulling from the front (wearing gloves), they removed the platens and dropped them with plastic and all into water. When they heard a crackle indicating that the plastic was cooling and shrinking away from the platens, they removed a beautiful, hard, shiny plastic, a bubbly form, or a gooey broken mass, depending upon the variables. After that they shaped their creation under a 600-watt spot heater, machined and cemented their forms until they achieved the desired expression.

Coloring Molding Powders

There is one difficulty, after all others are overcome—colored acrylic molding powders are supplied only in 50-pound drums *per color*. But there is another solution, not quite as satisfactory, and that is to mix your own color into acrylic molding powder purchased from a jobber. (For this process see the description on *dry-coloring*, Chapter III.) For dry-dyeing put ½ pound of clear molding powder in a quart jar with 30 to 200 grams of dye. Tumble well, preferably in a ceramist's ball mill. When put in the press, the dyed plastic should fuse and flow well—almost as well as the commercial product.

Molding and Casting with Methyl Methacrylate Monomer or Monomer-Polymer Mixture

Methyl Methacrylate Monomer

One of the most difficult techniques (Freda Koblick is the only artist I know who used it) is casting with methyl methacrylate monomer. The temperature is so tenuous and monomer-catalyst mixtures so critical that it is more than possible to get what is called a "runaway." "Runaway" is an excessive bubbling of the acrylic mixture caused by violently

Examples of "runaway" showing some colored solid areas as well as bubbly foam-like parts.

generated exotherm with a result that looks like an uneven foam—but where the intention is to get a clear product (see illustration); this is a frequent occurrence even in factories using acrylic monomer every day.

It is possible to buy an uninhibited acrylic syrup (acrylic monomer), add a small amount of 0.02% benzoyl peroxide catalyst, and then heat the syrup with a

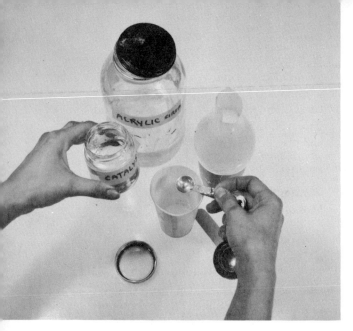

Add a small amount, less than 0.2%, benzoyl peroxide catalyst to acrylic monomer.

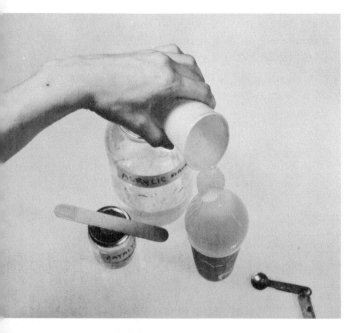

Stir and pour the mixture into a mold form—in this case a light bulb without metal parts.

Cure very carefully in a water bath that maintains a constant temperature and does not go beyond 120°F.

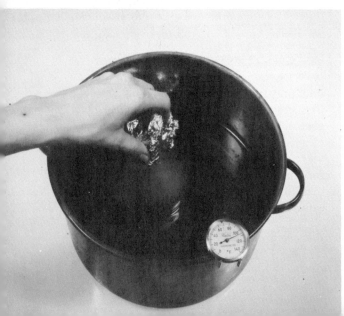

Mix a slurry of 40% acrylic monomer with 60% acrylic polymer. Add the polymer to the monomer in a fine stream. Stir vigorously and continue agitation until the mix shows no tendency to settle.

When the mixture is completely dispersed, empty it into a mold form (no separator is necessary). At this point you need controlled pressure and heat.

careful control in a hot water bath so that the acrylic maintains a constant temperature; or eliminate the catalyst and polymerize the methyl methacrylate with heat. The curing process is a long one and needs constant babying. Except for a little better clarity, the same effect can be obtained more easily and successfully with polyester resin.

Methyl Methacrylate Monomer-Polymer Molding

It is also possible, with some innovation, to cast with methyl methacrylate monomer-polymer mixtures. This process also has its difficulties.* The result is a crystal-clear hard plastic that can be designed to reveal all kinds of optical effects with prisms and internal refractions of light. The results can be stunning—or horrible. We have seen many decorative products on the market, illustrating both categories—as desk sets, paperweights, and "television" lights.

Formula

Acrylic resin powder (methyl methacrylate polymer) has a specific gravity of 1.18. Acrylic resin monomer has a specific gravity of .95 with a 23% shrinkage. A "slurry" of 40% acrylic monomer and 60% acrylic polymer reduces shrinkage to 7%. This mixture with its residual catalyst content in the polymer reduces the exotherm found otherwise in using a straight monomer and also minimizes shrinkage. When embedments are used, shrinkage can be critical. A suggested combination of pure acrylic is duPont's 4FC bead acrylic polymer (a powder) and Rohm & Haas' MMA monomer (liquid)—without any diluents—diluents tend to contaminate the mixture. These are mixed together until gelatinous.

Preparation of Monomer-Polymer Doughs

The polymer is slowly added to the monomer in a fine stream. The monomer is stirred vigorously during addition of the polymer, to avoid formation of lumps. Agitation is continued until the mix shows no tendency to settle. Agitation may have to continue for as long as 60 minutes, or just before the mixture becomes a gummy, non-pourable mass. When the mixture reaches the point where it shows no tendency to settle, it is covered and allowed to stand, at room temperature, until it reaches a semirigid, doughy consistency.

The dough mixture is poured to the desired depth, or if there are to be embedments, a layer of this gel is poured and the completely dried out (at 110°F.) clean object is placed on the gel and then covered with the rest of the acrylic mixture. Another possibility is to suspend objects in the gel mixture—they remain in place because of the high viscosity of the gel. Still another variation is to paint color on Kodapack film and suspend it in the acrylic gel. Kodapack disappears completely—into an invisible suspension.

This mixture can be made into a miniature size or into massive, very thick (several feet thick) forms. The pot-life, before the resin becomes too gelatinous to handle, is about 10 minutes.

Molds

All mold forms have to be designed to allow for shrinkage, otherwise bubbles form. Almost anything may be used—the rounded part of an electric light bulb, aluminum channeling or tubing, a corrugated cardboard box, lay-flat nylon tubing for casting rods—but they have to be clean. Any contamination will produce specks of dirt in the finished casting. No separating agent is necessary. Mixing implements made of glass can be washed clean with cold water; the acrylic peels right off.

Molding and Curing

When the gel gets reasonably hard, but is still rubbery, it is ready for curing—

* The information revealed to you here came in part through the openness of Mr. Roy Slipp of the Clearfloat Company, manufacturers of cast acrylic objects, windows, and air-sea-space components.

and this is where there is difficulty, for the acrylic monomer-polymer combination requires heat *and* pressure for curing. Actually, the commercial curing vehicle looks like a giant autoclave—the type seen in the dentist's office. In this chamber heat can be carefully regulated and charted while at a given pressure. The heat cannot go above 135°F. for this acrylic. The curing begins at 110°F. and is built up to 130°F. for as long as 10 to 12 hours; at one point the temperature may be brought up to 135°F. or 140°F. for a short time to yield a glossy finish.

Since a giant autoclave costs many thousands of dollars, how can curing be accomplished in a simple workshop? Actually, any vehicle that would have a temperature-pressure control would work—perhaps a pressure cooker. Perhaps your inventiveness will discover another way.

Small moldings can be cured in a small handpress. The mold can be heated by simply immersing it in hot water. You have to determine the amount of positive hand pressure by the composition of the dough thickness of the piece, curing temperature, and whether or not there are bubbles in the mix.

It is possible to make thin sections of 3/8″ and less in hand molds, with spring clamp pressure. In this case, the curing cycle would take one hour at about 160°F., followed by another hour at 212°F. The cycle can be reduced by adding 0.02% benzoyl peroxide to the monomer before the mix is made.

Bruce Beasley is one artist who worked out the mammoth problems in setting up an autoclave to fashion large solid castings. He can handle a piece fifteen feet wide by eight feet tall with a weight of approximately ten thousand pounds. See illustrations.

Coatings and Adhesives

It is possible to coat acrylic with the painting-adhesive vehicle Rhoplex AC-33 or polymers of esters of acrylic and meth-acrylic acids such as the Acryloid resins (Rohm & Haas). They produce excellent outdoor durability, are water-white and chemically inert. They can be air-dried. The Acryloids vary in flexibility and are soluble in many organic solvents such as toluol and xylol.

Acryloid B7 is slow drying, B-72 has excellent compatibility with pigment, and is faster evaporating. There are at least a dozen different types of Acryloids, each meeting a different need.

Acryloid finishes can be sprayed, roller coated, dipped, or brushed. When used as adhesives, the Acryloids should be coated on both surfaces. Allow the solvent to evaporate until the film feels tacky. The two surfaces are joined and held together with slight pressure.

Acrylic Modified Polyester Resin

Most polyesters are styrene modified. Since styrene is not so light-stable as acrylic nor does it have so good weatherability, acrylic modified polyesters can increase the weatherability and light-stability of polyester resin. In curing acrylic modified polyester (without a promotor), a step-wise cure is necessary along with some heat. To initiate the reaction, 1 cc. of cumene hydroperoxide is added to 1 part of the acrylic polyester and after mixing is followed by 5 grams of BPO paste (benzoyl peroxide). Infrared heat is applied until gelation, when heat is removed and the BPO completes the polymerization. The result is a hard, water-white, crystal material.

Liquid Crystals

Liquid crystals are organic compounds, physically liquid (or in paste form) which exhibit optical properties similar to those of crystalline solids. In particular, they are highly sensitive to temperature changes as the temperature varies. Minute changes in temperature will shift the color from one to another brilliant hue. Sensing temperatures range from 86°F. to 140°F. The kind of

Bruce Beasley finishing his cast acrylic sculpture.

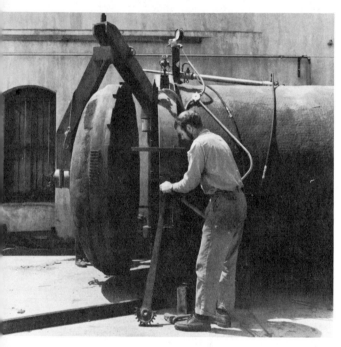

A view of Bruce Beasley's innovative "autoclave."

Another view of Bruce Beasley's autoclave.

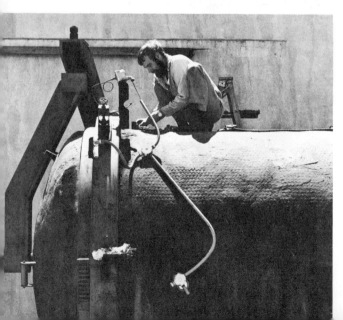

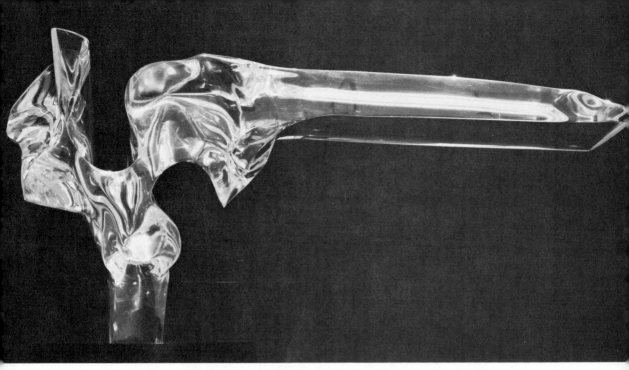

Bruce Beasley. "Polomon" (24" x 14", 1967). Cast Lucite.

liquid crystal used in the photograph has the texture of vaseline and can be applied with stick or spatula. Colors appear immediately when the temperature changes, and repeat themselves at the same temperatures. Thin sheets of acrylic should be used with a transparent top piece and a very dark background, as an under piece. Variations for changing the colors and for texturing are tremendous. The life of these crystals have not been determined because of the great range of variables in environment. They are precious materials, very expensive.

Applying jelly-like liquid crystals to a **very** thin (1/16 inch) acrylic sheet. Results are remarkable changes in color as applied heat changes in degree.

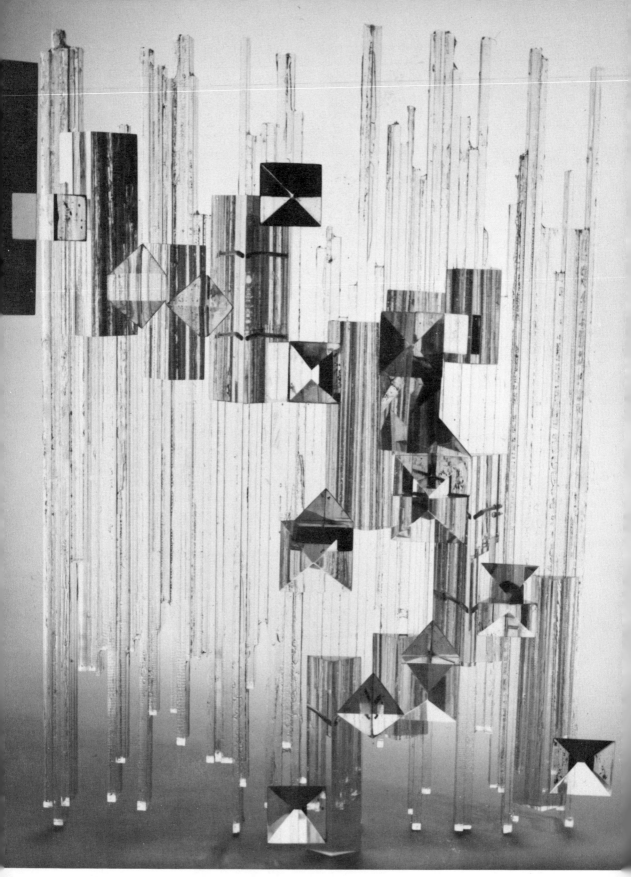

"Model for a Wall Panel" by Freda Koblick is 24″ x 18″ x 8″, of cast, carved, and cemented acrylic.

Courtesy Museum of Contemporary Crafts, New York

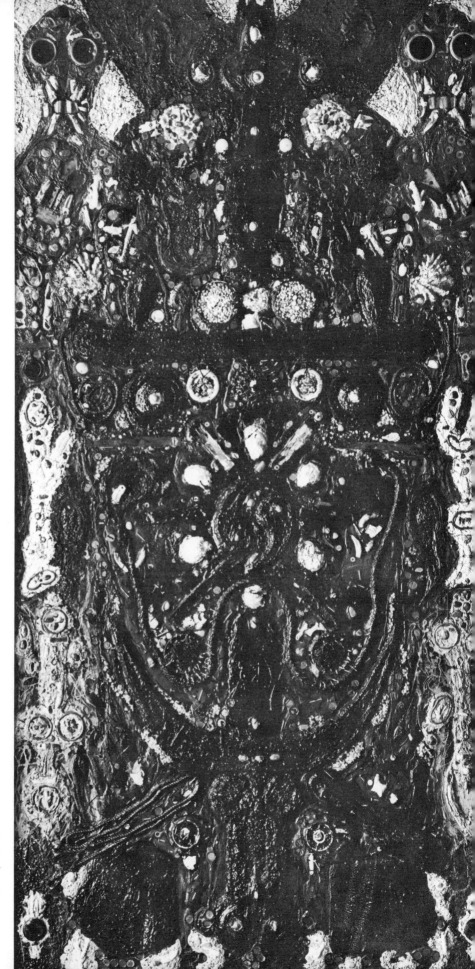

Alfonso Ossorio. "Sum 2"
(95″ x 48″, 1959). Use of
acrylic or vinyl medium to
adhere miscellaneous mater-
ials on composition board.
Courtesy The Museum of Modern Art

Working with Vinyls

Vinyls comprise a wide and versatile family of plastics. Their uses vary in the art studio: as mold release agents—polyvinyl alcohol; as paint binders and coatings—polyvinyl chloride, polyvinyl chloride-acetate; as adhesives—polyvinyl acetate (PVA); as impregnating material for wood; as skins for "cocoon" sculpture; and as flexible mold materials—PVA compounds; as filament-components for paintings—polyvinylidene chloride. And there are uses as yet untapped. The future should find many more applications of vinyls as art forms.

Vinyls are usually transparent, although they can be made opaque and can accept a wide variety of color. Some vinyls may be rubbery, others rigid. These materials usually have excellent water and chemical resistance as well.

Giving property data on each of the extensive list of vinyl polymers and copolymers probably would fill another book; therefore, only a property summary (average) of the more applicable vinyls will be given here.

Polyvinyl Chloride

Resistant to concentrated acids, alkalis and alcohols.
Nontoxic, odorless, tasteless.
Specific gravity—1.40.
Refractive index—1.53.
Self-extinguishing.

Polyvinyl Acetate

Soluble in organic acetones, esters, chlorinated hydrocarbons, aromatic hydrocarbons, and alcohols.
Insoluble in water, aliphatic hydrocarbons, fats, and waxes.
Nontoxic, odorless, tasteless.
Specific gravity—1.40 (approx.).
Refractive index—1.53 (approx.).

Polyvinyl Chloride-Acetate (copolymers)
 Chemically inert—unaffected by alkalis, oxidizing agents, and most inorganic acids.
 Excellent resistance to water.
 Specific gravity—1.35–1.45.
 Refractive index—1.52–1.53.
 Self-extinguishing.
 Heat resistance—130–142°F.
 Darkens after prolonged, intense exposure to sunlight.
 Machinability good.
 Transparent to opaque.
 Dissolves in ketones and esters.

VINYL AS A PAINTING VEHICLE

Polyvinyl acetate (known as Vinavil in Europe) and polyvinyl chloride-acetate make excellent paint binders. Like many competitive products, the quality varies from brand to brand and it was suggested by Dr. Robert Feller of the Mellon Institute to perform these simple tests:

1. Coat the support with your vinyl material; e.g., PVA.
2. Let it harden.
3. Scratch it to see if the film forms a tough surface.
4. Flex it to determine if the material is brittle.
5. Coat a piece of aluminum foil.
6. If the film, e.g., PVA, is a good brand, you can almost crease the coated foil without finding any cracks.

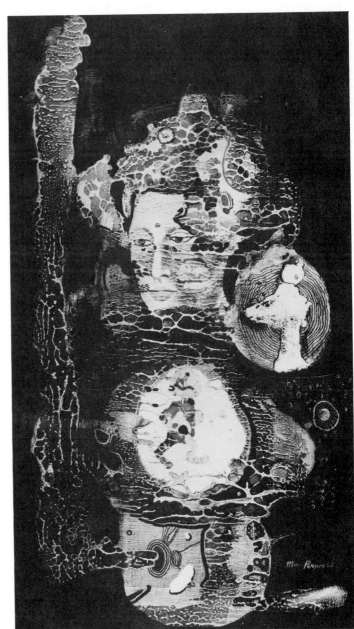

Vinyl as a Painting Vehicle

M. Persico, "Ritratto" (80 cm. x 50 cm., 1960). Painting of "Vinavil"—polyvinyl acetate.

Courtesy Galleria Schwartz, Milan, Italy

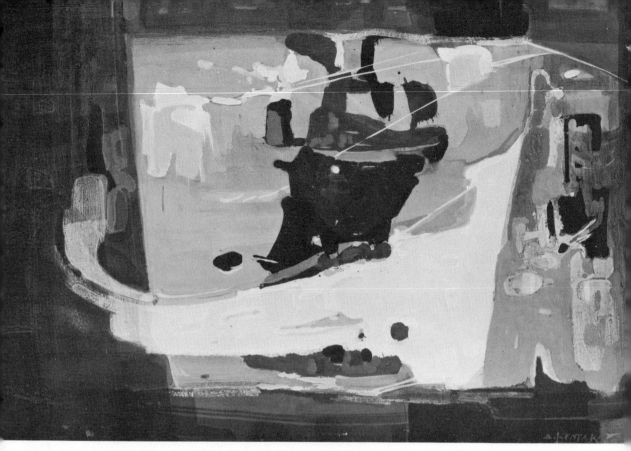

The same range of surface quality from glossy to matte is possible with PVA as with acrylic. PVA handles much the same way as acrylic emulsion. D. Kentakas, "Composition." Polyvinyl acetate.

7. Note whether the milky coating that is first applied becomes clear at curing.
8. Look for emulsions of the highest molecular weight.

Polyvinyl Acetate

Polyvinyl acetate painting vehicles have many of the same application qualities as acrylic emulsions (Rhoplex AC-33). They handle much the same way and have about the same range of surface quality from glossy to matte as acrylic emulsion. It is, however, easier to build up an impasto effect or to texture with polyvinyl acetate. The only difficulty in working with PVA is that the emulsion does not wet pigments properly and therefore needs more elaborate grinding to dissolve all the lumps of pigment. Using Tamol 731 (Rohm & Haas) facilitates the dispersion of pigment into binder.

The Bakelite Company manufactures a vinyl acetate "tempera" which is a vinyl acetate resin latex—WC-130. It is a water dispersion based on the "A" series of vinyl acetate polymer and small amounts of monomeric vinyl acetate. These films are brittle and hard (require a rigid ground for painting), have good resistance to scratching, and are very water resistant. A slight whitish opacity gives the medium good covering power. The suggested ratio of pigment to medium is 2 parts medium to 1 part pigment. This produces a matte film.

Unlike PVA emulsion, WC-130 has good pigment wetting power resulting in a thick and creamy consistency.

It is best to study the pigment-binder relationship—if the pigment sinks and the binder rises to the surface, then the pigment quantity should be increased. The mixing of pigment and vehicle is similar to mixing concrete. There is a balance,

246

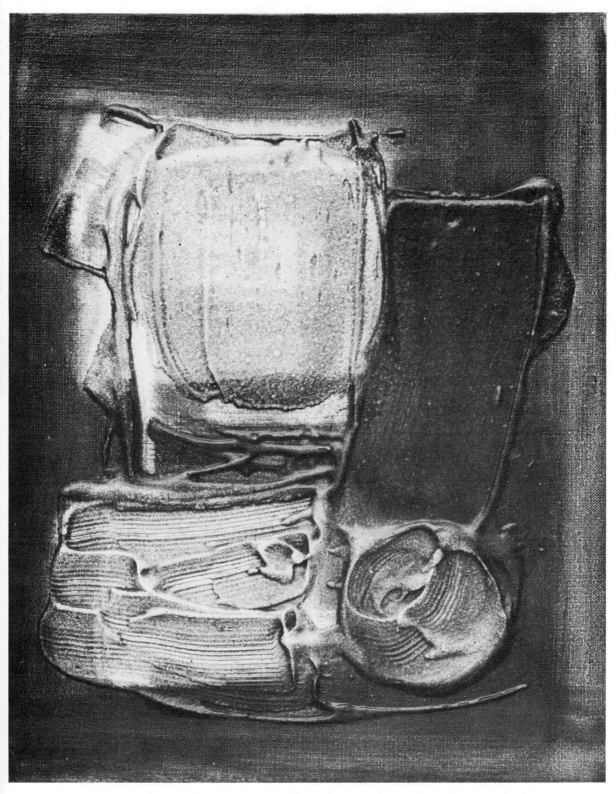

Impasto effects and textures are easily built up with a polyvinyl acetate binder.
T. Matlezos in this composition used fine sand as a filler.

Courtesy New Forms Gallery, Athens, Greece

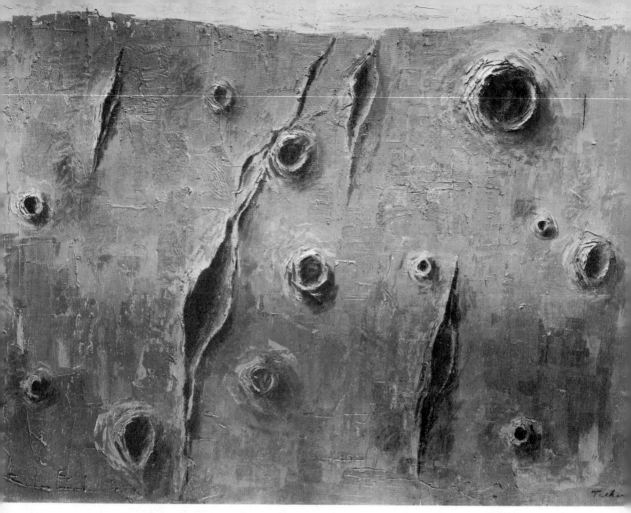

Albert Tucker used polyvinyl acetate emulsion worked into a thick impasto on hardboard for "Lunar Landscape." (37¾" x 51¼", 1957.) *Courtesy Collection, The Museum of Modern Art, New York*

a critical pigment volume concentration. An excess amount is extraneous; too little is no good. Porosity and glossiness are affected.

Polymer Tempera is a trade name for an emulsion combining polyvinyl acetate and water with a small amount of sodium lauryl sulphate or ammonium oleate.

Colors can be premixed and stored in glass jars to prevent discoloration or drying out. The medium can be thinned with almost 50% water. The more concentrated the medium the shinier the surface; more water produces a matte texture. If a high gloss is desired a few coats of undiluted polyvinyl acetate will accomplish this. Karl Zerbe mixes his medium with powdered clay, an inert filler, to form a thick buttery paste. The thickness of the me-

dium, therefore, can be modulated by the addition of water for thinness or a filler for impasto effects.

If a more transparent surface is desired, each successive layer and the final coat should be painted with a wash of alcohol. This causes a chemical reaction that permanently fixes the surface without dulling it.

The low acid content of PVA makes it an excellent adhesive-preservative. When combined with the best papers the result will be a long-lasting collage. Italian artists use Vinavil (Montecatini) as a binder, paint vehicle, and for thick impasto effects when combined with fillers.

Transparent paintings can be made with PVA on a roughened, clean piece of glass, or on a clean acrylic sheet

248

Lucio Del Pezzo in "La Fine Del Tempo" used PVA as an adhesive, gluing forms to his ground, and then with more PVA he painted the collage-painting.

Courtesy Galleria Schwartz, Milan, Italy

249

Irwin Rubin in "Construction #21" used PVA for the same purposes as del Pezzo, but with entirely different results. (24½″ x 24¾″, 1961.) *Courtesy Bertha Shaefer Gallery, New York*

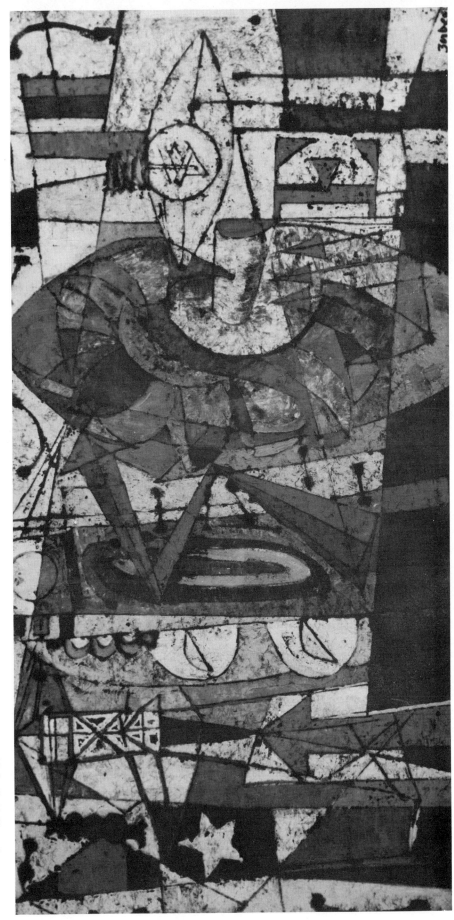

Karl Zerbe, using
polymer tempera (PVA)
mixed his medium with
powdered clay, an inert
filler, to form a thick
buttery paste.

Courtesy Karl Zerbe

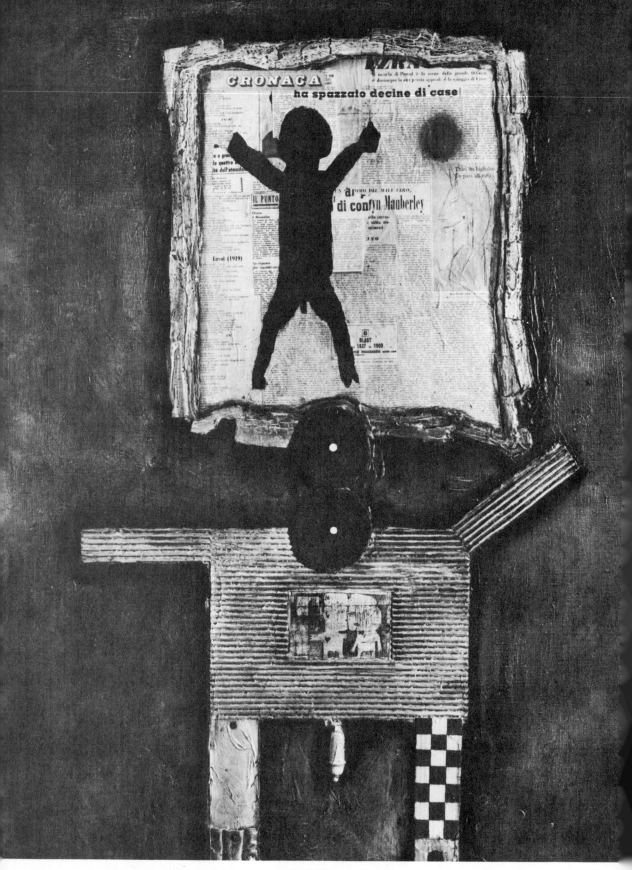

Polyvinyl acetate is an excellent adhesive. This is the function it performs in the following three paintings. M. Persico's "Cronaca: Il Poeta Nel Cervello." (90 cm. x 120 cm., 1961.)

Courtesy Galleria Schwartz, Milan, Italy

Robert Crippa, "Il Raguo de Icoro" Collage. (163 cm. x 136½ cm., 1962.)

Courtesy Galleria Schwartz, Milan, Italy

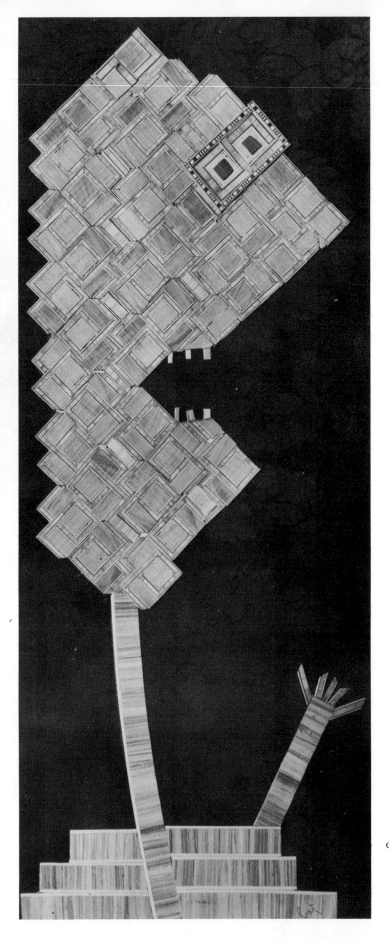

E. Baj, "Testa" Collage. (24
cm. x 58 cm., 1962.)
Courtesy Galleria Schwartz, Milan, Italy

(acrylics and PVAs have the same contraction and expansion ratios), or on a PVA sheet.

Polyvinyl Chloride-Acetate

Another vinyl material that has excellent weatherability is polyvinyl chloride-acetate. It can be applied to rough, porous surfaces, such as terra cotta, cement, process stone, and brick. There is an example of an exterior mural painted on a wall with a southern exposure, receiving an average of 7 hours of Mexican sunlight daily, that has successfully retained its original properties for eight years, with the exception of the darkening of chrome green. Polyvinyl chloride-acetate has a very low tendency to cross-link in sunlight; that is why it ages so well.

Another Bakelite (Union Carbide) product called "Vinylite" is a polyvinyl chloride-acetate that can be diluted with its solvent—methyl isobutyl ketone. The material looks like granulated sugar before the solvent is added. One hundred grams of polyvinyl chloride-acetate should be dissolved in 250–500 cc. of methyl isobutyl ketone. With constant and vigorous stirring it becomes a good brushing solution. More or less solvent will make a thicker or thinner water-white liquid.

Polyvinyl Chloride

Polyvinyl chloride is not a good painting vehicle unless it is stabilized with accurate concentrations of stabilizer. Otherwise it breaks down rather quickly and discolors badly.

Albert Jacquez has worked out the following formula:

Trade Name and Manufacturer	Formula %	Material
Geon 121 B. F. Goodrich Chem.	100	Polyvinyl chloride resin
G.P. 261 B. F. Goodrich Chem.	32.50	Plasticizer
G.P. 233 B. F. Goodrich Chem.	32.50	Plasticizer

Trade Name and Manufacturer	Formula %	Material
Monoplex S-70 Rohm & Haas Co.	5	Plasticizer
Advastab B.C. 105 Advance Solvent & Chemical Co.	2	Stabilizer
Barytes 12-V-6 Harshaw Chemical Co.	15	Stabilizer

With this formula, it is possible to paint in the traditional manner or use it as a silk screen pigment, to build up relief by applying layer to layer, or to squeeze the plastic from a tube. Any kind of ground can be used, from cloth to metal. Mr. Jacquez suggests applying a primer XA2-131 Plastisol Primer (Compo Chemical Co., Inc.) and then baking it at 400°F. for 5–10 minutes. He also fuses each layer in the oven or with heat lamps at 350°F. from 2–5 minutes, depending upon the thickness of the paint film. Should it be necessary to thin the material, tetrahydrofuran is a solvent.

For additional material on vinyl painting see the section in Chapter 8 entitled "Painting with Acrylic, Acrylic-Vinyl Copolymers and Vinyl."

WOOD IMPREGNATION WITH VINYL

Wood impregnation with vinyl forms a harder, more waterproof material. Wood is placed in a vacuum chamber; air is pumped from the pores. Liquid vinyl is added and the wood is soaked for fifteen to twenty minutes. After soaking, the wood is wrapped in aluminum foil and then cured in a 154°F. oven for twelve to eighteen hours. Then it is ready to be worked as any wood—machined with ordinary woodworking tools (shavings look like metal), sanded with sandpaper, smoothed with steel wool and can be buffed to a high luster. It can be nailed, glued and never needs refinishing.

VINYL SCULPTURE VEHICLES

Any of the painting vehicles discussed in the preceding section can be used as

(Text continued on page 270.)

PVA can be painted on a clean piece of glass with excellent long-range holding power. I. Rice Pereira used it in 1949 in "Inverted Light."

Courtesy Smith College Museum of Art, Northampton, Massachusetts

Sue Fuller's "String Compositions" were drawn with taut, nonsagging lines of Saran threads from the framing edges of her paintings. These polyvinylidene chloride threads do not sag and tighten with changes in weather and humidity. The range of color and thickness can be varied with a wide supply of extruded Saran threads.

Courtesy Bertha Schaefer Gallery, New York

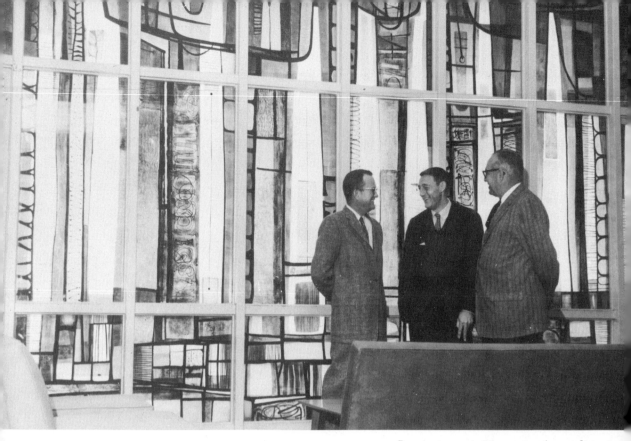

Laminators at Monsanto (specialists in this auto-safety glass process) covered the pigmented side of glass with three sheets of vinyl butyral—two clear and one translucent. All of this was then covered with another sheet of plain, clear glass and the whole sandwich was fused under heat and pressure into a solid sheet. The completed mural is part of the Memorial Union Building at the University of New Hampshire.

Courtesy Monsanto Chemical Division

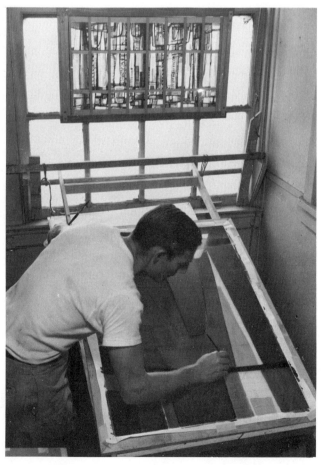

John Hatch, with technical assistance from the Monsanto people at Springfield, Mass., painted his designs directly on glass using organic light-stable, intense and translucent colors that could also withstand very high heat. *Courtesy Monsanto Chemical Division*

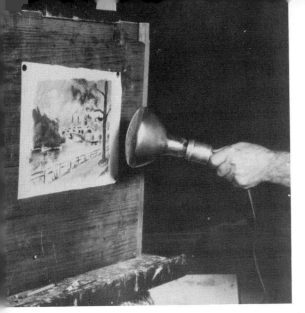

Left: Albert F. Jacquez either presses an electric iron over the canvas backing of his vinyl painting, or he uses a heating lamp by holding the infrared lamp in front of the painting and moving it back and forth to heat the whole picture surface. This kind of fusing takes longer than the oven method.

Right: Mr. Jacquez uses a broiler oven of a kitchen stove, placing his painting on a sheet of asbestos in a preheated 350°F. oven. Fusing takes only two to five minutes. Then it is removed and allowed to cool. A trick he uses to check for complete fusion is to fold the canvas. If the paint does not crack, then fusion is complete.

Courtesy Albert F. Jacquez

This painting, with at least seven layers, each layer fused separately to the underlayer, was painted by Albert Jacquez using his vinyl formula. "Ceremony: Chasing the Bad Spirit." (28" x 44".)

Courtesy Albert F. Jacquez

Roy Lichtenstein.
"Moonscape" (22" x 28",
1965). Serigraph on moire
patterned vinyl.
*Courtesy The Museum of
Modern Art*

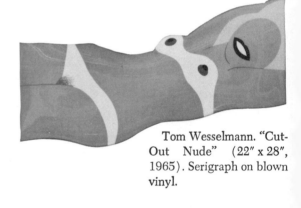

Tom Wesselmann. "Cut-
Out Nude" (22" x 28",
1965). Serigraph on blown
vinyl.

Robert Israel and vinyl sculpture. Made of six mg.
vinyl that had been heat sealed, creating a balloon
100 feet long and 108 inches in circumference. A
release mechanism at each end allows air to escape
when pressure inside is too great, and another valve
is attached to a small pump which continually forces
air into the tube. The size remains constant.

This is a five-color serigraph by Earl B. Winslow using the polyvinyl chloride formula. The screen print was done in the traditional manner, except that each color was fused before the next color was printed over it. The vinyl medium does not clog the silk screen, and fabrics can be used as a ground.

Courtesy Albert F. Jacquez

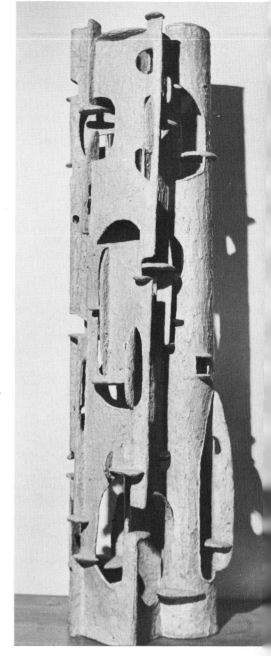

Leo Amino used polyvinyl chloride over a cardboard matrix for his "Construction" (1955). *Photograph by the author*

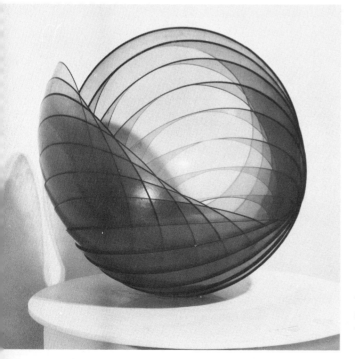

Deborah de Moulpied used vinyl discs, blow-molded into spherical saucers and adhered together for her "Form" (1961). *Courtesy Galerie Chalette*

Room Temperature Cured Vinyl Mold Making
Type I

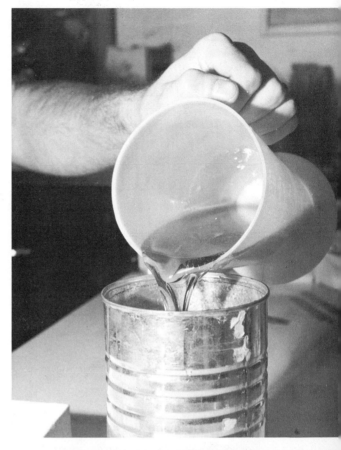

Measure and mix together two parts Adrub RTV 7122-2 (Adhesive Products Corp., 1660 Boone Ave., Bronx, N.Y. 10460) with one part hardener.

Stir thoroughly without introducing air into the mixture.

263

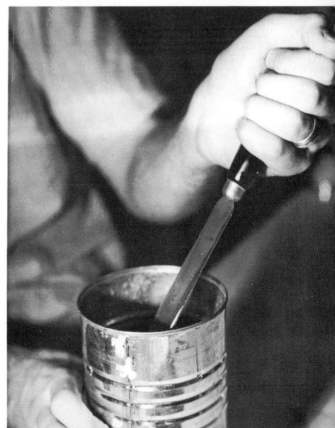

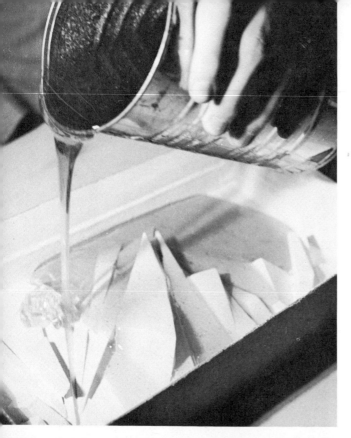

Before pouring the mold mixture over the bas relief that has been boxed to hold the mold material, coat with a separating agent such as soap, wax or polyvinyl chloride. The bas relief may have undercuts because this mold material is flexible and can be pulled away from undercut areas.

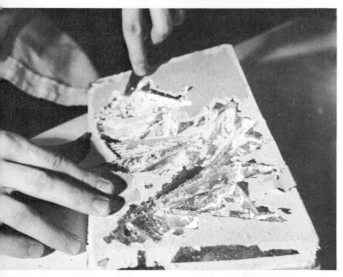

In twenty-four hours, remove mold from positive. Manufacturer's instructions do not recommend coating the sculpture, and this illustrates what happens. The original sculpture had to be pried out of the mold. Barring poor instructions, this is an excellent mold material. It does not require a plaster supporting jacket because it has enough body to support the casting material.

This is an example of a mold that had been poured over a bas relief previously coated with a mold release.

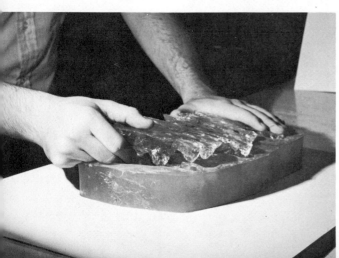

Room Temperature Cured Vinyl Mold Making

Type II

This is another room temperature vulcanized vinyl. Because the final mold is a thinner material and stretches more easily, this mold substance, Kwikset (Adrub RTV, Adhesive Products Corp.), is excellent for forms with extreme undercuts.

Carefully measure two parts Kwikset vinyl.

Measure one part hardener.

Mix together thoroughly.

Box form so that it sits in a container.

Coat form with a mold release such as soap, wax or polyvinyl chloride. Brush the liquid "rubber" over your sculpture and into all the crevices. Allow this layer to harden for about two hours, then mix another batch and coat the previous layer. Continue this process either by brushing or by pouring, until the mold reaches the desired thickness.

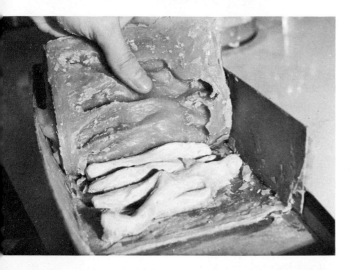

After curing for twenty-four hours, pull mold away from positive. If it has thin spots, mix another batch and patch the weak areas.

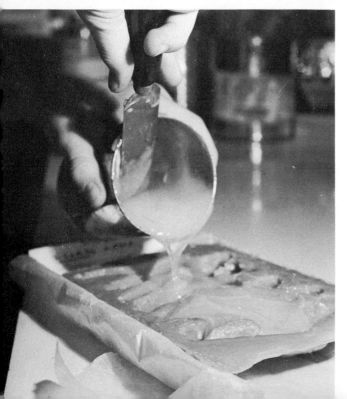

This was a very small bas relief and did not require a supporting plaster jacket because it could be propped without distortion. A thixotropic epoxy (Thermoset 115, Thermoset Plastics, Inc., Indianapolis, Indiana) was used for a casting material.

266

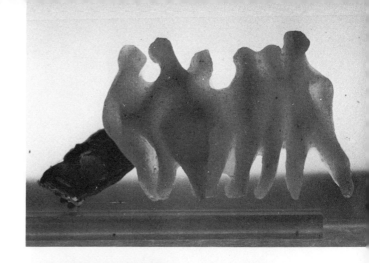

Thelma R. Newman. "Onlookers."

This is a larger Kwikset mold that required the separate casting of a plaster "jacket" to support the mold, which has an irregular bottom. Make certain that there are no undercuts in the underpart of the rubber mold; otherwise, when the liquid casting material hardens, it would lock your mold into the rigid plaster.

Important: Unless you want a rough, dull surface, remove the form from the mold while the polyester is in a gel-state, before it fully cures. (This is not necessary for epoxies.) Because of the shrinking action of polyester and the fact that styrene seeps from it, attacking the vinyl mold, the polyester will come out of the mold with "styrene seep," a rough surface.

The pewter-toned polyester (Adhesive Products Corp.) easily released from its mold and supporting plaster jacket.

Thelma R. Newman. "The Crowd."

Vinyl Mold Making

Place the positive form into a container that will hold the liquid mold material. In this case, a cut-down tin can was used.

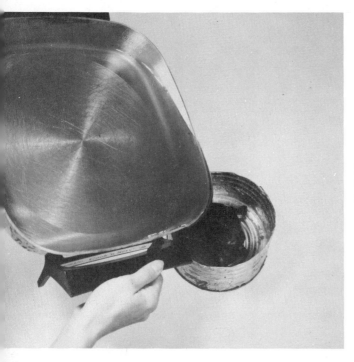

Pour the melted plasticized polyvinyl plastisol "hot melt" over the sculpture and into the container using one quick movement from one side to the other.

After the vinyl hot-melt cools, cut the object loose.

Gently release it from the vinyl. Then pour polyester resin into the mold cavity. Allow it to harden and release the polyester resin form.

The frog emerges, exactly duplicating the details of the original ceramic object.

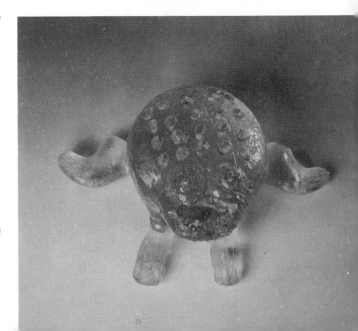

269

a sculpture material. For example: (1) polyvinyl acetate can impregnate paper into a mask or strips like papier-mâché and be built into a permanent sculpture that way; (2) polyvinyl chloride can be used to cover a cardboard or metal structure, such as Leo Amino's creation of polyvinyl chloride over cardboard; (3) polyvinyl chloride-acetate sheeting can be heat-formed in the same manner as acrylic sheet.

VINYL MOLDS

Polyvinyl acetate can be formulated with plasticizers into a flexible hot melt molding compound with a melting point of from 350°F. to 450°F., depending upon the additives. Some of these already formulated vinyl hot melts are supplied in a milky liquid which has to be fused and then remelted, or in shredded bulk form for remelting. The technique for use of this mold material is described in Chapter IV.

VINYL PRINTING

The same vinyl hot melt can be poured into a sheet, carved with linoleum cutting tools, inked, and printed as if it were a linoleum block. It is suggested that the most rigid hot melt material be used.

A vinyl substance marketed by Minnesota Mining and Manufacturing Company called "3M Printmakers Sheet" is an excellent base for printmaking, using the same principle as the vinyl hot melt sheet. A pencil drawing can be transferred to the vinyl sheet simply by placing the pencil side down on the vinyl and burnishing the back of the drawing. With this image transferred, linoleum cutting tools can be used to cut into the block. The material has an adhesive backing; therefore, it is possible to cut shapes out of the vinyl, fix them to a backing, and print from this plate. Since the material is firm but soft, carving is much easier than cutting into linoleum or wood, mak-

ing it possible to create either an intaglio or relief printing with the same material.

Vinyl-Acrylic Printing

Another most interesting and promising printing technique, developed by Arthur Hoener, who has done a great deal of experimentation with various polymer media, uses a copper or zinc etched or engraved plate. The entire process works in reverse, from front to back—etched lines to colored backing.

This is the procedure:

1. Rub dry pigment into the etched or engraved areas of the plate with a palette knife leaving pigment only in the depressions. The surface of the plate should be clean.

2. Pour the following mixture of a strippable clear coating of vinyl plastic over the plate —use just enough to cover the plate and engraving with a film or coating. Formula:

Bakelite Vinyl Resin VYNS	10 parts
Bakelite Vinyl Resin VYHH	5 parts
Flexol plasticizer "DOP"	5 parts
Methyl Ethyl Ketone	60 parts
Toluene	20 parts
Total	100 parts

3. Coat the plate containing the vinyl film with pigmented or clear acrylic Rhoplex AC-33. At this point, a stencil can be used to create patterns of color, or if individually different prints are desired, color can be freely painted onto the vinyl film with the acrylic-pigment mixture. Then, the pigmented Rhoplex AC-33 can be brushed on, layer upon layer, until the desired buildup of color and/or thickness is reached. (See Illustration, page 271.)

4. When dried, pull plastic film from the plate and glue to paper, cardboard, cloth, or any mounting desired. The finished print is flexible and washable. The result has a tactile quality uniquely characteristic of vinyl.

ROTATIONAL MOLDING WITH VINYL

The commercial technique of rotational molding for doll heads and bodies has relevance here for solutions to certain sculpturing problems.

Use either a clay (as specified by the

Arthur Hoener's vinyl-acrylic print.

A. Plate from which prints were made. 240-gauge vinyl was burned and affixed to the metal surface of the plate.

B. Joseph Demarais. "Untitled" (12″ x 27″). Intaglio relief.

Courtesy Joseph Demarais

rotational casting company) or wax that can be finely modeled. The form is then brought to a mold maker. This is the expensive part. A mold has to be made commercially for the rotational molding process. (A mold from a six inch form may cost over $100.00. As the form increases in size, the mold price multiplies.) There is an optimum size the ro-

tational molder can accept. After the initial outlay, the mold is then ready for the rotational molding process. Units from this process are inexpensive. (The more copies one orders the cheaper the unit price.) Vinyl can be cast in a number of different colors and the vinyl can be made rigid by being filled or backed up later with a stronger material.

COCOON MOLDING
WITH VINYL

Cocoon molding is another technique that has potential for the artist. It is not a new method, Herman Miller used it in the 40's for his balloon lamps and the U.S. Government has been using it for the mothballing of World War II fleets.

Cocoon coatings of vinyl (Cocoon Diversified Corp., 728 Cooper Street, Camden, N.J.) are tough, weatherproof skins that cling to most clean, dry surfaces. An armature of wire, tubing, or iron forms the framework to which the webbing holds when sprayed. The styrene webbing agent is sprayed, using a 10- to 20-pound quart pressure cup with an air nozzle (66p for webbing, Binks Manufacturing Co., 3114–44 Carroll Ave., Chicago) and a model 62 gun at 23 cubic feet of air per minute at 80 pounds of pressure. The material has to be properly atomized to spin its spider-like web, which can span from 12 to 18 inches. When cured (can be handled in two hours, is serviceable in 24 hours, completely cures in one month) the webbing has its own structural strength and when stored has an indefinite shelf-life.

Paper masking tape can be used as a base for spanning between the rigid armature, and when the web has cured, the tape can be peeled away. Spraying over pointed objects imposes a limitation. The cocoon tends to pull away. In order to avoid this, pad the pointed area with rags or paper toweling and tape.

The webbing should be sprayed at a low spraying angle and continued until the skin looks uniformly knitted into the proper sculptural planes. If the cocoon is not opaque, the coating may dissolve thin sections when it hits the webbing, much like blowing a hole into the skin of boiled milk.

Solvents to clean equipment are acetone, toluene or methyl ethyl ketone. Cocoon can be "cut" up to 75% with solvent.

Colors can be added at any stage. A base coat of a primer is often used over the webbing. For outdoor use, colors are necessary to prevent degradation. Translucent coatings will not hold up outside. The coating will turn brown and continue to degrade until it falls apart. Pigment shields the material from UV and actinic rays of the sun.

After the webbing is in place, a pigmented vinyl (RynoHyde 90) is sprayed on with a high velocity air nozzle cap (63PB-Binks). This material is inflammable in the liquid and spraying state because of the solvents and plasticizers used; but when cured, it does not support combustion. There is only mild toxicity, but adequate ventilation is important.

One gallon of webbing will cover 20 square feet at 20 mils thickness. Ten ounces of pigment to the gallon is recommended.

INSTANT VINYL "RUG"

Another process, still in the experimental stage, is a vinyl spray that hardens the instant it touches water and then settles to the bottom. The material and equipment for dispensing it are still under development (U.S. Naval Civil Engineering Laboratory, Port Hueneme, California 93041).

Solutions, presently used, consist of polyvinyl butyral resin, a chlorinated biphenyl mixture (Aroclor—Monsanto), and dibutyl phthalate dissolved in a water soluble solvent (Carbitol—Union Carbide). Divers' air bottles equipped with regulators are set to operate at 100 psi above ambient, are used to pump the material to a dispensing head equipped with a slot that determines the shape of the extrusion.

When the material reaches the water, solvent begins to migrate from it and the surface skins over. As additional solvent migrates, the skin becomes thicker and stronger. Adjacent layers can be put

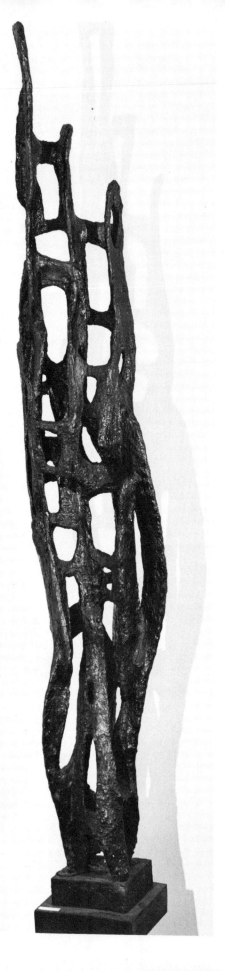

down and their edges will solvent-weld together. The overlay does not disintegrate within a short time and can be picked up after two days of curing.

Although this has not been applied to sculptural use, there may be potential here for underwater sculpture.

OTHER VINYLS FOR SCULPTURAL APPLICATIONS

Dewey and Almy Chemical Division of W. R. Grace Co., Cambridge, Mass., offers synthetic additives for Portland cement. Super-Bondit is a latex additive for concrete. It is added to concrete instead of water, and can be used to build up over an armature.

Duraweld is a vinyl acetate copolymer latex additive, requiring a mixture of 50% water.

Joseph Demarais. "Untitled" (6½').
Cement, latex and acrylic emulsion.
Courtesy Joseph Demarais

Painting with Acrylic, Acrylic-Vinyl Copolymers or Vinyl Mediums

USE OF MATERIALS

Grounds and Supports

Semi-Porous Grounds

Acrylic, acrylic-vinyl copolymers and vinyl can be applied directly to un-primed semi-absorbent surfaces such as cardboard, wood, and finely woven fabrics such as linens and fine canvas. If the paint sinks in too rapidly on the unprimed fabric, it is because the water is being absorbed too rapidly. To overcome this and still maintain the subtle effects of unprimed material, it is advisable to first paint the fabric with equal parts of water and matte medium.

Once dry, matte medium is practically invisible and yet it eliminates the high absorbency.

Porous Surfaces

More absorbent materials such as un-tempered masonite, cotton, and coarse canvas should be primed with gesso polymer primer. One coat is usually enough. Coats of gesso may be applied directly with a large stiff brush such as a house paint brush, roller or squeegee, to both sides (particularly if canvas).

Smooth Surfaces

Smooth surfaces such as metals or acrylic sheet must be thoroughly cleaned and then roughened to provide "tooth"

275

for the holding of the paint. Colors will adhere to glass and glazed ceramics if not disturbed by excessive abrasion or water soaking. Polymer colors on any smooth, impermeable surface can be loosened by prolonged contact with water.

Hard Porous Masonry

Porous surfaced masonry such as stone, cement, plaster, concrete or concrete blocks provide good tooth. Polymer colors resist the effects of weather better than any of the traditional materials. No paint, however, will withstand the effects of sun, rain, snow or chemical pollution indefinitely. There are so many variables that outdoor murals should be given a life expectancy of three to ten years.

One of the values in using polymer mediums, however, is that the paint has built-in flexibility and responds to changes in atmospheric conditions along with the ground; therefore, there will be no cracking of paint film.

Imprimatura

A little color can easily be mixed with gesso or polymer medium and painted as a tint over the ground. Wait for the priming to dry, dampen the surface and then lay on the *imprimatura* wash.

Initial Drawing

The initial drawing may be done with charcoal, Conte crayon, pastel, Wolf pencils, water-soluble lithograph pencils, India ink, or plain lead pencils. (Oil based pastels should not be used.) The *imprimatura* wash or *alla prima* (direct) painting may be done over the drawing without fear that the sketch material will bleed through. Portions of sketch techniques can be saved this way also, and incorporated into the painting by fixing them in place with a coating of water-thinned matte medium applied with a wide soft-haired brush. In later stages, charcoal, pastel and Conte

crayon may be worked directly into the wet surfaces or on dried color and then fixed with medium.

Painting Tools

Traditional painting tools such as brushes and palette knives suffice. Bristle, fitch, sable, sabeline and other natural bristles may be used. Synthetic bristles, such as nylon, work as well. The most successful brush, though, is the one with a thicker ferrule and longer hair, because it carries a larger load and allows for easier movement of color along a surface. Brushes used for other mediums may be used for polymers if they have first been cleaned in rubbing alcohol and then soap and water.

Care of brushes is simple. Keep a container of water handy so brushes can be rinsed regularly *before* paint hardens.

All kinds of painting knives are particularly useful. The heavier bodied polymers are particularly good for palette knife painting because of their buttery texture. After cleaning with water, the knives should be wiped dry to prevent rusting.

Palette and Colors

Manufacturers have limited the palette of polymer colors to thirty-five colors. A familiar array of earth colors, from burnt sienna through yellow ochre, is available. In greens, we have phthalocyanine, chromium oxide, cadmium and Hooker's green. Viridian is not compatible. The blues are phthalocyanine, ultramarine, cobalt and cerulean. Although there are a few shades of blacks and whites on the market, the best are iron oxide black and titanium white.

In the reds, alizarin has the same instability as viridian. There are new, excellent synthetic reds available beside the traditional cadmiums: Mars, Indian and Venetian reds; these are the "quinacridone" reds and crimsons. They have unequaled brilliance, clarity and permanence.

We find the "anthraquinones" in the yellow-orange family as well as the "dioxazine" colors in the violets meeting the same specifications. Also, on the market are the cobalt violets, manganese and Mars colors. In yellows, along with new synthetics are the traditional cadmiums, Hansa, ochre, Naples and zinc.

Very few impermanent polymer colors are on the market. Although there are not hundreds of years of testing behind the manufacture of colors for polymers, accelerated tests indicate that most polymers have many times the durability of traditional media such as oils.

Because the casein palette is different from oil and compatible with alkaline colors, so it is that the casein palette generally is used for the polymers.

Physical Palette

Disposable palette papers are very good to use. More permanent types are non-porous materials such as glass or Formica. These may be scraped free of dry pigments, or soaked in water to remove extraneous paint. Saran wrap or polyethylene is very good to have handy in order to prevent drying of paint on the palette. (Place over your palette between painting sessions.) Some manufacturers' colors may be kept soft by misting over with an atomizer filled with water. But a razor blade scraper is handy for scraping away unwanted dry color.

TECHNIQUES

The drying speed of polymers makes them particularly suited to *alla prima* technique. Used on a small scale, polymers are great for outdoor sketching and capturing the instant impression. Sixteen by twelve inches is perhaps the maximum for rapid outdoor sketching before the polymer hardens.

Systematic painting involving the building up of layers works well also. Polymer paint can not be degraded.

They dry so hard in a short space of time that other superimposed layers do not drag up the underpainting. It is possible, therefore, to build up many layers in a short period of time.

Unsatisfactory layers may be wiped out with a damp cloth, and if it is necessary to keep a surface workable over a longer period, then a spraying of water directly on the painted area will help.

Impasto effects can be worked up. Darks may be painted thinly and whites heaped on the ground.

Glazing a thin film mixed with water or medium can provide a succession of deepening glazes. Water and matte medium dry with a dull matte finish, while those mixed with gloss medium will wear a shine. Although a brush for glaze application is usual, rubbing color on with the tip of the finger or a wad of cotton will produce different effects.

Scumbling, the reverse of glazing, requires application of opaque passages of light or dark color over the contrast in under color. Then when partially dry, the top color can be dragged off with a stiff brush or palette knife. Overpainting is completely successful with opaque colors from your palette.

Gouache effects and washes can be created by just using more water with pigment. Water color techniques of crispness are easier to achieve because layers will not fuse unless you deliberately work color into color.

Mixed Media

Oil and Polymers

One general rule (with its exceptions: discovery through experimentation) where absolute permanance is a consideration, do not paint over oils with polymer colors. Once oil and polymer films are dry, they will expand at different rates and eventually separate. The same "law" holds true for painting over polymers with oils, unless the polymers have been applied in thin washes. Even

Even though it is not the best practice, many artists combine oil and polymer paints.

Harold Town. "Optical Number 9" (60″ x 60″, 1964). Oil and polymer paint on canvas.
Courtesy The Museum of Modern Art

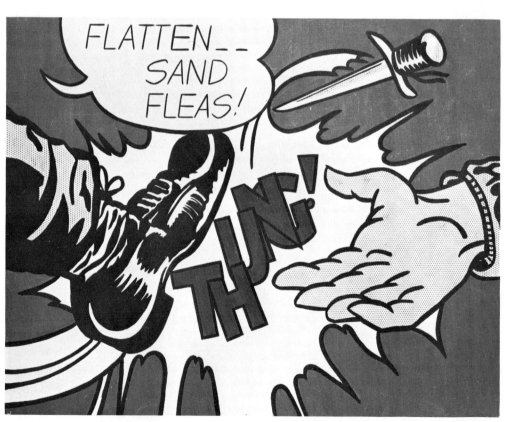

Roy Lichtenstein. "Flatten—Sand Fleas!" (34″ x 44″, 1962). Polymer paint and oil on canvas.
Courtesy The Museum of Modern Art

though it is not good practice, some artists do combine oil and polymer mediums.

Other Additives

Melted beeswax is another material that has been combined in a limited way with polymers with some success. It acts as an extender and provides a different consistency.

India ink has been overpainted on the polymer underpainting, with an overlayer of polymer then painted over the ink portion. This provides another texture dimension.

Addition of sand, glass beads and similar inorganic textures adds granular effects that catch light angles. These materials can be mixed into the paint and then applied or adhered to the wet ground that has at first been covered with a heavy layer of paint. The beads can be overpainted if desired.

Modeling paste can be formed as an impasto "underpainting" by buttering it onto the desired thickness. Then color can be developed over the basic impasto form.

Collage

Polymers are natural adhesives that will allow most materials to adhere permanently—particularly fabrics and papers. The basic polymer or matte medium (sans color) accomplishes this efficiently, either by underpainting the polymer layer or impregnating the added collage material with the polymer medium. (Try not to combine different polymer glues; unwanted chemical reactions might occur.) Work directly on either dry or wet undersurfaces. If, when applying fabrics or papers, bubbles form between the ground and added material, use a hard bristle brush, squeegee or roller to work out air. One can, however, drape impregnated materials into relief shapes and then overpaint where desired.

A novel collage effect can be achieved by finding color printing on coated paper such as old *Life* magazines. Apply a well-coated picture face down onto a fresh application of polymer medium, and after the polymer is thoroughly cured, soak away the paper back (uncoated part) with a soapy detergent-water mixture. After rubbing away the backing, what is left is the illustration intact on the background. Because of the great variety of printing inks and papers employed in the reproduction processes, it is possible that some illustrations will not work. *National Geographic* illustrations, for example, will not separate. You have to experiment.

POLYMER PRINTING MEDIA

Monotype

This technique is similar to usual monotype techniques, i.e., lifting a print from a design made with paint on a sheet of glass or some other smooth surface. With polymers, form your painting on glass. Textures can be scratched in; cardboard "combs" create interesting parallel line patterns, dry sponges other effects. After the design is complete and tacky, lay a sheet of slightly damp paper over the wet painting. Transfer the image by rubbing the paper with your hand or a roller. Then lift away the print. Successive prints can be made if the painting on glass is still wet and tacky. But each impression will be different. To maintain wetness, atomize a mist of water over the original plate.

Collagraphy

This is a print made from a relief-collage plate.

A relief plate can be made on masonite or some rigid water-resistant ground that will hold polymer gesso or polymer modeling paste. It is a good idea to roughen the plate's surface first and then apply two or three thin layers of gesso, allowing each layer to dry before applying the next. Then add the impasto material. Collage scraps such as fabric,

Brush an application of polymer emulsion over the "right" side of your magazine picture (the part you want to save). Let it dry for at least twenty minutes.

Brush another coating of polymer emulsion on your waterproof ground—such as acrylic sheet.

Smooth the magazine picture face side down on the moist polymer coated ground. Press out all the air bubbles. Try not to get any emulsion on the back surface. Let this dry thoroughly, for at least one hour.

If you use a waterproof ground, you can place the entire piece under a faucet and gently rub and peel away the paper as shown here. All that is left is the transparent print. If it turns milky, this will disappear when the resin cures. If you use a paper, canvas or wood base, before you affix the picture on the ground, soak the coated picture in a pan with a shallow layer of tepid water. Gently peel away the paper backing and place the picture-film into place on your coated ground.

This process may be repeated any number of times with overlays and also incorporated with painting.

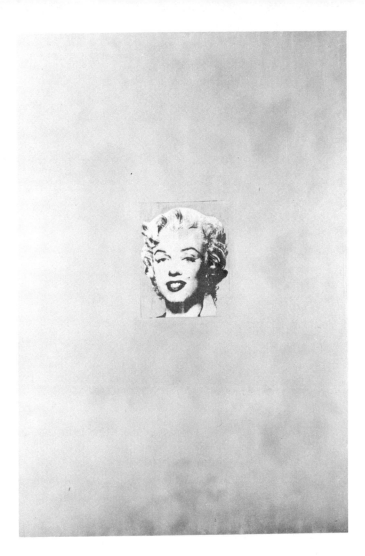

Andy Warhol. "Gold Marilyn Monroe" (83" x 57", 1962). Polymer paint silk screened, and oil on canvas.

Courtesy The Museum of Modern Art

netting, corrugated cardboard, sand, string etc. can be used. Impregnate and coat all materials with gesso. When dry, protect the plate by brushing three or four more coatings of polymer medium over everything on the plate.

Inking the collagraph plate is done in the traditional manner, using printing inks, rubbing off inks where necessary and pulling your print on dampened watercolor paper that is placed over the plate and burnished by hand with a spoon or stick so that an almost three dimensional impression is made.

Serigraphy

Polymer paints lend themselves to silkscreen techniques.

A polymer emulsion can be used as an excellent silk screen blockout liquid. It can be painted directly onto the silk. When dry, either water based printing ink can be used to pull prints or polymer colors slightly thinned with emulsion to the necessary consistency. When pulling the print using polymer paint, the screen should be frequently washed in water to prevent hardening of the polymer "ink."

Cloth silkscreened with acrylic, acrylic-vinyl copolymer or vinyl medium can be hand washed as you would a synthetic material without loss of the image.

Gesso Etching

Take a piece of masonite; coat it with four or more coats of gesso and then

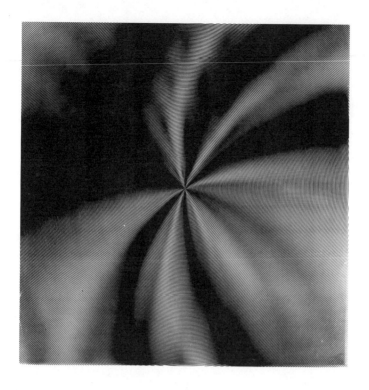

Gerald Oster. "Double Equispaced Circle" (39″ x 39″, 1964). Silkscreen on plexiglas.
Courtesy Howard Wise Gallery

sand it to a smooth surface when dry. With a soft brush, add six or more applications of matte medium to the dry gesso. After the gesso has thoroughly dried, incise lines with either a fine, sharp pointed instrument such as a needle or a woodburning tool. The quality of line will differ. If a mistake is made, just fill it in with more gesso and polymer coating. If the woodburning tool becomes gummy, wait for it to cool and clean it with acetone.

For printing, ink the plate in the usual manner as for etching, wipe away the ink from the surface, leaving ink only in the lines. Using damp printing paper, place it over the inked plate and run this through an etching press (or if not available, a wringer-type machine). The plate can be slightly heated when using oil based ink to achieve a sharper impression, but the number of prints will be reduced because eventually the thermoplastic polymer will become gummy.

(For more on painting vehicles, and vinyl printing, see "Vinyl Painting Vehicles," Chapter 7.)

Rogelio Polesello. "Untitled" (39″ x 25″, 1966). Polymer paint airbrushed on paper.

Working with Polystyrene and Polyethylene

POLYSTYRENE

Styrene is one of the least expensive of the thermoplastics. The surface of styrene is glossy and crisp—not like glass but like a hard transparent patent leather, if there could be such a thing. Styrene tends to be brittle and yellow when exposed to ultraviolet radiation, unless it is stabilized. It has high chemical resistance and low water absorption.

Because of the low cost and popularity of styrene, minimum quantities are huge—some manufacturers ·do not sell less than carload lots. Smaller amounts of styrene molding compounds or pellets can be obtained through jobbers. They are classified into four general groups: general purpose, high heat resistance,

medium impact, and high impact. The properties below are given for general purpose styrene.

Machining Styrene

Machining a styrene sheet can be accomplished with many of the same tools named in the section on machining acrylics and solid sheet. Surface temperature buildup can cause styrene to get hot and distort; therefore, the temperature must be kept below 140°F. This is achieved by reducing friction, providing proper chip clearance, and using either a gas or liquid coolant.

Polystyrene Painting

There is a polystyrene emulsion, SKU-2114 (Bakelite Co.), that is a milky white

1. BURNING RATE
 Slow.

2. COLOR
 Crystal clear, medium and high impact are opaque to translucent.

3. COLOR STABILITY
 Yellows; color possibilities are unlimited.

4. EFFECTS OF CHEMICALS
 Attacked by strong oxidizing acids, resistant to weak alkalis.

5. HARDNESS
 Rockwell (M) 75.

6. HEAT STABILITY
 150°–205°F., heat distortion temperature 180°–190°F.

7. MACHINING PROPERTIES
 Fair, better with coolant.

8. ODOR
 Sharp, pungent.

9. REFRACTIVE INDEX
 1.59–1.60; light transmission 80–90%.

10. SHELF-LIFE
 Indefinite.

11. SHRINKAGE
 Linear shrinkage per inch, 0.001–0.008.

12. SPECIFIC GRAVITY
 1.054–1.070.

13. STRENGTH
 Tensile strength: 5500–8500 psi
 Flexural strength: 8000–19,500 psi
 Impact strength: ft. lbs. in. notch 0.30–0.40.

14. SOLVENTS
 Esters, aromatics, higher alcohols, chlorinated hydrocarbons.

water dispersion. Upon drying this emulsion forms continuous polymerized films.

When polystyrene emulsion is allowed to dry on the palette, it has a slight yellow cast which disappears after 24 hours. Except for a very slight yellowness, the material handles much the same as Rhoplex AC-33—surfaces can vary from gloss to matte.

The emulsion easily wets pigments and forms a mixture with excellent handling properties.

It is important, when using polystyrene emulsion, to get a light-stable variety.

Poly-Mosaic

Poly-Mosaic is a thermoplastic material that probably is made up in part

285

of polystyrene. It is a transparent mosaic that comes in sixteen bright, clear colors. (Poly-Dec Co., Inc., P.O. Box 541, Bayonne, N.J. 07002)

Poly-Mosaic units can be cut easily with a tile cutter and can be fused into a rigid shape at 350°F. in an oven or broiler. A propane torch can be used to heat small units. After fusing, the sheet can then be sagged over a mold form to create three-dimensional shapes. Poly-Mosaic will not stick to glass, ceramic, plaster of Paris, wood or metal unless glued. An all-purpose plastic cement is probably the best gluing agent. Poly-Mosaic is said to have outdoor weatherability. Final shapes may be cut or drilled by hand or machine. Hot shapes can be cooled instantly under cold water.

Polystyrene Molding Pellets

Since colored pellets of polystyrene are available only in enormous quantities, they will have to be colored the same as in the descriptions in Chapter II and under "Coloring Molding Powders" in Chapter VI. Attractive pointillist effects can be achieved by fusing these coated pellets at 300–350°F. in an ordinary oven. Ten minutes produce a glistening, jewel-like effect, twenty minutes bring forth a bubbled surface, and in forty minutes the pellets are fused into a delicate Venetian glass texture. See illustrations on pages 290 and 291.

Small quantities of many different colors of styrene-type pellets called *Dec-ets* can be purchased from Poly-Dec Co., Inc., P.O. Box 541, Bayonne, N.J.

Expanded Polystyrene

(See chapter on Foams & Forming Methods.)

Styrene Variations

Styrene can be widely copolymerized. If you like some properties of styrene and not others, you can usually find a copolymer variation that will answer your needs. For example, there is styrene butadiene, styrene-acrylonitrile, acrylonitrile-styrene-butadiene (Cycolac), and methyl styrene.

Thelma R. Newman.
"Eclipse." Poly-Mosaic
and Polyester resin.

Poly-Mosaic

Poly-Mosaic are transparent, colorful tiles that can be cut easily with a tile cutter, or even with the blow of a hammer.

Place one or two layers of Poly-Mosaic on aluminum foil or an aluminum sheet. Overlapping is a good idea. The sixteen colors can be combined by overlapping to achieve very subtle effects.

Place in an oven regulated to 350°F. Allow to fuse. Texture effects depend upon the degree of fusing. If the tiles just slightly melt, there is a more definite mosaic texture. Increased fusing will eliminate the unit demarcations entirely. After fusing, remove from the oven and allow to cool. Cooling can be hastened by submerging the piece in cold water.

287

Thelma R. Newman. "Stained-Glass Mosaic."

Units of Poly-Mosaic were fused until the edges of the individual pieces were not apparent. Individual shapes were then cut on a machine saw; these elements were then rearranged and, with poly-styrene pellets as an additional texture, the entire piece was refused at 350°F.

Thelma R. Newman. "Harvest." Poly-Mosaic and Polystyrene pellets.

288

Styrene Molding Pellets

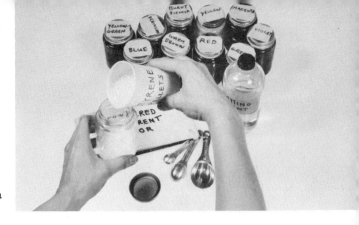

To color styrene pellets, pour some in a jar that has a lid.

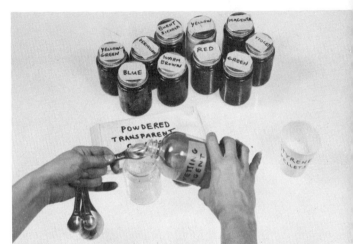

Pour enough wetting agent, such as mineral oil, into the jar to coat the surface of the styrene pellets.

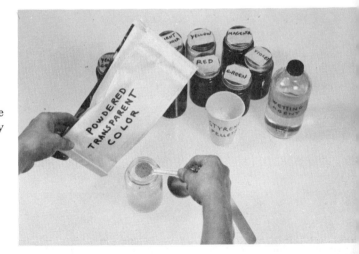

Then, add a little powdered color. The amount of color depends upon the intensity you wish.

Shake the mixture well.

289

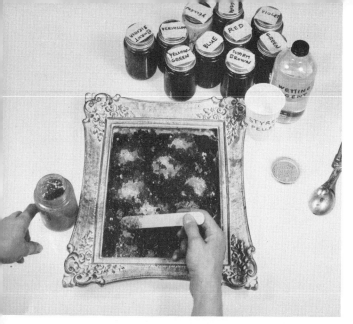

Within a frame (used only as a guide), and on a piece of aluminum foil, place the colored styrene pellets side by side, until the entire area is filled.

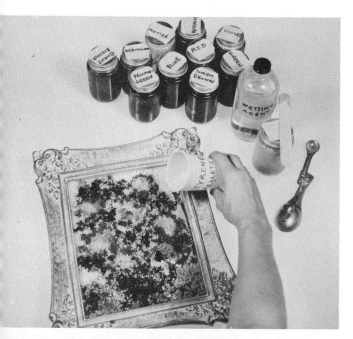

Sprinkle a layer of clear pellets over the whole piece. This helps to fill in areas that may leave holes when the styrene fuses.

Place the styrene composition in a kiln or oven held at 320°F.

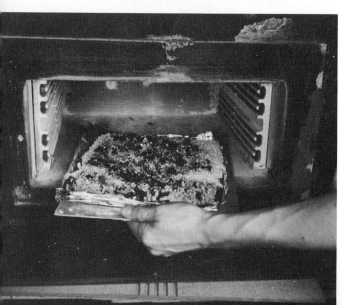

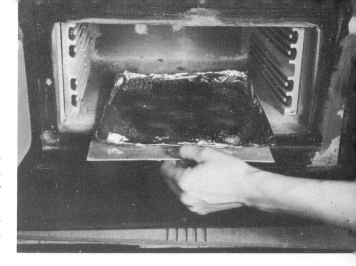

Remove the panel after five to ten minutes or when the pellets have fused to the degree that you wish. You may prefer a smooth or a pebbly surface. For the pebbly texture, remove the piece sooner than for a smooth surface, which has to fuse for a longer period of time.

Peel away the foil and frame the piece. Errors can be corrected by adding more styrene to the panel and re-fusing it in the oven.

The completed picture can be seen in the full color section. This painting, with its richly textured pointillist effect, has a crystal-like translucency.

Sara Reid used styrene pellets to texture these doors of polyester on acrylic.

Photograph by the author

POLYETHYLENE

Polyethylenes are odorless, nontoxic materials best known for their application as squeeze bottles. In recent years, a finely powdered polyethylene has been marketed that has potential as a waterproof art material. And, of course, as described earlier, polyethylene is a release agent for polyester and epoxy, providing an excellent mold material.

In appearance, polyethylene is milky white, translucent, and waxy to the touch. In thin sheets, it is quite flexible but in thick sections it can be stiff and rigid.

There are also high density polyethylenes and polypropylenes that are related in appearance but offer an improvement in properties. These materials are not necessary for the techniques described here.

PROPERTIES

1. BURNING RATE
 Slow.

2. COLOR
 Translucent to opaque.

3. COLOR STABILITY
 Unless a weather-resistant grade, crazes rapidly.

4. EFFECTS OF CHEMICALS
 Very resistant to almost all acids and alkalis, is attacked slowly by oxidizing acids.

5. HARDNESS
 Rockwell R-11.

6. HEAT STABILITY
 200-250°F. melting and distortion.

7. MACHINING PROPERTIES
 Good.

8. ODOR
 None.

9. REFRACTIVE INDEX
 1.51.

10. SHELF-LIFE
 Indefinite.

11. SHRINKAGE
 Approximately 0.03 to 0.05 linear per square inch.

12. SPECIFIC GRAVITY
 0.92.

13. STRENGTH
 Tensile strength: 500 psi
 Flexural strength: 4800–7000 psi
 Impact strength: ft. lbs. in. notch—no break.

14. SOLVENTS
 No known solvents below 60°C.

Polyethylene Techniques

In an aluminum or glass form that has been coated with a thin film of wax, draw or paint your picture or design. Use waxy crayons, powdered paint, or felt marking pens.

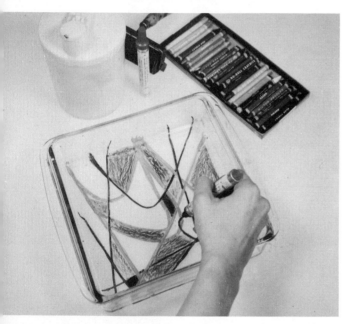

Evenly sprinkle a ¼″ layer of powdered polyethylene over the drawing.

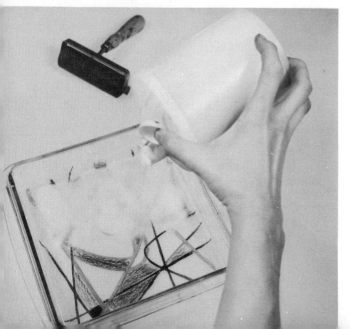

Using even pressure, roll out the poly-ethylene with a brayer until it looks flat.

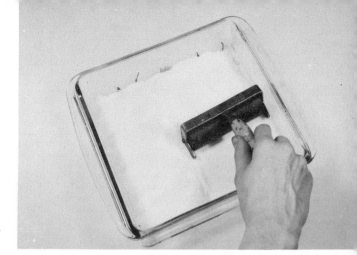

Fuse the polyethylene in an oven or kiln set at 350°F.

When the powder melts to a crystal clear film, remove the piece from the oven. The cooling process may be hastened by placing mold and polyethylene into cold water. Do not try it if you use a glass mold.

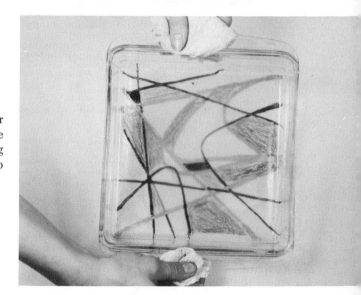

When cool, the polyethylene changes to a milky translucency, with the drawing embedded on the surface. Polyethylene can be easily trimmed with a scissors. Errors can be corrected by adding more polyethylene and/or color and re-fusing the material in the oven.

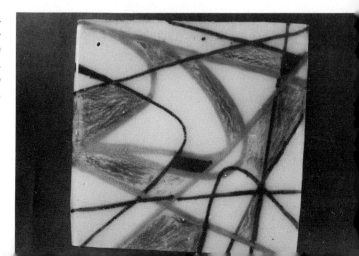

295

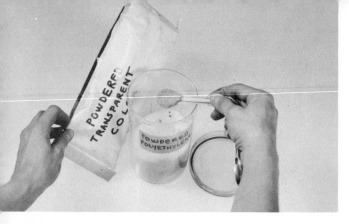

Add powdered color to powdered polyethylene. Shake well until the powdered color is evenly dispersed in the powdered polyethylene.

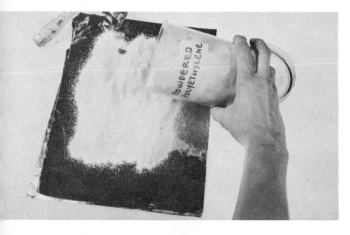

On a piece of waxy aluminum foil, sprinkle an even layer (about ¼″ thick) of the pigmented polyethylene powder.

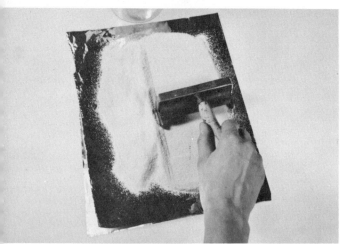

With a roller or brayer, distribute the powdered polyethylene into an even layer. Then place this in an oven or kiln set at 350°F.

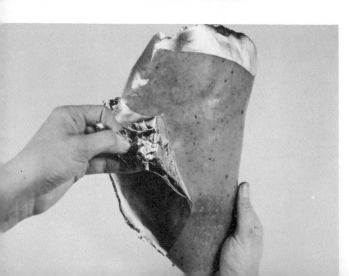

When the polyethylene has fused, remove and cool. Peel away the foil and you have a sheet of colored polyethylene. Make several different colored sheets in the same manner.

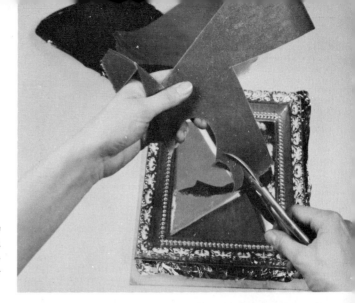

After collecting several colors, cut the polyethylene to shape and place these, with edges slightly overlapping, on a waxed aluminum sheet. (The frame here temporarily sets the boundaries.)

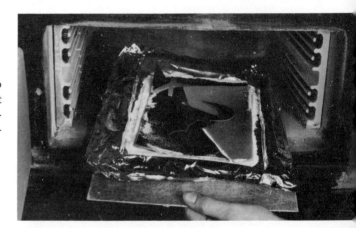

Insert the polyethylene arrangement into a 350°F. kiln or oven, again. Remove it when the separate pieces have fused together. Cool and then peel away the aluminum foil.

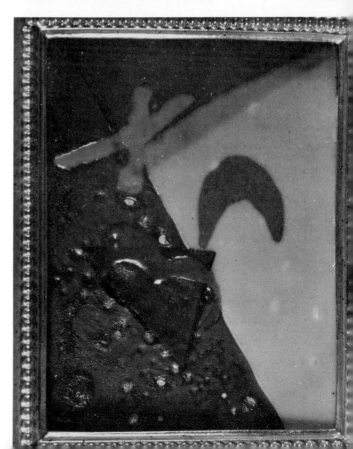

The results are very much like cut-paper pictures, except that the edges have a softer appearance.

Working with Silicones, Pyroxylin and Ethyl Silicate

SILICONES

The silicones are in a generic class of their own because of their many different forms—rubbers, resins, fluids, greases, and adhesives. The outstanding characteristics that all the silicones have in common are thermal stability at high temperatures—500°F. and above, flexibility at temperatures below minus 100°F.—resistance to water and weathering, and the ability to prevent other materials from sticking.

Silicone Release Agents

Release agents are available as fluids, solutions, and emulsions. We are most familiar with the spray-applicator types.

Each plastic and fabrication method requires a silicone of a different formulation. (General Electric and Dow Corning are two main sources of supply.) Some coatings of release agents are long-lasting, do not have to be reapplied for each use, and others are good for only one application.

A remarkable long-range release agent for treating glass is General Electric's Dri-Film SC-87. A few drops applied with a cloth to a clean surface will cover a very large area. An oily film is formed and must be buffed with a clean soft cloth after a few moments, until a bright, dry finish is obtained. A strong hydrochloric acid odor develops and one must

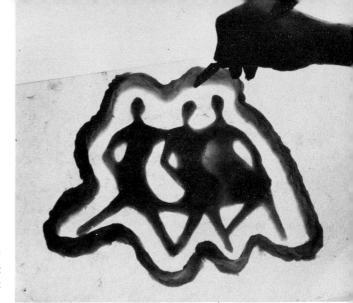

Making a Silicone Mold

Since RTV silicone does not generate very much heat when curing, it is an excellent material to mold over wax. Carve your wax bas-relief.

Measure and mix the recommended amount of catalyst into the RTV base material.

Since the catalyst is brown and the base is white, a marbled effect is created when mixing. Continue stirring the mixture until the material is one solid tan color.

299

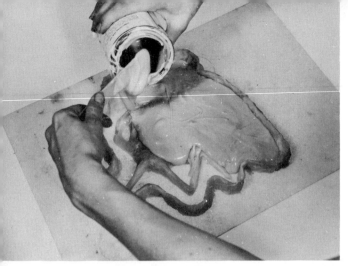

Immediately pour the RTV over your entire wax bas-relief. (The outside fence was placed there to contain the mold material.) If you choose to have a very thin layer of RTV (about ¼"), then you will have to make a plaster jacket later to support the mold and to keep it from warping out of shape when resin is poured into it.

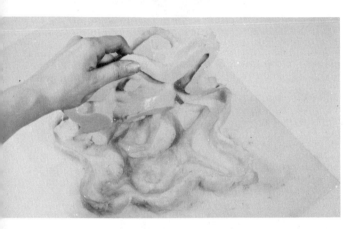

After several hours, when the RTV is no longer tacky, lift the mold from the bas-relief.

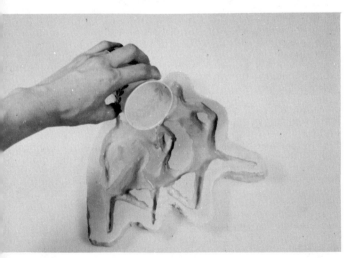

Now you may pour polyester resin into the new mold cavity. If you choose to use styrene or polyethylene you do so because the silicone holds up very well at elevated temperatures.

Upon curing, or fusing, as the case may be, carefully release the sculpture positive.

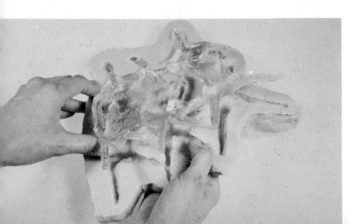

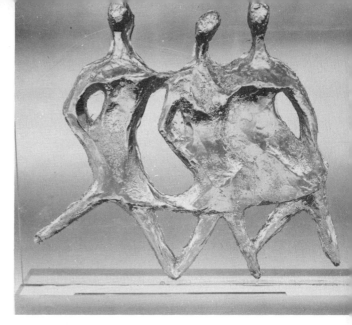

Mount the bas-relief with more polyester resin, if it is a polyester piece, on an acrylic sheet. The mold will provide continued accurate definition after dozens of pourings. "Three Sisters" by the author (1963).

take care not to inhale the fumes and to protect one's hands.

Silicone Mold Materials

Room temperature vulcanizing (RTV) silicone rubber is an excellent mold material (see Chapter III, section on Mold-Making for Casting).

Shrinkage is minimum, there is a built-in release agent, high temperature resistance—RTV mold plus plastic can be placed in the curing oven; there is a wide viscosity range; and RTV can even be molded over wax without melting it.

One can make an RTV positive from an RTV negative mold simply by coating the mold with petroleum jelly, paste wax, or powdered graphite. Because of the material's flexibility, undercuts are possible.

Small quantities of the metallic soap curing agent can be mixed with a spatula on a glass plate, or in the can with both a stirring and spreading action until the catalyst is thoroughly mixed.

The pot-life (after catalyst is mixed) is about 30 minutes to 4 hours, depending upon the amount of curing agent, the brand, and the temperature of the room. Curing time is from 24 to 48 hours and can be shortened by curing in an oven at 150–200°F.

Silicone Adhesive-Sealant

RTV silicone can be squeezed out of a tube, forming a channel of adhering, releasing material. This could become an effective dam to hold in a pool of polyester resin without leaving any residue that would have to be cleaned away later.

The application is as easy as squeezing toothpaste from a tube and the material will not sag or flow. No mixing is necessary and it cures at room temperature. This sealant (General Electric RTV 102) will bond to most clean surfaces without aid of a primer.

Silicone Painting Material

The three previous applications are used as means to an end. In this case the silicone material becomes the actual paint-binder.

Polysilicone resin is highly resistant to weather, is water repellent, maintains its color, and can withstand temperatures up to 500°F.

Albert Jacquez developed the following polysilicone formula:

Silicone resin	2 parts per weight
Titanox R. A. (white)	2 parts per weight
Acryloid B-72	5 parts per weight
Solvesso 100	1 part per weight

(A substitute for "Solvesso" can be Toluol or Xylol.) Fillers such as diatomaceous silica, calcium carbonate, magnesium silicate, mica are good heat resistant materials compatible with the polysilicone base.

Compounding with pigments, or in vessels containing lead, calcium, chromium, or tin will cause a rapid increase in viscosity and then gelation. Glass is probably the best storage and mixing container.

This silicone enamel formula can be applied like any painting medium. It cures at room temperature but its drying can be hastened by curing the painting in a 300 to 350°F. oven protected from open elements, for thirty minutes. This gives a very hard surface. Setting is very quick. Air hastens its cure. Overpainting is very difficult with this material; it tends to pull off the lower layer, if the lower layer has not hardened by then.

Albert Jacquez recommends the following palette as compatible both to silicone resin paint and temperatures up to 500°F., except that phthalocyanine blue fades when heated over 325°F.: red iron oxide, cadmium red, cadmium yellow, chromium oxide green, phthalocyanine green, carbon black, phthalocyanine blue.

ETHYL SILICATE

Ethyl silicate is another synthetic medium that lends itself to painting techniques. Siqueiros painted a mural in 1932 in Argentina with ethyl silicate. Ethyl silicate is a colorless liquid that will dry into a tough, hard surface and will not darken with ultraviolet exposure.

The medium can be applied with many techniques. Imagination is the only boundary. Flat painting, scumbling, modeling, dry brush, impasto, infinite textures—in fact, all are possible.

As yet, ethyl silicate is not commercially formulated as an art vehicle. It requires mixing or formulating by the artist. The base is condensed ethyl silicate and can be purchased from the Union Carbide Company. When combining the ingredients, accurate measurements are necessary, according to its formulator, José Gutierrez. The formula is as follows:

11 parts or 110 cc. ethyl silicate (it may be a brownish color)
3 parts or 30 cc. denatured alcohol (96% proof) or Synosol (Union Carbide Company)
1 part or 10 cc. H_2O (tap water)
½ part or 5 cc. hydrochloric acid

Pour the ethyl silicate and alcohol into a glass jar. Add the water and then the acid in that order. Stir *only once* with a clean stick or glass rod. In five minutes the mixture will exhibit an exotherm of about 38°C. In about fifteen minutes the medium should feel slightly sticky. If this does not occur, then something was done wrong. The mixture should be allowed to age for twelve hours in a closed container. Exposure to air, at this point or any point, will cause gelation.

Gutierrez recommends the following dry pigments as compatible for a permanent palette: Venetian red, Indian red, Puzzolian red, red iron oxides, all shades of yellow ochres, burnt or raw sienna, burnt or raw umber, all shades of cadmium yellow and red, cobalt blue, ultramarine blue and violet, cerulean, viridian, terre verte, chrome green, thalo green, vine and ivory black, and titanium dioxide white.

Rigid supports and rough grounds such as cement, brick, porous stone, and masonite are a good base for the ethyl silicate medium. Each layer of paint has to be roughened before painting the next layer. Note that the colors dry lighter than at the time of mixture. José Gutierrez' experience has recommended the following ground supports for ethyl silicate murals:

1. 1 pint gray or white cement (Portland type)
2. 2 parts rough marble dust or clean sand
3. add from $\frac{1}{10}$ to $\frac{1}{5}$ the volume of Celite #110 or Hyflo. Either will facilitate even setting and provide greater plasticity to the mixture.

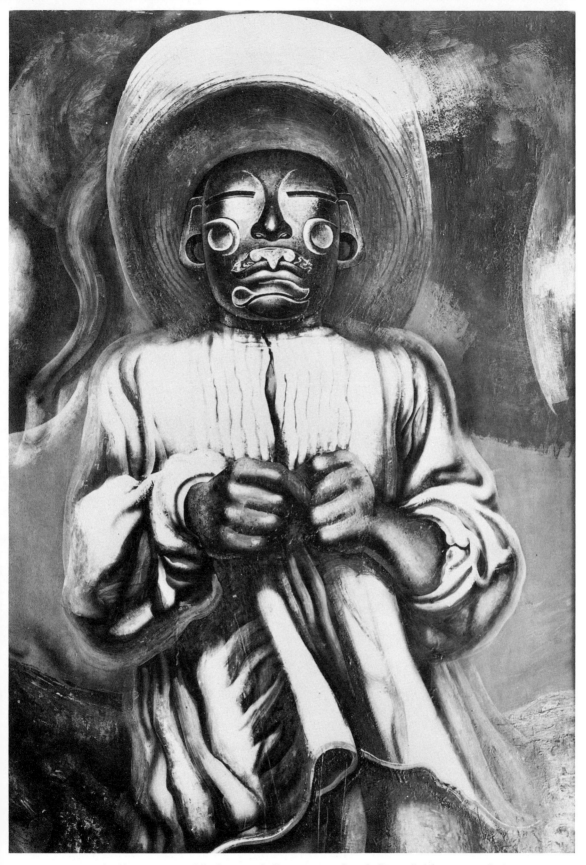

David Alfaro Siqueiros' "Ethnography" was painted with "Duco" (then Pyroxylin) on composition board in 1939. The color and texture have held up exceedingly well.

This painting by Lilo Salberg of Chile is built up of pyroxylin with the embedded additions of silver, coral, amber, beads, shells, mirrors, silk, cotton, metal threads—all to create a sensuous combination of textures and bright color merged into an encrusted impasto.

Courtesy Museum of Contemporary Crafts, New York

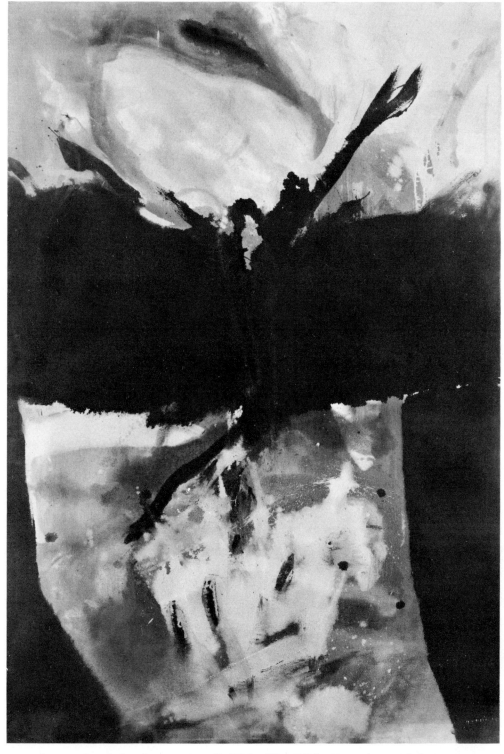

Helen Frankenthaler. "Trojan Gates" (72" x 48", 1955). Duco (pyroxylin) on canvas.
Courtesy The Museum of Modern Art

The above is the support and the following is the ground coat:

> Mix one part concrete as above, two parts fine marble dust, and one-fifth part Celite #110 or Hyflo.
> This final coat may be made smooth, rough, or with a finish like emery cloth.

A useful hint is to clean brushes in detergent or let brushes stand in pure ethyl silicate. The great "beauty" of this medium is that it is highly resistant to moisture and can even be used underwater.

PYROXYLIN

Pyroxylin, the first plastic material, is still being used today as an occasional art material. "Duco" (the automobile lacquer) was once made of a kind of pyroxylin. David Alfaro Siqueiros painted his "Ethnography" in pyroxylin and Jackson Pollack used Duco on his large canvases. Pyroxylin was the original nitrocellulose. It can be purchased in some paint stores in varying viscosities, from heavy to light. In its thick, honey-like or linseed-type state, it is a clear liquid.

Although the material has discolored in the outdoors, it has held up very well in many paintings. One requirement is that the ground be rigid. Masonite (the most compatible base—it is also a cellulose material), wood, celotex are all good supports for pyroxylin. Carbitol may be used as a thinner. One-tenth to one-twentieth of Carbitol can be utilized to control the viscosity of the pure medium. With flow-control, pyroxylin can be sprayed, brushed, or dripped onto a rigid surface. José Gutierrez suggests using a ground of two parts of pyroxylin to six parts of a good quality thinner and one part Carbitol. The ground dries in about fifteen minutes.

Marble dust, sawdust, threads of cotton, glass beads can be incorporated into the material for texture. Lilo Salberg of Chile encrusts paintings with all kinds of semiprecious and glittering materials. The pyroxylin can be painted over these textures to make an embedment, too. Sand also can create a bas-relief effect or a rough background.

Celastic

When fabric is dipped into a colloidal solution of pyroxlin and marketed under the name of *Celastic,* it can be used as an excellent sculpture material by just softening in a solvent such as acetone and applying. When dry, the pyroxylin form is exceedingly hard.

Celastic

Celastic (Woodhill Chemical Corp., Cleveland, Ohio 44128) is a cotton flannel impregnated with pyroxylin and fire retardant. It can be cut easily with a scissors into any shape. When dipped into acetone it softens.

Application is by wrapping pieces around a support or armature.

When it dries it becomes exceedingly hard and hornlike. Forms can be machined in various ways.

It can be painted or coated with various materials. In this case, an acrylic modeling paste is being applied. The result is a strong but very lightweight form.

Thelma R. Newman. "Dance-Kinetic." Celastic (pyroxylin) with a coating of Acrylic-Vinyl Modeling Paste.

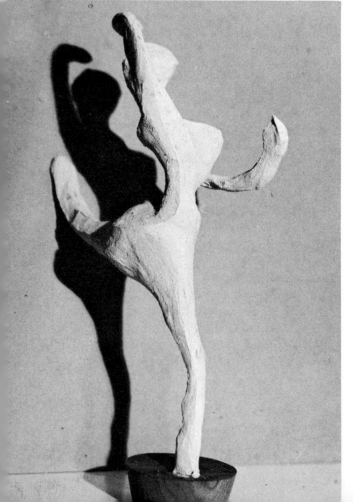

Working with Foams

Foams are beginning to achieve prominence in the sculpture field in a variety of functions—as the original form to be cast and then vaporized (see Alfred Duca's Foam Vaporization Casting, Chapter III), as a core material, a maquette for a sculpture, as the finished structural material itself, and more recently as a mold for concrete casting.

Foams have a ready volume. Mass can be quickly and easily manipulated. The different foams can suggest many varieties of expressive qualities from bulk to flowing mass. Whatever the intent, foams can inspire imaginative applications because they have no precedents in nature or in (prefoam) manufactured materials.

Foam as a Core Material

Using foam as a core, Wolfgang Behl, who likes working directly with sculp-

tural material from inception to completion, combines other plastics in his large-scale bas-reliefs. Foam cores are lightweight, strong, easily carved, and inexpensive.

After the foam is carved and coated with a plastic material, a layer of polyester impregnated fiberglass is superimposed over the form as a skin. Over this fiberglass, Mr. Behl models a layer of plastic filled with different aggregates varying in texture and color and becoming the finished surface. This final stage has infinite possibilities for variation. The outer surface may finally be filed and/or sanded.

One of the great advantages of this material is that it can be worked directly at the building site.

Foam as a Maquette or Sculpture

The ease of working with styrofoam block (expanded polystyrene) prompted

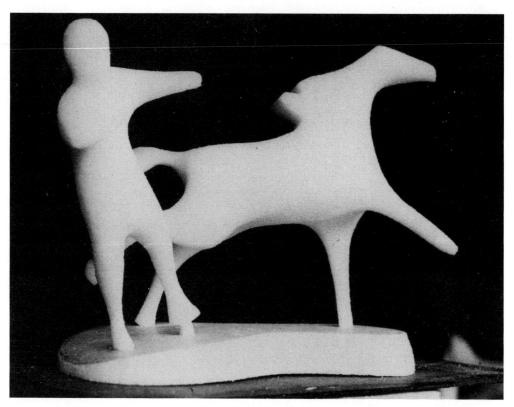

Alfred Duca's "Dismounted Rider" carved of expanded polystyrene. (10″ high.)

Joseph Konzal to build his models for marble monuments out of prefabricated interlocking blocks that can be assembled and disassembled for shipping. Mr. Konzal used a heated nichrome wire for cutting his shapes. In some cases he glued the blocks into place to each other.

Textures can be created in polystyrene foam by using various solvents, such as acetone or turpentine. Coating for styrofoam can be vinyl, latex or acrylic paints. Epoxy putties can also be used. Adhere parts with polyvinyl acetate, epoxy or acrylic adhesives.

Commercial hot-wire cutters for expanded polystyrene are available from Dura-Tech Corp., 1555 N.W. First Avenue, Boca Raton, Florida 33432, or you can make your own cutter. Plans may be obtained from the Dow Chemical Company, Plastics Department, Midland, Michigan 48640.

Polyurethane foam can be shaped with mechanical tools such as electric kitchen knives, drills, band saws with blade speeds from 2000′ to 5000′ per minute as well as various grades of sandpaper. Unlike carving styrofoam, stay away from heated cutters because the fumes would be hazardous. Adhesives for polyurethane foams are epoxy, ureas, phenolic or resorcinol base resin as well as contact rubber glues.

POLYURETHANE FOAMING

Polyurethane foams are thermosetting, rigid, closed cell, dense materials employing two products, a resin and a prepolymer. These polyether-type foams are highly resistant to water and moisture but discolor in sunlight. (See Roger Bolomey's panel on an outside building wall.) They adhere tenaciously to most materials and can be foamed-in-place eliminating cutting and gluing.

310

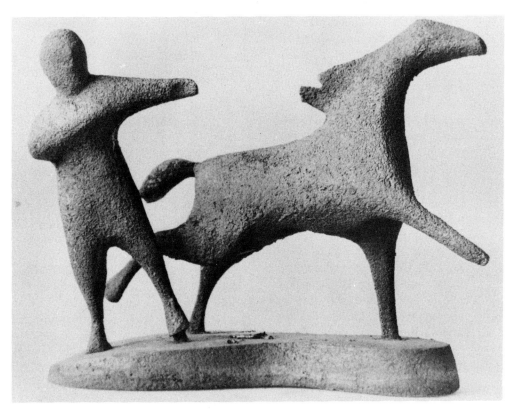

Mr. Duca's sculpture, after foam vaporization casting into metal.

Courtesy Alfred Duca

Foaming Procedures

1. Condition the ingredients temperature-wise. The fluorocarbon resin should be approximately 60–65°F. at mix time and the prepolymer 80–100°F. so that the average combines to 70 and 74°F. Raising the temperature above 74°F. will shorten the mixing time and may cause excessive fluorocarbon (blowing agent) loss.

2. The components (Reichhold Chemical Co.). Polyurethane Foam—5 parts 92–311 (freon portion-polyether resin) to 4 parts 92–342 (fluorocarbon-poly-diisocyanate) by volume or weight should be added in a suitable mixing container (a large tin can) so that the combined liquids fill the container from two-thirds to three-fourths full. The result is a brown foam.

3. High speed mechanical mixing is necessary. A paint mixing blade attached to an electric drill will do. For a 2″ diameter blade, mixing speeds of 2000 to 3000 RPM are suggested.

4. There should be adequate ventilation. Avoid breathing vapors or skin contact with the material.

5. Mixing blade placed beneath the liquid level, the stirring begins. Manipulate either the mixer or mixing can to get a thorough mixing. The clear amber color changes to off-white or cream color. During mixing the first indication of foaming reaction is due to exothermic heat. You can feel the mixing container getting warmer. Soon the liquid will change from off-white to white (depending upon the type of foam).

Color and slight change in vol-

311

ume indicate foaming activity and at this point the foam should be poured, allowing for continued foam expansion. Mixing should take from 30 to 40 seconds.

6. After 5 to 10 minutes the foam sets. In 24 hours the foam reaches approximately 90% of ultimate strength and cools off internally sufficiently to permit being worked.

7. Cellulose or a 1:1 mixture of alcohol and benzene, toluene, or acetone make the best solvents for cleaning equipment.

8. Polyether resins should be stored at 70°F. or lower, in tightly closed metal containers. To open container, first loosen the cap and allow pressure to be released, then remove the cover.

9. Avoid moisture contamination.

10. Cured foams can be easily trimmed, cut, and shaped with common woodworking tools.

11. Molds can be used but should be coated with release agents to per-mit easy removal of the polyure-thane foam. Polyethylene film, containers, coated paper, Carnuba paste waxes, silicone release agents, lightweight petrolatum, or machine oil are all effective. See step-by-step illustrations on pp. 328–329.

Another two-component foaming system, put out by Flexible Products Co. (1225 Industrial Park Drive, Marietta, Ga. 30060) results in a dense white foam with a glossy surface. It is the Flexipol 9022/8013-8AA system containing 9022, an isocyanate and 8013-8AA a cross-linker, catalyst and blowing agent. Mix 100 parts by weight of 9022 with 68 parts by weight of 8013-8AA accurately. Mix with a high speed drill with a high shear propeller, at 70–75°F. in a disposable container for 30 seconds. Pour into cavity or form. Foam rise should be completed in five minutes. Cooling the components will slow the reaction. Cure is completed in twenty-four hours. See illustrations on pp. 330–331.

Foam Core Sculpture

Interpreting Wolfgang Behl's technique, indicate your design structure with marking **pen** on expanded polystyrene (Styrofoam).

With sharp tools and knives, carve a relief from the Styrofoam.

Coat the foam with a layer of plaster of Paris. Polyester resin cannot be placed directly on expanded styrene because the styrene base in polyester dissolves the foam.

Mix a polyester aggregate and apply with spatula or palette knife to the plaster-coated relief.

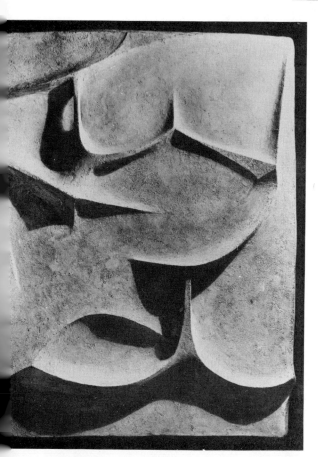

Wolfgang Behl, "Polyester Plastic Panel #1." (66″ x 49″, 1960.) *Courtesy Wolfgang Behl*

Wolfgang Behl, "Polyester Panel #2," 1959.

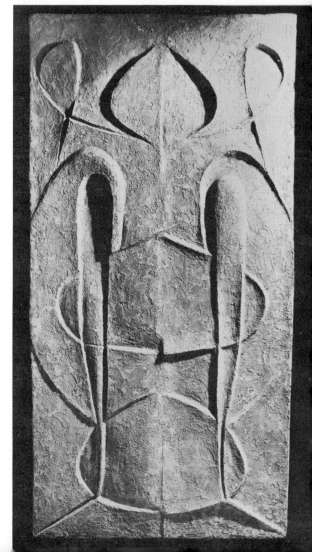

Foam as a Maquette

Using a saw of heated wire, slice the blocks of styrene foam into shape.

Courtesy Joseph Konzal

Stage one of a massive expanded polystyrene sculpture. Interlock large blocks of styrene foam one into another.

Courtesy Joseph Konzal

314

Stage two—continue fitting one block into the other until the structure is completed. Styrofoam glue can be used to adhere the parts, or the blocks can be marked and disassembled whenever necessary. *Courtesy Joseph Konzal*

Joseph Konzal's "Sun Gate" of expanded polystyrene stands 10'6" high and is 4' wide and deep. It was constructed as a maquette for a marble monument.

Courtesy Joseph Konzal

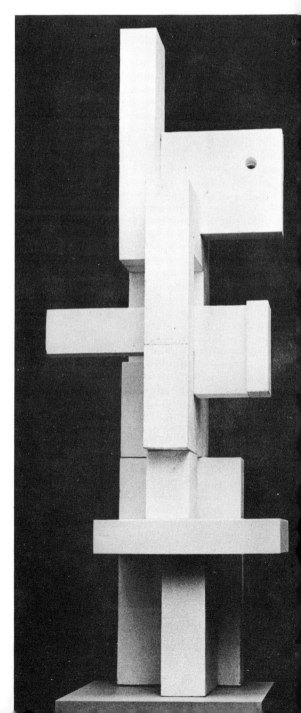

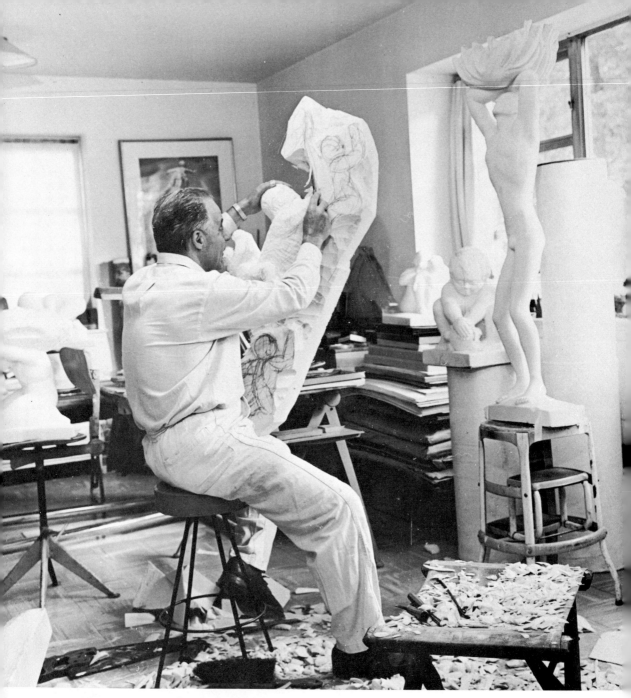

Domineco Mortellito carving "Tritons" shows how simple it is to hold the sculpture in hand while carving polyurethane foam.

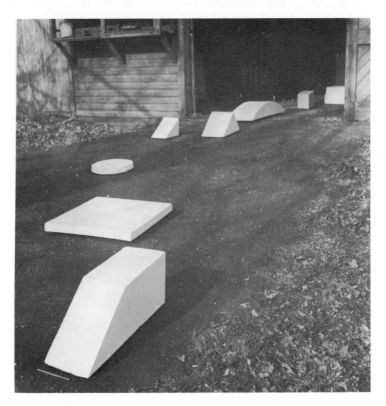

Robert Breer. "Mobile sculptures" (1965). Styrofoam shapes, with motors inserted, move in a random pattern.

Courtesy Frances Breer

Arline Wingate. "Torso" (1961). Styrofoam form textured with flame to be cast in bronze. *Courtesy Feingarten Galleries*

317

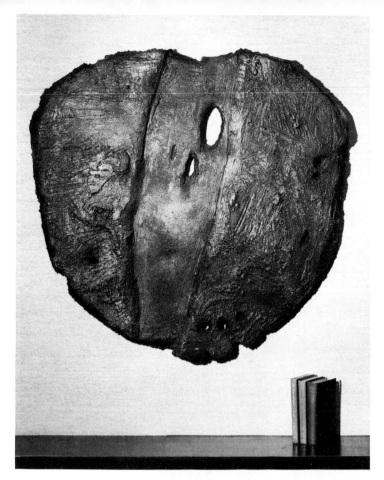

Jeff Low. "Moon Shield" (1698). Urethane foam with a sand-epoxy mixture for the outer coating.

Courtesy Jeff Low

Gianni Colombo. "Pulsating Structuralization" (36″ x 36″ x 9″, 1959). Styrofoam blocks in a wooden box with motor.

Courtesy The Museum of Modern Art

318

Foam as a Mold for Concrete Casting

Some sculptors, Robert L. Jones of California and Al Vrana of Florida have been using carved styrofoam panels (such as Dylite-Sinclair Koppers Co.) as mold relief forms for on-the-spot concrete casting.

The first step involves carving the styrofoam "boards" with either a very sharp knife or an electric steel wire knife which when heated, slices through styrofoams with very little pressure. It is best to avoid undercuts, unless the mold is expendable. Various parts of the form can be glued together with any non-acetone glue or special styrofoam glue. Finishing can be accomplished, if desired, by sanding with different grades of sandpaper. Different textures can be obtained with wire wheels and burrs or by using solvents.

As an intermediary step, it is possible to preserve a model of the original mold form by covering it with soap, or clay slip before casting with plaster of Paris. At this stage, the plaster of Paris model can even be used for ceramic casting.

For concrete casting, a removable wood frame has to be fitted around the carved styrofoam panel. Wire or rod reinforcing material should be arranged separately (so it does not mar the styrofoam) and then placed high enough over the styrofoam mold so that it later will be buried in concrete.

Mr. Vrana finds that a coating of pancake syrup acts as one of the best separators for concrete. Other common release agents are emulsified petroleum oil, paraffin, or polyvinyl alcohol. If release agents are not used, the polystyrene will stick to the concrete in specks. At this stage, if the styrofoam should stick to the concrete, it should *not* be removed with solvents because it absorbs into the concrete and forms a glazed surface.

Next, concrete with or without a texturing aggregate is poured into the mold form. Al Vrana uses Solite as an aggregate because it is light, attractive and gives the concrete a "soft" appearance. Ground brick or different colored sands can also vary color and still retain the quality of concrete.

After hardening, and while the styrofoam is still in place, the concrete form can be raised into location on its permanent site, and then the styrofoam can be stripped off of the concrete. Robert Jones holds his mold sizes down to two to sixteen square feet each. Al Vrana casts panels that are several stories tall. (He uses styrofoam adhesives and double-headed nails to clamp the styrofoam together until the adhesive holds. The nails are removed before carving.)

Al Vrana's Technique for Concrete Casting From Styrofoam Mold

First come sketches, then three-dimensional models. After that, the design is reversed to comply with the styrofoam molds. Drawings are enlarged via the grid system and transferred directly onto the styrofoam slabs.

Extra thicknesses are then cut as required, using an electrically heated knife.

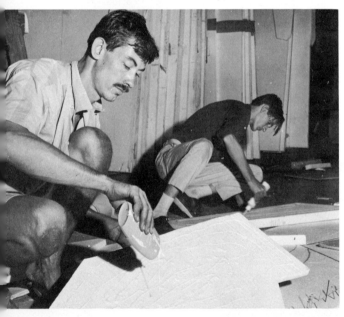

Cut-out pieces are then glued into place and pinned with nails until the glue hardens.

This is a glued up section of the panel mold showing different contours.

320

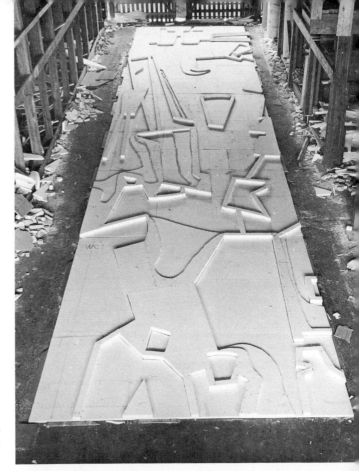

This is one wall section that has been glued up, with nail reinforcement removed and ready for grinding.

After the glue is hard, the grinding smooths out rough areas.

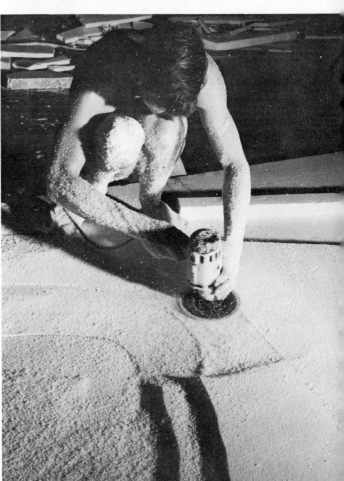

321

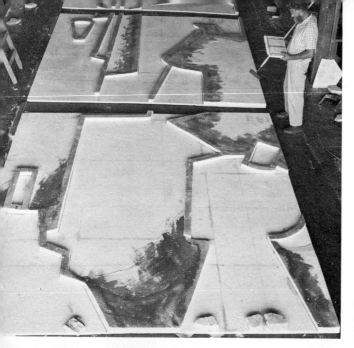

Finished mold is ready to ship. Dark areas are coated with a retarder to expose aggregate in the concrete. Texture on the foam is produced with the solvent, acetone.

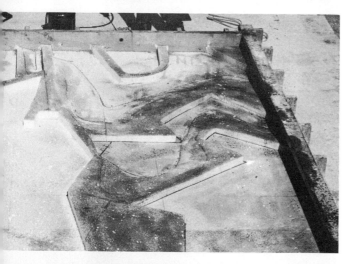

In the concrete casting yard, an oil parting agent is sprayed on the surface (not the side forms). The wood mold part is also coated with release agent and the casting can begin.

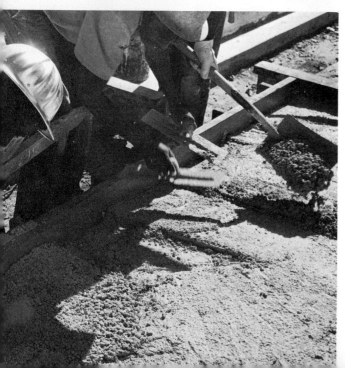

A face coat of white sand and aggregate cement is carefully placed in the mold up to two inches in thickness. This is backed up with wire mesh, and then four inches of gray concrete is added.

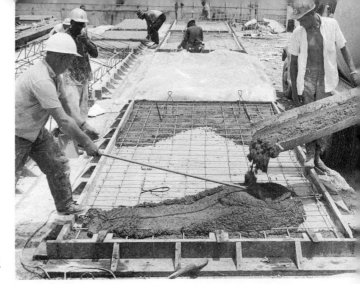

The gray back-up concrete is poured over the steel mesh.

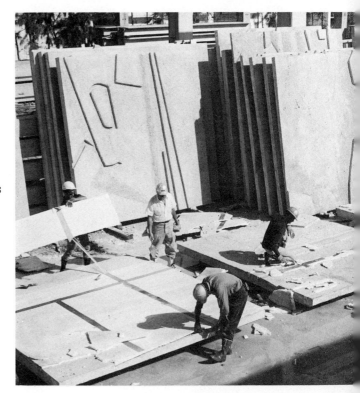

In this case the styrofoam mold is stripped off of the concrete.

Cleaning with a brush finishes the concrete panels.

323

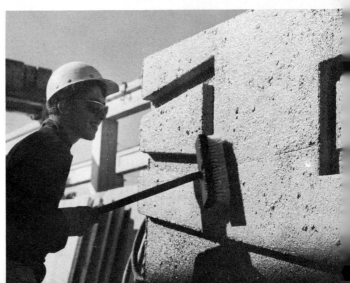

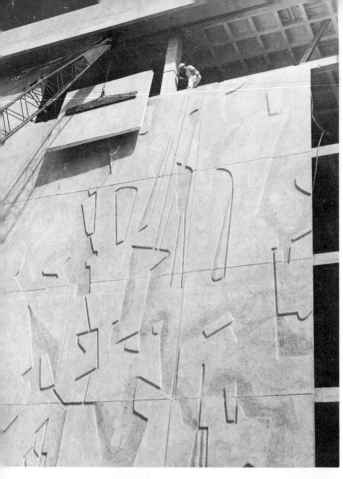

Erection of a panel on the building.

Close-up of the front of the building.

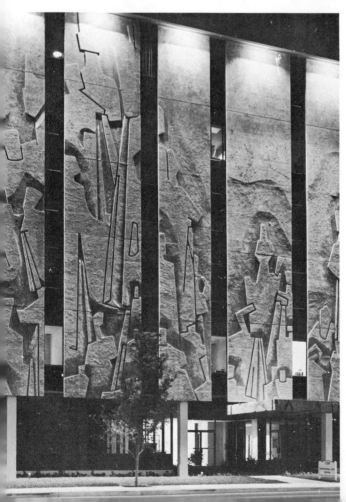

324

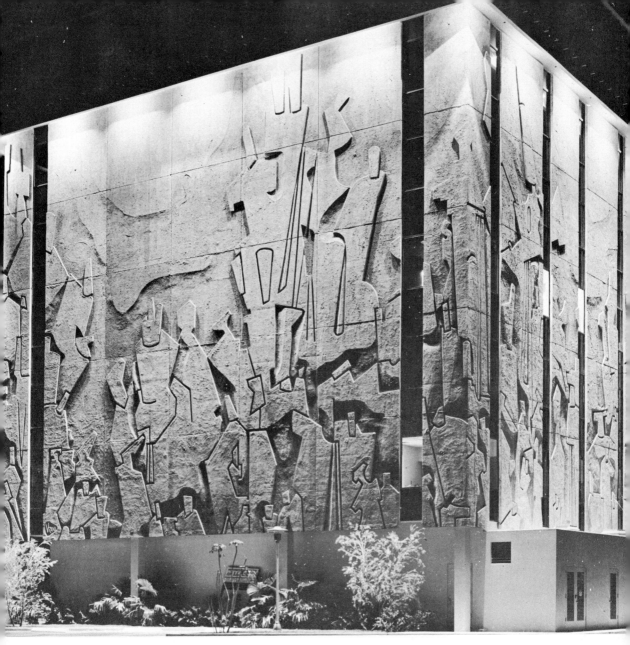

Southwest corner of the building.

Cast concrete panel by Robert L. Jones.

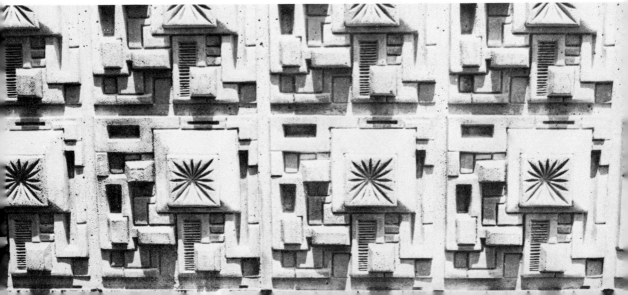

Expanding Polystyrene Beads

Coat a strong mold with wax.

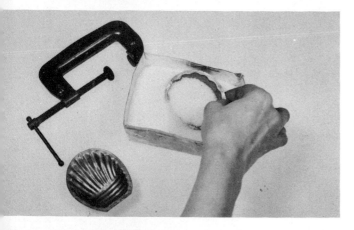

Partially fill half of the mold with polystyrene beads.

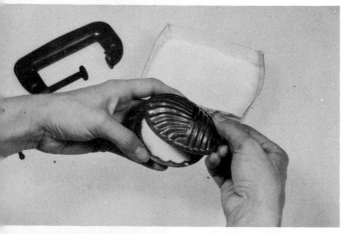

Cover the mold.

Tightly seal the mold.

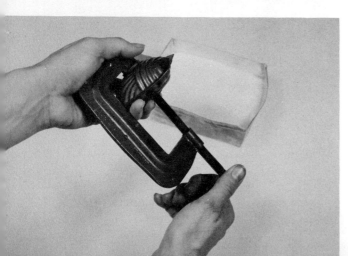

Place mold and contents in a hot-water bath at 200°F. for ten minutes.

Remove from heat.

Lift off cover.

Remove mold-positive.

327

Foaming Polyurethane

Measure four parts of diisocyanate and pour into a large container.

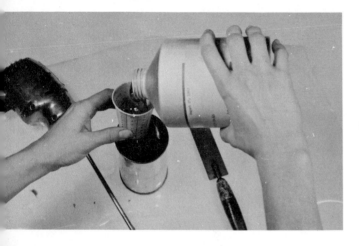

Measure five parts of the Freon portion and combine with the diisocyanate.

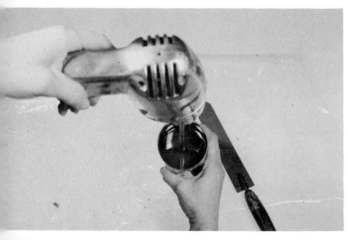

With a high-speed mechanical mixer, blend the two ingredients together until some heat is generated and the color of the material becomes much lighter. Keep the area well ventilated.

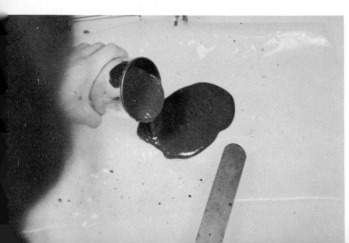

Pour the foaming plastic onto cellophane, allowing for much greater expansion of the material. Spread and control pouring with a spatula.

328

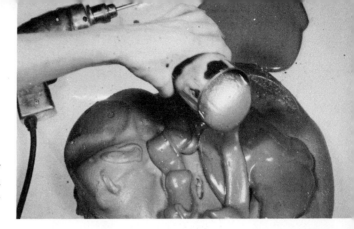

Roger Bolomey uses a two pound density polyurethane foam for his basic form, and a quarter pound density for a coating. Sometimes he adds color before mixing begins.

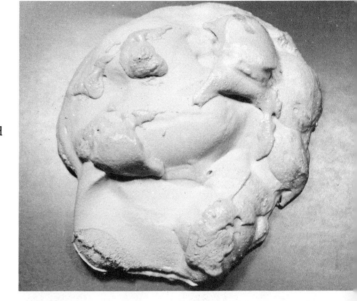

The result can be built upon and carved after curing.

Mr. Bolomey wishes to express a feeling of "movement within creation." The polyurethane foam qualitatively projects a natural feeling of direction and movement as illustrated in this 78" x 66" "Sculptural Relief #30" (1961). *Courtesy Roger Bolomey*

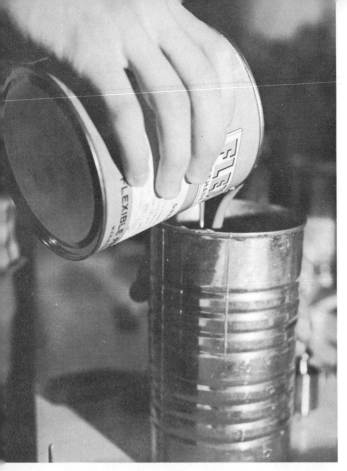

Foam-Making a "White" Fluorocarbon

Carefully and accurately measure 100 parts of Flexipol 9022 by weight.

Then add 68 parts by weight of 8013-8AA in the disposable container at a room temperature of 70–75°F.

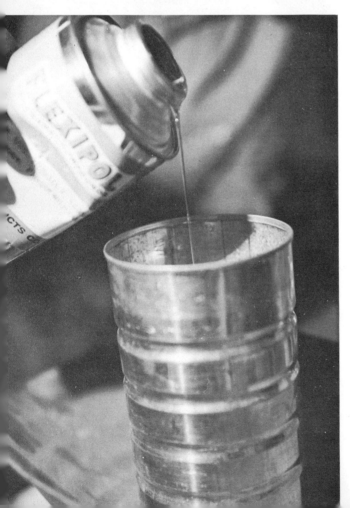

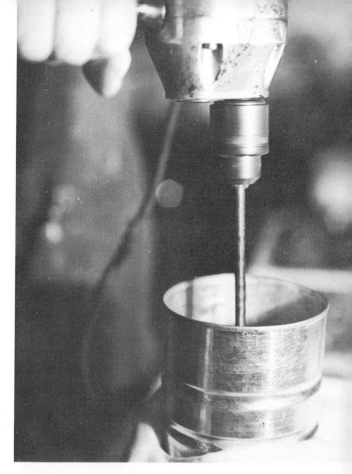

With a high speed drill and high shear propeller, mix both components together for 30 seconds, taking care to mix in the material on the sides of the container.

Pour it immediately into the cavity to be filled. The foam rise should be completed within five minutes. The result is a white, dense foam with a glossy surface.

331

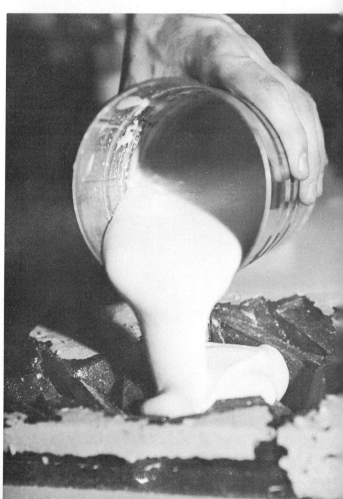

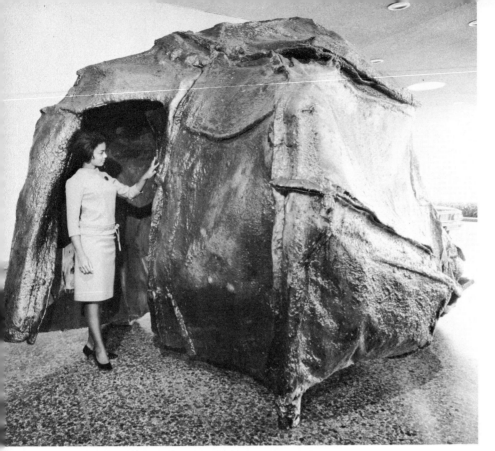

Mowry Baden. "The Trap"
(10' high, 1965). Polyester,
steel, fiberglass and urethane
foam.

John Chamberlain. "Hua" (32"
x 33" x 33", 1967). Urethane.
Courtesy Jared J. Sable Collection

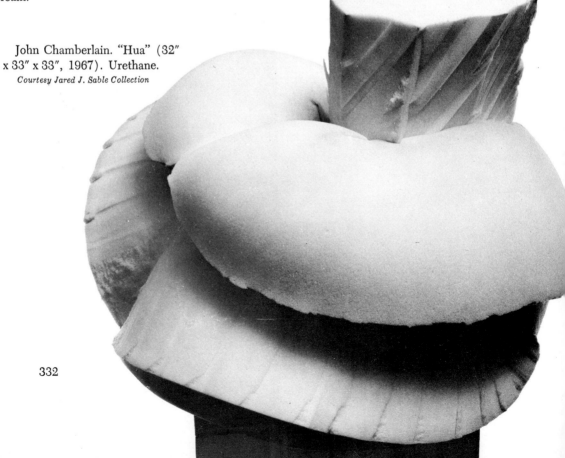

332

The "Plastic" Future

Polymer chemistry and engineering, as we have seen, have produced fantastic materials and there is no end to the perpetuation of discovery—it is continuous in this field. At this writing some ideas expressed here risk old age before they are even seen in print because of the emergence of new material.

One does not have to be prophetic to be able to predict the creation of new substances; our crystal ball can also presage the coming of new processes. But there are still other dimensions to be exploited—if we could discard mind-setting techniques custom-made for the old and mistailored for the new, with *new processes* particularly *for* these *new plastics*—

if industrial leaders can have enough foresight to support small-user markets, perhaps remembering that the artists and the craftsmen were innovators of most of the *basic* principles used in manufacture—if commercial rule-makers can recall history's lesson, that the artist and craftsmen had led in innovation, had predicted new design—then we will see a freshness and vitality emerging not only from the artists and craftsmen and the lab but from the designer and manufacturer too—and that will stimulate new markets.

Since the first edition of *Plastics as an Art Form,* an organization called E.A.T. (Experiments in Art and Technology,

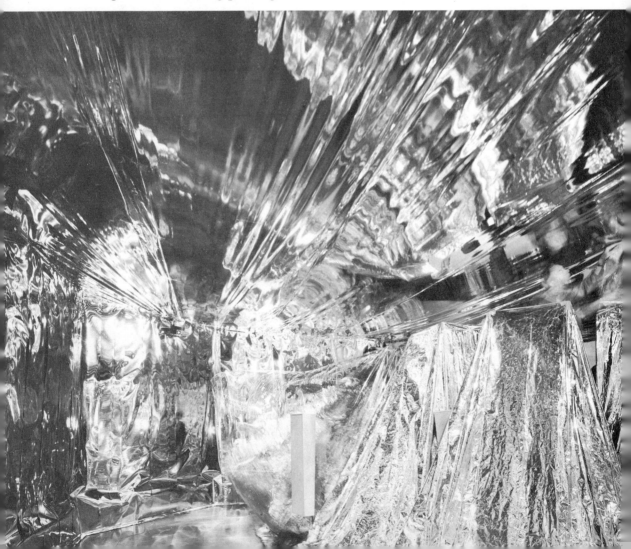

Les Levine. Interior of "Slip Cover" (30' x 31' x 10' high, 1968). Mylar and butyrate room with lights and air creating pulsating environmental effects.

Courtesy Les Levine

Inc., 9 East 16th Street, N.Y., N.Y. 10003) has been formed, in October 1966. It is the wedding of science and technology with art. The purpose of this tax-free organization is for the engineer and artist to work together to solve problems of expression and form using little known or complex scientific techniques. E.A.T. is supported in part by the National Endowment for the Arts and other foundations. Participating and associate membership for artists and engineers is free. The organization offers bulletins, help with special problems, assistance with safety factors, exhibitions and many other resources.

A look into the near future sees remarkable mutations from the wedding of electronic "brain" systems to plastics formulation and processing and from the incorporation of photosensitive materials in plastic texturing and finishing.

At this writing the acrylic rod can become a fuel propellant for the moon-stroller and a transparent shield to protect man from radiation rays. Others are used as delicious appetite appeasers— bulk without calories—and for chewing gum. Some are turned into human-type bones, cartilage, veins and arteries. Houses foam-made on location, dishes extruded as needed in one's own kitchen, and photosensitive plastic windows may make for the "better" life. All these aspects of plastic manufacture and use are already known or can be easily predicted. How far will imagination travel when we embark on scheduled vacation trips to outer space, or when we look for ways to control weather and our environment? What discoveries will emerge from conscious, creative research and what will be the outcome of accidents and mistakes?

It is fun to postulate, but getting back to the present we can look now beyond our new materials, new markets, and new worlds—and toward our unused resources. All the work you have seen here is unusual inasmuch as each artist has embarked on a search into a forbidding land and through his creative insight and ingenuity has given us a new vision in a heretofore solely commercial field. Plastics actually is the only formable material used by mankind that has *not* first passed through the artist's hands. It is a group of materials that compounds into divergency and fluency when the aesthetically and sensitively trained use it as "plastic" material. If this book accomplishes its purpose artist-craftsmen will use the theoretical and the practical shown here as a launching pad to propel them to new, exciting, fluid and plastic expression.

Appendices

A. Testing Properties of Plastics

There are many standardized laboratory tests that judge the degree of property value. It must be kept in mind that these tests examine plastics in the laboratory situation approximating at best, through mechanical device, the actual practical situation. The plastic tested, too, is not the finished work but a simple product of standard size and weight. Any judgment about a plastic has to be made with those limitations kept in mind. How the finished piece would react to the test elements would relate to how similar the finished product was to the test-plastic in the experimental laboratory situation. It should be kept in mind, too, that there are often gross exceptions to the following very general descriptions.

Density

Density, which equals mass over volume, is important because as a basic molecular property it affects almost every physical property. The hydrostatic method is one way used to determine density. In one test, a sample is weighed at a set temperature, first in the air and then submerged in a chemically inactive (inert) liquid of known density. An increase in density usually makes for greater crystallinity, more resistance to gas and moisture-vapor permeation, higher melting point; flexibility and film impact strength usually lessen as density increases.

Melt Index

The melt index usually classifies resins at their flow rate. An apparatus called a melt indexer measures an amount of melted resin that a weighted piston extrudes through an orifice in a specified period of time. The melt index of the resin sample is the weight in grams ex-

truded in ten minutes at a specified temperature. Lower melt indices point to properties of resistance to environmental stress-cracking and low temperature flexibility.

Melting Point

Melting point is the temperature at which a solid substance begins to melt when under standard pressure. When thermoplastics are heated, their crystallinity gradually declines, increasing the percentage of amorphous volume; then regular molecular structure becomes more random in arrangement. When rising temperature has caused the resin to lose all of its crystalline structure and become completely amorphous, it has reached the melting point. At this stage the polymer has changed from a solid to a highly viscous liquid.

Heat Softening Point

The heat softening point is not the same as the melting point. It is the temperature at which the finished article becomes too soft to withstand stresses and retain its shape. The tests for heat distortion in different plastics will vary. The Vicat test, for instance, is used on polyethylene specimens. It is the temperature at which a flat-ended needle under a weighted load penetrates into a standard thickness of the plastic specimen. Another test employs plastic under load at degrees Fahrenheit indicated in 100 degrees F. and up. A higher heat softening temperature may result in products that may withstand greater heat without distortion. In some plastics a high heat softening point reflects greater stiffness.

Yield Strength

Plastics are also tested for yield strength. This is the highest stress (tensile force) in pounds per square inch of cross-sectional area of a test specimen in a room temperature to which a plastic piece may be submitted and still return to its original shape when the pulling

340

force is removed. Related to this is the rupture point. This is expressed in percent of the original length of plastic at the moment of rupture (elongation) when subjected to a pulling force.

Creep

Appertaining to yield strength is creep. Creep is the gradual dimensional change of a material under load for an extended period of time. Creep at room temperature is often referred to as cold flow. The capacity of a plastic to be free from a tendency to creep is important when structural forms are created. Usually, plastics of high density have increased resistance to creep—or less tendency to flow under stress.

Stiffness

Stiffness is another polymer quality. It is expressed by modulus of elasticity. The modulus can be determined in three different ways. The first, the torsional modulus, is a measure of resistance of plastic to a twisting action. It is measured in inch/pounds. The second, flexural modulus, is a measure of the flexibility of a material to a bending action. This is also indicated in pounds/square inches. Third, tensional modulus, is a direct measure of the ratio of applied tension to the strain, or deformation it causes in the stressed material. This is also determined in pounds/square inches.

Higher stiffness in a polymer may mean that the form can remain stiff with thinner walls. Stiffness also means that the material will not bend easily; this could be a disadvantage where flexibility is desired. For instance, if a resin is combined with another material that expands and contracts at different rates, then it would be desirable for the resin to be somewhat flexible so that it will not resist contraction and expansion of the material. Stiffness increases with density and somewhat less with the average molecular weight. A resin of a given density and lower melt index would be slightly stiffer than one of a higher melt index.

Hardness

Hardness is another related characteristic, usually a higher density one. A lower melt index means slightly higher hardness. One method used to determine hardness is measurement of a specimen lying on a hard, horizontal surface as it is penetrated by a vertical steel indentor point. An instrument indicates how far the indentor penetrates into the specimen in fractions of an inch. Harder surface means better abrasion resistance.

Shrinkage

Shrinkage is another characteristic of plastics. Although epoxies have a very low percentage of shrinkage, it still has to be reckoned with in every fluid plastic. Any material, however, that is produced at a high temperature and then cooled to room temperature will normally contract. The amount of contraction depends largely upon the difference between processing and room temperature as well as the resin's coefficient of linear expansion. Density of resins influences the degree of contraction. Usually lower density resins are somewhat less susceptible to shrinkage. Also, an object made of a resin with a higher melt index has a slightly lesser tendency to shrink than one made of a resin of a lower melt index.

Warpage

Warpage is another quality concern in the mechanics of creating plastic forms. Warpage is caused by stresses in the object which result in distortion. Excessive pressures, uneven cooling, uneven distribution of reinforcement material—in fact, generally, unevenly distributed treatment will cause the piece to shrink non-uniformly when cooling. Hence, the result is a twisted and warped form.

Impact Strength

Impact strength and resistance to shock are properties that vary considerably among the polymers. Some plastics that have higher polymer density, a brittleness, can be given added impact strength through reinforcement with fiberglass. High impact strength is a measure of toughness. The dart drop test is used to measure strength. A weighted dart is released by shutting off an electromagnet which has held it in place. The plastic, held securely below the dart, is pounded by the released dart. Increasingly heavy weights are dropped onto the plastic. The percentage of failure is plotted against the weight in grams.

Brittleness

This is another property dependent upon molecular density and orientation. Again, higher density resins usually are more brittle. Brittleness temperature is the temperature at which a test piece of plastic will become sufficiently brittle to break when subjected to a sudden blow. If a plastic is to be selected for outdoor use, special attention should be paid to this property. Usually resins of lower melt index, lower density, and narrow molecular weight distribution have comparatively low brittleness temperatures. Internal stresses can also raise the brittleness temperature by many degrees.

Chemical Resistance

Many resins are noted for their chemical resistance. They are resistant to corrosive elements. Some plastics are resistant to corrosive chemical action to a certain point and then suddenly break down. Some corrosive chemical action can cause environmental stress cracking. When a plastic is formed it may have dormant stresses that show up under unfavorable conditions, for instance, when a piece is taken from a heated area and subjected to sudden coldness. There are some plastics, however, that have a great deal of impermeability to certain elements, and a susceptibility to others. Resins that are more crystalline (higher density and lower melt index) are more impervious to liquids and gases.

Transparency

Transparency and freedom from haze is an invaluable property for the artist.

Plastic held securely below the dart is pounded by the released dart. Increasingly high weights are dropped onto the plastic until failure is reached, thereby judging *impact strength*.

It insures clear suspension of color (if there is no oxidation and yellowing of the polymer). Where there is high transparency, there is a commensurately high percentage of light transmission. If a surface of plastic is rough, this roughness will diffuse light passing through the form and contribute to haziness. A partly crystalline, partly amorphous structure of resin also contributes to haziness.

Clarity is measured by the index of refraction. Everyone has noticed that a perfectly straight pencil inserted into a glass of water seems to be bent at the surface of the water. This apparent bending is due to the fact that light waves travel one and one-third times faster in air than in water. Since everything we see is through light reflected from the object, the slow down in the light waves reflected from the portion of the pencil under water gives us the visual impression of bending.

Light travels at different speeds in each transparent material and the ratio of the velocity of light in air to the velocity of light in the material is the *refractive index* of that material. The refractive index of polyester is 1.54 compared to 1.49 for acrylic and 1.59 for styrene.

Film Haze

Film haze is determined by means of a hazemeter—the percentage of light diffused by the specimen is measured by means of a photocell and recorded. The lower the percentage of light diffused, the less hazy is the plastic.

Optical Properties

Some plastics, such as the methyl methacrylates (acrylics), have excellent optical properties. These optical properties allow transmission of visible and ultraviolet light. A one-quarter inch methyl methacrylate sheet transmits 92% of visible light and has a refraction of 1.49 that strikes the first polished surface.

Dielectric Constant

Dielectric constant is a property that has little import for creative work with plastics, but because it is constantly referred to in specifications it is described here. Dielectric is a nonconducting material or electric insulator. Dielectric strength is the voltage at which an insulator breaks down electrically. A great many polymers do not absorb energy or transmit energy. Polyethylene, for instance, has outstanding electrical properties and has become an insulating material, replacing rubber.

B. Industrial Processing of Plastics

Not only does shaping of plastics imply molding as a physical step because at some point plastics are soft enough to be formed and shaped but it also points to a great many variations on its theme.

MOLDING

Some of the commercial molding techniques involve compression molding, transfer molding, injection molding, solvent molding, extruding, vacuum forming, blow molding, cold molding methods, and variations of all of these.

History does not reveal the exact date when man first developed his ability to mold an object. The technique goes back too far in history and was too universally used. Since mankind's first attempt to shape a piece of clay by pressing it with his hands and heating it in the sun, molding has been one of the most important

forming methods. It still is. In compression molding, for instance, instead of hands, a machine squeezes a material into shape by applying pressure; replacing the sun, or fire, for a heat source, there is mechanically operated electric heat. And rather than using one of man's first plastics—clay—the compression molding machine is fed with another plastic, a molding powder of plastic.

Compression Molding

The earliest commercial application of compression molding came when Thomas Hancock, in the early nineteenth century, perfected a process for molding rubber. However, it was Dr. Baekland's development of phenolformaldehyde resins in 1908 that launched the first synthetic molded material.

Compression molding is very much like making waffles. The basic procedure

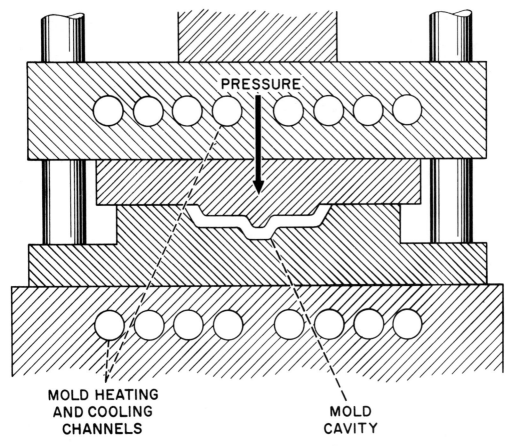

PRESSURE

MOLD HEATING
AND COOLING
CHANNELS

MOLD
CAVITY

Cross section of compression molding

is to take a molding compound (often thermosetting plastic), sometimes preheating it, and placing it into a negative or open mold cavity. The mold is closed; then heat and pressure are applied through a downward-moving force—a plug that softens the material and forces it to fill the mold cavity. The thermosetting material in the mold undergoes polymerization. When cool and the molded plastic has hardened, the mold is opened and the piece is removed.

The same method is used for thermoplastics, except that the basic polymerized material is used to fill the cavity, then heating and cooling occur in rapid sequence. When the material has cooled and hardened, it is removed from the mold. Articles containing undercuts, side draws, and small holes cannot be made by this method because they would be-

come locked into the mold after pressure and heat were applied.

Transfer Molding

A variation of compression molding is transfer molding. To overcome the disadvantages of compression molding and commensurate difficulty with articles having intricate sections, thin walls, and close tolerances, a "pot type" of transfer molding was developed (Shaw Insulator Company in 1926). Later, an improvement over this was the plunger type of transfer molding. In both these variations the material is preformed and preheated. When it is in its softened, semiplastic state it is deposited in a "pot" or "well" separate from the mold cavity. From this chamber it is forced by pressure through orifices into the closed cavity. Sprues and gates conduct the plastic material (as in

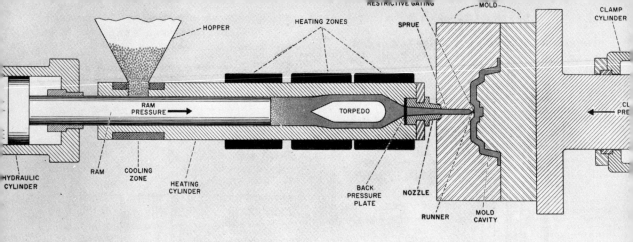

Cross section of a typical injection molding machine

bronze casting) from the supply source evenly into the cavity.

The loading time is usually shorter in transfer molding than in compression molding. Closer tolerances are possible because the mold is closed—the entrance is through sprues—and more complicated designs are possible in transfer molding.

Injection Molding

Injection molding has now become the leading method of forming thermoplastic materials. Its development was specifically for plastics. Modifications of the original patent (John Wesley Hyatt, 1872) grew with the evolvement of new plastics materials. Injection molding is based on the ability of thermoplastics to soften with heat and harden when cooled. (There are newer variations for the injection molding of thermosetting plastics.)

In injection molding, pellets or granules are fed from a feeder hopper into a long heating chamber called an injection cylinder. An injection ram or revolving screw compacts the material, after softening, at high pressure and forces it through a nozzle where it is injected into a cold mold, much like grinding meat in a grinder. When the plastic which has filled the mold cavity cools to a solid state, the mold is opened and the finished product is ejected.

Thermosetting materials are processed with jet, flow, or offset injection molding. Heat is minimized when the plastic flows through the injection cylinder and additional heat is employed when the plastic passes through the nozzle to the mold cavity. The heat in the nozzle has to be high enough to induce polymerization of the thermosetting plastic and then it has to be cooled to prevent solidification of the plastic in the nozzle.

Cold Molding

In 1908 another molding method was introduced. Cold molding, suitable for materials requiring resistance to heat, is a method, not a type of plastic.

The materials are placed in a kettle, mixed, and cooked until the proper viscosity is reached. It is then weighed or measured and placed into a conventional cold mold. Then it is subjected to pressure, enough to compress the material into the desired shape. It is now carefully removed from the mold and transferred to a heating oven until it becomes hard and infusible. Both organic and inorganic materials can be formed by this method. The result usually has a dull surface.

Solvent Molding

Solvent molding is a process for forming thermoplastic articles. Solvent is used to disperse the resin. A male mold is immersed in the resin-solvent solution or

dispersion and then withdrawn. A layer of plastic film adheres to the sides of the mold, after the solvent is drawn off or evaporates.

EXTRUSION

Although it is not strictly a molding process, because it does not use a "mold," extrusion is classified as a molding system and is often coupled with blow molding. (A plastic, here, is extruded into the blow mold and then it is blown into shape.)

Extrusion process is based on the concept that hot melted plastic can be forced through a suitable orifice producing a continuous shape. It is very much like squeezing icing through a pastry tube. Hand pressure on the pastry bag forces the plastic icing through a shaped opening at the apex of the tube.

In extrusion, dry plastic, usually in the form of pellets, is loaded into a hopper and fed into a long heating chamber where it is moved by means of a continuously revolving screw. At the end of the chamber the molten plastic is forced through a small opening, the shape of the rod, sheet film, or whatever cross-section profile controls the shape. As the plastic is extruded it is carried away, cooling as it goes onto a conveyor belt. Often blow-

ers or immersion in water aids in the cooling process. Sometimes other devices are added to the hot extruded plastic; blowing and pressure can change the cross section as it emerges from the extruding machine.

COATING

Coating is another family of techniques. The method of applying a coating to a material varies with the type of plastic to be employed. Sometimes it is sprayed on, other times dipped; another method applies air-suspended powdered resin by a sintering process. Over excessively heated metal surfaces, the plastic melts and adheres to the surface. This is a fluidized-bed technique. Knives as well as rollers can be used for spreading and coating.

Plastisols such as vinyl fluorides appear to have good weatherability. They have potential as a coating material applied over highly heated metal via dipping, spraying, or spreading. (Powdered vinyls—*Floflex*, Flexible Products Co., Marietta, Ga. 30060)

Calendering

Calendering is another method of coating. In the coating techniques both ther-

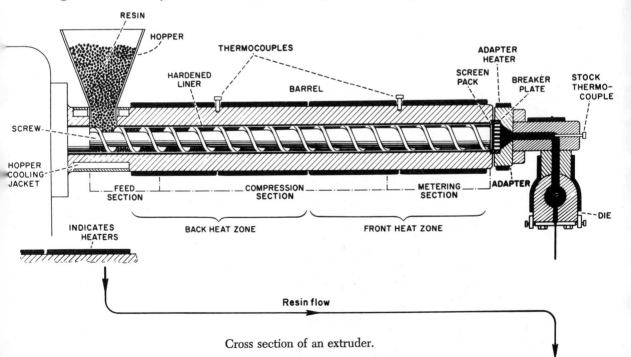

Cross section of an extruder.

Susy Green Viterbo of S. Columbomo, Italy (near Milan) forms a sculpture as it emerges from an extrusion machine.

Spatulas in hand, Mrs. Viterbo is poised before the hot, sticky plastic mass.

She pulls and twists the hot plastic aggregate into two directions and cuts it away from the machine.

The plastic removed from the extruder, she twists, pulls and pats the mass into a form. By now it is cooling and becoming rigid.

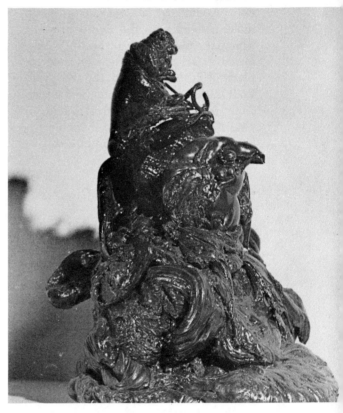

The final sculpture by Susy Green Viterbo, "Eagle in its Nest," is 30 cm. high and 20 cm. at its base. *Courtesy Susy Green Viterbo*

mosetting plastics and thermoplastics can be employed. The thickness of a coating depends upon how many applications are made, how many times an object is dipped, or the speed and space between the object to be coated and the applicator.

Calendering, sometimes a coating technique, is the making of thermoplastic sheeting and films as used by the plastics industry. In calendering, a plastic compound, usually a warm, doughy mass, is passed between a series of three or four large, heated, revolving rollers which squeeze the material between them into a sheet much like a rolling pin would roll dough into a piecrust. The final thickness of the sheet or film would be determined by the space between the last two rollers. Textural surfacing of the rollers could also texture the sheet of plastic. Calendering can also be used to fuse plastic to other materials such as paper, fabrics, etc. In this case, the coating compound

is passed through two upper horizontal rollers on a calender, while the uncoated material travels along through two bottom rollers. As the film and fabric or other materials pass through the same heated rollers they emerge as plastic-coated fabric.

SLUSH MOLDING

Slush molding is a variation of coating. Plastisols are usually used in this operation. Essentially, a preheated, hollow mold is filled with the liquid plastisol. The material adjacent to the walls is allowed to gel and the remainder of the plastisol is returned to the reservoir. Wall thickness is determined by the temperature of the mold and the length of time the plastic remains in the mold before emptying. Hollow sculpture can be formed in this manner.

ROTATIONAL MOLDING

In rotational molding, the form is made inside a closed mold or cavity. Virtually any shape or size can be made in this manner. The raw material in either a powder or liquid state is leaded into the mold or cavities and the mold halves are mechanically locked together. The prepared mold is next placed in a closed chamber where it is subjected to intense heat up to 900°F. while rotating biaxially. Rotation is at low speed, generally in the range of 0 to 40 *rpm* on the minor axis and 0 to 12 *rpm* on the major. Heat penetrates the mold or cavity walls, causing powdered raw materials to begin gelation. Simultaneously, the mold or cavities are rotating on a continuous basis and the material tends to seek the lowest point in the mold. The material "puddles" at the lowest point and gradually the entire area becomes coated with plastic evenly on the cavity walls. The part has now formed. The mold containing the part is then transferred to a cooling chamber where cold-water spray and forced air

cools the mold while it is continuing to rotate biaxially. This causes the part to cure evenly and the mold to reach handling temperature.

Spray Process

Applied with AIR atomized spray gun with a hopper feed of powder. Used with a pre-heated (350°–600°F.) substrate. Powder melts as it impinges on hot metal and flows into a smooth surface. Post baking is usually necessary.

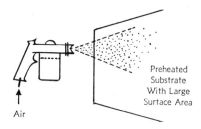

Preheated
Substrate
With Large
Surface Area

Air

Slush Molding

A pre-heated female mold is filled with aerated powder, excess is dumped and the molded object is removed after fusion and cooling.

Female Metal Mold Cavity

Rotational Molding

A multi-piece hollow mold is charged with a predetermined weight of powder. The mold is closed and rotated in an oven to distribute the plastic evenly over the surface of the mold while it is fusing.

Charged Mold
(Closed)

Rotate in
Planes
in Oven

Fused piece
in Cavity

C. Odor Test for a Very General Identification of Plastics

Plastics Material	*Odor* (Usually when heated)
Acrylics	Sweet, fruity odor
Butadiene–acrylonitrile copolymers	Hint of aniline
Casein	Burning hair
Cellulose acetate	Vinegar-like
Cellulose acetate butyrate	Rancid butter
Cellulose nitrate	Usually camphor-like
Epoxy	Phenolic odor
Ethyl cellulose	Burning oils and waxes; vinegar-like
Melamine formaldehyde	Resembles urea, ammonia, and formaldehyde
Phenolic	Carbolic; odor of phenol
Polyester	Odor of styrene (and infusible)
Polystyrene	Sweet marigold; strong sweet floral
Polyethylene	Waxy odor (not soluble in carbon tetrachloride)
Vinyl Molding Compounds	Chlorine
Urea formaldehyde	Strong formaldehyde odor

Solvents

| | RESINS | | | | | | | | |
SOLVENTS	*Acrylics*	*Alkyds*	*Cellulose Acetate*	*Epoxy*	*Polystyrene*	*Polyvinyl Acetate*	*Polyvinyl Chlorine-Acetate*	*Polyvinyl Butyral*	*Polyurethane*
ALCOHOLS Methyl Alcohol	I	P	P	P	I	S	I	S	I
Ethyl Alcohol (pure)	I	P	I	I	I	P	I	S	I
ESTERS Ethyl Acetate	S	S	P	S	S	S	P	I	S
Isopropyl Acetate	S	S	I	S	S	S	P	I	S
KETONES Acetone	S	S	S	S	S	S	S	I	S
Methyl Ethyl Ketone	S	S	P	S	S	S	S	I	S
HYDROCARBONS Aromatic: Benzene	S	S	I	I	S	S	I	I	I
Toluene	S	S	I	I	S	S	I	I	I
Xylene	P	S	I	I	S	S	I	I	P

Key: S = Soluble. P = Partly Soluble. I = Insoluble.

D. Health and Safety Factors

The toxicity and flammability of chemicals used in studio work with plastic should be of great interest to the artist-user, not only because safety and health depend upon this information-and-precaution knowledge, but to allay many rumors and misconceptions.

Since the artist does not handle large volumes, or formulate his own resin, many of the precautions should be judged on the basis of how much material is used and how long one works with it. Hobbyists need not worry if they just work with plastics occasionally. The toxicity of many of the chemicals is evident in the *initial* formulation of the resins and also to the constant user of *large* quantities of chemicals. The following report of toxicity should be interpreted as a "proportional hazard." The dangers are commensurate with use and quantity.

HEALTH HAZARDS

There has been a great interest in the toxic effects of plastics. Because of the scope required to cover the tremendous numbers and variations of plastics and their modifying agents, this material will deal only with the main types of plastics, agents, and their major working hazards. In discussing the toxicology of synthetic resins each general classification will be dealt with separately. No doubt there will be some overlapping since many chemicals produce similar reactions in comparable processes.

In general, the *AMA Archives of Industrial Health* states: "Polymerized synthetic resins, which form the base for many plastics, in themselves are usually not a hazard because of their insolubility and unreactivity. The risk arises from plasticizers, lubricants, stabilizers and fillers used with them to form the finished

plastic. There may also be significant hazards existing in the use or manufacture of the monomers of these resins, prior to polymerization."[1]

A house letter from the Monsanto Company carries this warning:

There are a number of insidious ways in which chemicals can cause harm other than by acute toxication. It is an established fact that many aromatic compounds and others, have a narcotic effect which can cause a worker to be more accident prone by lowering his awareness and lessening his powers of muscular coordination. Some chemicals such as triethanolamine, osmium compounds, ammonia, and many others can impair the eyesight of an individual and in extreme cases cause blindness. Other chemicals such as B-naphthylamine crysene and many polynuclear aromatic compounds are capable of producing cancer. Many solvents have an affinity for nerve tissue and in sufficient concentrations have a narcotic or anaesthetising action. This type of action may cause permanent or temporary damage.

Nearly all solvents are potential producers of dermatitis if allowed to come in contact with the skin. They act chiefly by a direct solvent action on the fat and cholesterol of the skin tissue. Among the solvents most likely to act as primary skin irritants are turpentine, the aromatic and chlorinated hydrocarbons, petroleum solvents, esters, ketones, alcohols, acids and carbon disulfide.

When a solvent is required to clean equipment, etc., one should always use the least toxic solvent that will do the job. For example, there is no reason to use benzine or toluene to clean equipment when alcohol will do the job. Also, always consider the fire and explosion hazards of the solvent being used. A moment's reflection on what solvent is best and least toxic, may help save a life.[2] *

In literature pertaining to health hazards of plastics and their additives, constant reference is made to the term "dermatitis." The *Plastics Safety Handbook* records a clear and concise definition of the term and its related aspects.

Occupational dermatitis of chemical origin may be caused by a primary irritant or by a sensitizer.

A primary irritant causes reaction by direct action on the skin of all individuals if the concentration and time of exposure are sufficient. Strong acids, alkalies, and solvents are examples of such irritants.

A sensitizer may not show any skin changes with initial contacts, but the skin may have become so altered that after a period of one to two weeks, or more, a subsequent contact will cause dermatitis. Examples of sensitizers are formaldehyde, hexa (hexamethylenetetramine), and certain amines.

A primary irritant may also act as a sensitizer. If an individual becomes too sensitive, even minute traces may cause a severe recurrence and he must be permanently removed from any possible exposure.

When operations or processes utilize plastics or other chemicals that are known to be capable of causing dermatitis, complete elimination of skin contact is, of course, the ideal preventive measure, but seldom attainable under operating conditions.[3]

Precautions and recommendations should be systematically followed. Many fields employ chemicals that are hazardous. In fact, a great number of art materials, in common use, are toxic. For example, in the field of ceramics there are many poisonous chemicals—many of them used in the formulation of glazes. Perhaps through their everyday practice warnings have lost their urgency.

[1] Rex H. Wilson and William E. McCormick, "Plastics," *AMA Archives of Industrial Health*, 21:56/536, June, 1960.

[2] Monsanto Co., "May Safety Meeting." May 23, 1962 (Mimeographed House Letter).

* In a letter dated May 14, 1962, from Assistant Research Director George W. Ingle of the Monsanto Co., the following difficulty was noted: "As to solvents, there has been a rash of problems—justification for various criminal acts, poisoning, etc.—arising from teen-age model-makers, 'sniffing' solvents from cements for plastics. Under the resultant 'jag,' various undesirable acts have been committed. An even more dangerous result can be permanent damage to vital organs, especially the liver. . . ."

[3] *Plastics Safety Handbook* (New York: The Society of the Plastics Industry, Inc., 1959), p. 74.

The degree of danger depends upon the individual characteristics of the material, in addition to:

1. The quantity of material involved
2. The frequency of use
3. Whether the material ignites and burns; whether it thermally decomposes by heat
4. The size of the working area
5. The source, proximity, amount, and type of ventilation
6. The working temperature, its duration
7. The room temperature.

In some instances plastics will be heated in the process of creating a form. Special attention must be given to the particular melting point, flash point, and decomposition temperatures. When heated to too high a temperature, these compounds will break down. This is called *pyrolysis*. Toxic gases may be produced by this thermal decomposition. The type and concentration of toxic gases depend on the quantity and kind of material, the size of the room, the kind and rate of ventilation, the temperature and duration of the thermal source. Examples of toxic materials are those released during pyrolysis of polyvinyl chloride and acrylonitrile materials; the products are carbon monoxide and hydrogen chloride. If additional agents are employed in the foaming of polyvinyl chloride, other volatile and toxic organic compounds are released in small quantities, as well.

These are the overall concerns. Each plastic has its own health aspects.

Acrylic Resins
(Methyl Methacrylate)

Polymerized acrylic resins are used as contact lenses, in facial surgery, as bone replacements, as artificial organs. The fact that they can be used successfully in these instances means that they do not have toxic effects—will not cause irritations in their polymerized form. These plastics are considered to be biologically inert and innocuous.

Vapors of monomeric methyl, however, ". . . have some systemic effects on the brain cortex and on the blood pressure, resulting in lowering."[4] There also have been cases reported of irritations to the mucous membranes of the nose and respiratory system.

Alkyd Resins and Modified Alkyd Resins (Polyester, etc.)

The alkyd resins are used in paints, for refrigerators and autos, food wrappings, ignition parts, and table coverings. These resins, according to two sources, are dermatologically inert.[5] Other sources state that these plastics are capable of causing occasional mild cases of dermatitis.[6]

Modified alkyd resins, such as the polyesters, are not considered toxic, either as end products or as resins. If the polyesters are modified with styrene, there might be occasional slight reactions. Styrene itself . . . "however, is not considered to be a serious health hazard in industrial use."[7] Generally, the polyesters are relatively inert and nontoxic. Allergy to polyester is rare.

Some modified alkyd resins (combinations of alkyd resins with glycols and styrene or vinyl chloride, or allyl alcohol) can be a primary irritant as well as a sensitizer. As polymerization proceeds with these materials there is consecutively less irritant power of the resin until completely cured, then the resin is innocuous.

[4] Rex H. Wilson and William E. McCormick, "Plastics," *AMA Archives of Industrial Health*, 21:57/537, June, 1960.
[5] G. E. Morris, "Condensation Plastics: Their Dermatological and Chemical Aspects," *AMA Archives of Industrial Hygiene and Occupational Medicine*, 5:37, 1952.
 Plastics Safety Handbook, The Society of the Plastics Industry, Inc., New York, 1959.
[6] Louis Schwartz, "Dermatitis from Synthetic Resins," *Journal of Investigative Dermatology*, 6:4:247, August, 1945.
[7] *Plastics Safety Handbook, op. cit.*

Amino (Urea and Melamine) Resins

These resins are manufactured into buttons, dishes, tabletops, soap fillers, finishes for textiles, and paper. Because they require heat and pressure for formulation, they are not practical for studio use. In its final cured state, the urea and melamine resins are not toxic.

The health hazards of urea-formaldehyde and melamine-formaldehyde resins are identical. In formulation their chief toxicity is exhibited by dermatitis. Exposure reactions to the amino resins during synthesis are much more pronounced than in the processing of resin. Formaldehyde may be considered a primary irritant. Any chemicals combined with formaldehyde will produce degrees of irritation if the concentration of formaldehyde in the atmosphere is permitted to reach sufficiently high levels. Irritation to eyes, nose, and bronchial tubes can then be controlled by effective ventilation and protective clothing.

The artist may use amino resins in their finally cured state. In that case he would probably employ machining and cutting operations. Resin dust may then be responsible for contact dermatitis from the presence of formaldehyde. Again protective clothing, adequate ventilation, and frequent washing of exposed skin will eliminate this possibility if one is sensitive to the traces of formaldehyde.

The *Plastics Safety Handbook* reports: "It is generally thought that about 1% to 3% of all people who are frequently exposed to formaldehyde will become sensitized to it. In these cases, re-exposure to even minute concentrations will result in a troublesome recurrence of contact dermatitis. Since these people cannot be desensitized, they should be permanently removed from any work that involves exposure to even small amounts of formaldehyde."[8]

Cellulose Plastic Materials

The cellulose materials are used extensively in packaging, frames for eyeglasses, cigarette filters, rayon acetate textiles.

All sources are in agreement that cellulose plastics can be used safely externally. They concur that only rare cases of dermatitis have been evidenced. Internal use (according to experiments feeding the material to fish and rats) can be hazardous. Also, some cases of dermatitis, although rare, have been reported in the production and manufacture of cellulose acetate. Heavy acetic acid content in the air can cause mucosil irritation, blackening of the skin, and erosion of the teeth. Lest this prove too frightening, note that acetic acid is a commonly used "stop bath" in the development of photographic films and prints.

Epoxy Resins

Epoxy resins are used in a varied and wide assortment of processes and products. They are surface coatings, castings, laminations, encapsulations, and adhesives.

The uncured liquid epoxy itself is considered safe and practically nontoxic. One brand of uncured epoxy was fed to rodents in doses ranging from six to thirty grams per kilogram of body weight without evidence of adverse symptoms.[9]

The fully cured epoxies, in addition, are practically nontoxic, nonirritating, and nonsensitizing.

The curing agents used to polymerize the epoxies, usually the amines, are caustic in uncombined condition. They can cause severe dermatitis and severe tissue damage when in direct contact with the skin for a sufficient period of time. If there is insufficient ventilation, high vapor concentrations of the amines (a curing agent frequently used) are irri-

[8] *Plastics Safety Handbook,* The Society of the Plastics Industry, Inc., New York, 1959, p. 65.
[9] Shell Chemical Company, "Industrial Hygiene Bulletin," SC:62-33, February, 1962, p. 2 (unpublished).

tating to eyes and mucous membranes. These amine curing agents, when improperly handled (without gloves and skin covering) can produce contact dermatitis, similar to that produced by poison ivy.

It has been reported that the alkanol amines, anhydride curing agents, have lower toxicity than the aliphatic amines (diethylenetriamine, triethylenetetramine, or diethylaminopropylamine) which are more commonly used. The less toxic curing agents offer a means of overcoming a major deterrent in using epoxy resins. Nevertheless, even those alkanol amines and anhydride curing systems can cause sensitization in a few users if there is excessive bodily contact.

Fluorocarbons

The fluorocarbons are used as tubing, insulation, coatings of molds and bread pans, and in surgery for sutures and tubing. The requirement of heat and pressure in processing limits their use in the art studio.

The fluorocarbon's end products are inert and nontoxic. But when conditions cause decomposition, toxic products may be produced. Teflon (trade name), an extensively researched fluorocarbon, reports ill effects when the material is used above 200°C.

The *Plastics Safety Handbook* reports:

Men exposed to inhalation of the pyrolysis products of Teflon have experienced a condition which very closely resembles the metal fume fever produced by inhaling an excessive amount of zinc fume. It has, in fact, been termed "polymer-fume fever." The symptoms are similar to those of influenza, with sore nose and throat, chills, fever, and body aches. Complete recovery with no aftereffects occurs in twenty-four to forty-eight hours.

Since metal fume fever is known to be caused by inhalation of finely divided zinc oxide particles, it has been supposed that the sublimate of Teflon is the cause of poly-mer-fume fever. This is only a hypothesis. The exact causative agent has not been identified because of inability to produce the condition in experimental animals.

Since hydrogen fluoride and some of the perfluorinated gases can cause pulmonary edema, it is possible that this condition might result from inhalation of the pyrolysis products of greatly overheated Teflon. However, there have been no reported fatalities attributable to this cause.

Experience has demonstrated that no inhalation hazard whatever exists when Teflon is handled below 200°C. Above this temperature, Teflon should be handled with good ventilation or by men wearing respiratory protection in order to avoid possible ill effects.[10]

Exposure, then, to fluorocarbon dust and to its decomposition products resulting from the high temperature of 200°C. should be avoided. Adequate ventilation, again, is a primary requisite.

Nylon (Polyamide Resins)

Nylon is used for stockings and textiles, surgical sutures, materials such as surgical tubing, catheters, toothbrush bristles, gears, slide fasteners, combs, etc. Nylon has met the rigid suture requirements of the field of medicine. Widespread use and experimentation have proved that nylon is not toxic and in external use rarely causes skin reaction.

There is no evidence to suggest that nylon is toxic. Considering its widespread use, even in monomer form it is low in toxicity, although in some cases it has affected the central nervous system and possibly caused allergic skin sensitization.

If heated to a sufficiently high temperature, it can yield toxic pyrolysis products. Nylon, generally, is more stable under heat than most other polymers.

Phenolic Resins

Phenolic resins are used in the manufacture of telephones, radio and TV cabinets, varnish, grinding wheels, plywood,

[10] *Plastics Safety Handbook,* The Society of the Plastics Industry, Inc., New York, 1959, pp. 71–72.

surgical braces, and other external surgical prosthetic devices.

Again, because of high heat and pressure requirements in manufacture, any studio use would be limited to machining.

The phenolics as finished laminations are inert and nontoxic. Their safety has been exhibited by their successful use as external surgical devices. During manufacture, however, workers exposed to these resins developed severe dermatoses. Phenol is caustic and causes burns. It can be absorbed through unbroken skin. If phenol contaminates a skin area through extended contact, general or systemic intoxication can occur.

Formaldehyde, also associated with phenol in manufacture, as has been mentioned, is also toxic. When phenol and formaldehyde are completely reacted, the risk of burning or toxicity is eliminated. If heat is applied, and ventilation is inadequate, concentrations of fumes can become great enough to cause local irritation of the eyes, nose, and throat. Before this happens, however, the odor gives pungent warning.

Polyethylene

Polyethylene is safely used in surgical repair, suture tubing, skull covering, plastic lung prosthesis, hernial repair, cartilage and bone substitutes, and as squeeze-bottles, kitchenware, packaging, etc.

Polyethylene is inert. It is a perfectly safe, nontoxic material. When adjuvants are used, such as antioxidants, some toxic reactions can occur. If the additives can be absorbed by body fluids, toxicity can occur.

Polyethylene also will pyrolyze at sufficiently high temperature and will yield not yet identified products which are irritating to the eyes and respiratory tract. Since the melting point of polyethylene is about 250°F., this pyrolyzing factor

has very little pertinence to studio uses of polyethylene, except in cases of extreme carelessness.

Silicones

Silicones are used for surgical needles, syringes, tubing, as ointment bases, for generator coils, polishes, coatings, and rubber.

Considering the general routes of entry into the body, silicones have a very low order of toxicity.

When introduced into the eye, silicone can cause conjunctival irritation but no corneal damage. Even when silicone-containing foods were fed to rats, a very low order of toxicity was shown. Skin tests also did not exhibit any irritation.[11]

The silicones, then, are practically physiologically inert and nontoxic. They are nonsensitizing and nonirritating.

Polystyrene

Polystyrenes are used in the manufacture of kitchen houseware, food packaging, toys, light fixtures, etc.

In its molded form or as supplied to manufacturers it presents no serious health hazards. There are no hazards from oral ingestion or skin contact. Polystyrene in its polymerized form is inert and nontoxic.

Some nervous excitement and occasional dermatitis have been reported when workers are exposed to the benzene in which it is dissolved during manufacture. Louis Schwartz reported dermatitis when styrene is made into synthetic rubber.

Application of heat to styrene releases an odor. When large quantities are handled it is recommended that the room be well ventilated.

Vinyl Resins

Vinyl resins are used for wearing apparel, packaging film, lining of tin cans,

[11] Rex H. Wilson and William E. McCormick, "Plastics," *AMA Archives of Industrial Health,* 21:62/542, June, 1960.

upholstery material, pipe and pipe fittings, sponges, dentures, phonograph records, anatomical repair film, and blood transfusion equipment. These resins are a group of materials; their individual health-affecting peculiarities vary.

No cases of dermatitis have been reported in the manufacture of vinyl acetate and vinyl chloride. Any irritation has been traced to the particular plasticizer and stabilizer, antioxidants, and coloring pigments contained in the resins. Otherwise these two vinyls are inert.

Polyvinyl pyrrolidone (PVP) has been given to humans and is nontoxic and can be used in the human body. Polyvinyl chloride (PVC) has been stored in the chest cavity with little reaction. During manufacture of PVC some slight skin irritation has been observed.

No special handling precautions need to be followed by the processor or fabricator of vinyls. Excessive dust, however, should be prevented. Processing involving any solvents or additives should be done only in a well-ventilated atmosphere.

Polyurethanes (Isocyanate Resins)

Polyurethanes are a high molecular weight polymer used in the manufacture of adhesives, rigid or elastic foams, and rubber.

The completely polymerized urethanes are, like most synthetic high molecular weight polymers, physiologically inert.

The diisocyanates, chemicals used in the formulation of polyurethanes, have toxicological properties. Inhalation by animals indicates great hazards. The animals that died showed acute pulmonary congestion and edema. During manufacture these compounds can be lethal in small amounts and are very irritating to mucous membranes, producing asthmatic-type reactions. The polyurethane monomers may also cause skin and eye irritations.

Polyurethane foam plastics, however, caused virtually no skin irritation or sensitization. This factor should be considered. The polyurethane foams probably are the most practical for studio use.

The usual cautions must be observed when there is a pyrolysis, because it may yield toxic products. Tests have shown that pyrolysis of isocyanate foam plastics are not any more hazardous than other foams.

Solvents and Additives

Since solvents and additives are commonly used along with the polymers, their health factors should be considered as well. The hydrocarbons are of greater importance. They have a wide variety of uses: as fuels, oils, lubricants, solvents, paints, and in dry cleaning.

Generally, the hazards associated with solvents depend upon their toxicity, vapor pressure, and method of application. Solvents can be classified according to three very general groups where there are exceptions under specific conditions. Broadly, the higher the boiling point of a member of the homologous series, the greater its toxicity.

There are three classifications:

1. The least harmful because of low vapor pressure or low inherent toxicity. They are the straight chain saturated hydrocarbons, ethyl alcohol, ether, acetone, dichloromethane, monochloroethylene, and tetrachloroethylene.

2. These are more harmful, with a higher proportion of toxicity. They are most of the chlorinated hydrocarbons, trichloroethane, homologues of benzene (benzol), chlorobenzene, hydrogenated cyclic hydrocarbons.

3. These are strongly poisonous under all conditions and require protection. They are methyl alcohol, methyl chloride, dimethyl sulfate, tetra and pentachloroethane, benzene (benzol), and carbon bisulfide.

Of the aliphatic and alicyclic hydrocarbons (the benzine group), benzine,

naphtha, and gasoline are the least hazardous. The benzol group and the aromatic hydrocarbons must be used with caution. Prolonged or repeated inhalation of benzol vapors can cause severe injury to blood-forming organs. Related materials—toluene and xylene—are less harmful because they do not cause injuries to the blood and blood-forming organs as is characterized by chronic benzol poisoning, but they are primary skin irritants because of their ability to dehydrate, remove natural oils from the skin. By rendering the skin more vulnerable they can enhance the sensitizing abilities of other chemicals.

Of the chlorinated hydrocarbons, generalities are difficult to formalize because of their wide range of volatility. They behave like their famous member, chloroform, as a narcotic. Under some conditions, chronic poisoning causes serious metabolic injuries, particularly to the liver, kidneys, and sometimes to the nervous system. They are also volatile and dangerous.

Carbon tetrachloride, the most commonly used chlorinated hydrocarbon, is one of the most toxic. Special ventilation facilities are required to remove vapors from the work area.

Alcohol, another commonly employed group, has its range of toxicity, too. Methyl alcohol is one of the most toxic and ethyl alcohol one of the least. They should not be inhaled.

Of the ketone group, acetone is a commonly used ketone. If kept below the flammability range, its vapors would cause little difficulty. The maximum acceptable concentration of methyl ethyl ketone (MEK) and methyl isobutyl ketone is less tolerable. Ketones, in excessive quantities, produce an irritant and narcotic effect.

The glycol and glycol derivative solvents have, in the main, low volatility and are relatively safe. Of these, dioxane

is toxic but its warning powers signal its danger by causing preliminary irritation to the eyes, nose, and throat.

Dermatitis can even occur among handlers of fiberglass. The glass fibers can mechanically irritate the skin by rubbing. Clothing covering the skin and gloves are recommended when using fiberglass.

FIRE HAZARDS

Use of flammable liquids in processing with plastics is a necessity. The greatest fire potential in the plastics industry comes from unpolymerized synthetic resin, plasticizers, solvents, cleaning fluids, and other components in coating and laminating work. Storage of large quantities, frequent handling, and machinery that can inflict injury multiply these industrial fire hazards. The private art workshop, where very much less material is needed, used, manipulated, and stored, is safer by comparison with industry.

It is commonplace for any art studio to store a supply of flammable materials. Alcohol, oils, turpentine, benzine, acetone, most of the solvents and some binders and vehicles, are potential fire hazards, requiring good housekeeping practices. Turpentine, for instance, has a low flash point of 95°F. The ordinary use of these combustible supplies should not lull the user into complacent disregard of safety aspects.

Since plastics are chemicals and processing plastics involves further use of chemicals, caution must be observed. Attention needs to be given to fire and explosion hazards.

Fire hazards seem to be grouped in "threes." There are three groups of flammability in plastics; and three essentials necessary for a fire; as well as three classes of fires. Plastics fall into three general groups, as established by tests at the Underwriters Laboratory.[12] They

[12] "Fire Hazards of the Plastics Industry" (New York: The National Board of Fire Underwriters. Revised Edition, 1955. Reprinted, 1959), p. 30.

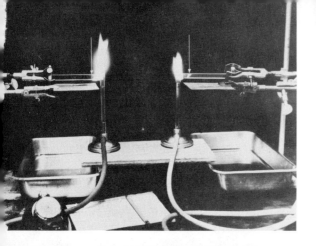

Acrylics, usually flammable materials, can be formulated into flame-resistant sheets, as these tests indicate. Top left: Flame is applied to both specimens (the flame-resistant sheet is to the right). Top right: When the flame is removed from both specimens, the standard acrylic sheet continues to burn. Bottom right: The Bunsen burner flame is again applied to the "flame-resistant" acrylic for thirty seconds. Bottom left: When the heat source has been removed again, the flame-resistant sheet on the right still does not flame, nor has the char reached the one-inch point.

Courtesy Modern Plastics

are those plastics which are more or less completely consumed and burn at a rapid rate. Most acrylics, polystyrene, cellulose-acetate, cellulose-acetate butyrate, and "Resistoflex," a polyvinyl alcohol, fall in this class. The second group are those which burn with a feeble flame that may or may not propagate away from the ignition point. The urea-formaldehydes, cast phenol-formaldehydes, cotton and wood-filled molded phenol-formaldehydes and a specimen of plasticized vinyl-chloride, vinyl acetate copolymers, fall into this group. The third group are those that burn only during application of test flame. Most of these are self-extinguishing; some burn slowly like wood. Asbestos-filled molded phenol-formaldehyde, plasticized polyvinyl-chloride, plasticized and unplasticized vinyl-chloride, vinyl acetate copolymers, some cold-molded plastics, are some of the plastics that fall into this group.

Essentials That Support Fire

Three essentials are necessary for a fire—fuel, oxygen, and a heat or ignition source. Housekeeping, storage, indeed, all fire prevention and protection principles are based on those three.

361

Flammable liquids and combustible dust are the most frequent causes of fire and explosion. A flammable liquid is a free-flowing substance which emits vapors capable of being ignited by any ignition source. The flammable liquid itself does not burn, but its vapors may burn when mixed with the optimum proportion of air or even explode when ignited. The National Board of Fire Underwriters demarcates a flammable liquid as liquid having a flash point below 200°F. and a vapor pressure not exceeding 40 pounds per square inch (absolute) at 100°F.

The rate of vaporization and the amount of air needed are not the same for ignition and burning of vapor-air mixture. The factors used to determine a flammable chemical are its flash point, ignition temperature, explosion range, vapor density, solubility in water, toxicity, specific gravity, and diffusion.

The lowest temperature at which a flammable liquid gives off vapors in sufficient quantities to form a mixture of air and vapor that is flammable immediately above the liquid's surface is called the "flash point." When the vapors of flammable liquids burn or explode there is a vapor-air mixture to support this condition. Each liquid has its upper and lower limits.

The vapor-air mixtures that lie between these two limits are the explosive range. This range is classified in industrial literature by an index of explosibility. An index rating of very much less than 0.1 is used to indicate materials which are primarily a fire hazard. In this case ignition cannot be produced by a spark or flame source, but only by an intensely heated surface. If the index of explosibility is indicated as <0.1, then the relative hazard is weak; from 0.1 to 1.0 it is moderate; 1.0 to 10 is strong; and >10 the hazard is severe.

These dust explosion hazards exist in the production of resins from the basic materials and in the formulation of com-

pounds for processing. The greater the rise in production the greater the potential danger through quantity. The degree of hazard depends upon the type of dust, its volume, and the extent of dust dispersion as well as the type of ignition.

Ignition temperature is the minimum temperature required to initiate or cause sustained combustion. Vapors of flammable liquids tend to diffuse in the air, completely dispersing and mixing like a drop of dye in water. The lighter vapors diffuse quicker than heavier vapors. The heavier vapors tend to resist dispersion and remain in low spots. They may flow along great distances on the ground.

If a plastic material is sprayed, ground, pulverized, screened, care should be taken to eliminate possible dust clouds. There should be an exhaust system at each operating point where dust is unavoidably released. If dust accumulates, it should be removed by vacuum.

Sources of ignition should be eliminated or isolated. Open flames, flame producing equipment, sparks from static charges (like unrolling a roll of plastic), discharges from electrical equipment, and mechanical sparks (sparks from welding equipment can fly 35 feet or more) should be removed from dust hazard areas and from the proximity of flammable liquids.

Flammable liquids should be stored and handled in closed containers. They should be isolated—away from fire sources and working areas. Containers storing flammable liquids should not be left open even while working.

Methods Used to Extinguish Fires

Fire control equipment should be kept nearby to extinguish any fire. There are three general methods for extinguishing a fire: first, by cooling; second, by excluding air (oxygen); and third, by removing the fuel. Combinations of these three are often employed, such as, a combination of cooling and air exclusion. Water is often the best cooling material. An as-

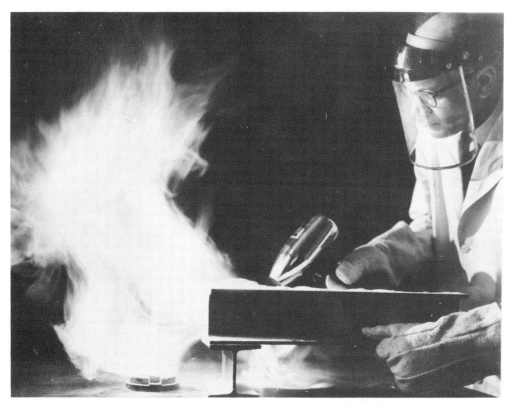

This laboratory experiment demonstrates the flammability of plastic dusts. The large white area to the left is a fire. The dust is from highly flammable cellulose acetate.

Courtesy Modern Plastics

bestos blanket or inert powders and gas can be used to suppress combustion. According to the Committee on Fire Prevention of the Society of the Plastics Industry, Inc., there are three classes of fires; each has its best extinguishing means.

Class A: fires of paper, wood excelsior, rubber, and general combustible fires require cooling and quenching. Carbon dioxide, dry chemicals, vaporizing liquids are used for small surface fires. Foam wets and smothers, soda acid quenches and cools, water cools and quenches larger fires in this class.

Class B: fires of burning liquids such as gasoline, paint, oil, grease, require a smothering action. Carbon dioxide, dry chemicals, vaporizing liquids, and foam are acceptable as extinguishers. Soda acid and water will spread this kind of fire and should not be used.

Class C: fires from machinery and electrical sources. Only carbon dioxide, dry chemicals, and vaporizing liquids are good extinguishers in this case. Foam, soda acid, and water are conductors and should never be used in electrically caused fires.

Carbon dioxide, dry chemicals, and vaporizing liquid extinguishers are the all-round best materials. These portable extinguishers should be placed in an accessible spot.

Safety Factors When Using Organic Peroxides

The organic peroxides impose a rather different situation, class, and method of control. Because of the potential destructiveness of *large* quantities of the organic peroxides, they require separate emphasis.

Organic peroxides can be solids,

liquids, and pastes. They are sold in varying concentrations to the specific processing requirements. Sometimes plasticizers or solvents are compounded with some of the concentrated peroxides. These materials, mentioned earlier, are used as catalysts for the polymerization of monomers. Actually, from a strictly chemical sense, these materials should not be termed catalysts because in their action to speed up or cause reactions they take part permanently in the polymerization. True catalysts actually start a reaction but can be removed or do not chemically combine with the reacting substances. A better term perhaps for these organic peroxides would be "initiator." Sometimes they are called hardeners, accelerators, actuators, driers, crosslinking agents.

The peroxide catalysts work, generally, by decomposing in the monomer solutions to form free radicals. These free radicals initiate and accelerate the formation of high molecular weight compounds which become a polymerized plastic.

There are three temperature classes of peroxides: low temperature 75°F. to 240°F.; intermediate 150°F. to 300°F.; and high temperature 240°F. to 300°F. This means that the initiators "work" within that temperature range. One organic peroxide may be added to a monomer to start the reaction, a second to continue the cure to a higher temperature, and sometimes a third can be added to complete the cure. These are usually room-temperature applications.

Working with fluid plastics necessitates the use of these "catalysts." Danger (although minimal because of the small amounts used in the studio) is present because the organic peroxides contain a large percentage of active oxygen. Oxygen supports combustion and explosion. Organic peroxide fires, therefore, are much more intense than fires involving ordinary flammable liquids or combustible solids. For example:

Organic peroxides decompose at low temperatures as a general rule. Acetyl peroxide (25% solution in dimethyl phthalate) is sensitive to heat and should not be subjected to temperatures above 90°F. Violent decomposition of this material may occur above 122°F. to 140°F. due to a self-accelerating decomposition. Methyl ethyl ketone peroxide (60% solution in dimethyl phthalate) will decompose rapidly at 257°F. Benzoyl peroxide which is heated over 176°F. for a short time will decompose with explosive violence, if confined.[13]

Most of the organic peroxides sold to studio users would be combined with diluents in the form of a paste or liquid. They are less sensitive to thermal shock or impact and burn at a slower rate. If these materials are exposed to sudden, excessive increases in temperature, they decompose violently—this is called thermal shock. The two most commonly used catalysts (for artist's use) are MEK peroxide and Benzoyl peroxide. MEK is the milder of the two.

[13] "Fire and Explosion Hazards of Organic Peroxides" (New York: The National Board of Fire Underwriters, 1956), p. 31.

E. Safety Procedures

A. General (For Professional Users)

1. "Allergic" people should not handle these materials.

2. Mixing, molding, curing, and tooling should be done in separate areas containing a ventilation hood that does not pull fumes up in front of the user's face, and connected to ducts that carry the vapors and dust safely outside the building.

3. Skin contact should be avoided, exercising caution and wearing protective sleeves, cotton-lined rubber gloves, clean uniforms.

4. Acetone or related solvents should not be used to clean hands—denatured alcohol is effective, followed by soap and water and then a lanolin hand cream.

5. Tables, machinery, tools, floors, walls, windows should be kept free of fiberglass spicules and resinous dust.

6. Paper towels should be used instead of rags for cleanup.

7. Grinding, sawing, polishing, dulling should be done under ventilated hoods to remove all dust and vapors.

8. Spilled solvents, resins, and catalyst should be washed from site with soap and water.

9. Neutral or acid soaps should be used in preference to alkaline or abrasive cleansers.

10. Water-soluble skin protective gels which are neutral in their pH offer a moderate auxiliary protection.

11. Protect working areas with disposable paper.

365

12. Rings and wristwatches should not be worn since they accumulate chemicals, sweat, and heat, making that skin area more vulnerable.
13. Work clothes should be of closely woven material and offer complete coverage.
14. Rashes should be considered and attended to immediately.
15. Keep fingernails short and clean.

B. Storage and Processing Rules for Organic Peroxides

Storage

1. Organic peroxides should be stored in their original containers. Methyl ethyl ketone (MEK), for instance, comes with a specially vented cap.
2. The same peroxides should be kept together. Care should be taken that they do not spill and mix together or with any other materials.
3. Do not store excessive amounts.
4. Temperature control is important in some cases. Refrigeration, although not always necessary, is a good idea. This would eliminate the dangers of overheating.
5. Always keep peroxides covered.

Processing

1. Avoid contamination of peroxides with other materials. In the case of benzoyl peroxide, this can be extremely dangerous. Use clean mixing equipment.
2. Never mix a promotor (accelerator) with an initiator or catalyst. This may cause an explosion. If a promotor is to be employed, stir it into the resin well. Then add the catalyst and mix that well, too.

3. Do not permit the catalyst to contact ignition sources. Do not smoke near a catalyst. Keep catalysts away from excessive heat.
4. Always use the proper amounts of catalyst with the monomer. Excessive amounts of organic peroxide will develop a very high exotherm. This often chars and cracks the product.
5. Be careful of impact and friction. Do not drop a bottle of peroxide. If some spills, wash it away with water, or soak up the peroxide with vermiculite or perlite, a noncombustible material, and then scrub the areas thoroughly.
6. Organic peroxides should not be added to hot materials or be placed in heated equipment. Beware the opposite. When a peroxide has crystallized due to freezing, let it thaw before handling. If the liquid has evaporated and crystals remain, treat it as an explosive. Carry it in an implement other than hands and discard it carefully.
7. Allow for adequate ventilation.

If an organic peroxide fire should occur, do not use fire extinguishers. Just sprinkle and pour large amounts of water on the fire. If it is a fire that can reach large quantities of organic peroxides, evacuate the building.

Actually, over five million pounds of organic peroxides are used annually. Many handlers are nonchemists, as well. There are few accidents. However, the potential hazards should always be kept in mind and the material should be treated with the prescribed caution.

F. Sources of Supply

Sources listed here are a random sampling, other places of supply can be found listed in your classified telephone directory. Most manufacturers prefer to sell only large quantities of supply. In that case, they will recommend a jobber for smaller orders. The companies marked with * also supply small amounts.

ADDITIVES

Ultra-Violet Light Stabilizer:

Tinuvin P
Geigy Chemical Corp.
Saw Mill River Road,
Ardsley, N.Y. 10502

Univul
General Aniline and Film Corp.
435 Hudson Street,
New York, N.Y. 10014

Epoxy Plasticizer:

Plastolein
Emery Industries, Inc.
Carew Tower,
Cincinnati, Ohio 45202

Gums:

CMC 120H or CMC 70-SH
Hercules Powder Co.
910 Market Street,
Wilmington, Del. 19804

Fire Retardants:

Hooker Chemical Co.
North Tonawanda, N.Y. 14120

Chlorowax:

Diamond Alkali Co.
300 Union Commerce Building,
Cleveland, Ohio 44115

Advastab BC-105:
Advance Solvent and Chemical Co.
Carlisle Chemical Works, Inc.
500 Jersey Avenue,
New Brunswick, N.J. 08901

Monoplex S-70 Plasticizer:
Rohm and Haas Co.
6th and Market Streets,
Philadelphia, Pa. 19106

ANTI-STATIC SOLUTIONS

Chemical Development Company
Danvers, Mass. 01923
Schwartz Chemical Company, Inc.
50-01 Second Street,
Long Island City, N.Y. 11101

CATALYST

Dowanol EP:
Dow Chemical Co.
Midland, Michigan 48640

Argus DB VIII:
Argus Chemical Corp.
633 Court Street,
Brooklyn, N.Y. 11231

MEK Peroxide, etc.:
Lucidol Division
Wallace and Tiernan Inc.
1740 Military Road,
Buffalo, N.Y. 14217

Nuodex Products Division
Heyden Newport Chemical Corp.
1 Virginia Street,
Newark, N.J. 07114

COLOR

Carbon Black:
Columbia Carbon Co.
380 Madison Avenue,
New York, N.Y. 10017

Dry Color and Polyester Paste and Liquid Dispersions:
Carbic-Hoechst Corp.
270 Sheffield Street,
Mountainside, N.J. 07092

Ferro Corporation, Color Division
Cleveland, Ohio 44105

Patent Chemical, Inc.
335 McLean Boulevard,
Paterson, N.J. 07504

Potters Bros., Inc.
Carlstadt, N.J. 07072

Plastic Molders Supply Co., Inc.
75 S. Avenue,
Fanwood, N.J. 07023

Plastics Color
Division of Crompton & Knowles Corp.
22 Commerce Street,
Chatham, N.J. 07928

FILLERS AND REINFORCEMENTS

Thixotropic Filler:
Cab-O-Sil
Cabot Corp.
125 High Street,
Boston, Mass. 02110

Thixogel
Interchemical Corporation
Finishes Division
1255 Broad Street,
Clifton, N.J. 07013

Ultrasil VN-3
Henley & Company, Inc.
202 East 44 Street,
New York, N.Y. 10017

Asbestos:
Carey-Canadian Mines, Ltd.
320 S. Wayne Avenue
Cincinnati, Ohio 45215

Raybestos Manhattan, Inc.
123 Steigle
Manheim, Pa. 17545

Calcium Carbonate:
Diamond Alkali Co.
300 Union Commerce Building,
Cleveland, Ohio 44115

Clays:
Whittaker Clark & Daniels, Inc.
100 Church Street,
New York, N.Y. 10007

Cotton Flock:
Plymouth Fibres Company, Inc.
Traffic & Palmetto Streets,
Brooklyn, N.Y. 11227

Limestone:

National Gypsum Company
Buffalo, N.Y. 14225

Metal Granules:

Metals Disintegrating Company
P.O. Box 290,
Elizabeth, N.J. 07207

U.S. Bronze Powders, Inc.
Route 202,
Flemington, N.J. 08822

Mica:

English Mica Co.
26 6th Street,
Stamford, Conn. 06905

REINFORCEMENTS

Fiberglass:

Burlington Glass Fabrics
1450 Broadway,
New York, N.Y. 10018

Ferro Corp.
Fiber Glass Division
200 Fiber Glass Road,
Nashville, Tenn. 37211

Pittsburgh Plate Glass Company
Fiberglass Division
One Gateway Center,
Pittsburgh, Pa. 15222

Western Fibrous Glass Products
739 Bryant Street,
San Francisco, Calif. 94107

Polyester Fabric:

Reemay
Du Pont
Old Hickory Plant,
Nashville, Tenn. 37211

Pre-impregnated Fabric:

Pre-preg Reinforcement Material
Cordo Division
Ferro Corp.
200 Fiber Glass Road,
Nashville, Tenn. 37211

Plastic Film:

FLEX-O-Glass, Inc.
1100 N. Cicero Avenue,
Chicago, Ill. 60651

MACHINES AND ACCESSORIES

Vacuum Forming Machines:

Di Arco Plastic Press
O'Neil-Irwin Mfg. Company
Lake City, Minn. 55041

Dymo-form
Dymo Products Company
P.O. Box 1030
Berkeley, Calif. 94701

Spencer-Lemaire Industries, Ltd.
Edmonton, Alberta
Canada

Strip Heaters:

Electric Hotpack Company, Inc.
5083 Cottman Street,
Philadelphia, Pa. 19135

Ovens:

Electric Hotpack Company, Inc.
5083 Cottman Street,
Philadelphia, Pa. 19135

Hot-wire Cutters:

Dura-Tech Corporation
1555 N.W. First Avenue
Boca Raton, Fla. 33432

MISCELLANEOUS

Liquid Crystals:

Liquid Crystal Industries
402 Princeton Drive,
Pittsburgh, Pa. 15235

Multi-lensed Plastic Sheeting:

Edmund Scientific Company
101 E. Gloucester Pike,
Barrington, N.J. 08007

Concrete Plastic Additives:

Dewey and Almy Chemical Division
W. R. Grace Company
Cambridge, Mass. 02140

Gypsum Plasters:

U.S. Gypsum Company
300 W. Adams Street,
Chicago, Illinois 60606

MOLD MATERIALS

RTV Silicone:

General Electric Co.
1 River Road,
Schenectady, N.Y. 12306

Dow Corning Corp.
Midland, Michigan 48640

Vinyl Hot Melt:

Flexible Products Co.
P.O. Box 306,
Marietta, Ga. 30060

Calresin Co.
4543 Brazil Street,
Los Angeles, California 90039

RTV Vinyls, Urethanes, Silicones:

Adhesive Products Corp.
1660 Boone Avenue,
New York, N.Y. 10060

General Fabricators
Van Nuys, Calif. 91408

Flexible Products Company
1225 Industrial Park Drive,
Marietta, Ga. 30061

Smooth-on Manufacturing Company
572 Communipaw Avenue,
Jersey City, N.J. 07304

PLASTIC POLISHES AND COMPOUNDS

Triple A Buffing Compound
Goodison Manufacturing Company
P.O. Box 128,
Rochester, Mich. 48063

Mirror Bright Polish Company
365 N. Altadena Dr.,
Pasadena, Calif. 91107

PLASTIC POWDERS AND PELLETS

Polyethylene, Polystyrene and Expandable Polystyrene Beads:

Koppers Co.
Plastics Division
Koppers Building,
Pittsburgh, Pa. 15219

Polystyrene Pellets:

California Crafts Supply
Box 154,
Buena Park, Calif. 90620

Dec-ets
Poly-Dec Company, Inc.
P.O. Box 541,
Bayonne, N.J. 07002

Shell Oil Company
Plastics Division
110 West 51st Street,
New York, N.Y. 10020

Poly-Mosaic:

Poly-Dec Company, Inc.
P.O. Box 541,
Bayonne, N.J. 07002

Polyethylene:

U.S. Industrial Chemicals Co.
99 Park Avenue,
New York, N.Y. 10016

Spencer Chemical Co.
Dwight Building,
Kansas City, Mo. 64105

PLASTIC PUTTIES

Plastic Wood:

Boyle-Midway
South Avenue and Hale Streets,
Cranford, N.J. 07016

Plastic Steel and Epoxy Bond:

Devcon Corporation
Danvers, Mass. 01923

Sculpmetal Company
701 Investment Building,
Pittsburgh, Pa. 15222

Duro-Plastic Aluminum, Liquid Steel, Gook, Celastic:

Woodhill Chemical Company
18731 Cranwood Pky.,
Cleveland, Ohio 44128

PROCESSED POLYMER PAINTS

M. Grumbacher, Inc.
460 West 34th Street,
New York, N.Y. 10001

Liquitex Permanent Pigments, Inc.
27000 Highland Avenue,
Cincinnati, Ohio 45212

Magna Color
Bocour Color Co.
555 West 52 Street,
New York, N.Y. 10019

Nu Masters Division
Hunt Manufacturing Company
1405 Locust St.,
Philadelphia, Pa. 19102

Politec
Jose L. Gutierrez
Calle Tigre #24,
Mexico 12, D.F.

Reeves and Sons, Ltd.
Lincoln Road,
Enfield, Middlesex,
England

or:

16 Apex Road,
Toronto, Canada

Shiva Artists Colors
Shiva-Rhodes Building
10th and Monroe Street,
Paducah, Kentucky 42001

F. Weber Company
Wayne and Windrim Ave.,
Philadelphia, Pa.

PAINT FOR PLASTIC

Glidden Acrylic Sign Finishes
Glidden Company
11001 Madison Avenue,
Cleveland, Ohio 44102

Keystone Refining Company, Inc.
4821–31 Garden Street,
Philadelphia, Pa. 19137

Paint Primer:

Plastisol Primer XA2-131
Compo Chemical Co.
Waltham, Mass. 02154

Barytes 12-v-6
Harshaw Chemical Co.
1945 E. 97th Street,
Cleveland, Ohio 44106

RELEASE AGENTS

Polyvinyl Alcohol:

Reynolds Metals Co.
6601 West Broad Street,
Richmond, Va. 23230

Partall:

Rexco Chemicals Company
11602 Anabel Avenue,
Garden Grove, Calif. 90240

Silicone:

Dri Film SC-87
General Electric Co.
Chemical Materials Department
1 Plastics Avenue,
Pittsfield, Mass. 01201

Ellen Products Company, Inc.
131 S. Liberty Drive,
Stony Point, N.Y. 10980

Specialty Products Corp.
15 Exchange Place,
Jersey City, N.J. 07302

RESINS AND SHEETING

Acrylic:

Lucite 44, 45
E. I. du Pont de Nemours & Co., Inc.
1007 Market Street,
Wilmington, Delaware 19801

Plexiglas—MMA Monomer, Rhoplex AC-
33, Acrysol GS, Tamol 731,
Acryloid B7, B72
Rohm & Haas Co.
6th and Market Streets,
Philadelphia, Pa. 19106

Perspex (British Acrylic)
*J.B. Henriques, Inc.
420 Lexington Avenue,
New York, N.Y. 10017

Imperial Chemicals Industries, Ltd.
Plastics Division,
Welwyn Garden City
Herts, England

Cadillac Plastic
148 Parkway,
Kalamazoo, Mich. 49006

Cast Optics Corp.
1966 S. Newman Street,
Hackensack, N.J. 07602

Industrial Plastics
324 Canal Street,
New York, N.Y. 10013
(Jobber of a large assortment of
resins, sheeting, fillers, findings,
etc.)

Epoxy:

DER 332
The Dow Chemical Co.
Midland, Michigan 48640

*Marblette
The Marblette Corp.
37–31 30th Street,
Long Island City, N.Y. 11101

Reichhold Chemicals, Inc.
525 N. Broadway,
White Plains, N.Y. 10603

Shell Chemical Company (see **Polyester Resin**)

Flameproof Polyester Resin:

Hetron Resins
Durez Plastics Division
Hooker Chemical Corporation
North Tonawanda, New York 14120

Polyester Resin:

Polyester Resin for Painting:
Polylite 8130, Polylite 92-311
Reichhold Chemicals, Inc.
RCI Building,
525 N. Broadway,
White Plains, N.Y. 10603

Water-white Polyester Resin:

Poly-lite 32-032, 32-033
Reichhold Chemicals, Inc.
RCI Building,
White Plains, N.Y. 10603

Shell Chemical Company
Plastics & Resins Division
110 West 51st Street,
New York, N.Y. 10020

American Cyanamid Company
Plastics and Resins Division
Wallingford, Conn. 06492

Diamond Alkali Company
300 Union Commerce Building
Cleveland, Ohio 44115
(This is the resin #6912 that is
manufactured in California.)

Water Extended Polyester:

Aropols Q6300, 6310, 6326, 6341
Ashland Oil Company
Columbus, Ohio

Polyester-Epoxy Alloy:

Oxiron
FMC Corp.
633 3rd Avenue,
New York, N.Y. 10016
or:
2121 Yates Avenue,
Los Angeles, Calif. 90022

Polyurethane:

Polyurethane 92-342
Reichhold Chemicals, Inc.
525 N. Broadway,
White Plains, N.Y. 10603

Polyvinyl Chloride:

Borden Chemical Co.
350 Madison Avenue,
New York, N.Y. 10017

Flexible Products Co.
P.O. Box 306,
Marietta, Ga. 30060

Geon 121
B. F. Goodrich
Chemical Division
1144 E. Market Street,
Akron, Ohio 44305

Polyvinyl Acetate:

Union Carbide Plastics Co.
270 Park Avenue,
New York, N.Y. 10017

Pyroxylin:

American Pyroxylin Corp.
72–86 Second Avenue,
Kearny, N.J. 07032
Celastic
Woodhill Chemical Corporation
18731 Cranwood Pky.
Cleveland, Ohio 44128

Urethane Foam:

Flexible Products Company
Marietta, Ga. 30060
(Make your own)

Artfoam
 100 E. Montauk Hwy.
 Lindenhurst, N.Y. 11747

Sprayable Vinyl (Cocoon):
Essex Chemical
Clifton, N.J.

R. M. Hollingshead Corp.
728 Cooper Street,
Camden, N.J. 08108

SOLVENTS

Acetone:
Shell Chemical Co.
 110 West 51 Street,
 New York, N.Y. 10020

Alcohol-"Synosol"
Union Carbide Co.
 Chemicals Co. Division
 270 Park Avenue,
 New York, N.Y. 10017

G. Trade Names, Type of Plastics and Manufacturers

Trade Name	Classification	Manufacturer
Ace Flex	vinyl	American Hard Rubber Co., New York, N.Y.
Ace Hide	styrene	American Hard Rubber Co., New York, N.Y.
Aceloid	cellulose nitrate	American Cellulose Co., Indianapolis, Ind.
Aceplus	cellulose acetate	American Cellulose Co., Indianapolis, Ind.
Ace Saran	saran	American Hard Rubber Co., New York, N.Y.
A-C Polyethylene	polyethylene	Allied Chemical & Dye Corp., New York, N.Y.
Acrilan	acrylic	Chemstrand Corp., New York, N.Y.
Acryloid	acrylic	Rohm & Haas Co., Philadelphia, Pa.
Acrylon	polyacrylic	American Monomer Co., Leominster, Mass.
Acrysol	acrylic	American Monomer Co., Leominster, Mass.
Alathon	polyethylene	E. I. du Pont de Nemours & Co., Inc., Wilmington, Del.
Allied	nylon	Allied Chemical & Dye Corp., New York, N.Y.

Trade Name	Classification	Manufacturer
Allymer	allyl	Pittsburgh Plate Glass Co., Pittsburgh, Pa.
Alpha 101 and 103	vinyl	Alpha Plastics, Inc., West Orange, N.J.
Alsynite	reinforced polyesters	Alsynite Co. of America, San Diego, Calif.
Alvar	vinyl acetate	Shawinigan Products Corp., New York, N.Y.
Amberlac	alkyd	Rohm & Haas Co., Philadelphia, Pa.
Amberlite	phenolic	Rohm & Haas Co., Philadelphia, Pa.
Amberol	phenolic	Rohm & Haas Co., Philadelphia, Pa.
Amerith	cellulose nitrate	Celanese Corp. of America, New York, N.Y.
Ameroid	casein	American Plastic Corp., New York, N.Y.
Ampacet	cellulose acetate	American Molding Powder & Chem. Corp., Brooklyn, N.Y.
Ampaloid	styrene	American Molding Powder & Chem. Corp., Brooklyn, N.Y.
Ampcoflex	vinyl	Atlas Mineral Products Co., Mertztown, Pa.
Ampcoflite	polystyrene	Atlas Mineral Products Co., Mertztown, Pa.
Amphenol	polystyrene	American Phenolic Corp., Chicago, Ill.
Apex	vinyl, polyethylene, etc.	Apex Electrical Mfg. Co., Cleveland, Ohio
Aqualite	melamine formaldehyde, phenol formaldehyde	National Vulcanized Fibre Co., Wilmington, Del.
Aquaplex	alkyd	Rohm & Haas Co., Philadelphia, Pa.
Araldite	epoxy	Ciba Co., Inc., New York, N.Y.
Acrolite	phenolic	Consolidated Molded Products Corp., Scranton, Pa.
Aristoflex	vinyl chloride acetate	Canadian General Tower, Ltd., Ontario, Canada
Aristolite	polyvinyl chloride	Canadian General Tower, Ltd., Ontario, Canada
Arochem	phenolic	U.S. Industrial Chemicals, New York, N.Y.
Aroclor	chlorinated diphenyl	Monsanto Chemical Co., Springfield, Mass.
Arodure	urea formaldehyde	U.S. Industrial Chemicals Co., New York, N.Y.
Aroplex	alkyd	U.S. Industrial Chemicals Co., New York, N.Y.
Aropol	polyester	U.S. Industrial Chemicals Co., New York, N.Y.
Atlac	polyester	Atlas Powder Co., Wilmington, Del.
Atlastavon	polyvinyl chloride	Atlas Mineral Products Co., Mertztown, Pa.
Avisco	rayon viscose acetate	American Viscose Corp., Philadelphia, Pa.
Bakelite	phenolic	Bakelite Co., New York, N.Y.
Bakelite	polyester	Bakelite Co., New York, N.Y.
Bakelite	polyethylene	Bakelite Co., New York, N.Y.
Bakelite	polystyrene	Bakelite Co., New York, N.Y.
Bakelite	vinyl	Bakelite Co., New York, N.Y.

Trade Name	Classification	Manufacturer
Beckacite	phenol	Reichhold Chemicals, Inc., New York, N.Y.
Beckamine	urea	Reichhold Chemicals, Inc., New York, N.Y.
Beckopol	phenol, copal	Reichhold Chemicals, Inc., New York, N.Y.
Beckosol	alkyd	Reichhold Chemicals, Inc., New York, N.Y.
Beetle	urea formaldehyde	American Cyanamid Co., New York, N.Y.
Boltaflex	polyvinyl chloride	General Tire & Rubber Co., Chemical/ Plastics Division, Akron, Ohio
Bolta-Quilt	vinyl	General Tire & Rubber Co., Chemical/ Plastics Division, Akron, Ohio
Boltaron	polystyrene	General Tire & Rubber Co., Chemical/ Plastics Division, Akron, Ohio
Boltaron	vinyl	General Tire & Rubber Co., Chemical/ Plastics Division, Akron, Ohio
Boronal	polyethylene-boron	Allied Resinous Products, Inc., Conneaut, Ohio
Butacite	polyvinyl butyral	E. I. du Pont de Nemours & Co., Inc., Wilmington, Del.
C-8	epoxy	Bakelite Co., New York, N.Y.
C.R.-39	allyl	Pittsburgh Plate Glass Co., Pittsburgh, Pa.
Cab-O-Sil	pyrogenic collodial silica	Cabot Corp., Oxides Div., Boston, Mass.
Cadco	acrylic	Cadillac Plastic Co., Detroit 3, Mich.
Calresin	vinyl	Calresin Corp., Los Angeles, Calif.
Cardolite	epoxy	Minn. Mining & Mfg. Co., Irvington, N.J.
Cascamite	urea	Casein Company Div., Borden Co., New York, N.Y.
Catabond	phenol formaldehyde	Catalin Corp., New York, N.Y.
Catalin	phenolic	Catalin Corp., New York, N.Y.
Catalin	polystyrene	Catalin Corp., New York, N.Y.
Catalin	urea	Catalin Corp., New York, N.Y.
Catavar	phenol formaldehyde	Catalin Corp., New York, N.Y.
Celanese	polyethylene	Celanese Corp. of America, New York, N.Y.
Calaperm	acetate	Celanese Corp. of America, New York, N.Y.
Celastic	pyroxylin	Woodhill Chemical Corp., Cleveland, Ohio
Celcos	acetate	Celanese Corp. of America, New York, N.Y.
Cellophane	cellulose	E. I. du Pont de Nemours & Co., Inc., Wilmington, Del.
Cellothene	polyethylene-cellophane	Chester Packaging Products Corp., Yonkers, N.Y.
Cellulate	cellulose acetate	National Plastics Products Corp., Odenton, Md.
Celluloid	cellulose nitrate	Celanese Corp. of America, New York, N.Y.

376

Trade Name	Classification	Manufacturer
Celluplastic	cellulose acetate	Celluplastic Corp., Newark, N.J.
Celoron	phenolic	Continental-Diamond Fiber Co., Newark, Del.
Cerex	styrene	Monsanto Chemical Co., Springfield, Mass.
Chemelec-300	polytetrafluoroethylene	U.S. Gasket Co., Camden, N.J.
Chemelec-500	polymonochloro-trifluoroethylene	U.S. Gasket Co., Camden, N.J.
Chromspun	acetate	Eastman Chemical Products, Inc., Kingsport, Tenn.
Cibanite	aniline formaldehyde	Ciba Co., Inc., New York, N.Y.
Clearsite	cellulose acetate, cellulose acetate butyrate	Celluplastic Corp., Newark, N.J.
Clearsite	polyethylene	Celluplastic Corp., Newark, N.J.
Clearsite	polystyrene	Celluplastic Corp., Newark, N.J.
Clearsite	vinyl	Celluplastic Corp., Newark, N.J.
Clopane	polyvinyl chloride	Clopay Corp., Cincinnati, O.
Cocor	cellulose	Continental-Diamond Fiber Co., Newark, Del.
Col-O-Vin	polyvinyl chloride	Columbus Coated Fabric Corp., Columbus, O.
Coltrock	phenolic	Colt's Mfg. Co., Hartford, Conn.
Consoweld	phenolic	Consolidated Water Power & Paper Co., Wisconsin Rapids, Wis.
Consoweld	melamine	Consolidated Water Power & Paper Co., Wisconsin Rapids, Wis.
Cordopreg	epoxy	Cordo Molding Products, Inc., New York, N.Y.
Cordopreg	polyester	Cordo Molding Products, Inc., New York, N.Y.
Cordura Rayon	acetate	E. I. du Pont de Nemours & Co., Inc., Wilmington, Del.
CO-3	acrylic	Cast Optics Corp., Riverside, Conn.
CO-4	acrylic	Cast Optics Corp., Riverside, Conn.
CP-1	polystyrene	Cast Optics Corp., Riverside, Conn.
CP-2	polystyrene	Cast Optics Corp., Riverside, Conn.
CR-39	allyl	Columbia Southern Chem. Corp., Barberton, Ohio
Cumar	cumarone indene; casting resin	Allied Chemical & Dye Corp., New York, N.Y.
Crystalite	methyl methacrylate	Rohm & Haas Co., Philadelphia, Pa.
Cycolac	polystyrene	Marbon Corp., Gary, Ind.
Dacron	polyester	E. I. du Pont de Nemours & Co., Inc., Wilmington, Del.
Darex	vinyl	Dewey & Almy Chemical Co., Cambridge, Mass.
Delrin	acetal resin	E. I. du Pont de Nemours & Co., Inc., Wilmington, Del.
Denflex	vinyl chloride	Dennis Chemical Co., St. Louis, Mo.
Dennis	vinyl	Dennis Chemical Co., St. Louis, Mo.
Diall	polyester	Allied Chemical Corp., New York, N.Y.
Diamond PVC	vinyl	Diamond Alkali Co., Painesville, Ohio

Trade Name	Classification	Manufacturer
Dow PVC	vinyl	Dow Chemical Co., Midland, Mich.
Dow Saran	saran	Dow Chemical Co., Midland, Mich.
Duco	cellulose derivative	E. I. duPont deNemours & Co., Inc., Wilmington, Del.
Dulux	alkyd	E. I. duPont deNemours & Co., Inc., Wilmington, Del.
Duralon	furane	U.S. Stoneware Co., Akron, Ohio
Duraplex	alkyd	Rohm & Haas Co., Philadelphia, Pa.
Durez	phenolic	Durez Plastics & Chemicals, Inc., N. Tonawanda, N.Y.
Durite	phenolic	Borden Co., New York, N.Y.
Elvacet	vinyl acetate	E. I. duPont deNemours & Co., Inc., Wilmington, Del.
Elvanol	vinyl	E. I. duPont deNemours & Co., Inc., Wilmington, Del.
Epibond	epoxy	Furane Plastics, Inc., Los Angeles, Calif.
Epon	epoxy	Shell Chemical Co., New York, N.Y.
Epoxybond	epoxy putty	Devcon Corp., Danvers, Mass.
Estron	acetate	Eastman Chemical Products Co., Kingsport, Tenn.
Ethocel	ethyl cellulose	Dow Chemical Co., Midland, Mich.
Ethofoil	ethyl cellulose	Dow Chemical Co., Midland, Mich.
Evenglo	polystyrene	Koppers Co., Inc., Pittsburgh, Pa.
Exon	polystyrene	Firestone Plastics Co., Pottstown, Pa.
Exon	vinyl	Firestone Plastics Co., Pottstown, Pa.
Fabrikoid	cellulose nitrate	E. I. duPont deNemours & Co., Inc., Wilmington, Del.
Fabrilite	vinyl	E. I. duPont deNemours & Co., Inc., Wilmington, Del.
Fashon	vinyl	General Tire & Rubber Co., Jeanette, Pa.
Fiberfil	polystyrene	Fiberfil Corp., Warsaw, Ind.
Fiberite	melamine	Fiberite Corp., Winona, Minn.
Fiberite	phenolic	Fiberite Corp., Winona, Minn.
Fibertuff	polystyrene	Koppers Co., Inc., Pittsburgh 19, Pa.
Fibestos	cellulose acetate	Monsanto Chemical Co., Springfield, Mass.
Flamenol	polyvinyl chloride	General Electric Co., Pittsfield, Mass.
Forbon	resin-free cellulosic plastic	National Vulcanized Fibre Co., Wilmington, Del.
Formvar	polyvinyl aldehyde	Shawinigan Products Corp., New York, N.Y.
Fostarene	polystyrene	Foster Grant Co., Inc., Leominster, Mass.
Gemstone	phenol formaldehyde	Knoedler Chemical Co., Lancaster, Pa.
Geon V	vinyl	B. F. Goodrich Chemical Co., Cleveland, Ohio
Gering CA	cellulose acetate	Gering Products, Inc., Kenilworth, N.J.
Gering EC	ethyl cellulose	Gering Products, Inc., Kenilworth, N.J.
Gering KRW	polymonochloro-trifluoroethylene	Gering Products, Inc., Kenilworth, N.J.
Gering NRW	nylon	Gering Products, Inc., Kenilworth, N.J.

Trade Name	Classification	Manufacturer
Gering SRW	vinylidene chloride	Gering Products, Inc., Kenilworth, N.J.
Gering TRW	polytetrafluoroethylene	Gering Products, Inc., Kenilworth, N.J.
Ger-Pak	polyvinyl chloride	Gering Products, Inc., Kenilworth, N.J.
Gilco	polystyrene	The Gilman Brothers Co., Gilman, Conn.
Glyptal	alkyd	General Electric Co., Pittsfield, Mass.
Good-Rite 50	styrene	B. F. Goodrich Chemical Co., Cleveland, Ohio
Hercocel A	cellulose acetate	Hercules Powder Co., Inc., Wilmington, Del.
Hercocel E	ethyl cellulose	Hercules Powder Co., Inc., Wilmington, Del.
Herculoid	cellulose nitrate	Hercules Powder Co., Inc., Wilmington, Del.
Hersite	phenolic	Hersite & Chemical Co., Manitowoc,Wisc.
Hycar PA	polyacrylic	B. F. Goodrich Chemical Co., Cleveland, Ohio
Hydrophen	phenol formaldehyde	Reichhold Chemicals, Inc.,White Plains, N.Y.
Insurok	phenol formaldehyde	The Richardson Co., Melrose Park, Ill.
Irrathene	polyethylene	General Electric Co., Pittsfield, Mass.
Isonol	polyols	Upjohn Co., Polymer Chemicals Div., Kalamazoo, Mich.
Isothane	polyurethane foam	Bernel Foam Products Co., Inc., Buffalo, N.Y.
Joda Acrylic	acrylic	Joseph Davis Plastics Co., Arlington, N.J.
Joda C/A	cellulose acetate	Joseph Davis Plastics Co., Arlington, N.J.
Joda C/AB	cellulose acetate butyrate	Joseph Davis Plastics Co., Arlington, N.J.
Joda C/N	cellulose nitrate	Joseph Davis Plastics Co., Arlington, N.J.
Joda E/C	ethyl cellulose	Joseph Davis Plastics Co., Arlington, N.J.
Joda P/E	polyethylene	Joseph Davis Plastics Co., Arlington, N.J.
Jodapac P/E	polyethylene	Joseph Davis Plastics Co., Arlington, N.J.
Joda Styrene H.I.	polystyrene	Joseph Davis Plastics Co., Arlington, N.J.
Kemat	chemically bonded glass mat	Fiberglass Industries, Inc., Hammond, Ind.
Kel-F	fluoroethylene	Minnesota, Mining & Mfg. Co., St. Paul, Minn.
Kodaloid	cellulose nitrate	Eastman Kodak Co., Rochester, N.Y.
Kodapak I	cellulose acetate	Eastman Kodak Co., Rochester, N.Y.
Kodapak II	cellulose acetate butyrate	Eastman Kodak Co., Rochester, N.Y.
Kodapak IV	cellulose triacetate	Eastman Kodak Co., Rochester, N.Y.
Koppers	polyethylene	Koppers Co., Inc., Pittsburgh, Pa.
Koppers	polystyrene	Koppers Co., Inc., Pittsburgh, Pa.
Korez	phenol formaldehyde	Atlas Mineral Products Co., Mertztown, Pa.
Korogel	polyvinyl chloride	The B. F. Goodrich Co., Akron, O.
Korolac	polyvinyl chloride	The B. F. Goodrich Co., Akron, O.
Koroseal	polyvinyl chloride	The B. F. Goodrich Co., Akron, O.
Kotal	alkyd	U.S. Rubber Co., Naugatuck, Conn.
Kotol	vinyl acetate	U.S. Rubber Co., Naugatuck, Conn.
Kralac A	styrene butadiene	U.S. Rubber Co., Naugatuck, Conn.
Kralastic	butadiene styrene	U.S. Rubber Co., Naugatuck, Conn.
Krene	vinyl	Union Carbide & Carbon Co., New York, N.Y.

Trade Name	Classification	Manufacturer
Laminac	polyester	American Cyanamid Co., New York, N.Y.
Lamorok	phenolic	Rogers Corp., Goodyear, Conn.
Lanese	acetate	Celanese Corp. of America, New York, N.Y.
Lauxein	casein	Monsanto Chemical Co., Springfield, Mass.
Lauxite	vinyl acetate	Monsanto Chemical Co., Springfield, Mass.
Loabond	polystyrene	Catalin Corp., New York, N.Y.
Loavar	polystyrene	Catalin Corp., New York, N.Y.
Lotol	resorcinol formaldehyde	U.S. Rubber Co., Naugatuck, Conn.
Lubrizol CA22	epoxy curing agent	Lubrizol Corp., Cleveland, Ohio
Lucite	acrylic	E. I. duPont deNemours & Co., Inc., Wilmington, Del.
Lucitone	acrylic	Celanese Corp. of America, New York, N.Y.
Lustrex	polystyrene	Monsanto Chemical Co., Springfield, Mass.
Lustron	polystyrene	Monsanto Chemical Co., Springfield, Mass.
Marblette	phenolic	Marblette Corp., Long Island City, N.Y.
Marbon	styrene	Marbon Corp., Gary, Ind.
Marco	polyester	Celanese Corp. of America, New York, N.Y.
Marvinol	vinyl	U.S. Rubber Co., Naugatuck, Conn.
Melantine	melamine formaldehyde	Ciba Co., Inc., New York, N.Y.
Melmac	melamine	American Cyanamid Co., New York, N.Y.
Melocol	polyamid formaldehyde	Ciba Co., Inc., Hoboken, N.J.
Melopas	polyamid formaldehyde	Ciba Co., Inc., Hoboken, N.J.
Melurac	melamine	American Cyanamid Co., New York, N.Y.
Metlbond	phenolic	Narmco Resins & Coatings Co., Costa Mesa, Calif.
Micarta	phenolic	Westinghouse Elec. & Mfg. Co., Pittsburgh, Pa.
Midlon A	cellulose acetate	Midwest Plastic Products Co., Chicago Hgts., Ill.
Midlon B	cellulose acetate butyrate	Midwest Plastic Products Co., Chicago Hgts., Ill.
Midlon E	ethyl cellulose	Midwest Plastic Products Co., Chicago Hgts., Ill.
Midlon H-1	polystyrene	Midwest Plastic Products Co., Chicago Hgts., Ill.
Midlon M	acrylic	Midwest Plastic Products Co., Chicago Hgts., Ill.
Midlon P	polyethylene	Midwest Plastic Products Co., Chicago Hgts., Ill.
Midlon S	polyethylene	Midwest Plastic Products Co., Chicago Hgts., Ill.
Moldarto	phenolic	Westinghouse Elec. & Mfg. Co., Pittsburgh, Pa.
MR Resin	polyester	Celanese Corp. of America, New York 16, N.Y.
Mylar	polyester	E. I. duPont deNemours & Co., Wilmington, Delaware

Trade Name	Classification	Manufacturer
Napon	epoxy	Atlas Mineral Products Co., Mertztown, Pa.
Nebellon	phenol formaldehyde	Reichhold Chemicals, Inc., White Plains, N.Y.
Nepoxide	epoxy	Atlas Mineral Products Co., Mertztown, Pa.
91-LD	phenolic	American Reinforced Plastics Co., Norwalk, Calif.
Nitrex	butadiene acrylonitrile	U.S. Rubber Co., Naugatuck, Conn.
Nitron	cellulose nitrate	Monsanto Chemical Co., Springfield, Mass.
Nobellac	phenol formaldehyde	Reichhold Chemicals, Inc., White Plains, N.Y.
Nobellon	phenol formaldehyde	Reichhold Chemicals, Inc., White Plains, N.Y.
Nubeloid	acrylate	Glidden Co., Cleveland, Ohio
Nubelon	styrene	Glidden Co., Cleveland, Ohio
Nubelyn	vinyl chloride acetate	Glidden Co., Cleveland, Ohio
Nylasint	nylon	Polymer Corp. of Pennsylvania, Reading, Pa.
Nylatron	nylon	Polymer Corp. of Pennsylvania, Reading, Pa.
Okon	bituminous	American Hard Rubber Co., New York, N.Y.
Opalite	acrylic	Catalin Corp., New York, N.Y.
Opalon	vinyl	Monsanto Chemical Co., Springfield, Mass.
Orlon	acrylic	E. I. duPont deNemours & Co., Wilmington, Del.
Paraplex	polyester	Rohm & Haas Co., Philadelphia, Pa.
Parlon	chlorinated rubber	Hercules Powder Co., Wilmington, Del.
Penacolite	resorcinol formaldehyde	Koppers, Inc., Pittsburgh, Pa.
Permaskin	vinyl butyral	Dennis Chemical Co., St. Louis, Mo.
Petrex	alkyd	Hercules Powder Co., Wilmington, Del.
Phenac	phenolic	American Cyanamid Co., New York, N.Y.
Phenolite	melamine formaldehyde	National Vulcanized Fibre Co., Wilmington, Del.
Plaskon	melamine	Allied Chemical & Dye Corp., New York, N.Y.
Plaskon	phenolic	Allied Chemical & Dye Corp., New York, N.Y.
Plaskon	polyester	Allied Chemical & Dye Corp., New York, N.Y.
Plaskon	urea	Allied Chemical & Dye Corp., New York, N.Y.
Plastacele	cellulose acetate	E. I. duPont deNemours & Co., Wilmington, Del.
Plastoloy	diallyl phthalate	Atlas Mineral Products Co., Mertztown, Pa.
Plastibond	vinyl chloride-acetate	Gordon-Lacey Chemical Prod. Co., Maspeth, N.Y.

Trade Name	Classification	Manufacturer
Plastiflex	vinyl	Calresin Corp., Los Angeles, Calif.
Plastilock	phenolic elastomer	B. F. Goodrich Co., Akron, Ohio
Plastok	bitumen	The Richardson Co., Melrose Park, Ill.
Plenco	phenolic	Plastics Engineering Co., Sheboygan, Wis.
Plexiglas	acrylic	Rohm & Haas Co., Inc., Philadelphia, Pa.
Plexigum	acrylic	Rohm & Haas Co., Inc., Philadelphia, Pa.
Plialite	rubber hydrochloride	Goodyear Tire & Rubber Co., Akron, Ohio
Pliobond	phenolic	Goodyear Tire & Rubber Co., Akron, Ohio
Pliofilm	rubber hydrochloride	Goodyear Tire & Rubber Co., Akron, Ohio
Plioflex	polyvinyl chloride	Goodyear Tire & Rubber Co., Akron, Ohio
Plioform	rubber hydrochloride	Goodyear Tire & Rubber Co., Akron, Ohio
Pliogrip	butadiene acrylonitrile	Goodyear Tire & Rubber Co., Akron, Ohio
Pliolite	styrene	Goodyear Tire & Rubber Co., Akron, Ohio
Plio-Tuf	polystyrene	Goodyear Tire & Rubber Co., Akron, Ohio
Pliovic	vinyl	Goodyear Tire & Rubber Co., Akron, Ohio
Plyophen	phenol formaldehyde	Reichhold Chemicals, Inc., White Plains, N.Y.
Polectron	vinyl carbazole	General Aniline & Film Corp., New York, N.Y.
Poly-Eth	polyethylene	Spencer Chemical Co., Kansas City, Mo.
Polyfoam	polyurethane foam	General Tire & Rubber Co., Chemical/ Plastics Division, Akron, Ohio
Polylite	polyester	Reichhold Chemicals, Inc., White Plains, N.Y.
Poly-Mosaic	thermoplastic transparent	Poly-Dec Co., Inc., Bayonne, N.J.
Polypenco	nylon	Polymer Corp. of Pennsylvania, Reading, Pa.
P.Q.L.	phenol formaldehyde	U.S. Rubber Co., Naugatuck, Conn.
Primal	acrylic	Rohm & Haas Co., Philadelphia, Pa.
Protecto	cellulose acetate	Celanese Corp. of America, New York, N.Y.
Protoflex	casein	Glyco Prod. Co., Inc., Brooklyn, N.Y.
PS-Resin	styrene	Dow Chemical Co., Midland, Mich.
Pva	polyvinyl alcohol	E. I. duPont deNemours & Co., Inc., Wilmington, Del.
Pyraheel	cellulose nitrate	E. I. duPont deNemours & Co., Inc., Wilmington, Del.
Pyralin	cellulose nitrate	E. I. duPont deNemours & Co., Inc., Wilmington, Del.
Redux	phenol acetal	Ciba Co., Inc., New York, N.Y.
Reemay	polyester reinforcement	Du Pont-Old Hickory Plant, Nashville, Tenn.
Resimene	melamine	Monsanto Chemical Co., Springfield, Mass.
Resinol	polyethylene	Allied Resins, Inc., Conneaut, Ohio
Resinox	phenolic	Monsanto Chemical Co., Springfield, Mass.
Resin-X	furan	Furane Plastics, Inc., Los Angeles, California

Trade Name	Classification	Manufacturer
Resistoflex PVA	polyvinyl alcohol	Resistoflex Corp., Belleville, N.J.
Resistojet	furan	Furane Plastics, Inc., Los Angeles, California
Resiston	polystyrene	Allied Resin Prod. Co., Conneaut, Ohio
Resorsabond	resorcinol-phenol formaldehyde	Koppers Co., Inc., Pittsburgh, Pa.
Revolite	phenolic	Atlas Powder Co., Stamford, Conn.
Rezyl	alkyd	American Cyanamid Co., New York, N.Y.
Rhoplex	acrylate	Rohm and Haas Co., Philadelphia, Pa.
Richelain	melamine, polystyrene, phenolic	The Richardson Co., Melrose Park, Ill.
Rucoam	polyvinyl chloride	Rubber Corp. of America, Brooklyn, N.Y.
Ryertex	melamine formaldehyde	Joseph T. Ryerson & Son, Chicago, Ill.
Saflex	polyvinyl butyral	Monsanto Chemical Co., Springfield, Mass.
Saran	vinyl chloride, vinylidene chloride	Dow Chemical Co., Midland, Michigan
Selectron	unsaturated polyester	Pittsburgh Plate Glass Co., Milwaukee, Wis.
Silastic	silicone rubber	Dow Corning Corp., Midland, Mich.
Silver Seal	acrylic, cellulose acetate, ethyl cellulose, polystyrene, nylon, polyethylene	Sunlite Plastics, Inc., Milwaukee, Wis.
Stix	neoprene rubber	Adhesives Products Corp., New York, N.Y.
Styraloy	polystyrene	Dow Chemical Co., Midland, Mich.
Styramic	polystyrene	Monsanto Chemical Co., Midland, Mich.
Styrofoam	polystyrene	Dow Chemical Co., Midland, Mich.
Styron	polystyrene	Dow Chemical Co., Midland, Mich.
Sunform	polyester	Sun Chemical Corp., Nutley, N.J.
Super-Bechacite	furan	Reichhold Chemicals, Inc., White Plains, N.Y.
Super-Bechamine	melamine	Reichhold Chemicals, Inc., White Plains, N.Y.
Sylplast	urea formaldehyde	FMC Corp., Organic Chemicals Div., Philadelphia, Pa.
Synthane	melamine formaldehyde phenolic, polyester	Synthane Corp., Oaks, Pa.
Syntite	vinyl alcohol	Midland Adhesive & Chemical Corp., Detroit, Mich.
Syn-U-Tex	urea formaldehyde	Minn. Mining & Mfg. Co., Irvington, N.J.
Synvar	furfuryl alcohol	Synvar Corp., Wilmington, Del.
Tec	cellulose acetate	Tennessee Eastman Co., Kingsport, Tenn.
Teca	acetate	Eastman Chemical Products, Inc., Kingsport, Tenn.
Teflon	fluoroethylene	E. I. duPont deNemours & Co., Inc., Wilmington, Del.
Tego	phenol formaldehyde	Rohm & Haas Co., Philadelphia, Pa.
Tenite	cellulose acetate	Eastman Chemical Products, Inc., Kingsport, Tenn.
Textalite	cellulose acetate butyrate, melamine formaldehyde	General Electric Co., Pittsfield, Mass.

Trade Name	Classification	Manufacturer
Thermoplax	bitumen	Cutler-Hammer, Inc., Milwaukee, Wis.
3-M	epoxy	Minn. Mining & Mfg. Co., Detroit, Mich.
Thiokol	polysulfide epoxy	Thiokol Corp., Trenton, N.J.
Thiopoxy 60 & 61	modified epoxy	Dewey & Almy Chemical Div., W. R. Grace & Co., Cambridge, Mass.
Trevarno	polyester, phenolic	Coast Mfg. & Supply Co., Livermore, California
Tygon		
Tynex	nylon	E. I. duPont deNemours & Co., Wilmington, Del.
Uformite	urea formaldehyde	Rohm & Haas Co., Philadelphia, Pa.
Ultrasil VN³	thixotropic filler	Henley & Co., Inc., New York, N.Y.
Ultron	vinyl chloride	Monsanto Chemical Co., Springfield, Mass.
Urac	urea formaldehyde	American Cyanamid Co., New York, N.Y.
Uraform	urea formaldehyde	Polymer Chemical Co., Cincinnati, Ohio
U-Sement	vinyl acetate	U.S. Rubber Co., New York, N.Y.
Valite	phenol formaldehyde	Valite Corp., New Orleans, La.
Velon	vinylidene chloride	Firestone Plastics Co., Pottstown, Pa.
Vermonite	acrylic	Rohm & Haas Co., Philadelphia, Pa.
Vibrin	polyester	U.S. Rubber Co., Naugatuck, Conn.
Vinal	polyvinyl alcohol	Union Carbide & Carbon Corp., New York, N.Y.
Vinalak	vinyl acetate	Reichhold Chemicals, Inc., White Plains, N.Y.
Vinaplas-Lac	vinyl acetate	Schwarts Chemical Co., New York, N.Y.
Vine-L	vinyl	Nixon Nitration Works, Nixon, N.J.
Vinylfilm	polyvinyl chloride	Goodyear Tire & Rubber Co., Akron, Ohio
Vinylgrip	cellulose acetate	Adhesive Products Corp., New York, N.Y.
Vinylite	vinyl acetate	Union Carbide & Carbon Corp., New York, N.Y.
Vinyon HH	vinyl chloride, vinyl acetate	American Viscose Corp., Philadelphia, Pa.
Vuepak	cellulose acetate	Monsanto Chemical Co., Springfield, Mass.
Vy King	vinyl butyral	Devoe & Raynolds Co., Louisville, Ky.
Vylene	polyvinyl chloride	Resiloid Corp., Brooklyn, N.Y.
Wallpol	styrene	Reichhold Chemicals, Inc., White Plains, N.Y.
Wataseal	polyvinyl chloride	Harte & Co., Inc., New York, N.Y.
Weldwood	urea formaldehyde	U.S. Plywood Corp., New York, N.Y.
Wynene	polyethylene, vinyl	National Plastic Products Co., Odenton, Md.
X-51	acrylic	American Cyanamid Co., New York, N.Y.
Zerok	vinyl chloride-acetate	Atlas Mineral Products Co., Mertztown, Pa.
Zytel	nylon	E. I. du Pont de Nemours & Co., Inc., Wilmington, Del.

Bibliography

A. BOOKS

Baldwin, John. *Contemporary Sculpture Techniques.* New York: Reinhold Publishing Corp., 1967.

Chaet, Bernard. *Artists At Work.* Cambridge, Mass.: Webb Books, Inc., 1960.

Cope, Dwight, Floyd Dickey (ed.). *Cope's Plastics Book.* Chicago: The Goodheart-Wilcox Co., Inc., 1957.

Doerner, Max. *The Materials of the Artist.* New York: Harcourt, Brace & Co., 1934.

Duffin, D. J. *Laminated Plastics.* New York: Reinhold Publishing Co., 1958.

Gloag, John. *Plastics and Industrial Design.* London: George Allen and Unwin Ltd., 1945.

Goldwater, Robert, and Treves, Marco. *Artists on Art.* New York: Pantheon Books, 1945.

Herberts, Kurt. *The Complete Book of Artists' Techniques.* New York: Frederick A. Praeger, 1938.

Hitchock, Henry-Russell. *Painting Toward Architecture.* New York: Duell, Sloan & Pearce, 1948.

Horn, Milton B. *Acrylic Resins.* New York: Reinhold Publishing Co., 1960.

Jacquez, Albert F. *Thermo-plastic Painting.* Chicago: Adams Press, 1960.

Jensen, Lawrence N. *Synthetic Painting Media.* Englewood Cliffs, N.J.: Prentice-Hall, Inc., 1964.

Kay, Reed. *The Painters Companion.* Cambridge, Mass.: Webb Books, Inc., 1961.

Kellaway, F. *Introducing Plastics.* London: John Crowther.

Kepes, Gyorgy. *Language of Vision.* Chicago: Paul Theobald, 1947.

Lawrence, John R. *Polyester Resin.* New York: Reinhold Publishing Co., 1960.

Mayer, Ralph. *The Artist's Handbook*. New York: The Viking Press, 1943.

Moholy-Nagy, L. *Vision in Motion*. Chicago: Paul Theobald, 1947.

Morgan, Phillip. *Glass Reinforced Plastics*. New York: Philosophical Library, 1957.

Olson, Ruth, and Chanin, Abraham. *Naum Gabo, Antoine Pevsner*. New York: The Museum of Modern Art, 1948.

Plastics Engineering Handbook of the Society of the Plastics Industry, Inc. New York: Reinhold Publishing Co., 1960.

Redfarn, C. A., and Bedford, J. *Experimental Plastics*. London: Iliffe & Sons Ltd., 1949.

Roukes, Nicholas. *Sculpture in Plastics*. New York: Watson-Guptill Publications, 1968.

Simonds, Herbert R. *Source Book of the New Plastics*. New York: Reinhold Publishing Co., Vol. I, 1959.

Woody, Jr., Russell O. *Painting with Synthetic Media*. New York: Reinhold Publishing Corp., 1965.

Yarsley, V. E., and Couzens, E. G. *Plastics*. New York: Allen Lane: Penguin Books, 1941.

B. PUBLICATIONS OF GOVERNMENT, LEARNED SOCIETIES, AND OTHER ORGANIZATIONS

Morris, G. E. "Condensation Plastics: Their Dermatological and Chemical Aspects." *AMA Archives of Industrial Health and Occupational Medicine*, #5, 1952.

Wilson, Rex H., and McCormick, William E. "Plastics." *AMA Archives of Industrial Health*, 21:56/536, June, 1960.

Janson, H. W. "Karl Zerbe." New York: Catalog *The American Federation of Arts*, 1961, p. 8.

Bakelite Company, "The ABC's of Modern Plastics." New York: Bakelite Company, 30 East 42 Street, *Second Revised Edition*, 1958.

Tenite Plastics Views, 1959. Eastman Chemical Products, Inc.

Esso Standard Oil Company, "Petrochemicals." New York: Education Division, Esso Standard Oil Company, 1958.

National Art Materials Trade Association, "Polymer Emulsion Colors." Hasbrouck Heights, N.J.: *NAMTA Sales Training Manual No. 12,* 1965.

National Board of Fire Underwriters. "Fire and Explosion Hazards of Organic Peroxides." New York, 1956.

Polymer Tempera Handbook. Somerville, Mass.: Polymera Tempera, Inc., 1956, pp. 6–7.

Allyn, Gerould. "Basic Concepts of Acrylic Emulsion Paint Technology." Philadelphia: Rohm and Haas Company, 1956.

Rohm & Haas Company. *Fabrication of Plexiglas*. Philadelphia: Rohm & Haas Company, 1959.

Rohm & Haas Company, Philadelphia. Company Bulletin 3e.

Winfield, Armand G. *Plastics for Architects, Artists and Interior Designers*. Stamford, Conn.: Society of Plastics Engineers, Inc., 1960.

Plastics Safety Handbook. New York: The Society of the Plastics Industry, Inc., 1959.

U.S. Industrial Chemicals Company. *Petrothene . . . a Processing Guide*. New York: National Distillers and Chemical Corporation, Second Edition, 1961.

C. PERIODICALS

"A Modern Medium for Fine Arts," *The Rohm and Haas Reporter*, September-October, 1957.

"Color in Plastics Is Everybody's Business," *Modern Plastics*, September, 1962, p. 85.

Hallman, Ted. "Plastic Screens," *Craft Horizons,* Vol. 18:6:20, November, 1958.

"How to Work with Gel Coats," *Modern Plastics*, June, 1962, pp. 120–121.

Krajian, George S. "Animated Exhibits with Acrylic Materials," *Curator*, III:2:129, 132, 1960.

Krieger, James H. "Future Role of the Chemist," *Progressive Architecture*, Vol. 61:6:203, June, 1960.

Leefe, Jim. "New Concepts for the Future: Architect," *Craft Horizons,* 22:3:68, May/June, 1962.

McGarry, Frederick J. "Structural Considerations," *Progressive Architecture,* June, 1960, pp. 169–171.

Monsanto Magazine, July, 1959, 39:3.

New Art Forms in Plexiglas, *Rohm and Haas Reporter,* 24:2:4, March/April, 1966.

Sanders, Morris. "Plastics and the Designer Today," *Task,* 1941, #2:35.

Schwartz, Louis. "Dermatitis from Synthetic Resins," *Journal of Investigative Dermatology,* August, 1945, 6:4:247.

D. ENCYCLOPEDIA ARTICLES

Encyclopedia of Polymer Science and Technology. "Fine Arts," Thelma R. Newman, 6:795. New York: John Wiley & Sons, Inc., 1967.

Modern Plastics Encyclopedia 1963. New York: Breskin Publications, September, 1962.

Modern Plastics Encyclopedia 1964. New York: Breskin Publications, September, 1963.

E. UNPUBLISHED MATERIALS

Feller, R. L. "New Spirit Varnishes." Pittsburgh: Mellon Institute. *National Gallery of Art Research Project No. 345-II,* July, 1961. (Mimeographed.)

Gutierrez, José. "From Fresco to Plastics, New Materials for Easel and Mural Painting." Ottawa: The National Gallery of Ottawa, Canada, 1956. (Mimeographed; out of print.)

Hoener, Arthur. "Plastic Tempera Mediums."

Jensen, Lawrence Neil. *Synthetic Media and Their Significance in Contemporary Painting.* New York: Columbia University, Unpublished Ed.D. project, 1962.

Monsanto Company, "May Safety Meeting," May 3. (Mimeographed House Letter.)

Pittsburgh Plate Glass Company, "Technical Data Sheet—Properties of Selection 5119." Pittsburgh: Pittsburgh Plate Glass Company. 3-24-54 Rev. I, p. 4. (Mimeographed.)

Pittsburgh Plate Glass Company, Technical Report, July 15, 1946.

Shell Chemical Company, Industrial Hygiene Bulletin, SC:62-33, February, 1962.

F. NEWSPAPERS

Canaday, John. "New Vistas Open for Sculpture," *The New York Times Magazine,* September 30, 1962, pp. 24–25.

Canaday, John. "Sculpture Coming Up," *The New York Times,* January 7, 1962, p. X23.

Hoving, Walter. "Are We Underdeveloped in Design?" *The New York Times Magazine,* November 18, 1962, p. 132.

Kramer, Hilton. "Plastic as Plastic. Divided Loyalties, Paradoxical Ambitions." *The New York Times,* December 1, 1968, p. D39.

Glossary of Terms

Accelerators: chemicals that speed up a re-action. Also known as *promotors*. They can never start reaction.

Acid Acceptors: compounds that stabilize chemically by combining with acids formed in the resin by decomposition, sometimes as a result of ultraviolet radiation.

Acrylic: a synthetic resin prepared from acrylic acid or from a derivative of acrylic acid. Common trade names are *Lucite* or *Plexiglas*.

Actinic Screen: materials which shut out the short-wave lengths of light, such as ul-traviolet, and their chemical reactions.

Addition Polymerization (or chain): a re-action that causes one molecule to hook on to another like molecule by addition to form a chain.

Alkyd: polyester resins made with some fatty acids as a modifier.

Allylies: a synthetic resin formed by the poly-merization of chemical compounds con-taining the group $CH_2 = CH - CH_2 -$. The principal commercial allyl resin is a casting material—allyl carbonate poly-mer.

Amino Plastics—Melamine and Urea: a synthetic resin made from reaction of melamine or urea (as the case may be) with formaldehyde or its polymers.

Amorphous Polymers: completely disorgan-ized random tangle of molecules, like a plate of spaghetti.

Antioxidant: substance that slows down or prevents oxidation of material exposed to air.

Bag Molding: application of pressure during bonding or molding, in which a flexible cover exerts pressure on the material to be molded, through the introduction of air pressure or drawing off of air by vacuuming.

Benzine Ring: the basic structure of benzine, it has a molecular structure made up of six carbon atoms having three double bonds joined in a ring.

Binding Medium: a liquid which carries the pigment particles and holds them together.

Bleed: to give up color when in contact with water or a solvent. Sometimes called *migration.*

Blowing Agents: same as *foaming agents.*

Blow Molding: a forming operation that forces air into a tube of heated plastic in a mold.

Blushing: when patches of whiteness appear in the cured resin. Unlinked portions in the molecular chain readily absorb moisture causing whiteness or blush.

Branched: a molecular structure of polymers (as opposed to *linear*), refers to side chains attached to the main chain.

Calendering: a process in which a warm doughy mass of plastic is passed between series of rollers and emerges in a flat film or sheet.

Casting: to form an object by pouring a fluid resin into a mold.

Catalyst: chemicals often used to initiate polymerization. They are supposed to act by their presence and not to be affected by the chemical reaction which they induce. In plastics, however, the catalyst can be combined and change its structure.

Cellulose: first modern plastic. A mixture of solid camphor and nitrocellulose under heat and pressure.

Cellulosic: a natural high-polymeric carbohydrate found in the fibrous matter of woody plants. Cotton fibers are one of the present forms of cellulose.

Chain Polymerization: (see addition polymerization) occurs when two different molecules react, usually spitting out water to become the repeating unit in the polymer chain.

Chemical Resistance: resistance of a plastic to chemical-acids and alkylines.

Coefficient of Linear Expansion: a fractional change in length (sometimes volume) of a material for a unit change in temperature.

Cold Flow: see *creep.*

Colloidal Dispersion: a finely divided mixture that is not chemically combined.

Copolymerization: polymerizing one plastic with another at the same time to vary or add properties to the base plastic. A copolymer is polyester which is copolymerized with styrene or methyl methacrylate.

Crazing: a network of fine cracks on or under the surface or layer of plastic.

Creep: dimensional change with time of a material under load. Creep at room temperature is sometimes called cold-flow.

Cross-Linking: setting up of chemical links between molecular chains. When extensive, as in thermosetting resins, cross-linking makes one infusible super-molecule of all the chains.

Crystalline Polymers: short sections of adjacent molecular chains lined up parallel to one another by forming regular crystal lattices, closely ordered like a pack of cigarettes.

Cure: change of physical properties by chemical reaction; usually accomplished by heat and/or catalysts, with or without pressure. Another term is *set.*

Density: weight per unit volume of a substance, expressed in grams per cubic centimeter, pounds per cubic foot, etc.

Dielectric: any material that will resist the passage of an electric current, such as a good insulator. Most plastics are good insulators.

Dimensional Stability: ability of a plastic object to retain its precise shape without change.

Dip Coating: applying a plastic coating by dipping an article into a tank of melted or liquid resin, and then chilling or rapidly curing the adhering plastic.

Dispersion: finely divided particles of a material in suspension in another substance.

Draft: the degree of taper of a side wall or the angle of clearance in a mold, to facilitate removal of parts from a mold.

Elastomer (elastomeric): an elastic, rubber-like substance, as natural or synthetic rubber.

Embedment: enclosure of an object in resin for presentation and display. The resin is always colorless and transparent.

Emulsion: a suspension of fine droplets of one liquid in another.

Encapsulating: see *potting*.

Epoxy: a straight-chain thermosetting plastic.

Exotherm: either the temperature/time curve of a chemical reaction giving off heat; or the amount of heat given off in a reaction.

Extrusion: an operation in which powdered or granular material is fed through a hopper, heated, worked through a revolving screw that forces the hot melt forward through a heating chamber and out through a shaping orifice—like the chopping of meat in a meat grinder.

Fiberglass: a material made of spun, woven, matted, or chopped fibers of glass made by spinning melted glass into filaments.

Filament: a long, thin, threadlike material; often extruded plastic made into yarn such as nylon.

Fillers: an inert substance added to a plastic to make it less costly, improve physical properties such as hardness, stiffness, and impact strength. The particles are usually smaller than reinforcements.

Fines: very small particles (under 200 mesh).

Flame Retardants: chemicals used to reduce or eliminate a plastic's tendency to burn.

Flash: extra plastic attached to a molding along the parting line.

Flash Point: lowest temperature at which a sufficient quantity of vapors are given off to form an ignitable mixture of vapor and air immediately above the surface of the liquid.

Flexibilizer: sometimes a plasticizer, is an additive that makes a resin or rubber more flexible.

Flexural Modulus or Strength: strength of a material in bending, expressed in tensile stress of the outermost fibers of a bent test sample at the instant of failure.

Flow: fluidity of plastic material usually during the molding process.

Foaming Agents: chemicals added to plastics and rubbers that generate inert gases on heating, causing the resin to assume a cellular structure.

Foam-in-Place: use of a foaming machine at the work location.

Gamma Transition or Glassy Transition: that change in the amorphous regions of a polymer from or to a viscous or rubbery condition to a hard or relatively brittle one. It is similar to the solidification of a liquid to a glassy state and occurs over a narrow temperature span. In this temperature region, hardness and brittleness undergo very rapid change. Usually thermal expansibility and specific heat also change within this temperature region.

Gamma Transition Temperature or Glassy Transmission Temperature: temperature region in which gamma or glassy transition occurs.

Gate: opening in a mold through which liquid is admitted.

Gel: a semisolid system consisting of a network of solid aggregates in which a liquid is held.

Gel Coat: a thin, outer layer of resin, sometimes containing pigment, applied to reinforced plastic molding usually as a cosmetic.

Glazing: thin or transparent painting allowing dry underlayers to show through.

Graft Copolymers: a chain of one type of polymer to which side chains of a different type are attached or grafted.

Granular Structure: nonuniform appearance of finished plastic usually due to incomplete fusion of particles within the mass.

Hardener: a substance added to a plastic to promote curing. See *catalyst*.

Heat Softening Point (or heat distortion point): the temperature at which a standard test bar deflects 0.010 inches under a stated load.

Homo-Polymerization: the polymer is built by additive combination of the monomer. For example, styrene by itself is a monomer; when combined with itself it becomes a polymer-polystyrene; that is, homogeneous or a homopolymer.

Ignitible Mixture: mixture within lower and upper limits of the flammable range that is capable of propagation of flame away from the source of ignition when lighted.

Impact Strength: ability of a material to withstand shock.

Impasto Painting: paint applied with a brush or palette knife to create thick textural effects.

Index of Refraction: the ratio of light velocity in a vacuum to light velocity in the plastic, or the ratio of the sine of the angle of light refraction measured from a perpendicular to the plastic surface.

Infrared: radiant heat (in the sense used here).

Inhibitors: chemicals that retard a reaction.

Injection Molding: a process that feeds pellets into a heating cylinder; with successive strokes a ram or a screw forces the melted material forward through a cylinder nozzle where it is injected into a cold mold.

Inorganic Pigments: natural or synthetic metallic oxides, sulfides, and other salts calcined during processing at about 1200 to 2100°F.

Isocyanate Resins: based on combinations with polyols (such as polyesters, polyethers, etc.). The reaction joins members through the formation of the urethane linkage.

Isomer: same chemical structure, composition, and weight with different configurations or grouping locations.

Laminate: superimposed layers of resin—impregnated or coated filler which is bonded together by means of heat and/or pressure to form a single piece.

Latices (*singular*, latex): a suspension in water of fine particles of rubber.

Lay-Up: process of placing reinforcing material into position in a mold.

Light Piping: ability of optical glass or polished acrylic to pass light from one end to another with little loss, even around bends.

Lubricant Bloom: an irregular, cloudy patch on a plastic surface.

Melamine: see *amino plastics*.

Melt Index: describes the flow behavior of a polymer at a specified temperature (374°F. or 190°C.) under specified pressure.

Melting Strength: strength of plastic while in a molten state.

Methyl Methacrylate: see *acrylic*.

Modulus of Elasticity: ratio of stress to strain in a material that is elastically deformed.

Mold Release Agent (separator or parting agent): a lubricant used to coat a surface to prevent plastic from sticking to it.

Molecular Weight: the relative average weight of a molecule of a substance, expressed by a number in a scale on which the weight of the oxygen atom was arbitrarily set at 16.

Monomer: relatively simple compound which can react to form a polymer.

Nylon: generic term for all synthetic polyamides.

Optical Properties: amount of transmission of visible ultraviolet light, haze, angular deviation, minor defects in a transparent material.

Orange-Peel: unintentionally rough surface, usually in injection moldings.

Organic Pigments: are usually characterized by good brightness and brilliance although not so permanent as inorganic pigments. They are divided into two classes, toners and lakes.

Organosol: a suspension of finely divided resin in a *volatile* organic liquid. The resin dissolves mainly at elevated temperatures. At that point the liquid evaporates and the residue becomes a homogeneous plastic mass when cool. Plasticizer can be dissolved in the volatile liquid.

Parting Agent: see *mold release agent*.

Parting Line: mark on a mold or cast where halves of mold meet in closing.

Phenolic: a thermosetting resin produced by condensation—a phenol-formaldehyde type.

Plastic: a substance which can be permanently formed or deformed under external stress or pressure, usually accelerated by the application of heat. The newly created form retains its shape by cooling, chemical action, or the removal of a solvent through evaporation.

Plastic Memory: quality of some thermoplastics to return to their original form after reheating.

Plasticity: quality of being able to be shaped by plastic flow.

Plasticizer: a plasticizer is a solvent that does not evaporate and makes the plastic material pliable, softer, easier to mold into shapes; any material capable of combining, but not chemically.

Plastisol: a colloidal dispersion (a suspension of finely divided resin) of a synthetic resin in a plasticizer. The resin usually dissolves at elevated temperatures. A homogeneous plastic mass results when the mixture cools.

Polyamide: a thermoplastic material—often fiber forming.

Polyester: a thermosetting resin of a syrupy consistency.

Polyethylene: a thermoplastic material formed under elevated temperatures and high pressures.

Polymer: the combined or joined smaller molecules that have formed larger molecules.

Polymerization: the act of combining two or more molecules into a single larger molecule. (Chain or addition polymerization—see *addition polymerization.*) (Condensation-three-dimensional polymerization—see *condensation polymerization.*)

Polystyrene: a water-white thermoplastic.

Pot-Life: length of time a plastic will remain a liquid before curing. To be distinguished from *shelf-life,* which see.

Promotors: a chemical, itself a feeble catalyst, that greatly increases the activity of a given catalyst.

Properties: physical qualities of plastics that enable differentiation of different plastics among themselves and other materials.

Purging: cleaning out one color or type of material before using a second color or material.

Pyrolysis: chemical decomposition by heat.

Quench: process of shock-cooling thermoplastic materials from the molten state.

Resiliency: ability of a plastic to quickly regain its original shape after having been strained or distorted.

Resin: a solid or semisolid complex, amorphous component or mixture of organic substances having no definite melting point and showing no tendency to crystallize.

Retarder: see *inhibitor.*

Scumbling: opaque instead of transparent colors are painted thinly over a dry undercoat. Surplus color is wiped off, stippled, dabbled, or rubbed with brush, rag or fingers.

Sensitizer: a chemical that after primary irritation causes sensitivity to the chemical from exposures which are so slight that they would have had little effect before sensitization. Its reaction is much like exposure of allergic people to poison ivy.

Separator: see *mold release agent.*

Set: converting liquid resin to a solid state by curing, by evaporation of a solvent, suspending medium, or gelling.

Setting Temperature: temperature needed to set a liquid resin to a solid state.

Shelf-Life: Length of time a resin will remain unpolymerized while stored.

Shrinkage: thermal contraction, continuing polymerization or cure, relaxing strains reducing the volume of plastic.

Silicone: highly heat-resistant resin derived from silica.

Sintering: process of holding powders or pellets at just below the melting point for about a half hour. Particles are fused or sintered but not melted.

Slurry: mixture of a liquid and fine material.

Slush Molding: method for casting thermoplastics in which liquid resin is poured into a hot mold where a viscous skin forms. Excess is drained off; the mold is cooled and the form is stripped out.

Solvent: any substance that dissolves other substances.

Specific Gravity: the specific gravity of water is 1. When a resin has a lower specific gravity than water, less than 1, it is lighter, will float, and has more volume for less weight; conversely, a resin with a higher specific gravity than water is heavier, will not float, and has less volume.

Spray-Up: spray gun used as a processing tool to disperse or deposit plastic, color, or fibers.

Stabilizers: ingredients added when compounding resins in order to maintain the desired chemical and physical properties at, or close to, their original values.

Step-Wise Cures: one catalyst initiates the polymerization, another one takes over above the temperature range of the first catalyst. This eliminates stresses from one temperature to another.

Stereospecific Polymerization: selectively directs the formation of polymeric chains having a predetermined steric configuration (among the many stereo-isomers theoretically possible in a given reaction). (Steric—relating to atoms in space: spatial.)

Storage Life: see *shelf-life*.

Stretch Forming: a forming technique where a heated thermoplastic sheet is stretched over a mold and subsequently cooled.

Sweating: exuding of droplets of liquid, usually plasticizer, on the surface of a plastic sheet.

Tensile Strength: measure of resistance against being pulled apart.

Thermal Degradation (thermal shock): a deleterious change in the chemical structure of the plastic due to excess heat.

Thermal Stress Cracking: crazing and cracking of some thermoplastic resins which result from overexposure to elevated temperatures.

Thermoplastic: material that softens when heated and hardens while cooling.

Thermosetting Plastic: a substance that becomes a solid when heated.

Thixotropic: the ability of a liquid to resist the pull of gravity. Materials that are gel-like at rest and fluid when agitated.

Translucent: letting light pass through but diffusing it so that objects on the other side cannot be distinguished.

Transparent: transmitting light rays so that objects on the other side can be seen distinctly.

Ultraviolet: zone of invisible radiations beyond the violet end of the spectrum. Their short wave lengths have enough energy to initiate chemical reactions and degrade some plastics and colors.

Undercut: protuberances or indentations that lock a solid form into its mold and prevent its removal.

Unsaturated Compounds: compounds having more than one bond between two adjacent atoms, usually carbon atoms, capable of adding other atoms at that point to reduce it to a single bond.

Urea: see *amino plastics*.

Urethane: see *isocyanate resins*.

U-V Stabilizer (ultraviolet): a chemical compound that when mixed with a thermoplastic selectively absorbs ultraviolet light rays.

Vacuum Forming: method of forming with sheet plastic. The plastic is clamped into a stationary frame, heated, and drawn by vacuum pressure into a mold.

Vent: a shallow channel or hole cut into a mold to allow air to escape as it is being displaced by a liquid.

Vinyl: a thermoplastic material formed through addition polymerization. Polyvinyl chloride, acetate, alcohol, butyral are members of this group.

Viscosity: the internal fluid resistance of a substance causing molecular attraction which makes it resist a tendency to flow. Low viscosity flows faster, like heavy cream. High viscosity flows slower, like molasses.

Viscosity Index: based upon an empirical number such as Pennsylvania Oil as 100, or an asphaltic oil as 0. It indicates the effect of temperature change on the flow of oil.

Warpage: dimensional distortion in a plastic object.

Welding: joining thermoplastic pieces by one of several heat softening processes; e.g., torch, friction.

Wetting Agent: a chemical that cuts the surface film of a material making it possible for color to adhere more tenaciously.

Working Life: period of time during which a liquid resin, after being mixed with a catalyst, solvent, etc., remains usable.

Yield Strength (or yield value): lowest stress at which a material undergoes deformation. Below this stress the material is elastic; above it, it is viscous.

Index

397

Overlay mats, 52–53
Overlaying cut forms, with polyesters, **137–140**
Oxidation, 44
 antioxidants, 44, 388
Oxiron, 173
 source of supply, 372

Paint, polymer, source of supply of, 370, 371
Painting
 with acrylics, 185–200, 201, 275
 drawing, initial, 276
 with ethyl silicate, 302
 grounds, 275
 mixed media, 277
 with polyesters, 119, 120, 121
 finger painting, **125–126**
 with polystyrene, 284
 with pyroxylin, 306
 with silicone, 301
 with vinyls, 245, 248, **259**, 275
Palettes
 for acrylics, 276
 color, 46–47
Paper, chopped, as filler, 50–51
Parkes, Alexander, 30
Parting agents, 58–59, 61, 71, 244, 319
 emulsions, 59
 sheet materials, 59
 silicone, 68, 298
 solvent solutions, 59
 source of supply, 371
 water solutions, 59
 waxes, 59, 312
Parting line, 391
Parylene, 29, 31
Pellets, molding, styrene, 46, 286, **289–292**
Pereira, I. Rice, **256**
Perline, 164
Permanence of work with plastics, 11, 13
Peroxides
 benzoyl peroxide paste, 238, 364
 butyl hydroperoxide, tertiary, 61, 67, 83
 methyl ethyl ketone; *see* Methyl ethyl ketone peroxide
 organic, safety factors when using, 363, 366
Persico, M., **245, 252**
Perspex, 185
 source of supply, 371
Pevsner, Antoine, **59**
Pezzo, Lucio del, 6, **10**
Phenolics, 31, 32–33, 67
 foamed, 43, 85
 odor of, 351
 toxicity of, 357
Phenoxy, 29, 31
400

Pigments, 45, 47
 inorganic, 45, 391
 organic, 45, 391
Plastic(s)
 definition of, 28, 392
 fluidity, 29
 foamed, 43
 media, mixing of, 20
 principal groups of, 31
Plasticizers, 31, 44, 46, 192
 source of supply, 367, 368
Plastisols, 42, 44, **268**, 347
 in slush molding, 350
 vinyl, in vinyl foam production, 42
Plastolein epoxy plasticizer, 46
Plexiglas, **15, 74**, 87, 185, **221**, 222, **232**
 heating of, 85
 source of supply, 371
Plexiglas Cement II, 87
Plug assist, 80
Polesello, Rogelio, **283**
Polishing operations, 91; *see also* Finishing
 for acrylics, 92, 227
 for polyester, 119
Politec, source of supply of, 371
Pollack, Jackson, 5, 306
Polyamides, 29, 31, 38–39, 392
 toxicity of, 357
Polycarbonates, 29, 31, 38–39, 86
Polyesters, 11, 29, 31, 34–35, 46, 99–172
 acrylic modified polyester resin, 239
 acrylic strips with, 131, 154
 adhering objects with, **127–136**
 drawing with, **148–149**
 premolded forms, **128–136**
 assembling material for work with, 103
 bas-relief with, 8, 121, **122–123**
 base panel construction, **104–110**
 beginning work with, 101
 blushing in, 117
 bubbles in, **65**, 118
 casting of, 118, **158–161**
 cracking of, 117
 lost wax, **164–166**
 into wax mold, **156–158**
 catalysts for, 103, 113
 color mingling, **111**
 colors for, 110
 crystal clear (Diamond Alkalis), 115, 117
 cube forms with, **128–129**
 dull spots in, 118
 dull surface of, 118
 embedded forms with, **133, 134**
 fiberglass reinforced, **64–66**, 100

Polyesters (cont.)
 finger painting with, **125–126**
 flameproofing of resin, 114
 gel coats, 114
 glass tesserae with, **134, 136**
 grouting mixture with, **136**
 impregnating with
 cloth, 119, **140–141, 162**
 rice paper, **142–143**
 lack of adhesion in spots, 118
 laminating of, **64–66**, 99, 118, **144–147**
 machining of, 100, 118
 marbelizing effects for, 110
 milky color of resin, 117
 modified by epoxy, 173
 source of supply, 372
 odor of, 100, 351
 overlaying cut forms, **137–140**
 painting with, 23, **119–121**
 finger painting, **125–126**
 gesso formula, 119, 120
 glazing effect in, 121
 impasto binder for, 121
 prime coat for, 119, 120
 pits in, 118
 Polylite, 117–119
 problems, 117
 projects with, **121–172**
 properties of, 100–101
 resin proportions, 113
 sand with, **150–154**
 sculpture with, 13, 116, 121, **158–172**
 carving solid form, **158–164**
 casting solid form, **115–116**
 form building, **170**
 impregnated fiberglass in, **167–169, 332**
 lost wax casting, **164–166**
 source of supply, 369, 372
 tacky surface of, 112, 117
 texturing of resin, **123–124**
 thixotropic mixture with, 48, **150–155**
 toxicity of, 355
 translucency rather than transparency, 118
 warping with, 112, 117
 water extended, 114
 working procedure, **101–103**
Polyethylene, 29, 31, 38–39, 86
 for casting molds, **68**, 71
 odor of, 293, 351
 as parting agent, 71
 properties of, 293
 source of supply, 370
 techniques with, **18**, 88, **294–297**
 toxicity of, 358
Poly-Lite, 58, 75, 114
Polymers, 5, 6, 29, 31, 94, **197, 199**, 275, 276, 277
 amorphous, 388
 crystalline, 389
 graft copolymers, 390
Polymer Tempera, 13, 248, 251

401

THELMA R.NEWMAN

through her education, training, and subsequent career is more than qualified as an expert on plastics and their role in the art world today.

She received her bachelor's degree from the College of the City of New York, her Master of Arts degree from New York University, and she earned her doctorate at Columbia University, Teacher's College. She has also studied sculpture under Seymour Lipton at the New School for Social Research, photography with Charlotta Corpron, Aaron Siskind, and Josef Breitenbach, and stained glass window making as an apprentice to J. Gordon Guthrie at Durham and Sons.

Widely known as a lecturer and a recognized teacher and authority on plastic sculpture and other art forms, she has exhibited her work expressing light and transparency in cities throughout the country. She has her own studio in which, between teaching, consulting and lecturing, she constantly seeks new worlds to conquer in the realm of plastics. In addition to this she is also Executive Director of *Classroom Renaissance* in the state of New Jersey, and a senior member of the Society of Plastics Engineers.